Life on a
modern planet

A manifesto for progress

Richard D. North

Manchester University Press
Manchester and New York

Distributed exclusively in the USA and Canada by St. Martin's Press

Published by Manchester University Press
Oxford Road, Manchester M13 9NR, UK
and Room 400, 175 Fifth Avenue, New York, NY 10010, USA

Distributed exclusively in the USA and Canada
by St. Martin's Press, Inc., 175 Fifth Avenue, New York,
NY 10010, USA

British Library Cataloguing-in-Publication Data
A catalogue record for this book is available from the British Library

Library of Congress Cataloging-in-Publication Data
North, Richard D., 1946–
 Life on a modern planet : rediscovering faith in progress /
Richard D. North.
 p. cm.
 Includes index.
 ISBN 0–7190–4566–5
 1. Human ecology. 2. Progress. 3. Technology—Environmental
aspects. 4. Science and civilization. I. Title.
GF50.N67 1995 94–28599
304.2—dc20 CIP

ISBN 0 7190 4566 5 *hardback*
 0 7190 4567 3 *paperback* (Not available in the USA)

Photoset in Linotron Sabon
by Northern Phototypesetting Co. Ltd, Bolton

Printed in Great Britain by
Bell and Bain Ltd, Glasgow

Contents

List of illustrations

Acknowledgements

Many people helped with information and fact-checking during the writing of this book. I thank them for their help and for adding to the fun I have had as I plunged into trying to understand ecological, economic, social and political matters which I often found daunting. As well as some British government officials who had better stay anonymous, Michael Grubb, Lloyd Timberlake, Christopher Potter, Jeff Cooper, John Ashby, Ian Campbell, Tom Wilkie, Ivan Hattingh, Rob Lockwood, Trevor Uprichard, Dan Luecke, Jim Edwardson, Richard Sandbrook, David Cumming, Chris Rose and Sue Mayer all saw drafts of the book and made useful, and sometimes very tough, criticisms. I owe them a great debt. I am as grafteful for the advice I ignored as for the advice I accepted.

I am of course tremendously pleased that Richard Purslow of Manchester University Press responded so quickly and enthusiastically to the book.

It is a pleasure to thank ICI for their financial support. Their contribution allowed about six months additional work to be done. I especially thank John Coleman and Dr Richard Robson for their open-ended, no strings attached, approach.

ICI's contribution, of information as well as money, followed the appearance of two challenging articles I wrote on ICI in the *Independent* and *The Sunday Times*. ICI did not ask for the right to any sort of editorial interference: they gave me the money and let me get on with my work. I hope and believe ICI's involvement demonstrates that a great British firm understands that helping the environmental debate find maturity is important to industry's future, as it is to the millions of people who are now and will be industry's employees,

neighbours, customers, shareholders and pensioners.

The staff at the Chemical Industries' Association let me use their information office as a library, and that saved me a lot of trouble as well as giving me a gratefully-accepted haven on daytrips to London. Hereford Library staff were very helpful.

My family have seen plenty of acknowledgements before from me, but they deserve to know that I appreciate what a joy they are, as they put up with having a writer around.

The errors in this book are of course, all mine. I will owe a debt of thanks to any reader who feels moved to comment on this edition, in the hopes that future versions will be as good as I can make them.

Dedicated to the North and Wymer families

Prologue

In Mathare Valley, Nairobi, Kenya (November 1989 and April 1992)

This book is written in the belief that the very large numbers of people who now live on the planet, and the prospect that those numbers will shortly double, require us to think carefully and boldly about the means by which decent life-chances can be spread throughout our world. This is a poor moment in which to lose our nerve.

I have been writing about green issues for twenty years. For much of that time, I was regarded as one of that small but growing body of people who were usefully promoting the green concern, and was probably thought of as a propagandist for the cause.

This book may be seen as a betrayal of that work and stance. I do not think it is. It is an attempt to reconcile my preoccupation, shared with many, about human relations with nature with another obvious concern – the wellbeing of the human species.

The book is an account of what can reasonably be said about the future of the human species and the planet on which it lives. I paint an outlook which is fairly optimistic.

I have spent some time in Mathare Valley, an inner city shantytown in Nairobi.[1] Mathare is a steep-sided gully with a river running through it. It is surrounded by some very prosperous suburbs. It is what you would expect a shanty to be. Tin shacks predominate. They often have no windows and are built on earth (mud in the rainy season); they are about the size of a kitchen in a cramped modern flat. Rubbish heaps are everywhere, and merge with the streets. There are communal lavatories scattered around, and quite a lot of the people use them. There is a good deal of brain malaria around, and it makes its victims into hopeless cases before it kills some of them.

There are grown men and fathers in the valley, but they rather seldom stay with the mothers of their numerous children and many spend as much time with mistresses as with their families. Most families are headed by women, many of whom are looking after the children of dead or absent sisters. No one knows how many of the men, women and children have AIDS, but there are plenty and perhaps even a majority who do, which is not surprising granted that most of the men are very promiscuous and many of the women survive partly on something close to prostitution. There are plenty of kids nursing dying mothers and trying to look after younger siblings too.

So the place is a pretty good mess, in which thieving relieves the misery of some, and adds to that of others, but pervades the whole place as much as the heavy stink. There is a good deal of exploitation of the extremely poor by the very poor, and of any sort of poor by the very recently ex-poor. The civic authorities are variously reported to be hopeless, helpless and helpful. Bit by bit, the tin shanty is being replaced by a multi-storey concrete one in which there is more profit for landlords and perhaps a slight chance of marginally improved hygiene – along with even greater opportunity for overcrowding.

People who work in the valley say it shows how at some point in degradation many people lose much chance of hanging on to their dignity. It is also true that some very poor people, luckier by nature or granted extraordinary toughness, become more and not less noble in the face of this misery. Partly under local leadership, there was schooling going on in the valley, and a kids' football league.

And there was an extraordinary amount of coming and going. If people have the smallest chance of making something like a living, they will be out there trying to find it with tremendous vigour. Mathare Valley is a desperate place, but it heaves with the toing and froing of 150,000 people trying to better themselves, whatever the odds.

Indeed, that is why it exists. Many of the people in Mathare Valley came because they would rather be dirt poor in the city, where there is a chance that something may come up, than be dirt poor in the village where they are pretty sure nothing will. It is hard to see it at times, but to some extent Mathare Valley is a place where the most adventurous of Kenya's many poor people live. It will not serve the people of the valley to assume the game is lost, because many of them have not themselves given up.

We cannot be over-confident. There is a sheer scale to Mathare Valley, and other big cities, which not only worries us, but feels distinctly modern. This century has seen compassion institutionalised, but also made widespread; it has seen Mao, Hitler and Stalin institutionalise violence on a huge scale. It has witnessed a new brand of social alienation which all the new institutions of welfare have proved powerless to halt – and may even have caused. It has seen new communications technologies which have been hugely successful at delivering trivial, vulgar and violent images. More constructively, they have delivered a new awareness that mankind is one interdependent species amongst many others, all living on what we suddenly see as an improbable, lovely, spaceship.

The century has seemed to accelerate human exploitation of nature, and predictably, a countervailing green thinking. The public is ambivalent about this new orthodoxy. It strikes a chord, and yet meets a reluctance at the point at which people are supposed to respond to the new ideas by overthrowing old habits and beliefs.

I think the greens' contribution is often spiritually deficient and usually practically redundant. The greens, like many feminists and socialists, belong to a blame culture which is dangerous and unhelpful because it is unnecessarily cheerless while not helping find solutions to real problems.

Greens, in particular, often characterise industrialists and scientists as misdirected and even as enemies. In fact greens are themselves a product, and a quite important flowering, of a science-based industrial society. Whether we are consumers, school-children, employers, employees, shareholders, politicians, pensioners, or neighbours, we have an identity of interest in economic wellbeing. In particular, we are all deeply involved in, and require, a degree of scientific, technical and industrial success.

Argument – even high-toned dissent – will have a role in our progress. But the core message of many Greens, that western industrial civilisation is dangerous by its very nature, will, I think, be proved wrong. Indeed, I think purist Green thinking is itself the greater danger. The Third World is crying out for much which is at the heart of western civilisation. The poor of the world have, in particular, a greater need of western industrialists than of Western green dissent.

Notes

1 For further reading on the shanties and other settlements of the Third World, see the United Nations Centre for Human Settlements' *Global Report on Human Settlements* (Oxford: Oxford University Press, 1987).

Introduction

This book has three main messages. The first is that though human numbers have grown dramatically and will soon double, this species and planet have rather good prospects. Much of this picture is given in section I. The second message is that the wellbeing of humankind, and the planet on which we live, depends on technical sophistication rather than Ludditism. The rich world has spawned a good deal of doubt and fear about its own progress, and affects a dislike of its own technology. Many people fantasise that there is some sort of simple life which might be an improvement. This view is very flawed. Much of this message is in section II.

My third proposition is that the rich world indulges in a dangerous idealism about the relations between human beings and nature and would do well to attempt a sounder reconciliation between its dreams and the realities of life. In particular, the tradition of research, sound politics, commerce, and robust debate which characterises the western world is much less flawed than is often supposed. Much of this message is in section III.

The problem that most besets green-minded people is that of human numbers. But there is very little that is easy or pleasant that we can quickly do to reduce population, or even much slow its expansion. One of the most important informing ideas of this book is that it is entirely wrong – as well as ineffective – to regret the numbers of humans who will shortly live on this planet. Each new person is, after all, a person; not known to us personally, but as valuable as any other. Chapter 1 in particular attempts a sketch of the present condition of the large numbers of people on earth.

There is a body of sound opinion which suggests that in a

generation or so we can expect to see 10 billion humans on this planet. This is because, as I discuss in Chapter 2, there are already so many young, fertile people on the earth today who live in societies where fertility is falling but still prized.

It is not likely that poor women could, let alone should, be bullied or coerced into having fewer babies than they want. Rather, they should be enabled and encouraged to have only as many babies as they would like: babies by choice rather than chance, as the British Overseas Development Agency slogan has it.[1] We have good evidence that women who see a secure future for their children and themselves become keen on family limitation. In several chapters, but initially in Chapter 2, I will be looking at the conditions which produce a sense of security. They do not by any means add up to what the west thinks of as affluence. But they are crucially dependent on economic growth. It would be easy to imagine life in the Third World becoming easier if there were fewer people. Instead we need, more practically, to remember that there will be fewer people only when life becomes easier.

This book argues that we face immense challenges of an unprecedented but recognisably human kind to which, with any luck, we will find characteristically human solutions – solutions which are characteristic of our progress so far. Chapter 3 discusses the prospect for human food supplies and farming, and Chapter 4 discusses energy prospects (and does so within the context of human effects on the planet's climate).

Humankind does not, like other creatures, merely react to environmental circumstances. In some very real sense, humans manipulate them. Our farming is of course a way of bending the productivity of environments towards our needs. Human beings were the first species to find ways to unlock stored energy without metabolising it from other life forms.

Our facility with technical advances allows our huge numbers, but it also frightens us. The middle section of the book takes several nuts-and-bolts cases which show how environmental issues are seldom quite what they seem. I examine some famous environmental 'disasters', a very distrusted chemical (chlorine), and some favourite environmental panaceas. The chapters in this section are detailed because it is important to see that it is only when hard questions are asked about such issues that the extraordinary wrongness of some common perceptions about the environment is revealed.

Humankind is unique. Only of humans is it true that they often seem to want to dominate not merely large numbers of their fellows but also every habitat they see. We have boundless ambition, and a limitless list of whims to gratify. Few humans do not chafe against the constraints imposed by their social or physical environments.

But neither territorial nor social dominance is as often or cruelly sought by humans as some greens and doomsters like to suggest.[2, 3] Humans are fascinating partly because we delight in each other and in other species in a way which is unimaginable in other animals. As humans, we are also deeply romantic about our history, and troubled by our present and our prospects. Section III begins by examining our thinking about the supposed nobility and purity of our past worlds. Our love of the primitive and the wild is discussed in chapters 9 and 10.

The process of looking after a huge number of humans will involve institution-building and many changes in the way we live. But it need not at all involve the Utopian spiritual transformation for which many purist greens call. This is just as well, given that humankind has always searched fitfully for spiritual transformation, and found it hard to come by. Chapter 11 suggests that there may be much less of a real conflict between realistic green thinking and the workaday world than might be supposed.

Human thinking about survival is bedevilled by our need to plan for everybody as best we may. Humans have to strategise as though *all* humans mattered. We are not free to imitate nature in behaving as though the sufferings of individuals were a matter of indifference. The final chapter charts the way in which western thinking has already become more helpful to the prospects of the very poor, whose treatment is always civilisation's hardest measure.

In the epilogue, we visit Mexico to see how there is really no such thing as the Third World. Countries around the world are leaping into industrialisation and it is fascinating to see the mistakes they are making – and avoiding.

A word about bias

John Maddox, the editor of the British science journal *Nature*, opened his groundbreaking book *The Doomsday Syndrome* by saying that the book was 'not a scholarly work but a complaint'.[4] Over twenty years later, as I too suggest that much Green campaigning is

misguided, I know that people will say this is not a scholarly work and is biased.

I do not pretend to perfect balance in what I write. But I think I can claim a certain fundamental fairness of approach, and that – in any case – there are enough references in the book for readers to be able to check its judgements for themselves.

This book often refers to 'despairists', 'doomsters' and 'Greens' and always with disapproval. I have adopted the convention of using 'Green' with an upper-case G to denote the purist thinking and thinkers of which I disapprove, and I keep 'green', with a lower-case g, for the more generalised ecological and environmental concern almost everyone now feels. All the individual despairists, doomsters and Greens I criticise are intelligent and have, most of them, con- tributed something to making green issues register – as they should. I criticise them for exaggerating the bad news and ignoring or under- playing the good news about this species and its prospects.

My scepticism about environmental campaigners has grown as I have increasingly found them blinkered by romantic dogmas, by political correctness or by the desire to excite their supporters or the media. I do not underrate what campaigns have achieved, but I want to correct the widespread habit of overrating it. In particular I am concerned that some of their successes have been achieved at the expense of honesty of debate, and that matters because the cultural environment is as important as the physical environment.

My criticisms of the media have arisen because of long experience of an unholy alliance between journalists and environmental cam- paigners. Sometimes, the media get it right. The tabloid press is capable of suddenly biting back at the 'environmental correctness' it sees around it, and the quality press always was a mixture of very good reporting and very bad. The tabloid media enjoys calamity, but the quality press has a more dangerous attachment to the idea that conspiracy and cover-up stalk our society. Often, the desire to paint society in these colours means that instead of political cover-up we have journalistic hype.

It is always a problem to know which scientists to trust. Some scientists may be intellectually blinkered by a desire to further their careers. Some others who work for campaign bodies (see Chapters 4 and 7) have a distinctly Green bias. I often criticise them.

I have come to respect the rigorousness of the process – mostly public – by which 'conventional' scientific statements are assessed

and honed by fellow scientists. Whenever I refer favourably to the opinions of scientists, it is because their work has been in the public scientific domain and been subject to powerful scrutiny. It is not so much the individual scientist I trust as the process in which he or she operates. That does not mean that scientific processes necessarily lead to well-run societies: scientists as much as anyone else, and perhaps more, need to operate within a social consensus.

It will surprise some readers, perhaps, that I am so keen on industry. This is simply because I have come to accept that, while we need to regulate the entrepreneurial and innovative human spirit, it has benefited society enormously. I am, I suppose, a post-socialist and post-Luddite. I hope no one will think me a gung-ho boomster on that account, but I am tolerably relaxed that western industry does its work within democratic controls, which we can tighten if we want.

Of course, one good test of a civilisation is its system and style of government. I largely enjoy ours. In its ecological thinking and regulation, it has a way to go. But then so has the electorate. One could no more approve a government which lost touch with what people want in the way of environmental control by being too adventurous, than one could approve a government which abdicated all leadership in the area. Most western governments are a little further ahead in the most important ecological matters than the bulk of their citizens, but have not left their voters hopelessly behind. Good.

I often praise western civilisation. I use the idea of the west to embrace liberal democracy, modern technology, and capitalism, which are the west's progeny but not, of course, its property. I also use the west as a shorthand for the countries of the Organisation for Economic Co-operation and Development, which includes Japan. Other cultures and non-OECD countries become honorary westerners when they embrace any parts of this inheritance. I am unabashed in my praise of the west. I think it has achieved very much, but I do not imagine that its way of life or seeing the world is the only viable or valuable one. I do however believe that the west has made at least the first part of the adjustment to living within a constraining ecological envelope and to a degree of social equity which is admirable. I agree with those who sense that there is some sort of global culture emerging and that it is predominantly western. The global culture will, with any luck, combine wealth creation with

environmental awareness and equality of opportunity with quality of opportunity. The west has seen its economic domination subside somewhat, and probably will see it subside further. The global culture will look only partly western by the time its centres of vigour are in Asia and elsewhere in the ex-Third World rather than New York or London. And yet the west invented so many different forms of progress (in commerce, the science that drives industry, and politics) that it is not absurd to use 'western' as a synonym for progressive.

I use the words 'Third World' often but with a little reluctance. The preface and epilogue show why I do not really believe that there is such a thing. On the other hand the term 'developing countries' is scarcely an accurate term for places where often the problem is that they are *not* developing very much.

Notes

1 *Children by Choice Not Chance* (London: Overseas Development Administration, March 1993).

2 Ponting, C., *A Green History of the World* (London: Sinclair Stevenson, 1991).

3 Sale, K., *The Conquest of Paradise* (London: John Curtis and Hodder and Stoughton, 1991).

4 Maddox, J., *The Doomsday Syndrome* (London: MacMillan, 1972).

I
Too many humans?

1
Snapshot of a modern planet: busy and largely successful

At the end of the Second World War we barely knew how to feed two billion people; now we feed something like five billion. Humankind is doing much better than is commonly supposed.

The doom that never came

At the time of Christ the human population of the earth was perhaps 200 million, about a twenty-fifth of what it is now. The pyramids had stood for three thousand years. The human enterprise could already be reckoned as mature, and in some important ways it was recognisably modern. At least a few favoured places had made many cultural achievements: written language, mathematics, and government. If technology was crude by modern standards, in places there was a style of agriculture which many people on earth today can only aspire to. By the time of Christ, this species had already seen civilisations come and go, their decline partly a result of the failure of their farming methods, and partly the result of natural climate changes.

Developing in technology and understanding, accumulating skills, the species passed the 1000 million mark around the year 1800. In 1993, there were getting on for 5500 million human souls.[1] About 2000 years after Christ, we can expect to see something like 6300 million people. There is wide agreement (discussed in Chapter 2) that the human population will be 10 billion sometime in the next century.[2]

The world's population was somewhere around 2 billion around the end of the Second World War. So the last couple of generations of

humans have already accomplished about half – perhaps a little less
– of the extra feeding and providing required in the period from the
mid-twentieth to the mid-twenty-first century.

This view contributes to the difficulty of believing the familiar
story of rising numbers as an unfolding disaster. The idea of the
'population explosion' is deeply-embedded in the way modern
people see their world. It is normal now for people to believe that
human numbers will create the world-shattering apocalypse which it
was once believed nuclear warheads would create. We have sub-
stituted one bomb for another. Luckily, the facts are at variance with
the fashionable view.

Environmental gloom is quite a recent human perception, and yet
it is old enough to have accumulated a history from which we can
take some comfort. If the gloomy prognostications of the 1960s and
1970s had been right, the human predicament would be much worse
than it has turned out to be.

One of the first environmental luminaries was Paul Ehrlich, Pro-
fessor of Biology at Stanford University. His writing continued a
theme made famous by a nineteenth-century classic, *The Essay on
Population*, by Edward Malthus. Malthus and Ehrlich both argued
that the rate of population growth was exponential, and that of food
production arithmetical. This is to say that populations grow very
fast – snowball – but food production only grows slowly and
steadily. Result: starvation and famine. So far, Malthusianism has
not made its case.

Paul Ehrlich is important because he articulates so clearly the
fallacious thinking of most casual observers. His most famous book,
The Population Bomb, published in 1968, begins:

> The fight to feed all of humanity is over. In the 1970s, the world will
> undergo famines – hundreds of millions of people are going to starve
> to death.[3]

As John McCormick points out in his history of the emergence of
green thinking and campaigning:

> Ehrlich was an unashamed neo-Malthusian. Criticisms that he was
> alarmist did not upset him. 'I *am* an alarmist', he told *Playboy* in 1970,
> 'because I'm very goddamned alarmed. I believe we're facing the *brink*
> because of population pressures.' ... Ehrlich warned that (1)
> hundreds of millions of people faced starvation in the 1970s and

1980s, (2) the limits of human capability to produce food by conventional means had nearly been reached, (3) attempts to increase food production would cause environmental deterioration and reduce the earth's capacity to produce food, (4) population growth could lead to plague and nuclear war, and (5) the only solution lay in a change in human attitudes.[4]

As evidenced by their latest book *The Population Explosion*,[5] the Ehrlichs (Paul Ehrlich is joined by his wife Anne for later books) do not seem to be much chastened by the way their earlier predictions of mass starvations and a world incapable of growing sufficient food were found to be off-beam. Writing in 1990, the Ehrlichs say that about 10 million people, mostly children, have annually perished needlessly of hunger and hunger-related disease over the past couple decades. This is sad enough, if true, but is a much lesser effect than they predicted two decades earlier. But the passing years have not brought the Ehrlichs to a happier interpretation of the data they very usefully draw to people's attention.

According to *The Population Explosion* something pretty dreadful is already happening, with worse to come:

> The alarm has been sounded repeatedly, but society has turned a deaf ear. Meanwhile, a largely prospective disaster has been turned into the real thing. A 1990s primer on population by necessity looks very different from our original work. *The Population Explosion* is being written as ominous changes in the life-support systems of civilisation become more evident daily. It is being written in a world where hunger is rife and the prospects of famine ever more imminent.

The truer picture is much more richly-textured than the Ehrlichs imply. The World Bank, in one of the bold sentences its annual *World Development Report* favours (this one was issued in June 1991), puts things very differently:

> Famines disappeared from Western Europe in the mid-1800s, from Eastern Europe in the 1930s, and from Asia in the 1970s.[6]

Of course, it is nonetheless true that hundreds of millions of people are undernourished, and millions die of diseases against which better nourishment would have provided part of a defence.[7] A billion people are classified as poor and over half of them live in extreme poverty. Even allowing for the difficulty of assessing these things across profound cultural barriers, there clearly is widespread hunger

and malnutrition in the world, and they contribute to an essentially avoidable death-toll. The World Health Organisation suggests, uncontroversially, as the Ehrlichs do, that these deaths arise because of hunger's power to weaken people's ability to fight commonplace disease:

> Interactions between nutrition and infection to produce the 'malnutrition/infection complex' create the greatest public health problem in the world.[8]

However, the famines and mass starvations predicted by Paul Ehrlich are not happening in the 1990s, and did not happen in the 1970s or 1980s either. Such famines as we see, it is widely agreed, are the result of war, not ecological collapse.[9] The evidence that mass starvation is avoidable and will probably stay avoided gets more convincing, not less, as we shall see in Chapter 3. Similarly, the evidence is that economic incompetence and political nastiness are far more likely contributors to present and most future disasters than is the environmental failure predicted for so long by the Ehrlichs.

Sketching the success in food

The World Health Organisation gives a clear, blunt picture of the world's present human food supply:

> Current and emerging food production and preservation capabilities are sufficient to ensure an adequate global supply of safe nutritious food. The food trade has increased markedly, resulting in an international market and creating a growing demand for the safe preservation of food during prolonged shipment. Improved food storage and processing considerably increase the availability of food for human consumption by limiting food spoilage and reducing food and crop wastes. Chronic hunger is due less to food shortage than to lack of purchasing power or of land on which food can be produced, or disruption of food distribution systems by civil unrest or violence. However, drastic changes in the agriculture, food and fishery sectors will be required to achieve an adequate food supply for the 7000 million or more people who will inhabit the world by the year 2010, if damage to the environment and risk of spreading infectious diseases are to be avoided. In particular, the problems of pre-harvest and post-harvest losses will need to receive special attention. . . . Although agricultural supplies in most parts of the world appear to have kept up with the demand for food and, on the whole, per caput food supplies

have shown some improvement over the last two decades except in some parts of Africa, FAO has estimated that by the end of the century the number of seriously malnourished people will reach 590 million.[10]

It is a common misconception that the entire developing world is suffering hunger. In fact, says the main UN development agency:

> There has been a general global improvement in food production and calorie supplies. The daily supply of calories in the developing world improved from 90 per cent of total requirements in 1965 to 107 per cent in 1985. Confirming this evidence, production data show a roughly 20 per cent increase in average calories supplies per person between 1965 and 1985.[11]

Not only is there enough food in the world as a whole to feed everyone now on it, there is enough food in the developing world to feed every one of its citizens. However, the picture is uneven, both between countries and within them. UNDP continues:

> Countries having the most urgent need for food show the slowest progress. For the poorest countries [as a group], the daily per caput calorie supply increased only from 87 percent of the total requirements to 89 percent between 1965 and 1985.[12]

The annual account by the Food and Agriculture Organisation of the United Nations of the condition of world farming and food put it in this way at the very beginning of this decade:

> A wide gap of over 900 calories per caput per day currently separates average calorie supply in developed and developing countries. However, since calorie supply rose faster in developing regions, the gap has narrowed significantly since the early 1970s. Thus DES [dietary energy supply] in developing countries was equivalent to 65 per cent of that in developed countries in 1969–71 compared to 72 per cent in 1986–88.[13]

So, far from the familiar, wrong view about food supply, we can say that while the developing world is probably overfed, as well as financially embarrassed by the amount of food its farmers produce, the Third World is not, as a whole, hopelessly out of touch with the rich-world production and consumption record. It is true and a pity that the rate at which the Third World is catching up with the rich world slowed in the 1980s. The per caput supply of food rose less quickly in all the regions of the developing world in the 1980s than it

had in the 1970s.[14] All the same a situation which is improving less quickly than it used to is *still* an improving situation – not a deteriorating one.

Because so much suffering is involved, it is important to see the shadows in this fairly bright view. The numbers of undernourished people in the world have been rising for at least twenty years. According to the FAO, the hungry within the developing countries outside the Eastern Bloc and China rose by an estimated 15 million during the 1970s and by 37 million during the first few years of the 1980s. The hungry then numbered about 512 million. Even so, while the absolute numbers of undernourished people were rising, 'their proportion in relation to total [developing world] population declined during the period to an estimated 21 per cent in 1984–86'.[15] The proportion of hungry people seems continuously to fall, but fast-rising population numbers ensure that the absolute number of hungry people sadly increases slightly too.

The majority of the hungry are in the Far East, but that region also delivers great progress, so that while it held 61 per cent of all the hungry in the developing market countries in 1969–71, fifteen years later it held 56 per cent of them.

Africa was, as we shall often see, a hard case. During the 1980s the calories per caput decreased very slightly across the continent. Unlike other regions, the proportion of Africans who were hungry rose, as did the absolute numbers. About a third of Africans are hungry, as was the case in the early 1970s.[16]

Part of the present human miracle is that so much – a clear and large majority – of the world's population is adequately fed, while a sizeable proportion of the world seems to suffer damage to its health because it eats too much (Chapter 8 looks at this issue). About a quarter of the human race is positively spoiled and much of the rest flourishes in ways which were unimaginable to the nineteenth-century mind and certainly were not expected by the grandparents of children now alive.

The wider success

During the past twenty-five years, the world's population has risen by about 1500 million. During this time of unparalleled increase in numbers of human beings, there have been great advances, not merely in the absolute amount of wealth the world's people generate,

but the degree to which it is available in places we think of as poor. As the World Bank reports:

> During the past three decades the developing world has made enormous economic progress. This can been seen most clearly in the rising trend for incomes and consumption: between 1965 and 1985 consumption per caput in the developing world went up by almost 70 per cent.[17]

Most of Asia, for instance, has done extraordinarily well. The United Nations Children's Fund (UNICEF) noted in 1990:

> the giant economies of China and India and the populous nations of Bangladesh, Pakistan and Thailand have also experienced ten years of rising per caput incomes and slow falls in the proportions of their populations living below the poverty line.[18]

This is not to forget the poverty to be found in the self-same countries. As UNICEF continues:

> approximately 40 per cent of all the young children who die in the world each year, 45 per cent of the children who are malnourished, 35 per cent of those who are not in school, and over 50 percent of those who live in absolute poverty are to be found in just three countries – India, Pakistan and Bangladesh.[19]

Much of the new wealth in the world goes into armies and Mercedes Benzs and services for the tiny minority of very rich, and does so in much more marked degree in poor countries than in rich and western nations. It is a paradox that the greatest inequality is to be found in the poorest countries. This is not a trivial inequality. It is not merely that the many are poor and that there are a tiny minority who are rich in huge disproportion to them. Far more important is the fact that the rich minority apportion to themselves not merely huge wealth, but a large proportion of the wealth of their society. Moreover, the rich minority often feel little obligation to share their well-being. For a sense of this, consider how a 2 per cent rise in taxation of the richest fifth of the population in Latin America would raise all the poor of the region above official poverty levels.[20]

All the same, economic growth in poor countries seems usually to translate – albeit with painful imperfection in places – into human wellbeing. In the words of the United Nations Population Fund:

> Life expectancy in developing countries increased from 51 [years] for men and 53 for women in 1965–70, to 59 and 61 in 1985–90. In

1965, for every 1000 children born worldwide, 103 died before their first birthday. By 1985–90 the yearly toll had been cut to 71. Average daily calorie intakes jumped from 2116 in 1965 to 2509 two decades later.[21]

In a country such as the Republic of Korea, the transformations can be extreme and very heartening. Food, health and education services are being delivered in a society in which until recently they were very scarce. In Mexico, the successes are as marked. According to the Mexican government:

> The average rate of illiteracy from 1941 to 1950 was 42.2 per cent, dropping to 23.7 per cent in 1970, 17 per cent in 1980 and 8 per cent in 1989. The goal set by President Salinas de Gortari's administration is to reduce illiteracy to 5 per cent by 1994.

The country is aiming at universal vaccination of children against the major killer diseases, and has a longrunning if limited social security programme. In Brazil, to cite another example of very rapid progress, under the leadership of a young governor, one of the country's poorest states, Ceara, cut infant mortality by a third in four years. The infant mortality of that state is now heading for Mexican levels (30 deaths before age one per 1000 live births rather than the 55 deaths which occur on average in Brazil). The country's infant mortality remains at least twice that of China, though the latter country has a per capita income one eighth that of Brazil. But the progress in Ceara shows what a very small shift in resources can achieve. Seven thousand workers, a network of community-run clinics and basic medicines have worked the miracle.[22]

Success is more general than might be supposed:

> The developing countries have made significant progress toward human development in the last three decades. They ... immunised two-thirds of all one year olds against major childhood diseases. The developing countries also made primary health care accessible to 61 per cent of their people and safe water to 55 per cent (80 per cent in urban areas). In addition, they increased the per caput calories supply by about 20 per cent between 1965 and 1985.
>
> Their progress in education was equally impressive. Adult literacy rates rose from 43 per cent in 1970 to 60 per cent in 1985 – male literacy from 53 per cent to 71 per cent and female literacy from 33 per cent to 50 per cent. The South's primary education output in 1985 was almost six times greater than that in 1950, its secondary education

output more than 18 times greater. The results were 1.4 billion literate people in the South in 1985, compared with nearly a billion in the North.[23]

But surely the rich countries are getting richer and the poor countries are getting richer much more slowly? Was this not the message of the greedy 1980s, whether we look at nations or income groups within them?

There is hope even here. The gap in monetary growth between rich countries and poor countries is widening, even as most poor countries get richer. But that is not true of what one might call the wellbeing gap, which is the measure that matters. The United Nations Development Programme, in a very important new line of thinking, has invented the Human Development Index (HDI, see Chapter 12) as a way of assessing the progress of nations towards providing the framework within which their citizens are able to live decent lives. The HDI is distinguished from Gross National Product or other monetary measures of overall affluence or poverty. It takes into account the health, education and social security of citizens, especially those citizens not able to fend for themselves, as well as their wealth or lack of it. UNDP has recently tried to build-in ideas about political freedom. The HDI picture is rather encouraging:

> North-South gaps in human development narrowed considerably during this period [the 1960s–1990s] even while income gaps tended to widen. The South's average per caput income in 1987 was still only 6 per cent of the North's, but its average life expectancy was 80 per cent and its average literacy rate 66 per cent of the North's. The North-South gap in life expectancy narrowed from 23 years in 1960 to 12 years in 1987, and the literacy gap from 54 per centage points in 1970 to less than 40 per cent in 1985. The developing countries also reduced their average infant mortality from 200 deaths per 1000 live births to 79 between 1950 and 1985, a feat that took nearly a century in the industrial countries.[27]

This implies that the development of the Third World may mirror that of the rich world, but happen more quickly. It also suggests that quick Third World development does not depend on western levels of affluence being developed everywhere.

People we now count as very poor indeed can expect to benefit from conditions of medicine, mobility, education and hygiene available only to the very rich of previous generations, and in some

respects not available to anyone of any station in life until the past couple of generations.

Notes

1 All population figures are from McGraw, E., *Population Today* (London: Kaye and Ward, 1979).

2 United Nations Population Fund *State of the World's Population 1992* (New York: UNFPA, 220 East 42nd Street, New York, NY 10017, USA, 1993) pp. 1–2.

3 Ehrlich, Paul R., *The Population Bomb* (New York: Ballantine Books, 1968) referred to in Simon, J. *Population Matters* (New Jersey: Transaction Publishers, 1990).

4 McCormick, J., *The Global Environmental Movement* (London: Belhaven Press, 1989).

5 Ehrlich, P. and Ehrlich, A., *The Population Explosion* (London: Hutchinson, 1990) p. 10.

6 World Bank, *World Development Report, 1991* (Oxford: Oxford University Press, 1992) p. 13.

7 World Health Organisation, *Our Planet, Our Health Report of the WHO Commission on Health and the Environment* (Geneva: WHO, 1992).

8 *Ibid.* p. 67.

9 *Ibid.* p. 60.

10 *Ibid.* pp. 60–1.

11 United Nations Development Programme, *Human Development Report 1990* (Oxford: Oxford University Press 1990).

12 *Ibid.* p. 23.

13 Food and Agriculture Organisation, *The State of Food and Agriculture 1990* (Rome: FAO, 1991) p. 30.

14 *Ibid.* p. 31.

15 *Ibid.* p. 31.

16 *Ibid.* p. 31.

17 *World Development Report 1990* p. 1.

18 United Nations Children's Fund, *The State of the World's Children 1990* (Oxford: Oxford University Press, 1990) pp. 12–13.

19 *Ibid.* p. 13.

20 *Financial Times* March 26 1993, quoting *World Development Report* 1990.

21 *The State of the World's Population 1990* (Oxford: Oxford University Press, 1991) p. 3.

22 'Brazil state leads in saving children', *The New York Times*, May 14 1993.

23 *Human Development Report 1990*, p. 17.

24 *Ibid.* p. 24.

25 *Ibid.* pp. 24, 25.

26 *The State of the World's Children 1990* (Oxford: Oxford University Press, 1990) p. 45.

27 *Human Development Report 1990* p. 17.

2

Defusing the population bomb: fertility, famine and affluence

In 1992 I met a small-scale farmer and conservationist in Nairobi. This man was one of those many African men who have broken free of their village and rural traditions very recently, but are married to women who remain more firmly rooted in theirs: 'I always thought that Africa was really a hopeless case,' he said. 'Its population growth was so enormous, and I could see nothing that would change it. But I have begun to think that things might change very quickly. My own wife has said to me that she thinks she should have no more children. Mind you, we have four already and that is too many.'

The human population of the world is likely to be 10 billion sometime next century. This chapter tells why, and suggests some reasons to suppose that benign processes, and not disaster, may well stabilise the human population at about that figure, before what will probably be a long slow decline in numbers.

The global picture

The human population will rise, unless tragedy intervenes, and there is nothing we can do about it. Broadly speaking, the western world has achieved a situation in which its population is stable. The western population is expected to grow only a little if at all. (Though the possibility of immigration, and the high fertility of immigrants, complicates this picture somewhat.) But the Third World's population will grow fast: at an overall rate of about 2.1 per cent.

The Third World has a death rate close to the west's. But it has double the west's birth rate. To bring the two scenarios into line, and that will take time, the average Third World woman would need to

have as few babies as her average western sister. That is, less than two, rather than her present something-like-four.

In the meantime, expect lots of babies. As the UNFPA (United Nations Population Fund) says in its 1992 annual report:

> World population in mid-1992 will be 5.48 billion. It will reach 6 billion in 1998. Annual additions to world population in the next decade will average 97 million, the highest in history. Nearly all of this population growth will be in Africa, Asia and Latin America. Over half will be in Africa and South Asia. The medium, or most likely, projection of population growth implies a near doubling of world population to 10 billion in 2050. Growth will probably continue for another century after that, to 11.6 billion in 2150.[1]

These are fairly optimistic figures, and constitute UNFPA's 'medium' projection. Within the range of possibilities UNFPA discusses is a more worrying view, the 'high' projection, which would put numbers at '12.5 billion in 2050 and heading towards 20.7 billion a century later'. Even the medium view depends on success in helping developing countries to reach by 2000 the position in which mothers have around 3.3 children each. This would require a lot of good luck, but is not out of sight, according to UNFPA:

> In family planning alone, reaching the medium projection means increasing the numbers of couples practising contraception [in developing countries] from 381 million in 1990 to at least 567 million by the year 2000. The cost of doing so will involve a doubling of resources devoted to population activities, from 4.5 billion US dollars to 9 billion US dollars. This is a relatively modest sum, just four days' military expenditure by the industrialised countries. If efforts are not maintained and it takes an extra 10 years to get down to 3.2 children per woman, then we would be on course for the high projection. The cost of a ten year delay would be an additional 2.5 billion people on earth by the year 2050, equivalent to the whole world population in 1950.
>
> However if all governments, North and South, devote adequate resources to a broad strategy centred on all aspects of human resource development in developing countries, it might just be possible to come closer to [our] low projection . . . we could achieve a global population in 2050 of perhaps 8 to 8.5 billion, 1.5–2 billion less than the medium projection. This is why the 1990s are so decisive.[2]

Kenya: the good news

Kenya provides an example of a country where these global scenarios can be seen in more comprehensible detail. It is an extremely prolific country. As the World Population Conference heard in Bucharest in 1974:

> The recorded total population of Kenya at the time of the first national census in 1948 was 5.4 million. In the censuses of 1962 and 1969, the total population had risen to 8.6 and 10.9 million respectively. The total population had therefore approximately doubled in 21 years.[3]

By 1990, Kenya's population was 24 million, growing at 3.7 per cent a year. Its total population by 2025 was projected to be 79 million.[4]

In Kenya's case, we see a classic, but extreme, modern picture. The country is able to keep more and more people, and especially babies and children, alive. But families are still locked into having large numbers of babies. This process implies the need for very dramatic changes in habit for Kenyan women, who on average had over eight babies thirty years ago and still have over six (well above the Third-World average of something-like-four).

Africa's high growth rates have seemed obstinate but may well change dramatically:

> Total fertility rates (measured as births per woman) in sub-Saharan Africa as a whole have remained unchanged at about 6.5 for the past twenty-five years – a level much higher than in other parts of the world that have similar levels of income, life expectancy, and female education.
>
> Recent statistics provide encouraging indications that a number of African countries are at or near a critical turning point. Total fertility rates have already fallen in Botswana (6.9 in 1965 to 4.7 in 1990), Zimbabwe (8.0 in 1965 to 4.9 in 1990), and Kenya (8.0 in 1965 to 6.5 in 1990) and are beginning to decline in Ghana, Sudan and Togo.[5]

These figures lie behind a World Bank assumption that sub-Saharan Africa's population will rise from 500 million at present to about 1.5 billion by 2030 and almost 3 billion by 2100 (with the AIDS epidemic possibly reducing growth by 0.5–1 per cent by the early decades of the next century).

Exponential growth

We need a lot of good luck here because of the exponential effect of population growth in societies in which high birth-rates are not matched by high death-rates. For exponential, read snowballing. A cohort of young people who breed more young people who breed yet more young people sets in train big increases in total numbers. There is some evidence that even after steep declines in fertility, many Third World countries seem to be stuck at the point where women have about twice as many babies as would be needed to reach replacement levels (families replacing themselves generation upon generation, but not increasing their number).

So we see very stubborn qualities to population growth. They imply that while we can hope that the growth in human numbers is eventually brought as low as possible by benign forces, we must in the meantime assume human numbers will continue to rise quite dramatically.

But even though large human numbers are an inevitability, we need not exaggerate the power of the trap we are in. Though we are seeing a record number of births, the rate of increase in human numbers is now less than was recently the case. This fact is not at odds with the inevitability of huge and record new numbers of births. Though the world's fertility is now much lower than it was in the 1960s (the world's population is growing at about 2 per cent as against about 4 per cent then), even a low percentage growth of a big snowball makes for a very big snowball.

On the other hand, the tendency to lower population growth rates is happening even quicker in the Third World than it did in the North, as the *Economist* pointed out:

> The transition that took a century to achieve in the west has come about in a generation in some developing countries. Third World fertility has dropped further and faster than anybody foresaw 20 years ago.[6]

Shouting the odds

What are the chances of the Third World following Europe and much of the rest of the rich world into low death-rates, low birth-rates, and low population-growth?

It is relatively easy to see the way in which an endless round of

childbirth was unavoidable and not entirely undesirable in even quite recent history. In non-technological societies, children can be useful quite young and can, with luck, grow old enough to be useful when their parents are infirm. They are cheap labour when they are young and an insurance policy when they grow up. The chances of death amongst a mother's children have historically been so great that it made sense to have plenty.

In technological, developed societies, much of this picture changes. Where a family's income comes from a job and a wage rather than from working the land for subsistence, it is less obvious how young children can contribute to bringing home the bacon. For urban families, and these constitute a rapidly increasing proportion of the developing world's people, there are, for instance, no animals to be watched over, no stones to be picked from the fields, no birds to be scared away from young seeds. Conversely, children in cities are likely to need jobs in the industrial or service sectors of the economy and so need to be formally educated. So the expense of schooling becomes even more necessary. Thus, children are increasingly perceived as costing, not earning, money. Besides, the likelihood of a baby's growing into adulthood is fast improving. There is less and less need for families to produce 'surplus' babies.

So the world is changing into a place in which families feel less need to have large families. It is the degree to which choice in the matter has come into play which also marks this century out. The moral and social climate in which families are formed has changed in many parts of the world, and conspires with new technology to put real power into the hands of families. Here is the good news of the Kenyan case in more detail:

> A 1989 survey found that the proportion of women using any method of contraception had risen to 27 per cent, from 17 per cent only five years earlier. Two-thirds of these were using a modern method. The fertility rate [numbers of babies per woman of child-bearing age] had dropped from 7.7 to 6.7 over the same period, a level not expected before 1995 even on the United Nations' low projection.
>
> And there was good reason to expect further improvement if services could be extended and improved. Half of all women with four living children wanted no more. The mean ideal number of children was only 4.4. For 15 to 19 year olds it was only 3.7.[7]

The younger generation of Kenyan girls are expressing a desire to bear and raise the number of children which coincidentally is the

number which would bring the medium, quite optimistic, population growth rates of human numbers. Not that mothers or families wanting fewer children necessarily turns into low numbers. Mothers may not be able to fulfil their wishes. While many Third World women want many children, many others want fewer than they have:

> A survey of married women found 46 per cent in Peru had not wanted their latest child; 37 per cent in South Korea; 34 per cent in Sri Lanka.[8]

In other words, mothers are not getting their own way:

> There is good evidence for a considerable level of existing unmet demand [for contraception]. Many women in developing countries have more children then they want; in 23 out of 38 countries in the World Fertility Survey, more than a quarter of women had larger families than they would have desired, and up to half of the women aged 40 to 49 did not want their last birth. The proportion of unwanted births is 10 to 20 per cent overall.[9]

The reasons are not hard to find, and – perhaps oddly – they make for optimism. In many countries, the attitudes of family-makers are heading in the right direction and only services remain to be provided (the position would be far more dangerous if this was reversed):

> In many countries family planning services are virtually non-existent, despite the apparent demand. In Ghana, for example, 20 per cent of the women in rural areas and 28 per cent in the cities say they want no more children, yet modern family planning services reach less than 7 per cent of the women. Ghana's fertility rate is 6.4. In Indonesia, where about half of the women want no more children, family planning services reach 44 per cent of all women. Indonesia's fertility rate is 3.3.[10] In Africa . . . 77 per cent of married women who want no more children are not using contraception. The proportion in Asia is 57 per cent. Only in Latin America does it fall below half, at 43 per cent. If anything these figures probably underestimate unmet need for family planning services. They do not include unmarried women who need to avoid pregnancy, or married couples who would like to delay their next birth. Nor do they include married couples using unreliable or inconvenient traditional methods.
>
> If these people could be reached, contraceptive prevalence could be increased immediately by perhaps 6 per cent of all married couples in Africa, 15 per cent in Asia and 18 per cent in Latin America.[11]

Such improvements, UNFPA reckons, would go a long way towards

meeting their middle-road target, in spite of very regrettably leaving perhaps 75 per cent of couples in Africa and Asia without contraception.

Winning the changes

UNPFA estimates that people are prepared to spend up to two hours a month and 1 per cent of their income on the family planning issue. It thinks that for about 60 per cent of the Third World, contraception is available in exchange for this sort of effort. But the figure varies dramatically:

> Some 95 per cent of people in East Asia have this level of access, 57 per cent in Southeast Asia and Latin America, and 54 per cent in South Asia. But in the Muslim world the proportion falls off to 13–25 per cent, and in sub-Saharan Africa to a mere 9 per cent. Not surprisingly, the rank order for use of contraception is exactly the same.[12]

And so is the rank order for population growth rates.

The methods by which those who want contraception can be helped to obtain it are well-established. They might be summarised as a matter of attitude and of access. Some institutions deliver both. Clinics can provide both access to friendly advice and affordable contraceptive methods. Everyone has known for decades that cheap, cheerful and commonsensical clinics work in poor countries, but they have been threatened in recent years by very tight government budgets. It is important to note that the best sort of clinic is not simply devoted to birth control. In keeping with the argument that improving the survival of their children is important in persuading parents to have fewer children, lowering fertility will probably flow best from clinics which are devoted to family health rather than simply to family limitation.

The education of women has long seemed to be a key. Report after report stresses that educated women have smaller families:

> Education's impact on fertility and use of family planning is ... strong. Women with seven years of education tend to marry an average of almost four years later than those who have had none. The level of contraceptive use among these educated women is very much higher – two-and-a-half times on average, almost four-times higher in Africa.
>
> The first three years of education do not make much difference –

indeed in Africa, women with one to three years' schooling have slightly higher fertility than those who have never attended school. But four to six years' education lowers fertility by between 5 per cent in Asia and Africa and 15 per cent in Latin America. The greatest effect occurs when women have seven or more years of education. These women have on average 2.2 less children each than those who have no education at all. The husband's education makes much less difference – families where the husband has had seven years in school have only 1.3 children fewer than those where he has had no schooling.[13]

The case is put succinctly by the World Bank:

> Investments in female education have some of the highest returns for development . . . Evidence from a cross-section of countries shows that where no women are enrolled in secondary education, the average woman has seven children, but where 40 per cent of all women have had a secondary education, the average drops to three children, even after controlling for factors such as income. Better-educated mothers also raise healthier families, have fewer and better-educated children, and are more productive at home and at work.[14]

It is easy to believe, and it is often suggested, that men are the real block to reducing the size of families. UNFPA notes that many women say their husbands would beat them if they began to use contraception. But while this might be true in some cases, in many others, the matter had not been discussed within families at all.[15] My conversations in Africa matched a strong prejudice of mine: that women are obstinate in promoting their cherished values and far more powerful in family life than one might believe, whether in wanting many babies or deciding to reduce family size.

Making the poor world richer, and more equitable, is high on our list of means by which population growth can be reduced benignly. In the meantime we are bound to look for any signs that things can change quickly even if economic growth is slow. One is that almost all the population growth in the developing world will take place in cities. According to the World Bank:

> In 1990 most people lived in rural areas. By 2030 the opposite will be true: urban populations will be twice the size of rural populations. Developing countries' cities as a group will grow by 160 per cent over this period, whereas rural populations will grow by only 10 per cent. By 2000 there will be twenty-one cities in the world with more than 10 million inhabitants, and seventeen of them will be in developing

countries.[16]

Cities can produce great squalor and nastiness. Both were histori-
cally much evident in the emerging cities of the west. But cities are
also the location of great, wildfire changes in the way people live and
reproduce. We have good evidence that fertility rates in cities can be
reduced quite quickly:

> As people move into towns, they have smaller families. A recent
> survey of 22 developing countries found that in all of them urban
> fertility rates were lower than those in the countryside.[17]

The reasons are not hard to find. We have noted that increasing the
healthiness of babies is likely to lead to smaller families. Residents of
urban areas have a higher chance of obtaining clean water and
disposing of dirty water than do their rural cousins. Generally
speaking they have a higher chance of reaching health care. As the
WHO says:

> Urban growth can bring substantial health and environmental
> benefits. The concentration of production in urban areas brings many
> cost advantages in waste management, while the per caput cost of
> piped water, many kinds of sanitation, education, health care and
> other service is also less in concentrated populations. The process of
> urbanisation generally accompanies, and contributes to, the develop-
> ment of a more prosperous and productive economy.[18]

A less tangible advantage of urbanisation might well be that newly-
urbanised populations are more likely to hear messages about
fertility and family planning, from television, radio and newspapers
– while simultaneously being more likely to be free to think and
choose for themselves, released from the inhibitions and taboos of an
older generation in the village.

The conventional image of the Third World and its emerging
mega-cities is that future generations will be condemned to live in the
latter. In fact, in the developing world a peasant who moves to an
urban area is not necessarily moving to a city, still less one of the
mega-cities. The WHO says:

> Estimates for 1990 suggest that less than 2.5 per cent of the urban
> population of the developing countries live in cities with 10 million or
> more inhabitants, and less than 25 per cent in cities with 100,000 or
> more inhabitants.[19]

So the new urbanites may be going to places which are free of inhibiting tradition, but able to deliver essential services, without necessarily falling into the enormous kind of problem which very densely packed big cities will pose.

A second, more obvious, factor is that political leadership can be a definite spur to very rapid and greatly reduced fertility. Leaving aside the allegedly aggressive methods of China or India, several countries around the world demonstrate that leadership counts. UNFPA takes heart from the case of Mexico, which in the mid-1970s had a growth rate of African proportions (annual growth rate 3.2 per cent, fertility rates of 6.75 children per woman):

> Then, quite suddenly in the mid- and late-1970s, things began to change dramatically. The total fertility rate dropped to 4.89 children in 1975–80, then again to 4.2 in 1980–85. Over the years from 1970–75 the birth rate fell from 43 to 32 per 1000. Population growth plunged to its current rate of below 2 per cent.
>
> A steep rise in government commitment, availability of family planning and public attention to the topic brought about this sudden shift.[20]

The commitment from central government galvanised a network of local women which distributed contraceptives in 13,000 villages and this, combined with other initiatives, quadrupled contraceptive use until 42 per cent of women were using modern methods. The point UNFPA draw from this experience is one which with luck can be applied much more widely:

> over the years the essential groundwork of progress in education and women's advancement had been laid. By 1975 adult literacy was 76 per cent. Female primary enrollment was over 100 per cent and level with male.[21] Infant mortality was down to 60 per 1000. The social setting was in place and success awaited only a catalyst – easy access to family planning.[22]

The UNFPA puts Zimbabwe, Indonesia, Mexico, and the Republic of Korea amongst the leadership-inspired fertility-reducers.

It is worth pointing out here that the prevelance in a region of the Roman Catholic church does not seem to affect the prevalence of contraception. One African woman, living in a shanty breeze-block house in Lusaka, Zambia, told me that she was a devout Roman Catholic and had been on the pill for years. I had the impression that her priest was one of those many Roman Catholic priests who

suggest that 'natural' contraception is morally to be desired as a counsel of perfection, but that in the real world modern contraception methods achieve another moral good, namely families which stand a chance of flourishing.

My acquaintance certainly felt no guilt about crossing town for her supplies and using them. It is also true that she had at least four children: far fewer than would probably have been the case a few years ago, but too many to be a comfortable African average.

However we interpret these encouraging signs, we see that we are committed to very quick growth in human numbers. The rest of this book looks at how all these new people might be accommodated.

Notes

1 United Nations Fund, *State of the World's Population 1992* (New York: UNFPA, 1993) p. 1.

2 *Ibid.* pp. 34–5.

3 Johnson, S., *World Population and the United Nations* (Cambridge: Cambridge University Press, 1987) p. 104.

4 *State of the World's Population 1992* p. 40.

5 World Bank, *World Development Report 1992* (Oxford: Oxford University Press, 1993) p. 26.

6 'Squeezing in the next five billion', The *Economist*, January 20 1990.

7 UNFPA, *State of the World's Population 1990* p. 17.

8 'Squeezing in the next five billion', The *Economist* January 20 1990.

9 *State of the World's Population 1992* p. 19.

10 World Bank, *World Development Report 1990* (Oxford: Oxford University Press, 1991) p. 26.

11 'Squeezing in the next five billion', The *Economist* January 20 1990.

12 'Squeezing in the next five billion', The *Economist* January 20 1990.

13 *State of the World's Population 1990* p. 15.

14 *World Development Report 1992* p. 29.

15 *State of the World's Population 1992* p. 25.

16 *World Development Report 1992* pp. 27–8.

17 'Squeezing in the next five billion', The *Economist* January 20 1990.

18 *Our Planet, Our Health* p. 31.

19 *Ibid.* pp. 201–2.

20 *State of the World's Population 1990* p. 16.

21 Quite how it could be over 100 per cent escapes me.

22 *Ibid.* p. 16.

3

Feeding the future billions: some clues

Driving along the red-brown tracks of the lush hill country near Arusha in Tanzania, a small-scale farmer turned to me and asked, as though I might know the answer better than he: 'Why is it that this continent still has the sort of farming which would have been recognisable by Christ? Why can't we change?'

Homo sapiens has used farming to feed huge numbers of people. This chapter looks at the evidence which suggests that even a doubling of human population need not produce the starvation which is widely forecast.

Humankind the farmer

Humankind has become a chemist and an electrician, and before that human civilisation has been defined by its ability to mine and smelt, and to make steam work. In the future, human beings are almost certain to become strongly identified with the culture of bugs and the manipulation of genes. But these industrial activities disguise a fundamental truth: human beings are farmers.

There has been something resembling a human on the planet for about 4 million years. Hominids have existed for about one thousandth of the earth's history. A million years ago there is something more obviously human, and it becomes more and more obviously so about 100,000 years ago. The last 10,000 have been the farming years, and they have mattered to us partly for the odd reason that they seem to us like the years in which ever larger numbers of people ceased to be preoccupied with getting food.[1, 2]

What made human beings develop, in the latest tenth of their

history, the techniques of farming? Little is known about why humans slipped out of previous habits and into cultivation. But the process was quick, according to Sir John Burnett, executive secretary of the World Council for the Biosphere:

> Clearly the boundaries between foraging and farming, especially if the former is associated with storage of seeds or fruits, and that between hunting and herding, are exceedingly narrow and must have been so for many millenia. It is, therefore, a quite remarkable fact that the change to early pastoral or farming communities was a relatively rapid process; moreover it was very recent, commencing perhaps not more than 20,000 years ago, becoming detectable some 10,000 years ago and being almost universal adopted as the dominant pattern for the future from about 6,000 BC.[3]

Was the farming revolution and the steady, fast increase in human numbers technology-driven, or did the technology derive from the desperate need to feed the large numbers of people that pressed on the earth? Did humans become farmers because they were so numerous that no other course but a development of high productivity was open to them? Or did they become numerous because high agricultural productivity allowed it? Did human beings become more prone to famine in farming years, or less? Some of these questions are unanswerable because the evidence is so scanty. Still, they are important to us, so we have always attempted answers to them.

It is fashionable now to say that early on and ever since, humankind the farmer has failed. The despairists like to point out that entire farming civilisations have collapsed in hot countries. In this view, deforestation and overgrazing denuded the Mediterranean basin. They led to soil erosion in what are now Iran and Iraq which were then further damaged by the salts which uncontrollably built-up in badly-managed irrigation schemes. It is less often said of these disasters that the climate seems to have been turning against agriculture in those regions at about the same time, and that while there is almost always a risk of erosion following deforestation and of salivation following irrigation, they need not be crippling.

The idea that early societies were uniquely rich and environmentally friendly is as wrong as the suggestion that Stone Age life had nothing to offer except brutality. There are interesting modern

cases of famine striking at African farming regions while hunter-gatherers nearby went unscathed.[4] But mankind has often called a famine what is really only a matter of food shortages. This is pointed out forcibly by Peter Garnish,[5] who also found that despite much discussion about famines and ecological degradation during the classical period, the Mediterranean remained a breadbasket capable of feeding large numbers of non-farmers. This was in spite of a local climate which varies greatly in space and time.

Regional trade and local government action often ensured that shortages did not become famines. That general picture has been true in quite recent history. In nineteenth-century Britain – especially the Hungry Forties – many people experienced food shortages. But this was more because rapid industrialisation had created distortions and strains in the market, than that the fields were failing to produce.[6] Farm productivity soon continued to rise handsomely to meet the case.

Monoculture is often criticised, and it is true that sometimes farmers have concentrated on too few crops. The Irish potato famine was an obvious example of over-dependence on a single harvest. Even so, it was the failure of the trading system and of government to bolster demand in a period of local shortage which produced the hunger in Ireland. In Scotland, there was the same dependence on the potato crop, and the same catastrophe threatened when it failed. But landowners and the government combined to make supplies of food available.[7]

The past cannot have been as awful as the despair industry has it. We know perfectly well that the farming and trading system fed fast-rising human numbers, and whatever its periodic failings these were not for long sufficient to dent the onward march of the number of humans on the earth which its general success allowed. We do not know the whole reason why people using Stone Age technologies managed and manage to feed about a tenth of a person per square kilometre while even primitive agriculture manages to feed ten or twenty times that number. But we do know that in the modern world, we can support over 300 people on that area of land.[8] Doubtless, such productivity is a mixed blessing, but it is clearly a considerable technical and probably a social triumph too.

Constraints all around the world

While it is likely that the planet can support as many people as it has
to (as we shall see later), we are not in a particularly good position to
know to what degree the poor of the Third World will be able to
grow the food with which to feed themselves. If they cannot grow
enough, or earn enough to buy in food, then the rich world will have
to do something about the situation. The difficulties will be more
political and economic than ecological. They will also be technical,
and we will look at aspects of that soon.

Bodies such as the Food and Agriculture Organisation of the
United Nations (FAO)[9] are struggling to adjust to new demands and
put these alongside their historic core goal of a vast increase in
production. The new demands are being made by the alert con-
sciences of the western governments and the prickly sensitivities of
governments in the ex-colonies. International aid agencies now need
to show they care about ecological concerns. They must not be
thought patronising to governments in the Third World. They must
be highly sensitive to the needs of peasants. This is asking of the
farming revolution something very new: that it be conducted with-
out social and environmental trauma.

There has never been an increase in agricultural production which
did not involve the use of less labour per hectare of land. The
agricultural revolutions we have seen have all led to fewer people
being needed on the land, and therefore all raise the problem of what
happens to surplus labour.

Almost all agricultural improvement has grown out of increased
specialisation within individual farms and usually within whole
districts of the countryside. The history of agriculture has been the
history of farms getting bigger, employing fewer people, and being
part of an efficient market. Farming has gone from the variety
subsistence requires to the specialisation which increases yields. It
has done what the market required.

But it is by no means clear that the competing need both for more
food production and more jobs in the Third World countryside can
be reconciled. Everyone now seems to agree that the Third World is
looking for some brilliant new accommodation between the old and
the new. This is the way FAO expresses it:

> To meet the declared objectives of SARD [Sustainable Agriculture and
> Rural Development] most developing countries will have no choice

but to intensify agriculture. Experience in developed countries shows that intensification can lead to pollution and problems of waste disposal. Moreover it can encourage consumption patterns that are ecologically and economically unsustainable. Other forms of agriculture and rural development are therefore needed, requiring an appropriate balance between both intensification and diversification in the choice of production systems, technologies and practices.[10]

When FAO's advisers look at different regions, they see different problems, naturally. In Africa they note that there are large areas of land which hold untapped agricultural potential, and that:

There is more scope in sub-Saharan Africa than in any other region of the world for increasing input use to achieve sustainable agriculture with higher production. However, inputs such as fertilisers and pesticides should be used wisely, by integrated plant nutrient management [which uses as much on-farm nutrient and humus as possible] with emphasis on local inputs, and by integrated pest management with emphasis on biological and agronomic methods.[11]

By comparison with this sense that Africa was waiting for big increases in production, the Asian and Pacific region was already in many places facing difficulties from the overuse of chemicals, and suffering very unequal distribution of the benefits of modern agriculture.

FAO sees the Asian and Pacific region as having experienced a massive increase in cropped land alongside a massive increase in the numbers of landless peasants. It sees little chance of industry employing these millions of people. It sees people pushed onto steep or otherwise unsuitable land, and much farmland undernourished:

Appropriate technologies do not exist to sustain present and future populations for many resource-poor areas, and even some resource-rich areas are reaching their maximum output. The systems used by many producers are unsustainable, due either to commercial over-exploitation or an attempt to meet survival needs, and are induced by inadequate or inappropriate public or private incentives. Strategies to achieve sustainable crop, livestock forestry and fishery production systems, and combinations of them, will fail unless they are complemented by policies to slow down population growth and enhance alternative employment opportunities.[12]

In the case of Latin America and the Caribbean region, FAO suggests that while there are areas of poverty on the Asian scale, there are also

generally wider opportunities for growth. There is land which is barely exploited at all, there are some chronically discouraging government policies and there are the usual egregious examples of skewed land ownership. The picture may look bleak, but it is not – generally speaking – as ecologically bleak as all that.

Almost all informed views suggest that if economic policies in poor countries were rewritten to favour agriculture there would be big increases in food production. That sounds reasonable. But even if land reform could give more peasants more land; even if capitalists could be attracted to put in big effective plantations where appropriate; even if unadventurous farmers could be encouraged to be as good as their best neighbours; even if there is a considerable following wind, there is a general assumption that with present technologies, present aid flows, present trading circumstance and present Third World politics there will be many people very hungry in the Third World.[13] Even so, it is important not to overstate the difficulties we face.

Destructive myths: the anti-farming propaganda

There is a potent myth that the further back in history one goes, the better the farming practices one finds. Yet research constantly turns up intriguing data to confound this anecdotal gloom. A recent contribution to *Nature* pointed out:

> Although it is widely believed that the Spanish encountered an almost pristine landscape in AD1521, some archival and palaeolimnological studies have suggested that extensive land clearance began before European contact . . . We identify three periods of accelerated erosion and conclude that erosion rates [before the advent of the Europeans] were at least as high as those after the Spanish conquest. One implication of these results is that soil erosion caused by the Spanish introduction of plough agriculture was apparently no more severe than that associated with traditional methods; it is therefore questionable whether a return to traditional methods would have significant environmental benefits.[14]

Seeing a patchy record in modern farming, too many commentators pile on the misery. The World Resources Institute in Washington each year publishes *World Resources*. It is an excellent source of information. Yet people who know anything about Britain will be

surprised to find in the 1992–3 edition a soil erosion map of the world which shows about a third of the country as one of many 'Areas of Serious Concern'. It is shaded in the same colour that, more plausibly, covers parts of Africa and India. Intrigued as to how anyone could seriously suggest that Britain is at risk of becoming a dustbowl, I contacted the leading British soil research institution, the Silsoe campus of the Cranfield Institute of Technology. The staff there kindly sent an overview paper by one of their experts, Professor R. P. C. Morgan, who was – hardly surprisingly – the source from which a Dutch institution[15] had put together data which underpinned WRI's map.[16] What faraway Washington did not see as the most obvious nonsense, one would have thought a nearby Dutchman might have.

The paper I was sent of course did not say anything very alarming about Britain's soils,[17] because their structure and fertility are by and large in good health. However, Britain's fields are required to be very productive indeed and are kept in good health only by expert farming skills and by inputs of synthetic or mined chemicals. Nonetheless, soil is being lost to runoff quicker than it is being replaced, and, says the paper: 'Soil erosion could threaten crop yields in the first quarter of the next century if allowed to continue at present rates.' In that sense it is at risk. But there is no reason to suppose that the skills or the chemicals are going to dry up; nor that any additional materials the soil might need cannot be found and applied. The problem is more in semantics than in soils. The paper said clearly enough that there is more soil erosion in Britain than people think and that about a third of the country's arable land has highly erodible soils. The author describes his work as

> an assessment of areas with erosion risk and areas of actual erosion. Where land is under dense vegetation cover or where soil conservation measures are practised, such as use of shelter-belts or plough-press tillage to control wind erosion, there may be little or no erosion. But this, however, does not detract from the risk of erosion in such areas if conservation measures are not employed and so it is appropriate to class these areas as having an erosion risk.

This sounds sensible, and strikes a useful cautionary note. But it is not very different to the statement that a man walking in London's streets is at severe risk of death from passing cars unless he takes sensible self-preservation measures such as staying on the pavement.

One can go round the developed world like this. In the United States, the *Global 2000 Report* to the President, *Entering the Twenty-First Century*, stated:

> Although soil loss and deterioration are especially serious in many LDCs (Less Developed Countries), they are also affecting agricultural prospects in industrialised nations. Present rates of soil loss in many industrialised countries cannot be sustained without serious implications for crop production. In the United States, for example, the Soil Conservation Service, looking at wind and water erosion of US soils, has concluded that to sustain crop production indefinitely at even present levels, soil losses must be cut in half.
>
> The outlook for making such gains in the United States and elsewhere is not good. The food and forestry projections imply increasing pressure on soils throughout the world.[18]

This was just the kind of thing to give the troops. It called to mind images of the horrible scenes familiar to readers of John Steinbeck and American history: the Dustbowl years. These and much less respectable predictions were very dire and made routinely. And yet the crisis has passed, even before it began to be economically significant. By 1995 various programmes in the United States are likely to have succeeded in 'reducing soil erosion in the USA by two thirds', says Lester Brown, of the World Watch Institute in Washington.[19] The reversion of inappropriate arable land to pasture or woodland is one of the main chosen techniques for combating soil erosion, as Brown points out,[20] but he makes of this an argument that soil erosion has indicated the final ecological limits which farmers are constantly trying to cross. It is just as reasonable to suggest that land which was turned to heavily-subsidised inappropriate grain-growing (much of it for consumption by animals) can be returned to much less damaging direct production of animal protein on the hoof.

Many North American environmentalists now stress that North American farming may yet die of thirst. The western states are accused of mining the underground water supplies of aquifers and overstretching the amount of water abstracted from rivers.[21] Yet what seems to be happening is much more an extravagant squandering of water because of its artificial cheapness than an absolute shortage.[22] Lawns right across the western states remain verdant, and farmers pay small fractions of the cost of the water they

use in irrigation. Long before the United States runs out of water a new balance of interests should emerge. Water will achieve its proper price and demand fall into step with supply. It is not necessary and frugal use of water which has caused a problem in the United States, but profligacy.

Almost all green writers – including many of the moderates as well as all the purists – seem in thrall to the difficulties posed by the physical constraints to world food production. Even some of the most intelligent and informed of the green commentators, including Lester Brown of the Worldwatch Institute,[23] Fred Pearce, a regular contributor to *New Scientist* and author,[24] and Paul Harrison,[25] often stress the gloominess of the picture.

Characteristically, the gloomy view notes that historically irrigation schemes were often poorly-planned. It also notes that such schemes have often brought an increased risk of water-borne disease and soil wastage.

A rounder picture comes from Ian Carruthers, Professor of Agrarian Development, Wye College, University of London. He believes that the idea of 'poorly performing irrigation' has become entrenched in spite of evidence that productivity of irrigated land is, clearly, often high. Besides, he says, the failure of irrigation to perform as well as it might often flows from projects which ignore the knowledge of local farmers and from schemes whose financing did not include a proper commitment to long-term – very necessary – management. He suggests:

> There is another puzzle concerning irrigation performance which most evaluations show to be sub-standard. There is a hard to prove but often claimed statistic that 35–50 per cent of the world's food now comes from such 'poorly performing' irrigation (mostly of rice – the first line of defence against Malthus). More importantly 50–60 per cent of the vital increments to developing world food supply between 1960 and 1980 came from irrigated land (mostly wheat – the second line of defence – and rice). In principle, this high marginal return to irrigated agriculture can be expected to continue because only when water supply is assured will farmers invest in the costly seeds and fertilizer and other yield increasing and quality enhancing innovations that are still emerging, albeit perhaps more slowly, from the agronomists' high-tech pipeline.
>
> This 'poorly performing' irrigated agriculture has been the major confounder of the expert opinion in the 1970s which predicted a doubling of world food prices in real terms by the 1990s. Prices are

presently at historically very low levels and look set to stay there so
long as irrigation continues to improve (and the industrial world
continues to subsidize its own agriculture through production
enhancement techniques). Perhaps the troubles of irrigation are more
apparent than real and it is the high visibility of the infrastructure that
creates the problem.[26]

The gloomy, general view notes the shortage of good new land to
exploit and the presence of much land which is already over-
exploited. It creates the impression that hunter-gatherers were the
wisest of humans, and that nowadays only tribal people or poor
peasants are worth listening to. It always celebrates the successes of
peasant agriculture (where they can be found) and seldom notes the
success of larger-scale farmers.

The pervasive gloom has created potent myths. For instance,
everyone knows by now that overpopulation and modern farming
techniques are producing desertification. 'The Sahara Desert is
expanding southwards, engulfing degraded grasslands, at a rate of
590 kilometres (300 miles) every year,' says Jonathon Porritt's *Save
the Earth*.[27] And yet, in *Wasting the Rain*, Bill Adams, a Cambridge
University geographer, puts quite a different case:

> Overviews of the droughts and famines in Africa in the 1970s and
> 1980s have tended to focus on the problems of 'desertification'. The
> word was coined by the French ecologist Aubréville in 1949 to mean
> the process by which desert-like conditions (arid areas with few
> plants) develop. In the 1970s use of the word expanded enormously,
> and desertification became a central element in debates about Africa's
> 'crisis'. By the late 1980s it was clear that there were significant
> problems emerging in the use of the term. It was ambiguous and had
> suffered what one analysis [by the British geographer, Andrew War-
> ren] wryly described as an 'erosion of meaning'. It was widely taken to
> mean any loss of biological productivity which might lead to desert-
> like conditions. Thus this 'desertification' included waterlogging and
> salinisation of irrigated land as well as loss of biomass, loss of
> vegetation cover or soil erosion.
>
> Part of this verbal inflation can be traced back to the United Nations
> Conference on Desertification which was organised by the United
> Nations Environment Programme in Nairobi in 1976. Worthy though
> this effort was, it made 'desertification' a highly politicised concept.
> Aid agencies wanted to be seen to put money into stopping it.[28]

Any agricultural project could get itself a better name by being

relabelled, 'desertification control'. In the sudden alarm, some projects were instigated which had scant chance of success. But it is surprising how little we really know about how much damage is being done or what needs doing. The harder people look, the more confusing an honest assessment becomes. As Bill Adams says:

> It is now clear that simple and rather sweeping ideas about desertification are unhelpful, and can be seriously misleading. For example, there is remarkably little good evidence to support the widely-held view that the Sahara is advancing southwards year by year.[29]

These words are echoed in detail by the International Union for the Conservation of Nature and Natural Resources (IUCN) in its report on a very big study on the Sahel, published in 1989.[30] Its brief popular summary of the 1989 Sahel studies carries a simple headline on its front cover: *The Sahel – Out of the Myths.*[31]

Yet there can be few people who take even a passing interest in Africa who do not believe that deserts are spreading everywhere in the continent. Worse, the view the despair industry promotes is that deserts grow solely because people are pressing too many domesticated animals and too many ploughs into the fragile terrain which they are forced to colonise as population densities increase. Peasant as well as capitalist culpability satisfies some Greens because messages of human failure reinforce the campaigners' distaste for growing populations. They bolster the argument that human beings are already reaping a harvest not of food but of crisis as they push the planet beyond its supportive limits. This view leaves out of the picture the confusing evidence that in some places in Saharan Africa productivity is rising, agricultural areas expanding, and cattle numbers rising.

All these need underpinning by better resources if they are to be sustainable, as Bill Adams points out.[32] Yet they indicate that Africa is nowhere near its productive limits. There is a good deal of evidence that soil degradation may in part be the result of one of Africa's periodic, normal and regular dry spells. Not a drought, the knowledgeable people are careful to point out, but a desiccation.[33] Droughts are short and fairly rare; desiccations can be very long and common. Africa has seen a period of about thirty dry years during which it would have been very remarkable if farmers had found life easy. The difficulty for everyone trying to think about the problem is

that it looks as though Africa has to assume such things will happen periodically for ever.

Africa is a dry place. But modern agriculturalists were surprised by the continent's recent arid conditions because of a relatively wet recent period, during the 1950s and early 1960s.[34] Drought or desiccation, famine or food shortages, had often disturbed European observers of Africa in the middle of the last century,[35] but that was at levels of population well below those that modern medicine and hygiene now allow, and before the advent of widespread agriculture. Moreover, Europeans first saw Africa after a period when widespread disease had wiped out many people and animals.

So Africa of course faces enormous difficulties to do with large numbers of people and animals trying to make a living in a continent whose present and future may well be drier than we have grown to expect. But there will probably be better years too. Knowledgeable commentators on Africa note that even in very dry places, it is amazing what can happen when the weather is wet at the right times of year. Land which had been given up for dead is suddenly verdant. Land which was assumed to have become irreversibly degraded by human activities is found not to be so; grass swards which look as though they have been overgrazed turn out to be in surprisingly good health and perhaps to be working at their optimum productivity.

There are elements of the standard, sad view of Africa, and other arid and semi-arid areas such as Mexico, which hold up. There are plenty of places in which more and more people are pressing onto inherently unproductive land. Often they are pressing onto the sides of hills which were once grassed and wooded, and turning seasonal streams into deep gullies. There are places where soils develop a hard surface, through which neither shoots can grow upward nor rain soak downward. Quite often, cattle herders have become very rich in cattle at the same time as the amount of grazing land for animals has shrunk because of population pressures. The result is a risk of erosion. We know that there is overgrazing and there are inappropriate agricultural practices. We know that in many places land should either be rested or better fertilised and nourished with water-retaining organic matter. We know there are traditional and modern techniques which could be introduced (we know this last especially because of excellent work by Paul Harrison).[36] We also know that in many countries marketing methods and infrastructure

are so primitive that it is barely surprising that farmers are poor. We know that in many places, cattle herders need to have fewer, better animals which go to market at a useful age.[37] In some cases, grazing clubs can make an enormous difference to the productivity and impact of herds.[38] In others quite a small effort would usefully plant quick-growing grasses and stabilise river banks.[39]

That progress is being made and that the issues are very old can be seen very clearly in Machakos in Kenya. In the 1930s the British district authorities were concerned that the area was heavily over-exploited by humans and animals. They took pictures to show the case, and the place looks barren indeed. As the World Bank's *Environment Bulletin* said, in reporting some work it had funded the British Overseas Development Institute to lead:

> In the late 1930s, the District was considered by the Colonial adminis-tration to be degrading alarmingly and to be rapidly approaching, if not exceeding, its capacity to support inhabitants and their livestock. Today, the area has a population five times as great and the value of agricultural output per head (at constant prices) is estimated to be three times larger than it was then.
>
> Cultivation has expanded by four times and there has been a corresponding reduction in the area of general grazing, bush and scrub. Much of the land used is now under continuous cultivation, and almost 100 per cent of the area is cultivated in some form of terracing.
>
> The rate of erosion has been sharply reduced, although it still does occur, and there is no evidence that the quality of soils is declining under current practices.[40]

The reforms which produced this turnaround look like a textbook case for much of the rest of this chapter. The farmers of the area were helped to find useful markets, have sold produce for cash, took advantage of handy advice. Two of the researchers for the study believe that this Kenyan area goes a long way to disprove Malthusian gloom:

> Machakos illustrates that land use and carrying capacity are not fixed. The land resource can be improved by investment in new technologies, knowledge and improved management techniques. These factors are assisted by a rise in population densities from very low levels. A recent cross-country study found that growth in rural non-farm incomes and in population density were both strongly related to higher agricultural income of the agricultural population.

These relationships showed up much more clearly in Asia than in Africa, where most rural population densities are below 80/km^2, but were evident in a densely populated area of Southeastern Nigeria.[41]

The real agenda

When we look closely at agricultural issues, which often seem ecological, we find that in important ways they are not. They are overwhelmingly human and institutional. When you ask experienced people about why Africa looks as though it is going to be hungry, they often paint a picture which seems much more real, much more densely complicated, much more fully human, than the picture which the Greens have mostly given us. A catalogue of difficulties includes:

- too little technical education;
- too few sources of advice;
- too few local markets for trading inputs or produce;
- too few fair sources of very small loans;
- too little good land for small farmers;
- too few opportunities for very small farmers to become small farmers;
- too few opportunities for small farmers to become medium-scale farmers;
- too few western capitalists prepared to invest in large plantation schemes;
- too few non-government organisations of every sort to ginger and encourage;
- too much late payment of fixed and low state prices for produce;
- too many village elders and witchdoctors who hate to see young people get ahead;
- too few energetic and public-spirited public servants at any level;

The answers to some of these problems fly in the face of Green convention.

Many people have a strong intuitive sense that poor farmers should grow and eat their own food. Peasant subsistence has a powerful pull on western imaginations. However, it must be asked why very few well-off farmers in the rich world bother with any subsistence farming. How different should the picture be in the Third World?

The romance of self-sufficiency springs partly from a belief that

subsistence farming is somehow more secure than dependence on markets. Clearly, people in cities need the market to bring them secure food supplies. But even people in the countryside may find that both cheapness and security in food supplies are more easily had from the market than their own fields. This is likely to be a part of their calculations even when they are quite or very poor. The essence of this new security is that cash – even in small quantities – is a virtual guarantee of food, even if one's own land has seen a reverse in productivity, perhaps because of the weather. The creation in Africa of a vigorous trading sector is seen by some knowledgeable white Africans as the rebirth of what was quite a strong tradition of rural markets which colonialists stamped out the better to ensure that they had labour for white-owned farms.

Not that cash is always king. Many modern urbanite Third Worlders – especially men – live in cities in the hopes of getting work and money. They do so while depending on their wives to keep a village plot ticking over, available as a last resort larder. Besides, as one experienced agricultural adviser pointed out to me on reading a draft of this chapter, cash can corrupt. He said that, too often, cash is squandered on beer and prostitutes: subsistence crops might have helped the family rather more.

So the picture is complicated. Yet, it seems fair to suggest that modern country people do not want the promise of a very slightly improved version of a primordial way of life which they left or want to leave because it did not pay and did not attract. Even poor people eschew backbreaking work in a claustrophobic family or village environment. These aspects of peasant life only satisfy those who have never known anything different or have never known it at all.

The rural dream of rich world romantics can no more be expected to survive in Africa or other Third World places than it has anywhere else. Yet young disaffected, talented and useful men and women may come back from the cities into the countryside. The present best-hope youngsters who are already there may be enticed to stay.

Modern Third World country people want the chance of a decent living gained by the nifty deployment of very small amounts of skill and capital. They want a scale of technology which is cheap but saves sweat. They may well become beneficiaries of the small-engine and hydraulic revolution which has yet to come to much of the Third World. Technology is decried by romantics because it so often seen in its nineteenth-century guise. This was the version of machine and

technique which gave us factories and other forces of centralised enterprise gathered round monolithic machinery. The nineteenth-century anarchist and geographer Prince Kropotkin may, however, be proved to have been merely a little early in predicting the arrival of decentralised, often hand-held, machinery everywhere in the world. This is the power-tool scale of technology which was celebrated by Ivan Illich half a century after Kropotkin. Interestingly, labour-saving devices may not create unemployment. Many useful soil- and water-conserving jobs are now left undone because they are uncongenial and unprofitable. Quite small changes in markets and machinery may change that dramatically.

There has for years been a fierce debate about economic measures to increase food production, and the latest intelligent fashion is to argue that, amongst much else, the agriculture sector is an engine for economic growth. This might seem obvious, but it is not self-evident. For several decades, it has been assumed that even poor countries should concentrate on developing an industrial economy and that doing so would put money into the hands of farmers, and they would produce food as a consequence. Now, increasingly, it is argued that it is worthwhile concentrating policy directly on improving the means farmers have of getting a living.

The economic and social reforms that will bring about successful, small and medium-scale farming are emerging. They flow from the defeat, partly as a result of sustained bullying from western governments, of Third World command and control economic policies, and also from the gradual, forced, erosion of Third World élites, and perhaps especially in land reform. The changes will make sure the grower, and not a bureaucrat, gets the profit from his or her crop.

There has been a good deal of discussion about how poor countries should put agriculture higher than industrialisation on their agenda of development goals. Actually, it seems they need to progress together. Without paying customers, farmers starve. As Profesor A. H. Bunting of Reading University, a very experienced agronomist, points out, few countries have ever grown rich by growing food. Rather, a healthy agricultural sector followed wealth. On the other hand, without benign government help – and aid – it is unlikely that farmers will have an effective infrastructure through which to supply their customers.[42]

No reforms will produce a limitless supply of food. But they will make it increasingly likely that it will be small- and medium-scale

farmers in lucky parts of the world's continent who get nicely affluent by supplying food to the unlucky parts. This will be a marked improvement on the situation whereby North American and European farmers are heavily subsidised to do so.

At present, many farmers cannot afford labour and chemicals because their produce does not find a market. Much of the ecological damage done by farmers stems from the lack of profit they find in the enterprise. Soils are left undernourished, wells and terraces unmended, irrigation works poorly managed, not because the fields were asked to do too much work, but because too little cash came in for the produce they grew.

Breaking through the barriers

The Green Revolution has lifted much of Asia and Latin America out of famine in the past two or three decades. This is a matter of applying plant-breeding techniques – the core of the revolution – to create plant strains which could be heavily fertilised without falling over on their stalks. But agricultural experts do not expect the Asian and Latin American Green Revolution miracles to be repeated on the same scale in Africa or indeed in any area with very poor soils, adverse terrain or climates.

Equally, though, environmentalists do not do well when they snipe at the Green Revolution. It was more helpful to Asia and Latin America than it is fashionable to admit. In future a revised version of it will be helpful to Africa. Certainly, the Green Revolution involved social upheaval because it required and rewarded farmers who had access to skills and capital rather than the very small-scale farmer. Consequently, it was the large farmer rather than the small who benefited from it most. But the fact remains that in the huge areas where the Green Revolution took off, there had been a high expectation of famine as populations increased, and those famines did not happen. Instead of importing food or being dependent on food aid, these regions were – against all expectations – growing their own food.

In areas where the revolution took off, people lost their jobs, and that is a pity. But plenty of them found the means of making enough money to buy the cheap produce the revolution brought to the market. Without the revolution it is likely there would have been neither the produce nor the farmwork. Social and ecological prob-

lems went along with the Green Revolution, and it is tempting to see them as making the case against technological innovation.[43] But they do not. Technological revolutions can be very brutal – as can economic transformations – if they are not cushioned by alert and conscientious social action. That makes a better case for a better politics than it does for abandoning technological change.

It is said that the Green Revolution was an ecological disaster. But at least one British aid official believes that such impoverishment of the soils as has been caused by the revolution's methods could be fairly easily cured by a little education and investment: 'Nothing has been irrevocably lost,' he says.[44] Indeed, it is often for the absence of a few easily-delivered minerals, rather than for the lack of major inputs, that the soils of, say, the Punjab are impoverished.

It is also true that the Green Revolution involves many farmers in a vicious cycle of pesticide application. They are obtaining very high yields with new strains which are vulnerable to pests which the old strains had evolved alongside and with which they could co-exist. But after a spate of bad-news stories, we are beginning to hear that the Green Revolution is starting quite successfully to combine high yields with freedom from the need to use high doses of pesticides. Integrated Pest Management (IPM) – which uses a wide range of ecological insights to reduce dependence on chemicals – has, for instance, proven very successful in protecting some of Indonesia's hugely-expanded rice crop. IPM will save countries millions of dollars of pesticide subsidies for their farmers. When more farmers pay the full cost of their pesticide-use IPM will take off dramatically.[45]

It has become fashionable to celebrate only the small farmer. This is a big mistake. We cannot afford to forget how successful plantations can be. At Mpongwe, in Zambia, to take just one example, the British Commonwealth Development Corporation has a big scheme which produces rainfed maize and soya, and irrigated coffee and winter wheat. Alongside a Zambian firm, the British development agency has become a 50 per cent shareholder in the enterprise, which CDC manages. With 4000 hectares in production and a further 8000 hectares to come, this is just the sort of large-scale operation which seems inappropriate to the romantics who think that only peasant agriculture is right for poor countries, and that it must be wrong for partly foreign-owned farms to be able to export some of their profits out of Africa. And yet on these thousands of

hectares, 1000 fulltime employees have livings, and in good years 2500 seasonal employees get part of theirs. New and improved housing, a primary school for 700 pupils, a clinic, shops and a bank have all been created as part of the scheme.[46]

The land CDC and its Zambian partner uses was underemployed before they came along. It now produces foreign exchange and food for a country in bad need of both. It is also producing an important intangible: a success story in a country which needs them. Beyond the general lesson that Africa's soils and water supplies are not all as hopeless as they look, and Zambia's happen to be very good, CDC's scheme will also be helping to answer questions about what works and where. It is far better that this sort of experiment at least in part happens with foreign capital, especially if – sadly – it turns out not to work for long. If one such scheme does not work, then the next is more likely to because of the lessons learned.

Presuming that CDC's scheme flourishes, then perhaps some of Africa's rich people will follow where British enterprise helped lead. The capacity to take big risks, teach big lessons, and produce big quantities of food and foreign exchange is what the British brought to the scheme: that is surely a large series of pluses. It is CDC's purpose to invest money and management precisely in schemes and countries perceived as being too risky for most western firms.

There is a growing awareness that plantation schemes have often proven that – contrary to myth – even tropical land can remain in good heart for many years under intensive production. Moreover, there is a growing awareness amongst some academics that they have generated a new and not altogether accurate myth about the virtue of small-scale production. Professor Tim Harding, director of the International Centre for Plantation Studies at the Silsoe campus of the Cranfield Institute of Technology, puts it this way:

> I've been involved with tropical agriculture for twenty years and especially with small-scale farming. More recently, with this new Institute, I've become very much involved with large scale operations and have witnessed the extraordinary contribution they have made. You have to see the infrastructural developments which have gone along, which they have paid for: schools, hospitals, roads. I tended to view plantations as everyone else views them. You hear that they're exploitative, paying appalling wages to the labour force, devastating the environment, tearing out national forest, that their profits are repatriated to the United Kingdom and the Netherlands. In short that

they are run by exploitative capitalists. Then there is the question of corruption.

You'd have to say that some of the multinationals can be accused of these things. There are some that I wouldn't work with. You worry about them all to some extent; they're in business and they have a labour force which is comparatively underpaid. But you see their conditions tend to be better than those of their neighbours; that people are keen to work for them. After all, their employees get education, health, welfare and that is all held in high regard. Indeed, the multinational corporations are under presure to maintain high labour forces, while most of them would be more profitable if they were allowed to mechanise.

Tea companies, for instance, wouldn't mind having fewer, better paid workers. In principle they're interested in developing labour productivity, say by the use of shears in tea plucking.

Plantation companies like foreign exchange crops: they like long-term tree crops, such as tea, coffee, cocoa, palm oil, sugar cane. And then you see that most of these big companies acquired concessions maybe a hundred year ago, and many have worked the same land for many years.

Tim Harding is sure that plantations have a role, but of course does not dismiss the received wisdom that smaller-scale farming also has one, especially in producing very high grades of some crops, though in small quantities. Acre for acre, small-scale farming can produce very high yields. But it is extraordinarily difficult to get really large volumes of crops from small-scale farming, if you look at the problem from the point of view of production from a region rather than from an individual plot. And it is very hard, too, to match small-scale farmers with the scale of food storage and processing which is the key to modern cheapness of production.

The CDC scheme affronts romantic ideals of several kinds. It produces cash crops, and at a plantation scale. It uses African land to produce crops which are not for local consumption. It has been a familiar Green argument for many years that poor people should work toward self-sufficiency and subsistence, and that any other route to growth is exploitative.

Overstated, as it often is, this view is nonsensical. Like Paul Harrison,[47] I have met farmers in Kenya and Tanzania whose handful of acres produce a wide range of crops, some of them for sale to Europeans. Two of the liveliest Africans I have met were engaged in producing carnations and would not have been without the crop. As

we have already seen, cash is an important key to security in poor as well as in rich countries. And variety of crop can powerfully help farmers insure cheaply against the diseases which may strike at any time.

It will not be by peasants alone or plantations alone that the Third World produces food and a living for its people. It will not be by relying on exclusively modern or exclusively traditional techniques. And it will not be by notions of self-sufficiency, either. It will be an amalgam of farming and trading techniques which will, with luck, help the poor countries of the world to discover their agricultural potential. It will also be by the application of techniques which have hardly been invented yet.

The bio-industrial revolution

We know that about 90 per cent of the increase in food production in recent decades has come from increases in yield of food per acre of land, and only 10 per cent or less from increases in land under production.[48] It is clear that in many places, perhaps most places, the new lands which might become arable or more intensively pastoral are less and less likely to be highly productive.

For at least one industry the constraints facing farmers seem almost like good news. Biotechnology offers a route out of some of the difficulties which afflict conventional agriculture. To take one major United Kingdom example, ICI Seeds (now known as Zeneca) has made a big effort to explain its potential role to anyone who will listen. This is only appropriate for a business which the public believes is more likely to make a Frankenstein than a new version of the miracle with fishes and loaves.

Under the general banner 'Growing for a Better Future', ICI Seeds (as it then was) produced several accounts of the new opportunities and some of the attached dilemmas.[49, 50, 51, 52] One of these, *Crop Protection In the Developing World*, readily accepts many of the conventional limitations which block big new productivity increases. If there are limits to new land, to new supplies of water, and to new increases in the uses of pesticides and fertilisers – and there clearly are – then it makes sense, in the biotechnological view, to optimise their use.

Most of the major crops of the world – including rice, wheat, and soya – are drawn from a very broad genetic base, cross-bred, and

have been shifted out of their region of origin by pioneer agriculturalists, hundreds or even thousands of years ago. They have become prone to disease as they have become more productive, but they have also been developed to grow in areas where they could not have managed hundreds or thousands of years ago.

Zeneca maps out three stages in the likely future development of these ancient techniques, all of which will produce plants which deliver more and more of what humankind desires with less and less dependence on resources in short supply. In the short term, until the mid-1990s, the main developments will be in techniques which make hunting through existing plant gene types quicker and more efficient. Increasingly, in the mid-term, by the late 1990s, technology will allow the transformation of plant types by the addition of particular genes conferring particular new advantages. In the longer term, technologists expect to be able to make what Zeneca calls 'more fundamental changes', which will take the manipulation to the point of creating new species.

The promise and threat of biotechnology flow from the skill mankind has developed in getting into the engine room of life; into, that is, the cells and genes which are life's building blocks. This new technology seems to many people to be an offence against nature. Biotechnology is viewed with the same suspicion that was once reserved for nuclear power. It is only forty years and less since nuclear power was touted as the source which would produce electricity 'too cheap to meter'. The risks and costs have emerged later (and been exaggerated, as we discuss in Chapter 4).

Biotechnological development faces the obvious problem that we might create a monster – a virus against which we have no defence, a new super-weed, a new agricultural pest capable of wiping out entire crops. The industry and its regulators insist that biotechnology is doing little that nature could not do for itself. The regulators and the semi-official bodies which advise them clearly believe that we can proceed slowly, testing our confidence at every point.[53] But will the cautious optimism of industry and regulator still quiet anxiety?

Nuclear power and biotechnology share qualities of fearfulness and incomprehensibility. Confidence about technologies such as these will not come because Joe Public understands them. The non-technicians amongst us will far more likely come to trust biotechnology, or nuclear power, because we learn to trust the institutional process by which technologies and processes are judged

on our behalf. The penultimate chapter of this book looks at some institution-building which may help this process. Familiarity helps. Every year that passes without a major western nuclear accident helps that industry, and with luck biotechnology will have an even better record.

The debate surrounding biotechnology has so far made one feel mildly confident that the progress of this development will be like most others: noisy, controversial, occasionally surprising in its capacity to go wrong, but controlled with increasing sensitivity and alertness as the years roll on.

But how much will gene manipulation help feed the world? The developments which we see so far are in products from which industry can predict high profits. So we find ourselves reading about the engineered tomato rather than the engineered rice plant. This is the way capitalism often works with the technologies it pays for, and the result is blind but often benign. The market funds marketable research into high-price product. But discoveries soon find their more general, and more generally useful, low-price outlets. It will not be at all surprising if insights which Zeneca or any other firm gains in tomatoes will soon be used in more nutritious plants, or that processes explored initially for private profit and for use in the rich world will be found to work well and cheaply in the Third World. Doubtless, we will have to explore ways for governments, foundations and charities to fund private firms to develop seeds and techniques for their dissemination in poor countries.[54]

Third World researchers worry that genetically engineered substitutes for pyrethrum, cocoa, vanilla and gum arabic could soon be produced in laboratories and factories in the west rather than in the tropical countries in which they are valuable cash crops.[55] One simply has to hope that cases of loss will be matched by examples of other crops made to grow with less water, or less chemical inputs, than are presently needed and that these benefits help the poorer countries.

In any case, the general lesson of the past is that these sorts of concerns evaporate. In the instance of computing, there were fears that IBM would somehow monopolise hardware and software. What has happened, instead, is an explosion of variety of suppliers. Indeed, biotechnology is more like computing than it is like nuclear power in this sense: it will often be cheap, simple, easily dispersed into the market, and profitable to use.

The global good news

The Third World will be very unlucky indeed if it does not grow very much more food than it now does, and with less ecological damage. But there is no certainty that it will be self-sufficient in food. Professor Ian Carruthers of Wye College, London University, wrote recently, after six months travelling in the Third World:

> In thirty years' time four out of five of the world's urban people will live in the developing world. I cannot see the bulk of food supplies for these cities of the developing world coming from their hinterland but only from overseas. In 20 to 30 years' time the cities of the developing world will be fed from Chicago and possibly Kiev.[56]

This may not matter.

Martin Brown and Ian Goldin[57] have pulled together many of the teasing paradoxes of world farming and food supply. Their message, drawing on a wide range of studies, is that the world as a whole can grow and trade quite enormous quantities of food. This food is likely to get cheaper in almost all cases (with rice as a possible exception) as technologies increasingly bite. Much of this bulk and cheapness can probably be achieved within tighter ecological controls. The most obvious and predictable source of the bulk and cheapness of food is the rich world. There will perhaps be the same number of very poor hungry people in the world in the next century as there are now: maybe a few more, maybe a few less. The proportion of the world's population which cannot feed itself by its own efforts will fall somewhat, but the absolute numbers of hungry will rise somewhat.

Mssrs Brown and Goldin's arguments imply that the world is nowhere near exhausting its capacity to feed humans. The food can be there when there are ten billion people to eat it. What is much less clear is how the very poor of the world will lay their hands on it.

The authors provide some ways of thinking about this problem. No one knows what the Third World will be growing in the future. It would not, for instance, make sense for the poor of the world to be told to try to buy expensive local produce as opposed to cheap foreign produce merely on the grounds that it was produced by people of the same nationality as themselves. On the other hand, buying foreign food, however cheap, involves economies in getting hold of foreign exchange, and that may not be as easy as all that. The balance between earning the foreign exchange by exporting industrial or farm products and growing the food for oneself is a fine one

and there are no clear answers as to where the line should be drawn.

But Brown and Goldin offer quite firm guidance on a related topic. They stress that if one is trying to get a rural economy going then the cheapness of the produce which farmers grow will help a great deal. Modern analysis suggests that if a farmer can reduce costs, and sell food into markets cheaply, that will do the farmer and the economy and the customers far more good than rigging things so that the consumer pays, and farmer is paid, falsely high prices.

These are arguments of immense hopefulness. They suggest there will be an abundance of cheap food available in international trade during the next century. The proportion of this tradeable food which would be required to feed those who are predicted to have difficulty feeding themselves in the market is very small. In other words: the food needs of the poor of the world are likely to add up to a very small percentage of the total food which the world will be growing very cheaply by then.

It is surely likely to be possible to make the next little leap. If we have, say, half a billion hungry people and lots of food around, we will work out a way of getting the food to the people if we want to.

Notes

1 McEvedy, C. and Jones, R., *Atlas of World Population History* (Harmondsworth: Penguin, 1985).

2 Polunin, N. and Burnett J. (eds), *Maintenance of the Biosphere*, International Conference on Environment Future (3rd ICEF) (Edinburgh: Edinburgh University Press, 1990).

3 *Ibid.* p. 5.

4 Lee, R. and DeVore, J., *Man the Hunter* (Chicago: Aldana, 1972).

5 Garnsey, P., *Famine and Food Supply in the Graeco–Roman World: Responses to Risk and Crisis*, (Cambridge: Cambridge University Press, 1988).

6 Thompson, E. M. L. (ed.), *Cambridge Social History of Britain* (Cambridge: Cambridge University Press, 1990) pp. 251–78.

7 *Ibid.* p. 206.

8 Polurin and Burnett, *Maintenance of the Biosphere* p. 7.

9 See especially FAO/Netherlands *Conference on Agriculture and the Environment* (6 volumes) Rome, FAO, 1991. (The Den Bosch conference.)

10 Den Bosch conference declaration, FAO, 1991

11 *Ibid.* p. 11.

12 Den Bosch Regional Document No. 2, p. 19.

13 Alexandratos, Nikos, *World Agriculture in the Next Century: Challenges for Production and Distribution* Paper presented at XXIth International Conference of Agricultural Economists, Tokyo, Japan, 22–29 August 1991 (Rome: FAO, 1992).

14 O'Hara, S. *et al.*, 'Accelerated soil erosion in a Mexican highland lake caused by preHispanic Agriculture', Letters to *Nature*, vol. 362, March 4 1992.

15 International Soil Reference and Information Centre, Wageningen, the Netherlands.

16 World Resources Institute, *World Resources 1992–93* (Oxford: Oxford University Press, 1992) p. 117.

17 'Assessment of soil erosion risk in England and Wales', *Soil Use and Management*, vol. 1, no. 4, December 1985.

18 The Global 2000 Report to the President, *Entering the Twenty-First Century* A Report Prepared by the Council on Environmental Quality and the Department of State, vol. 1, 1980.

19 Porritt, J., *Save the Earth* (London: Dorling Kendersley, 1991) p. 69.

20 Brown, L. and others, *State of the World, A Worldwatch Institute Report on Progress Toward a Sustainable Society* (New York: WRI, 1987) p. 124.

21 See Pearce, F. *The Dammed* (London: Bodley Head, 1992) and Ehrlich P. and Ehrlich, A. *The Population Explosion* (London: Hutchinson, 1990).

22 For the view that curbing excess and waste is probably the sufficient key to solving the North American West's water problems, see Charles Wilkinson, *Crossing the Next Meridian: Land, Water and Future of the West* (Washington DC: Island Press, 1992).

23 See especially Brown, L. *et al.*, *The State of the World 1990* (New York: W. W. Norton, 1990).

24 Pearce, F., *The Dammed*, (London: Bodley Head, 1992) p. 183.

25 Harrison, Paul, *The Third Revolution* (Harmondsworth: Penquin, 1993).

26 Carruthers, Ian, 'Look at it this way' *Outlook on Agriculture* vol. 21, no. 4, 1992. (See also 'Population growth and natural resource use; do we need to despair of Africa?' *Outlook on Agricultue* vol. 22, no. 4 1993 (CAB International, Wallingford Oxon OX1 ODE, UK)).

27 Porritt, J., *Save The Earth* p. 59.

28 Adams, W. M., *Wasting the Rain: Rivers, People and Planning in Africa* (London: Earthscan, 1992 p. 52.

29 *Ibid.* p. 54.

30 International Union for Conservation of Nature and Natural resource, *The IUCN Sahel Studies 1989* (Gland, Switzerland: IUCN, 1989).

31 International Union for the Conservation of Nature, *IUCN Bulletin* vol. 20, no. 7–9: *Sahel: Out of the Myths* (Gland: IUCN, 1989).

32 Adams, W. *Wasting the Rain* p. 59.

33 Wilhite, D., Easterling, W., with Wood, D. (eds.), *Planning for Drought*, (Boulder: Westview Press, 1987) p. 3ff.

34 Wilhite, D., *et al.*, *Planning for Drought* p. 6.

35 Anderson, D. and Grove, R. (eds.), *Conservation in Africa: People, Policies and Practice* (Cambridge: Cambridge University Press, 1987) p. 29.

36 Harrison, P. *The Greening of Africa* (London: Pulsdon, 1987) and *The Third Revolution* (Harmondsworth: Penquin 1993).

37 Conversations with Kenyan conservationists.

38 Conversations with aid workers in Lesotho.

39 Conversations with aid workers in Lesotho.

40 'Kenya study leads to land resource recommendations', *Environment Bulletin* Winter 1992/3, The World Bank, Washington.

41 Mary Tiffen and Michael Mortimore, 'Population growth and natural resource use: do we need to despair of Africa?' *Outlook on Agriculture* vol. 22, no. 4, 1993. The study on population densities mentioned is Haggblade, S., Hazell, P., and Brown, J., (1989), 'Farm-nonfarm linkages in rural sub-Saharan Africa', *World Development* 17(8), pp. 1173–1202.

42 Bunting, A. H., 'What is this thing called development?' *CDC Magazine*, no. 3, 1991. (Commonwealth Development Corporation, 1 Bessborough Gardens, London, SW1V 2JQ.)

43 A useful debate on these issues is in *Choices, The Human Development Magazine*, June 1993, United Nations Development Programme. (Division of Public Affairs, One United Nations Plaza, New York, NY 10017.)

44 Overseas Development Administrataion briefing.

45 'Less pesticides do not mean less rice' FAO press release, 11 May 1992.

46 *CDC Development Report May 1993* (London: The Commonwealth Development Corporation 1993).

47 Harrison, P. *The Third Revolution* p. 124.

48 *World Bank World Development Report 1992* p. 135.

49 Macer, R. and Bartle, I., *Crop Biology in the Developing World* (ICI Seeds, 1990).

50 Macer, R. and Bartle, I., *A World Perspective on Population, Agriculture and Food* (ICI Seeds, 1989).

51 Beringer, E., Bale, M., Hayes, P. and Lazarus, C., 'Assessing and monitoring the risk of releasing genetically manipulated organisms', first published in Proceedings of the Royal Society of Edinburgh B100, 1992 (Symposium: Opportunities and Problems in Plant Biotechnology) and then by ICI Seeds, 1992.

52 Straughan, R., *Ethics, Morality and Crop Biotechnology* (ICI Seeds, 1992).

53 The Royal Commission on Envionmental Pollution, *The Release of Genetically Engineered Organisms to the Environment*, Report 13 (London: HMSO, July 1989) p. 36.

54 Brown, M. and Goldin, I., *The Future of Agriculture, Developing Country Implications* (Paris: Organisation for Economic Co-Operation and Development, Development Centre, 1992).

55 *The Sunday Times*, Nairobi, November 20 1988.

56 Ian Carruthers, 'Going, going, gone; tropical agriculture as we knew it', *CDC Magazine* no. 12, 1993; Bunting, A. H. 'What is this thing called development?' *CDC Magazine*, no. 3, 1991.

57 Brown M. and Goldin, I., *The Future of Agriculture, Developing Country Implications* (Paris: OECD, 1992).

4

Fuelling the future billions: some clues

The latest big environmental issue – human effect on the atmosphere – is serious by almost everyone's reckoning. Even when one strips out the hype, atmospheric change remains a serious threat. Yet human innovativeness is probably equal to finding a series of at least partial solutions, and this chapter suggests that the modern version of the energy crisis need not defeat us. The nuclear option deserves to be reassessed, not least because the public may find that it dislikes a big contribution from some renewable energy sources.

From science to policy: clearing the air

People have always had all sorts of ways of altering the atmosphere in which they live, usually for the worse. Smoke nuisance has required regulation since the medieval period and we have known for well over a century that our combustion creates acid rain.[1] Some modern problems have presumably been with us from the beginning. In the Third World, perhaps 700 million people endure quite serious health risks from the smoke which fills their houses and huts from smoky fires.[2] The World Health Organisation calls this the worst occupation-related health problem on the planet.

We hear more about problems which seem distinctively modern. Cities all over the world suffer direct pollution from vehicle exhausts. These are thought to have a direct health effect. But they also contribute to a variety of atmospheric effects, including seasonal smogs, formed as by-products of combustion reaction with sunlight. In the 1950s, London and many other cities suffered winter smogs caused by smoke particles, until coal-burning – much of it domestic –

was banned in and near towns. We now have summer photo-chemical smog, mostly caused by emissions from vehicles working in areas which are subject to windless, oppressive weather. Such smogs are reckoned to affect around one billion people around the world.[3]

The problem of vehicle exhausts can be reduced by an end-of-pipe technology, the catalytic converter. Catalysts can go some way to diminishing the emissions of nitrogen oxides and volatile hydro-carbons, an important source of the problem. The difficulty here is that such converters do not much help if they are badly maintained, or are used as an excuse to continue with big, inherently polluting engines in an uncontrolled number of cars.

It is an important argument against the use of catalytic converters on vehicles that they do nothing to reduce carbon dioxide emissions (see the remarks on global warming below), and even tend to pander to the idea that conventional engines can be clean. It is argued persuasively by some engineers that reliance on the introduction of catalytic converters took the west's eye off the development of leaner-burning engines (which use fuel much more efficiently than present types). These engineers now hope that lean-burn engines will be introduced, and that catalysts can be designed to work with them (unlike existing types).[4]

The western world, and some less obviously rich countries, have already moved against photochemical smog by legislating for cata-lytic converters on vehicles. But photochemical smog in most countries is not a problem of the worst sort. It is temporary, in the sense that if cities impose half decent regulations, it can be diminished or banished overnight. Moreover, its effects are tangible and afflict the polluter. The polluter and the victim tend to be identical, which makes the politics of the issue relatively easy.

Acid rain is a rather tougher case. It was and is caused importantly by dirty power stations generating electricity whose use can be reduced, certainly, but is also inevitable and unavoidable. The form and seriousness of the effects of acid rain are debatable, and usually most serious many miles from the offending plant. There is recent evidence to confirm an earlier hypothesis that natural sulphur emis-sions from the sea are greater than previously thought, and may be contributing as much as a third of the acidity blown into Sweden and Norway. This somewhat reduces the blame which had attached to British sources.

International negotiations have sought to control acid rain by

imposing limits on the amount of sulphur dioxide emitted by each country, and have largely succeeded, though the limits may need tightening up somewhat.[5] When the international agreements were negotiated in the 1980s, the solutions were thought to be very expensive, especially because it seemed inevitable that generators would have to retrofit clean-up technology. In the event, a switch to gas as a fuel, and recession, did much of the work for regulators and generators.

The west has been debating acid rain and smogs intensely for twenty-five years and more. By the mid-1980s, when it became very obvious that something was wrong with the ozone layer which shelters earth from ultra-violet light from the sun, there was a good deal of green awareness and readiness to act. This is reassuring, given that, although smogs were local, and acid rain regional and international, ozone depletion was global: it was inherently less easy to grasp. The other issues had been fairly comprehensible and had vociferous victims. The ozone hole was remote, intangible, and complicated. All the same, politicians had had the acid rain and smog experiences to sharpen their sense that these sorts of issues have a power to excite people. They had also realised that environmental regulation was a little cheaper than they first thought. Besides, the bills were passed quickly through to consumers. Politicians had learned that, if the public wanted environmental controls, there was often political mileage – and small cost – in giving the public what it wanted.

After a false start in the 1970s, the ozone hole issue really came into enormous prominence in 1985, partly as a result of work by the British Antarctic Survey which identified a seasonal ozone hole at the southern polar region. This new work blossomed into a strong theory of anthropogenic ozone depletion, and in particular of how emissions of CFCs (chlorofluorocarbons) released damaging chlorine into the stratosphere.

It is not clear how important the thinning of the ozone layer is, and there remains some dispute in judging the roles of people and of natural forces in producing the thinning. James Lovelock, who invented the equipment which led to the discovery that chlorine was a problem, has always been sceptical that the phenomenon is a major problem.[6, 7]

There is evidence that volcanoes are factors in ozone loss, though more as an exacerbation than a major cause.[8] Ozone depletion may

have helped offset the global warming effect of various gaseous emissions.[9]

If some data seems to let us off lightly, other work suggests that increased ultraviolet (UV) radiation may diminish important phytoplankton production in the oceans of the world, and increase cataracts and skin cancers.[10] Conversely, anxiety about the human health effects of increased UV radiation may make people cautious about baring skin and leaving eyes unshaded. There may be fewer skin cancers and cataracts around the world when there is publicity about lessened ozone.[11]

The issue has never been straightforward, but seemed to merit a precautionary approach (see Chapter 11). During the early part of the debate, ICI and most other chlorine producing firms (and ICI much longer than the leading US firm, Du Pont) argued their corner with too little appreciation of the strengths of the case against the chemicals they were selling. In the event, by the late 1980s ICI and the others were willing to embrace regulation of CFCs because they realised that not only were there alternatives which they could make and sell, but that the alternatives were more profitable.[12] In the CFC case, hardly anyone argued for an end-of-pipe solution (though recycling might have helped more than it was allowed to). A straight ban of the offending chemicals always seemed the attractive answer.

Negotiations for the 1987 Montreal Protocol, the international agreement to reduce the emissions of CFCs, were bedevilled by a factor which became even more serious in the case of the greenhouse effect and global warming a few years later. It has been possible to persuade Third World countries to tolerate strict CFC regulations because it was possible to persuade them that they could be given access to the alternative technologies. This is going to be a much tougher business as we try to encourage energy use which does not tend to warm the planet.

Almost all human activities contribute to the emission of gases which are thickening the existing gaseous warming blanket which has always wrapped the earth. This blanket lets the sun's heat into our atmosphere but decreases the amount of heat which escapes back into space. The planet would be uninhabitably cold but for some sort of atmospheric mantle to warm it. The point is that now we seem to have over-egged the pudding. On present trends, some-time half way through the next century, the global-warming potential of emissions will be twice what they were at the beginning

of the industrial revolution. The methane from our rubbish tips, cattle and rice paddies; the CFCs we have used so freely until recently; and the carbon dioxide from our burning of fossil fuels are three of the most important contributors and will continue to be.

An important feature of the global warming problem is that it is the rich world which has contributed most to the industrial growth which lies behind it. The less developed countries now want to pursue growth strategies, in many cases have the fossil fuels needed, and will be reluctant to forgo that growth on account of the diminished environmental 'headroom' mankind now has.

If the global warming is serious, so are its implications for the future of our heavily-populated planet. A mountain of scientific evidence has been generated by teams of researchers mandated and funded by governments around the world to investigate the phenomenon. This internationally coordinated effort produced a consensus view in 1990.[13] It centred on a prediction that if they were not abated, gaseous emissions might produce a warming in the range of 1.5 to 4.5 degrees celsius. The scientists took care to stress that there were huge uncertainties within important parts of the analysis, but that emissions were certainly producing a warming effect. The warming effect is, if not a much larger, certainly a much quicker, change in the world's temperature than any other in human history.[14] However, and the flavour of this is much harder to convey, it is very unclear what the consequences of the warming will be. That human beings adding a warming effect to the planet does not necessarily mean it is being warmed proportionately, or even at all. There may be contrary phenomena.

The worst gaps in our understanding attach to feedback loops in the climate system and weather-producing mechanisms of the earth. These loops, which are responses to change, can variously accelerate or diminish the effect of the change which triggered them. There are simply dozens of big unanswered questions here. For instance, as the oceans of the world are warmed, will they absorb more or less carbon dioxide? As the planet warms, will the polar ice caps absorb more water, or less? Might big volcanic eruptions cancel out the warming effects of years of carbon emission, as the eruption of Mount Pinatubo seems to have done in June 1991? An even bigger issue surrounds the role of clouds and water vapour. At least one important North American scientist heavily criticises the consensus view that clouds will provide a positive feedback and increase

warming. Richard Lindzen, a professor of Meteorology at the Department of Earth Sciences at the Massachusetts Institute of Technology, argues forcibly – but very controversially – that they will provide a negative feedback. In other words, that the increased warmth will be, to some extent, self-limiting.[15]

Beyond these uncertainties as to the machinery at work in global warming and cooling, we are even less sure what the effects of a given warming might be in different places around the world. By some accounts, the seas will rise and flood many places where people live and work. In other accounts, the sea level will fall.[16]

The bottom line in the very important issue of food production seems to be that 'studies have not conclusively determined whether, on average, global agricultural potential will increase or decrease'.[17] Opinion on global warming is, of course, divided. At an obvious level, there is dispute as to whether any effects of warming can yet be detected. Then there is dispute as to whether the absence of any definite evidence that human influence has yet produced effects is a good reason for now doing rather little about the problem. There is the problem of whether the phenomenon is a problem at all, and more particularly, to what degree. Many people who have lived through previous environmental scares have become inured to them. The sceptics feel that, since so many previous scares became canards, we should not be rushed into inappropriate action by what may turn out to be yet another in the line.

Many people feel that the climate issue is a perfect example of the need to act in line with the precautionary principle (see Chapter 11). To do so would be to act in advance of final and incontrovertible proof that there is, or is about to be, an environmental crisis. Let's listen to this case first.

John Firor, erstwhile director of the US National Centre for Atmospheric Research in Boulder, Colorado, believes that it is inappropriate to wait for further evidence that might produce greater precision about what the warming effect may be. In his view, the science is solid enough to justify firm action now. Dr Firor says our understanding of the seriousness of the problem will not be much enhanced by narrowing the range of predictions we make about how much the planet is warming and where the impacts will fall.

This case relies on our certain knowledge that the world's climate is inherently variable and that our warming almost certainly represents an acceleration of its variability. Dr Firor says:

If you look back 300,000 years you find that a stable climate is almost unknown. Except for one 10,000 year period, which is the present period, the earth's temperature has wandered around within a range of 2–3 degrees celsius. In our period it has wandered around by 1 degree. This interglacial is extraordinarily stable. Our best reckoning is that a business-as-usual scenario will produce a warming of about 3 degrees.

On this argument, we are throwing into the climate equation exactly the kind and degree of change which has pre-historically been associated with quite big changes in the habitability of regions of the earth. What is more, we are doing in a century or so that which nature habitually achieves across a millenium.

This view properly recognises that the world's climate seems quite naturally to be a temperature rollercoaster. It seems very like a fairground ride. Our warming influence promises to accelerate the ride, and thus be dangerous, whatever its detailed outcomes. The crucial point about this argument is that whatever the degree of uncertainty we feel about our knowledge of the climate system, we know that we are adding a warming effect whose effects we cannot be certain about. These uncertain new effects will fall on a system which is already uncertain. This view sees it as unlikely or even inconceivable that it could be a sound principle to add to a risky system a further element of riskiness, and to do so in the hope that somehow the system will accommodate the new factors and ameliorate them.

If this sense of a white-knuckle ride and its acceleration do not suggest the need for a precautionary response, it is hard to see when such a response could be justified. This becomes especially the case when we remember the evidence which suggests that, while the rich world may well be able to adjust to climate changes, the poor world will find the adjustments far harder. The essence of this argument is to remind us that a Holland may be able to adjust to rising seas – should that prove to be an effect of global warming – but that a Bangladesh would find it far harder. Similar difficulties surround the response of poor countries, say in Africa, to changes in the patterns of agriculture. An adjustment which might be tolerable in the US might be punitive in the sub-Sahara.

Beyond the idea that it is the rich who caused the problem and the poor whose response to it we must worry about, there is the difficulty that the worst effects will fall on future generations. This is usually

described as a matter of 'intergenerational' equity.

If we accept that we are adding to uncertainty, and that the worst effects may befall poor countries, then the rich world, the main present contributor to the effect, has an obligation to reduce its own emissions, and quickly. There is a clear moral need for the present generation, especially in the rich world, to develop better technologies for the 10 billion quite affluent people we expect soon to be on earth. If we do not, then the carelessness of the present generation of energy-extravagant westerners may well leave as a legacy an energy-hunger which will be unsupportable in future generations.

In recent years, the view that we are threatening our climate has come under full-frontal attack.[18, 19] I think it is fair to say that it has survived the crudest of these. But those who argue that we face catastrophe and must take very fast remediable action remain vulnerable to some serious criticisms.

In June 1993, the National Geographical Society's Journal, *Research and Exploration*, published a remarkable series of essays on the global warming debate. There were several which stated the consensus view. But there was a long piece by Richard Lindzen which cited suggestions that the doubling of carbon dioxide might well not happen in the first century of the next millenium, or at all. But Lindzen does not dwell on this hopeful scenario. He suggests not merely that warming may induce a response in the planet's water vapour and clouds which will provide a cooling effect, but, more radically, he argues that:

> It is commonly suggested that society should not depend on negative feedbacks to spare us from a 'greenhouse catastrophe'. This is a peculiar perversion of science, if the negative feedbacks are a sound consequence of scientific knowledge. Moreover, what is omitted from such suggestions is that current models depend heavily on artificial 'positive' feedbacks to predict high levels of warming.[20]

The strength of this argument is that it goes some way to undermine even the need to defend the 'do-little' case from the precautionary case. A scientist of Lindzen's stamp is simply saying that the 'problem' is a result of poor science and that, to that extent, there is no need to respond to it.

However, policymakers and the public have to judge the weight of Lindzen's arguments against those of the consensus view. This

cannot be easy. Freethinking people have a respect for the lone voice in science. It is often the right one. Besides, Lindzen is not entirely alone. Professor Keith Browning, onetime director of research of the United Kingdom's Meteorological Office, is chairman of the Cloud System Science team of the Global Energy and Water Cycle Experiment. He is solidly part of the gobal warming establishment, and yet in a long article for the Royal Society[21] he argued that it was dangerously easy to be wrong about the feedback effects of clouds – positive or negative – in such a way as to dramatically alter assumptions about the effects of global warming.

And yet the admitted uncertainties about global warming and its impacts do not necessarily add up to a case for complacency. The consensus scientific view seems to be that the issue is serious and demands action. Presumably, scientific discussion on the subject will mature, and perhaps reconcile the opposing cases.

In the meantime, there is a further line of argument which is, if sound, very helpful. *Research and Exploration* includes an essay by Michael E. Schlesinger, a professor in the Department of Atmospheric Sciences at the University of Illinois. The essence of the paper is to present work which suggests that, irrespective of the severity of the impact of global warming, there will be very little to be lost by delaying for a decade the commencement of emissions reductions.

This does not imply we need do nothing, but it suggests that the science allows us to tackle the issue in a way which suits our habits of thought and behaviour. One advantage is that we can undertake further research. A second, perhaps greater one, is that we can gradually now begin to do those things which are relatively painless and which will have pay-offs whatever the outcome of the global warming debate. We have, surely, a strong sense that industries and societies can adapt to most changes, provided they are slow. We hope against hope that global warming's impacts will emerge gradually, if we must endure them at all. But we also hope that a gradual reponse will be sufficient because – if for no other reason – that will allow a new generation of technologies to emerge without our having to junk existing technologies or rush into untried ones.

This line was expressed most clearly by the late David Thomas, *The Financial Times* environment correspondent until his death in Kuwait in 1991. Thomas argued against action on greenhouse emissions which could not be justified on other grounds, at least until the scientific research became more certain.[22]

Thomas was writing at a time when governments around the world were being pressed to say what they would do about the phenomenon. President Bush was almost alone amongst the western leaders in pronouncing himself a sceptic on global warming. Yet he followed a line set by his science adviser, Allan Bromley, who was a hardline doubter but even so acknowledged that action was justified provided it made sense on other grounds. Bromley called this 'insurance' action.[23] In fact, the United States's very public caution on the theory of global warming, and limited acceptance that action was justified if it helped other problems, was not extraordinarily different in effect to what was happening – or not happening – elsewhere. Margaret Thatcher was extremely vocal on the significance of the global warming theory, and made a famous speech in October 1988 describing global warming as a giant and unwitting experiment with the world's atmosphere. She was using a description which had first been used of the phenomenon by researchers in 1957.[24] Thirty years after the problem had first been mooted, and in spite of her admiration for the science, Mrs Thatcher showed no appetite for the policies which would have been required to combat the problem, nor even for limited 'insurance' action which could be justified on other grounds.

When the issue came to a head at the 1992 Rio Earth Summit, with a different premiership in Britain, it was agreed to aim at stabilising global CO_2 emissions at 1990 levels by the year 2000. According to the consensus view, such a target still commits the world to considerable continuing warming caused by human effect. President Bush refused to sign the agreement, though President Clinton and his environmentalist vice president, Al Gore, have signalled their intention to join the European Union, Japan and the others in doing so. It is an open question whether Mrs Thatcher would have signed or not. John Major, her successor, did.

It is hard, of course, to translate a generalised concern into firm regulatory action. Politicians are, naturally, reluctant to ask electorates to take very extreme steps unless there are obvious and certain benefits to be had. The trouble for policymakers is that they cannot point to a sure problem and easy solution in the case of global warming. It is a much harder case than acid rain or smog, and harder even than ozone depletion.

The upshot has been fairly gentle action which can be characterised as being worthwhile whatever is eventually believed about

global warming. The measures, generally no more than small taxes on energy use, will encourage energy efficiency and so slow the rate at which we will run out of fossil fuels. They will reduce acidification and photochemical smog. And they will – if they reduce the attractiveness of private motor vehicles – encourage public transport and thus ease both congestion and pollution in cities. These are all worthwhile in their own right, and so fulfill the requirement of not leaning too much on a global warming hypothesis which has yet to attract the public or even universal acceptance amongst serious scientists. They are also controversial. A tax on warmth is presented to electorates as inflicting hypothermia and new expense on the elderly and poor.

Anyway, around the world, treasuries are discussing or introducing energy taxes. These need not disturb our economies, even at levels much greater than envisaged at the moment. There is an emerging view that energy taxes are a less distorting way of raising government revenue than sales, corporation or income tax.[25, 26] Energy taxes may not inhibit economic growth and may even promote it (see Chapter 11 for further discussion on this point). They need not be inflationary, provided they replace other taxes.

Equally, however, we should not be beguiled into thinking that very light taxes will produce emissions-limitations. High levels of energy taxes, or other strict controls, will be needed to produce the degree of energy-sipping the world probably requires. There is no sign that these are likely to be quickly forthcoming.

Because of the persistence of greenhouse gases, action now will not produce any benefit in global warming terms for many years. So we need to start soon if we want to see our actions produce an effect within, say, two or three generations. Granted that our descendants may be glad we took quite intense action, and yet that we want the necessary policies to be brought in gradually, we need to give serious thought to a programme which demonstrates commitment to continuous, gradually intensified action. If we delay, we risk not only condemning future generations to severe climate effects, but also condemning them to rapid and catastrophic adjustments to avoid a worsening situation.

Action will have to be internationally coordinated. All the rich countries will need to penalise greenhouse emissions in harmony, or those that do so will suffer unfair competition from laggards. It will help if the rich countries see themselves as needing in any case to

invest in industries which use brainpower rather than large quantities of energy. Their willingness to do so will be helped by the awareness that that they cannot compete with heavy industry in the Third World.

It is only about five years since we saw the first very unavoidable indications that global warming might be a serious problem. Politically speaking, events have moved at astonishing speed. The climate issue has so far followed the recent benign pattern of scientific information turning into ministerial policy, and often without much serious electoral interest. We find it hard to shake off the conventional view which says that politicians are lazy and self-centred. Yet it seems that on the big environmental matters, regulations and policies get formulated regardless of whether the public is pressing for them. Acid rain, smog and the ozone hole have at times broken out of the green ghetto and seemed of general concern. But global warming, whose existence has emerged mostly because of publicly-funded research, attracted government attention without setting the public alight. It is an issue – and not the only one – where government has slightly outpaced the public.

The good thing about all this is that it need not much hurt governments to do the right thing. The Marshall Plan, which was designed to help Europe after the Second World War, cost the United States taxpayer about 2 per cent of GDP. That kind of effort, repeated now, might be about what is required to help the poor world develop with the best, rather than the worst, technology. Al Gore is surely right to argue that we need to consider such a plan for the poor countries of the world as they seek technology transfer.[27]

It is extremely unlikley that the poor countries of the world will agree to anything which causes them difficulties unless the rich demonstrate their willingness to undertake great changes as well. What is more, unless the west undertakes those changes, the technology will not be there to be spread around the world.

This account of the global warming issue – that 'insurance' action is worth taking – seems robust. It should stand the test of any good news that the phenomenon is not as severe as was thought, and it would only be strengthened by further bad news. It is an argument worth pursing with policymakers, with or without more evidence.

Energy crisis: what energy crisis?

Fossil fuels will, sooner or later, become scarce. Before then, global warming requires us to turn to other sources of energy. Having to do so may pose very much less of a problem than is commonly supposed.

In 1991, I went to Golden, Colorado to meet researchers at the US Government's leading renewable energy centre. I met a man who was very thrilled by a tank of water which was full of swirling green algae. It looked unprepossessing, with its little paddle keeping straggly seaweed stuff on the move. But the US Government's National Renewable Energy Laboratory's Chris Rivard was practically breathless in its praise. Imagine a dirty pond which eats carbon dioxide and produces oil at the same time. That is what NREL's Aquatic Species Programme thinks it can achieve with micro-algae. The researchers were within sight of helping solve the greenhouse and the Gulf effects at a stroke of their paddle.

Of course, it will not happen tomorrow. In 1991 Dr Rivard put the remaining problem simply:

> There are species of micro-algae which grow very fast, and convert sunlight and carbon dioxide into biomass at least five times faster than ordinary plants. And there are others which produce terrific quantities of oil. To make a buck, we have to find a species which does both.

In 1993, when I revisited the laboratory, John Sheehan, a NREL ethanol worker, told me:

> We've been isolating strains of algae which can grow in such a way that 60 per cent of their bodyweight is in the form of oil. Algae can take CO^2, which is low in calorific value, and turn it into something with a very high calorific value. That's a pretty neat thing. We're targetting a use of algae now: to recover CO^2 from power plant stack gases. Literally, that is just bubbling the gas through the algae. We have a whole programme working on these lipids [fats]. We're tweaking the metabolism of bugs to help us. We have now demonstrated that we can produce about a barrel of oil per acre of algae a week: we need to get it up to about five.

In another technology, the NREL researchers are hoping to produce ethanol from cellulose from trees, instead of from the starch from various cereal plants which is used now.[28] Researchers believe they will soon be able commercially to produce the gas from woody

material, by the use of bugs genetically engineered from a bacterium found in a hot spring in Yellowstone National Park.

There have been several breakthroughs already, enough to suggest that if only the cropland expected to be idled in the United States to prevent costly food mountains were put to this use, 15 per cent of the projected total energy demand of United States in 2030 could be met from this source. There is an ecological neatness about burning biomass, or the exhalations of biomass (like methane). When we dig up coal, the carbon contained in it makes a oneway trip into the global warming greenhouse. When we burn biomass, the biomass production needed to replace our consumption itself locks up new quantities of carbon, in what is a recycling process. The NREL researchers are also pretty sure they can make good progress in fermenting municipal waste. There is progress well away from ultra-sophisticated Colorado. In Mauritius, thousands of homes are using 'green gas': bottled gas made from fermented chicken droppings.

New tricks like these will use the sun's energy – there is no other – but in ways far more elegant than those we have deployed so far. Oil is only what bugs have made of rotting forests. Coal is even less clever stuff: just anaerobically decomposed and compressed forest. Modern technologies promise vastly to improve on them.

The US Department of Energy in February 1991 published a National Energy Strategy which rather disappointingly suggested that alternative sources might provide about 16 per cent of electricity needs by 2010. This was a good deal less dramatic than the contribution NREL and four other agencies had told the department was possible. The agencies conservatively suggested that if solar energy was explored with vigour (they posited a doubling of research effort), solar would become competitive enough with other sources to provide nearly a third of the United States' energy needs by 2030.[29]

NREL's energy policy director, Tom Bath, thinks that even that number is too low. In 1991, he told me:

> I'm convinced that if we made it a national objective to increase the contribution renewables could make, by 2030 we could get 50 per cent of our energy from them without any major change in the way we live.

In 1993, he said the estimate held good. There had been no big technological breakthroughs, but progress was coming along well enough. Again and again, researchers said that improved

engineering, and above all cost reduction, was the key.

The optimism that solar energies can make a large contribution to replacing fossil fuels does not have to assume there is draconian change towards a *dirigiste*, command and control society. It survives an assumption that the full, normal, foot-on-the-floorboards attitude to power survives. There is certainly no need to assume that we will have to become cave-dwellers or hippies.

Indeed, some of the renewables are close enough to price-competitiveness for NREL to reckon that a doubling or trebling of the research budget would put solar energy into the marketplace quicker – and with far less chance of upsetting politicians – than would an artificial punishment of fossil fuels or government-imposed premiums gifted to the suppliers of solar energies. Of course, NREL staff also believe that if oil and coal were to bear their full environmental cost, renewables would break through even quicker. By the end of the century, oil from micro-algae should be competing on price with oil from the bugs of millions of years ago.

Soon after the turn of the century, an even more spectacular technology should be commonplace. We could be on the brink of running a hydrogen – rather than a mostly oil and coal – economy. There are several ways of obtaining hydrogen. One could take a patch of desert and a very small percentage of the water which falls on it and add photovoltaic (PV) power, of the kind which runs calculators now. According to the World Resources Institute:

> A photovoltaic-hydrogen system would consist of four major parts. It would have an array of solar modules that would collect sunlight and convert it into DC electricity, an elecrolyser that would use this electricity to split water into hydrogen and oxygen, a compressor that would bring the produced hydrogen up to the required pressure, and a hydrogen storage unit. If the hydrogen production exceeded on site demand, the system would also include a pipeline that would carry the excess hydrogen to remote users.
>
> Where should the PV hydrogen systems be located? Would it be better to produce the electricity locally, thereby avoiding the expense of long-distance transport? Or should the electricity be produced primarily in the sunniest areas, making it possible to extract more useful energy from a given solar cell and thereby reducing the cost of PV electricity?
>
> The choice is not a difficult one. Even for PV DC (direct current) electricity production costs in the US$0.020 to US$0.035 per kWh expected for sunny areas near the turn of the century, electricity

production for electrolysis would still account for 60 to 70 per cent of the cost of hydrogen delivered to consumers a thousand miles from the production site.[30]

So, luckily for sunless British interests, transporting hydrogen long distances is quite cheap. In any case, the gas can be produced using any source of electricity. Hydropower might be ideal. Nuclear power is a possibility, and confers the advantage that the high-risk end of the process could be located in secure sophisticated societies, but the energy consumed in poor and even unstable ones. The hydrogen gas could be burned in cars or power stations, to choice. It could be bottled and shipped wherever it was needed, or piped there.

Hydrogen can be chemically reacted in clever fuel cells to produce electricity with at least twice the efficiency with which coal can be burned. Hydrogen would be a fuel used without any carbon emission – so no global warming would result from it. There need be little or no smog or acid rain contributions from it, either. Combustion of hydrogen does produce nitrogen oxides, but these can be catalysed quite easily.

Photovoltaic arrays could be pressed into service without being used for hydrogen manufacture. One could build arrays, and then use cables to move the resultant electricity where it was needed. At the present stage of development, 23,000 square kilometres of land would need to be under sun-farm to provide the United States' current electricity supply. According to NREL researchers, the area demanded could well halve as technologies improve. In any case, even the larger figure is only about the area of water in false lakes behind Canada's hydroelectricity dams. There is a bombing range owned by the US Air Force in Nevada which could alone provide two-thirds of the larger figure. PV can be used on a very small scale at remote sites. It may well be cheaper to give consumers an array of PV cells than to build the power station and long powerlines we have always used so far in rural districts.

Cost will be a serious constraint, at least at first. Hydrogen is likely to remain a more expensive fuel than gasolene. But, according to Bob McConnell, in charge of the PV programme at NREL, progress may be swift:

Today, PV generated electricity is five times the price of your ordinary electricity at home. But we may be well be able to halve the price in 5 or 10 years: we're getting to an exciting stage when something like

that could happen. Manufacturers are still finding ways to build manufacturing plants.

Even so, it may well be that all the renewables will remain uncompetitive with fossil fuels, at least if the consumers of the latter continue to buy and use them without paying a penalty for the pollution they cause.

We could make the fossil fuels pay a penalty to take account of our view of their ecological costs, and then watch renewables emerge strongly. Another approach would be to achieve our consumption of energy, but use less heat as we do so. We waste so much of the heat we turn into energy, and then waste so much of the energy, that the costs of being more careful almost always repay themselves time and time again.

The idea of energy conservation chills the blood of many westerners, who fear it to be the preserve of woolly-hats and naysayers. We should perhaps think of energy efficiency rather than energy conservation. Either way, we could hugely reduce our energy demand without changing our way of life. A couple of hundred miles west of Golden, there is the Rocky Mountain Research Institute, at Old Snowmass. Here, Amory Lovins – ex-Friends of the Earth, and now as much a consultant to electricity, utilities and corporate America as a hero to the ecofreaks – tirelessly assembles the data. 'In all, we know how to run the present United States economy on one-fifth of the oil we are now using', he wrote in the *New York Times* in December 1990, when preparations for the Gulf War were concentrating Americans' interest in oil. Lovins' scenario assumes that existing technology is applied to cars, industrial and office kit, and households. It assumes, for instance, that windows are fitted with a newish super glass; fitted in double glazing, this glass improves insulation six times. It means that a north-facing window in winter Colorado produces a positive, passive, heat gain in the building it lights. 'If fully used in the United States, these windows would save as much oil and gas as the North Sea produces, or twice the Alaskan fields,' Lovins says.

Amory Lovins was speaking in a solar house a mile and a half above sea level, which, he says, 'could tentatively claim the world altitude record for passive solar bananas'. He has a micro-rainforest for an office. Most days he has no need to light the woodburning stove, even in winter.

It is true that Lovins is a near-fanatic. He has put huge amounts of time and talent into designing his house so that it hardly uses fossil fuel for space and water heating and about a tenth of the normal amount of electricity. But his research is impeccable and routinely bought-in by very hardnosed people. When he says that US cars could improve their fuel consumption by five times (and European cars perhaps by three times), and be safer and nippier than existing cars, he is only citing manufacturers' information. When he says that there are showers which use a quarter of the hot water more commonly used – 'but get you just as wet' – he is pointing at one which can be bought off the shelf. The glory of it is that we can take Lovins' scenarios with a pinch of salt, and still come out ahead. We will not need his devotion to the cause to follow where he has pioneered.

Of course, the majority of people are suspicious. Hardly any of us likes spending money upfront, say to improve insulation, even if the long-term savings will pay back the increased investment in a year or so, as they often do. We beware buying the first generation of new whizz-bang technology when we know the scene is changing fast, and next year's will be better, and far cheaper.

Even so, in the United States, renewables now supply more electricity than nuclear power. Super-windows took 60 per cent of the double-glazing market in the three years to 1991. Sales of lightbulbs which sip electricity, and whose increased cost in the shops is easily paid for over their lifetime, used to double every year; in 1990/1991, they leapt sevenfold.

The message is that the market will take us toward solar power, slowly. To some degree not yet clear, perceptions of pollution problems, the greenhouse effect, diminution of finite supplies and their problematic security, may make us want to go further, faster. But it will be our political decisions, not technological barriers, which will decide how fast we take our place in the sun.

Beauty or beast? nuclear power

Feelings against nuclear power run very deep, and support for it comes almost exclusively from the small army of scientists and specialists who have dared to think the unthinkable.[31] Most of them earn a living in the industry or know it well as regulators or politicians in sponsoring ministries. They have signally failed to communicate their enthusiasm to most of the rest of us.

It is very difficult to make a cool assessment of the economic and ecological costs and benefits of the existing nuclear technologies. The industry has been so nannied economically by governments around the world, and so bullied by environmentalists and regulators, that its true costs and benefits are seldom known. Public concern forces up the price of engineering nuclear facilities to satisfy nervous outsiders and politicians. In some countries, such as the United Kingdom, the state then finds ways of meeting the bill. Luckily, in some, such as Finland, there is a nuclear sector which controls the entire process from power-station to waste disposal: the solid profitability of its stations shows that nuclear power can actually supply energy to its customers at a discount against conventional fuels.[32]

We know the fossil fuel technologies with which nuclear power is in competition are flawed and probably ought to be penalised. As burners of fossil fuels begin to be charged and taxed to reduce the pollution they cause, that will militate in favour of alternatives such as nuclear power, especially if our fear of radiation is to some extent replaced by our fear of global warming. Oddly, it may well be the stubbornness and narrowness of view of the environmentalists which holds us up here. The Greens call for transformations, but do not like to have to undergo them.

The public does not yet share and may never share the industry's feeling that nuclear waste can be stored fairly easily, even without the heavily engineered disposal sites which are planned. Everyone is concerned, and some people are positively alarmed, by the suggestion that men employed in the industry have a raised chance of having children who develop leukaemia.[33] It is hard to grasp that this association has not been shown to have been caused by nuclear radiation, and may not be more significant than similar connections between occupations as varied as farmwork, coal mining and the chemicals industry and the formation of cancers.[34] The suggestion is in any case contradicted by later evidence.[35] There is a general and false belief that connects the fact that human foetuses can be damaged by high doses of radiation with the impression that there must be generation upon generation of mutation following radiation doses such as those experienced at Hiroshima and Nagasaki.[36] In fact, though we know that high doses of radiation do produce mutations in mice, by far the worst exposure to radiation experienced by humans so far, that in Japan, did not produce measurably different levels of birth defects. This does not mean

humans are different to mice in this respect. The mice were given continuous, very high doses, rather than a single 'blast' of radiation.

The anxiety amongst some of the public about nuclear power was real enough before the industry produced an accident which seemed to match the chemical disaster at Bhopal, India. The fire at Chernobyl seemed to fulfil the green anxiety that nuclear might or might not be tolerable when it works, but when it goes wrong it is cataclysmic. Many people probably believe, contrary to all the evidence, that tens of thousands of people died as result of the Chernobyl accident in April 1986. They believe this not least because respectable newspapers, journals[37] and television stations gave credence to the view – hotly disputed by western experts – of a handful of scientists from what was then the Soviet Union. On the fifth anniversary of the accident in April 1991, the media stoked the fires of anxiety in spite of surely knowing – and certainly not mentioning – that a small but authoritative British team[38] and a much larger international team of specialists[39] were about to report a very different and much happier message. One team had already reported with a view sufficiently different to the Russians' version that it deserved to be taken into account.[40]

As pulled together in the International Chernobyl Project, the facts of the Chernobyl accident seem to be that 31 people very closely involved at the station, and very heavily contaminated, did indeed die, as the conventional account of the effects of high doses of radiation would have predicted. This order of deaths puts the accident in the league of mining or oil production disasters, which have often produced far greater tolls, and sympathy for the victims, but no comparable outcry.

Our present knowledge of the health effects of radiation suggests that decades after the accident there will be a rise in cancers, perhaps in the range of thousands, in the contaminated population. But expert opinion mostly believes that these cancers will probably not be so numerous as even to be noticeable in the general cancers which would be found in any population.

There is the additional difficulty that medical investigation and epidemiology is weak in the ex-Soviet Union, so the background level of cancer-formation is unclear, and so, therefore, will be the assessment of Chernobyl's effects.

There has been a view that a hundred or so children have thyroid cancer over and above the number which would be expected in a

normal population. Researchers on the spot have attributed these to the Chernobyl accident.[41] But other researchers, from Japan and the United Kingdom, have strongly challenged the likelihood of such cancer developments. A series of letters in *Nature,* the journal which first published the new claim, has suggested explanations other than the Chernobyl accident.[42]

Beyond the human misery it caused, there are several ways in which Chernobyl is important as a case. One is that it provides a textbook example of how not to run a nuclear power station, and thus should reinforce most of the messages which are already familiar to people working in, and regulating, the industry. If Chernobyl usefully stiffened the resolve of the western nuclear industry to remember that accidents can happen, it is also a comfort to know that the nuclear industry of the old Soviet bloc is now receiving a good deal of help from the west in improving its technology and operating standards.

A second useful outcome of the Chernobyl accident is the degree to which it revealed how debates about risk are bedevilled by the prejudiced reporting of the media. A third is that one of the very attractive results of our increasing epidemiological knowledge is that while it reveals some very complicated issues about what causes illness in a population, it increasingly holds out the prospect that we will know both the good and the bad news about the effects of much human activity. The prompt publication of news of those thyroid cancers speaks not only about the relative smallness of the effects of the radiation from Chernobyl, but also about the readiness of the scientific world to discuss them.

It is anyone's guess whether increased understanding about radiation and human health will contribute to making nuclear power more or less acceptable. In the wake of the Chernobyl accident and its own dismal experience in persuading people to like the idea of living near storage sites for various pretty inoccuous sorts of radioactive wastes, the British Government in 1989 decided that these were issues whose political acceptability might be improved by a spell on the backburner.

Over four years later, in March 1994, ministers are on the brink of announcing a promised fundamental review of the prospects for the nuclear industry. The political difficulty remains, as it has always been, that the public thinks of this technology as an affront to nature. It seems anti-green. Yet, one can argue tentatively that the industry's

processes are quite natural, and that some natural comparisons make the industry both more comprehensible and rather less frightening.

'Eighteen hundred million years ago, there was an entirely natural, spontaneous nuclear power station in the earth's crust,' says Dr Ron Flowers, now retired from his work at the United Kingdom Atomic Energy Authority, but still an important figure in the small world of nuclear power. Nuclear scientists are pleased that creation made its own reactor at Oklo, in Africa's Gabon, partly because it shows human beings did not introduce the splitting of atoms in a chain reaction to this planet. Still less did they invent this fission process. And part of the industry's pleasure flows from the way the radioactive 'wastes' (by-products would be as good a word) from that natural reaction seem to have stayed conveniently in place ever since, just as the scientists hope to persuade us that modern nuclear wastes can be made to stay where they are put.

Oklo was a reactor for thousands of years, and reminds us of our origins. We and our planet are wastes from a fusion reactor, the sun. Nuclear fusion is the collision and combination of lighter elements, as opposed to fission which is the fragmentation of heavier elements. Both release some of the prodigious energy contained in atoms. As Dr Sue Ion, technical director of British Nuclear Fuels, says: 'The fusion process produces both stable and unstable elements or isotopes. These unstable elements from our origins in the sun form the basis of the present nuclear industry and contribute to the natural background of radioactivity.'

The radioactivity of the earth's elements is decaying, but at different rates (expressed in half-lives), with different intensities of energy, and by a number of different routes, including electron-like fragments called beta-particles, the heavier alpha-particles, and gamma rays. Alpha, beta and gamma radiation have ascending powers to penetrate materials, including human tissue, but all can damage cells (and not merely in proportion to their penetrative powers).

Plantlife on earth is now dependent, as is our climate, on the heat of the sun's continuing fusion reaction, and the discussion of how that heat passes through lifeforms is at the very heart of the fashionable science of ecology. Yet the widely distrusted technology of nuclear physics is doing something elegant, too. Scientists have found ways of restoring to its former vigour some of the dying

radiation from the nuclear explosion which formed our world, so that it can reproduce the Oklo process. As a power-generating technique, it has the merit over traditional fossil-fuel burning that it adds very little to atmospheric pollution.

There is good and bad news about the radioactive wastes and emissions from the nuclear industry. Even during its relatively unsophisticated infancy, they did not add significantly to the amount of radiation the average citizen received from the radioactive rocks beneath his or her feet and from continued bombardment from outer space. Hospitals and surgeries contributed far more to the average dose. More recently, the industry's discharges have been reduced, in some cases tenfold, and in the case of Sellafield's emissions to the sea, a hundredfold.

In any case, because we know a good deal about man's response to really large extra doses of radiation, we can be fairly confident that radiation doses have to be a hundred or hundreds of times average background levels to cause us measurable harm. This strong guess is in part derived from the effects of the radiation from atomic bombs used at the end of the Second World War. The bombs' radiation – about a hundred times background – caused about an eighth more people to die of cancer than would have been expected in an equivalent non-exposed population. In the Japanese case, 42,000 people were exposed to an average dose of 300 mSv (average UK exposure 2.5 mSv). By 1986, 3291 of that population died of cancer, about 400 more than would have been expected in a non-exposed population.[43] But it is important to remember that the nuclear industry does not multiply the dose most people receive by tens or hundreds, but only increases them by a few thousandths.[44]

Even to the 1000 nuclear workers most exposed (with doses about ten times average background), the industry poses little more exposure to radiation than Concorde's flight crews experience by spending their working lives high enough in the atmosphere to be less shielded from cosmic radiation than the rest of us.[45] Nuclear workers in general do not have elevated cancer rates, though there is some very recent evidence that some of them may have been exposed to radioactive dust which has produced elevated rates of cancer of the prostate gland.[46, 47] There is epidemiological – in effect, circumstantial – evidence that the children of the most exposed nuclear workers are, like workers in a wide range of industries, slightly more than usually prone to leukaemia.

The debate about 'clusters' of elevated risk is densely complicated and it is probably best not to pretend to much confidence about where it will end. The difficulties centre on two quite different isssues: are the clusters real (that is, do they truly reveal an increased local likelihood of illness); and are they the actual creation of some candidate cause (such as a nuclear installation)?

Radiation is in any case a killer which usually leaves no fingerprints. People downwind of Chernobyl will die, just as people from Hiroshima and Nagasaki have died, because of the radiation they received. But it will be impossible to identify the individuals concerned, partly because it will be impossible to separate them from the roughly quarter of the population that die from naturally-caused cancers. Nonetheless, accidental and routine discharges of radioactive material must be assumed to kill people – real individuals, not statistical fantasms – and it makes the matter more odd and troublesome, not less, to point out that people are dying the whole time from the effects of very similar but quite natural radiation.[48]

Against those anxieties, it is worth positing a very different line of argument. Radiation from the nuclear industry, like other carcinogenic agents, may well operate cumulatively and jointly with other causes of cancer. In other words, it may be something of a necessary statistical fiction to imagine that a source of radiation must always be thought of as producing any particular number of deaths. It may well be better to think of it as one of many cancerous factors afflicting victims, and to remember that the majority of ingredients in the cocktail, by far, are wholly natural.

Anyway, it is clearly right both to assume that people should be shielded from all avoidable radiation, while at the same time remembering that we all face a wide range of life-threatening risks and – so far as we know – the overwhelming majority of us will, quite rightly, not have the nuclear industry stamped on our death certificates as the cause of death.

While nuclear fission is in principle natural, it creates local concentrations of radioactivity not seen on earth for billions of years. The process of turning uranium into fuel does not create more radiation than the earth began with, but it does concentrate the radiation in a much smaller bulk. The real difficulty is that using the fuel in a reactor prduces very much more problematic radioactivity than was in the original uranium. If this were not so, reactor waste could, in

principle, simply be returned to the mines whence it came, and the earth's crust would be no more radioactive than before. Instead, nuclear reactors produce the most potent and longlasting radioactive materials we know. This material must be stored, dumped or reprocessed.

We have gone further than creation. Human beings have developed chemical techniques for recycling the spent fuel from nuclear reactors into new fuels: a form of uranium, and plutonium. The latter is useful for bomb-makers, and its potential value to terrorists means that it has to be accounted for very carefully (though the plutonium from dismantled Soviet ballistic missile warheads would make a far more likely source of mischief).

Reprocessing is a way of recovering unused uranium from the spent fuel discharged from nuclear power stations for reuse, having been recycled into fresh fuel. In addition, reprocessing can also recover the plutonium which has been created in the fuel as it was 'burned' in the reactor. This plutonium might possibly be used in fresh fuel elements. The remainder is highly active fission products, which are the useless ash from the nuclear combustion, and contain the majority of the radioactive waste from the process.

The recovery process redistributes some of the radioactivity of spent fuel into bulkier, though much less potent, radioactive wastes. But it also creates a very small amount of highly active, 'high' level waste of which it is the only, source. The point is that just as nuclear power stations produce very difficult wastes, so too, in their own way, do reprocessing plants.

The prize the latter offers is the prospect that the recovered materials may one day provide a fuel source for fast-breeder reactors, which have the advantage of generating their own fuel. However, their development is stalled partly because uranium is cheap. The recovered fuel can also be, and is, treated for use in conventional reactors.

In Britain, recycling of spent fuel is done at Sellafield. In 1994 a new reprocessing plant, THORP, some of it paid for by Japanese customers, and with contracts already signed for its working life, finally cleared all the required regulatory and legal hurdles. The opposition to the plant was unusually divergent, including *The Economist*[49] and Greenpeace. The industry insists the profit from the operation more than justifies the marginal increase in radioactivity emissions it will involve. But critics point out that the

industry is prone to large economic misjudgements and at least significant technical ones: not much would have to go wrong for the profit to disappear. It is clear that the reprocessing of spent nuclear fuel would not now be embarked on by the contemporary nuclear industry. The low price of uranium has meant that recovering plutonium as fuel is not – for the moment – economic. Only contracts signed in times of high uranium prices make Sellafield's THORP worthwhile. All the same, many nuclear scientists believe the recycling and fast-breeder route is the ecologically-sound future.

In Finland and Sweden, the nuclear industry decided years ago against reprocessing. The Finns and Swedes have been planning – with much greater success than the British – for the deep disposal of their nuclear waste in its unreprocessed, but carefully treated, state. Both countries have built repositories 50–70 metres down in crystalline rock.[50] These are the final resting place of fairly shortlived radioactive wastes, whose radiation will fall to that of the background radiation in the host rock in about 500 years. The Finns and Swedes are already well advanced in building underground laboratories to research the very much deeper disposal of very longlived wastes.[51] Because both the Finns and Swedes will be disposing of unreprocessed spent fuel rods, which are very highly radioactive, the waste will be in containers of thick copper.[52]

It is of course right to take nuclear waste very seriously. However, the immense precautions taken with waste may lead some people to believe that that it is even more problematic than they imagined. Why else go to such lengths? Asked to describe a no-frills approach to the various wastes of the British nuclear industry, Dr Flowers suggests that the vast bulk of them (most of what the industry categorises as 'low' level wastes) are such that a dustbin load would be no more problem to have around the house than a dustbin of domestic waste; 'You wouldn't handle it and then lick your fingers, but you wouldn't need a shield.' He continues:

> A couple of dustbin loads in your house wouldn't approach the natural background levels of radiation. There is a smaller quantity of wastes, called 'intermediate' level, which require a sealed container and a few inches of concrete shielding to protect us against exposure to gamma radiation and ingestion of toxic dust. Only about a thousandth of the radioactive wastes is what is called 'high' level and it is this material which must be treated as a very toxic substance requiring several feet of concrete to protect us from the intense gamma radiation.

There is a doubledecker-load of high level waste in the United Kingdom, and its danger comes from its very active decay processes, which lead to the relatively short period of its intense radioactivity (in other words, its short half-life). As Dr Bob Holmes, head of BNFL's Company Research Laboratory says, 'The activity in our high level waste will fall over, say, 500 years, to a thousandth of its present level and be equivalent to our intermediate level waste'. High-level waste will become as radioactive as low-level waste in 10 million years, or as radioactive as the original uranium from the earth's crust, in about a million years. However, we can draw some comfort from the fact that highly penetrating radioactivity will substantially reduce much quicker. After less than a thousand years, a sheet of paper would stand as sufficient barrier between our skin and the emission of the waste's radioactivity. But we would still have to guard very closely against eating or inhaling it: it would, in other words, be exceedingly dangerous in air or water.

The British disposal plan, for which permission is currently being sought by the industry, is to bury the low and intermediate nuclear wastes 650 metres deep in the earth's crust. If this sounds like dumping, one should remember that the waste will be in containers designed to delay corrosion, and these will be sealed in caverns backfilled with material chosen to have a benign chemical effect on the waste. The whole will then be housed in an area which will have to pass tough tests as to the likelihood of any radioactivity getting into water which could reach the biosphere.

Even so, it is proposed to delay the disposal of the high-level wastes. They generate heat, so it is deemed wise to store them above ground for a generation, until they have cooled and decayed somewhat, before some sort of deep burial.

There is fierce controversy surrounding the plans of NIREX, the state-owned company charged with exploring deep disposal. One newspaper report, by a respected science correspondent, lent credence to the view of a retired British nuclear scientist that it was at least theoretically possible that the proposed site, at Sellafield, might develop an Oklo-like nuclear reaction.[53] The odds against this are almost vanishingly small, and suppose that water in the rock disposal site might bring the very small and scattered quantities of plutonium in the waste together, and thus create the conditions for a reaction to set up. The suggestion has strengthened calls for the site's geology and hydrology to be closely investigated (as they will in any

case be). It may be that the final view is that Sellafield's convenience as a site already dealing with waste, and the source of much the country's waste, is outweighed by the geological and hydrological claims of other places in Britain.

Nuclear technology involves dangerous material and processes. So do the coal and oil technologies, which have killed and diseased far more employees and customers in accidents, smogs and mines. Even a very bad nuclear accident, such as that induced by extreme folly at Chernobyl, did not kill nearly as many people as died in the Piper Alpha oil field accident (whose death toll was 167). However, there will be hundreds and perhaps thousands of cancers because of Chernobyl: radiation doses kill most of their victims after a delay of a couple of decades.

Why take the risks associated with even well-managed nuclear power? Sometime halfway through the next century, and barring accident, there will be 10 billion energy-hungry people in the world. Of these, many will live on bits of the earth's crust which are rich in coal and to a much lesser extent oil. Both these are the product of the arrested and modified decay of plantlife orginally fuelled by the heat of the sun's fusion reactions. Neither will last indefinitely, and in any case their use is expensive if limiting or adjusting to their pollution is taken into account. If global warming becomes a prime factor, we will have an additional motive to shift towards non-fossil fuels. True, solar power technologies can do a good deal with the present warmth of the sun, but they are expensive. We may yet be very glad that we know how to use the radioactivity which remains from the earth's creation.

I suspect that we will find the nuclear industry less frightening, and perhaps more valuable, as we go on. Nuclear power is not widely challenged by the uncommitted public for all that it has always proved a potent rallying issue for campaigners. It creates unease. But we need not overdo the sense of difficulty. There is every chance that the present generation of western children will grow into adults with a more relaxed attitude to nuclear power than their parents, not least because the youngsters have lived alongside it without obvious or serious mishap for all their lives. It may well be that in twenty-five or fifty years, the relative value of atoms for energy will look distinctly favourable.

Notes

1 McCormick, J., *The Global Environmental Movement* (London: Belhaven Press, 1989), p. 182.
2 *Our Planet, Our Health* (Geneva: WHO, 1992) p. 162.
3 *Ibid.* pp. 145ff.
4 North, R., 'Green motoring: still miles away', *The Observer* (*Life Magazine*), November 23 1993.
5 Fred Pearce, 'Will Britain fail the acid rain test?', *New Scientist*, December 5 1992, and 'How Britain hides its acid soil', February 2 1993.
6 Roan, S., *Ozone Crisis* (New York: John Wiley, 1990) p. 29.
7 *Gaia, the Practical Science of Planetary Medicine* (London: Gaia Books, 1991) p. 164.
8 Brasseur, G., 'Volcanic aerosols implicated', *Nature*, vol. 359, September 24 1992.
9 *Scientific Assessment of Ozone Depletion*, December 17 1991, sponsored by World Meteorological Office, United Nations Environment Programme, NASA, NOAA, UK Department of the Environment (Nairobi: UNEP, 1991).
10 *Environmental Effects of Ozone Depletion*, 1991 Update (Nairobi: UNEP, 1991).
11 Concar, D., 'The resistible rise of skin cancer', *New Scientist*, 16 May 1992.
12 Communications with ICI executives.
13 Intergovernmental Panel on Climate Change, *Climate Change*, (Cambridge: Cambridge University Press, 1990).
14 Firor, J., *The Changing Atmosphere*, (Stanford: Yale University Press, 1990) p. 70.
15 Lindzen, Richard S., 'Absence of scientific basis', *National Geographic Research and Exploration* 9 (2) pp. 191–200, 1993.
16 A sense of the rich difficulties of these arguments can be had from the following selection of recent contributions:
Rind, D., Rosenzweig C. and Goldberg, R., 'Modelling the hydrological cycle in assessments of climate change', *Nature*, vol. 358, July 9 1992. MacAyeal, D., 'Irregular oscillations of the west antarctic ice sheet', *Nature*, vol. 359, 3 September 1992, pp. 29–32. Sugden, D., 'Antarctic ice sheets at risk?', *Nature* vol. 359, 29 October 1992, pp. 775–6. Lacis, A. and Carlson, B., 'Keeping the sun in proportion', *Nature* vol. 360, 26 November 1992, p. 297. Miller, G. and de Vernal, A., 'Will greenhouse warming lead to Northern hemisphere ice-sheet growth?', *Nature* vol. 355, 16 January 1992, pp. 244–6. Pearce, F. 'American sceptic plays down global warming fears', *New Scientist*, 19/26 December 1992, p. 6. Davidson, G., 'Icy prospects for a warmer world', *New Scientist* 8 August 1992, p. 23. Gribbin, J., 'Has the bubble burst on global warming?', *New Scientist* 22 August 1992, p. 15.

17 International Panel on Climate Change (IPCC) *Policymakers' Summary of the Potential Impacts of Climate Change*, Report from Working Group II, first draft, WHO/UNEP, April 1990, p. 2.

18 Seitz, F., Jastrow, R. and Nierenberg, W., *Scientific Perspectives on the Greenhouse Problem* (Washington DC: George C. Marshall Institute, Washington 1990).

19 Lawson, H., 'Conspiracy in the air: A cold hard look at "global warming"', *The Sunday Times*, 12 August 1990; 'The Greenhouse Conspiracy', *Equinox*, Channel 4 same date. I responded to these arguments in Richard North, 'The greenhouse effect: cold logic or a lot of hot air?', *The Sunday Times* August 19 1990.

20 Lindzen, R., 'Abuse of scientific basis', *National Geographic Research and Exploration* 9 (2) 1993, pp. 191–200.

21 Browning, K., 'Clouding the issue', *Science and Public Affairs* (London: Royal Society Spring 1992).

22 Thomas, D., 'The cracks in the greenhouse theory', *Financial Times*, 3/4 November 1990.

23 D. Allan Bromley, 'The making of a greenhouse policy', *Issues in Science and Technoloy* Fall 1990.

24 Firor, J. *The Changing Atmosphere* (Stanford: Yale University Press, 1990) p. 48.

25 Baker, T., 'Green futures for economic growth', *Cambridge Econometrics* 1991, p. 95 (21 St Andrew's Street, Cambridge CB2 3AX).

26 Grubb, M., *Energy Policies and the Greenhouse Effect* (Dartmouth: The Royal Institute of International Affairs, 1990) pp. 71ff. See also M. Grubb, 'The costs of climate change: criticial elements', Paper to the IIASA conference on the 'Impacts, costs and possible benefits of measures to limit climate change', Laxenberg, October 1992.

27 Gore, Al, *Earth in the Balance* (New York: Plume, 1993) p. 296.

28 It is worth noting that Dr Michael Grubb, Head of the Energy and Environmental Programme at the Royal Institute of International Affairs, commenting on this text, thought that neither 'green slime' nor ethanol were the most promising of many "biomass" routes to new energy supplies.

29 *National Energy Strategy* (Washington DC; Dept of Energy, February 1991).

30 Ogden, J. and Williams, R., *Solar Hydrogen, Moving Beyond Fossil Fuels* (Washington DC: World Resources Institute, 1989).

31 For one of the few non-specialist, mildly 'pro' but fairminded accounts of the industry and its prospects, see Michael Cross's 'Nuclear power on Britain's back burner', *New Scientist*, November 6 1993.

32 'Finns profit from cut-price nuclear electricity', cites Finnish academic research into the country's nuclear industry's balance sheet, September 1993, *British Nuclear Industry Forum*, (22 Buckingham Gate, London SW1E 6LB).

33 Gardner, M., *et al.*, 'Results of case-controlled study of leukaemia and lymphoma among young people near Sellafield nuclear power plant in West Cumbria, *British Medical Journal*, vol. 300, 17 February 1990, pp. 423–34.

34 *Ibid.*

35 *Daily Telegraph*, 30 April 1993, reporting paper by Kinlen, L., in *British Medical Journal* same date.

36 Crow, J., 'Dispersing the clouds', *Nature* vol. 357, 7 May 1992 p. 31.

37 Marko Boujcun, *New Scientist*, April 20 1991 'Dying scientist says chernobyl killed 7000, *Independent on Sunday*, April 14 1991.

38 The Watt Committee (of 61 British professional institutions), *Five years after Chernobyl: 1986–1991 A Review* (London: The Watt Committee on Energy 1991).

39 International Atomic Energy Authority (IAEA), *The International Chernobyl Project: An Overview: Assessment of Radiological Consequences and Evaluation of Protective Measure*, Report by an International Advisory Committee (convened by the European Commission and the United Nations), IAEA, April 1991.

40 'Report on assessment mission to the areas affected by the Chernobyl disaster', The League of Red Cross and Red Crescent Societies, February 1990.

41 Kazakopv, V., Demidchik, E., Astakhova, L., 'Thyroid cancer after Chernobyl', *Nature*, vol. 359, 3 September 1992.

42 Beral, V., Reeves, G., Shigematsu, I., Thiessen, J., 'Childhood thyroid cancer in Belarus', *Nature* vol. 359, 22 October 1992.

43 KSU Analysis Group, 1991, S-611, 82 Nykoping, Sweden.

44 European Commission, *Radiation and You* (Brussels: EC, 1991). For further information contact Director-General Environment, Nuclear Safety and Civil Protection, Rue de la Loi 200, B-1049, Brussels, Belgium.

45 In 1987 four British workers recieved in excess of the legal limit of 50 mSv; 1000 received doses above 15 mSV. Annual average worker dose is 2 mSv. Subsonic aircrew are exposed to about 2 mSv and supersonic crews to 2.5 mSv-17 mSv. Coalminers average 1.2 mSv. Radon-exposed miners receive about 14 mSv. *Living With Radiation* (London: National Radiological Protection Board, HMSO, 1990).

46 'Radiation: effects and control', UKAEA, Feb 1993, p. 24.

47 Laurence, Jeremy, 'Cancer risk uncovered in nuclear workers', *The Times* 28 November 1992.

48 Perhaps the best discussion of this whole difficult matter comes in The Health and Safety Executive's *The Tolerability of Risk from Nuclear Power Stations* (London: HMSO, 1988) and *Quantified Risk Assessment: Its Input to Decision-Making* (London: HMSO 1989).

49 *The Economist*: 'Britain's plutonium dilemma', November 27 1993, and 'Uranium, Plutonium, Pandemonium', June 5 1993.

50 'VLJ-Repository: final repository for operating waste at Olkiluoto', TVO (Teollisuuden Voima Oy, SF-27160, Olkiluoto, Finland); 'Final repository for radioactive waste – SFR, SKB (Swedish Nuclear Fuel and Waste management Co., PO Box 5864, S-102 48 Stockholm, Sweden).

51 'The ASPO hard rock laboratory', SKB, see 'Final disposal for radioactive operational waste', *ibid.*

52 'Final disposal of spent nuclear fuel', TVO, 1992.

53 Dr Tom Wilkie, 'Nuclear waste dump under Cumbria', *The Independent On Sunday*, 30 January 1994.

II
The consumer, the campaigners and chemophobia

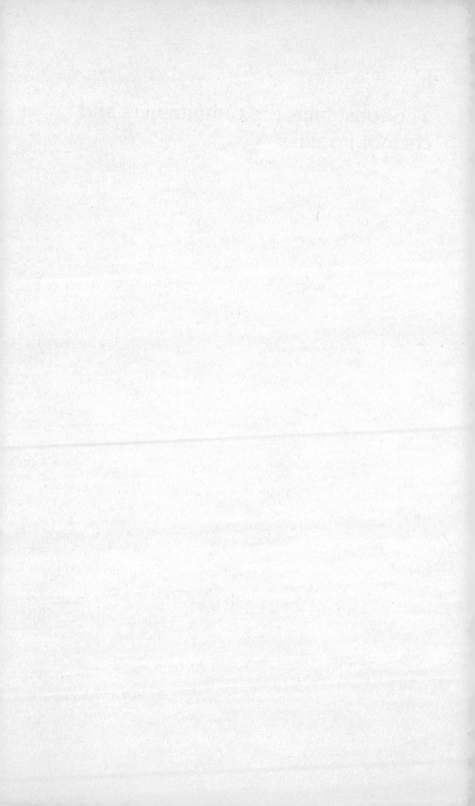

5

The myth of ecological disaster: Apocalypse not yet

The media and the environmental campaigners have enjoyed twenty years of 'environmental disasters'. This is a uniquely modern phenomenon which makes exciting broadcasting, sells newspapers, and attracts membership to campaign groups. But it is a largely invented idea. This chapter looks behind two classic types of 'disaster' and finds cock-up and misfortune, but little evidence that the technosphere is out of control.

Oil slicks: the media's classic 'ecological disaster'

On the morning of Tuesday 5th January 1993, Britain woke to dramatic news. The Liberian-registered tanker *Braer* was drifting, without power, in heavy seas ten miles off the rocky Shetland coast, way up where Scotland's offshore islands become sub-Arctic in their remoteness. The ship was reported to have been powerless since 5.20 a.m. On board were about 85,000 tonnes of light Norwegian crude oil, a crew of 34, among them a radio operator who reported that the ship was in trouble, but the cargo was not.

At 10 a.m. it seemed likely that the ship would hit the southern tip of the islands. 'Shetland is now expecting a major environmental disaster,' said BBC Radio 4's news. At 11 a.m. there were new, slight hopes that the ship might miss the islands. Tugs were on their way. The weather was atrocious, with winds blowing at 60 or 70 miles per hour. But perhaps, even if the ship did hit, said the news, a major environmental disaster might be averted if the ship went aground on sandy beaches.

At noon, it was reported that the worst had happened. The ship –

now unmanned – was impaled on rocks on Garth's Ness, near Quendale Bay at the southern tip of the islands, and oil was thought to be spilling. It was repeated that the oil was light crude which breaks up easily in heavy seas. It was said to be one of the worst parts of the coast for the ship to have grounded. 'There are fears that it will soon begin to break up in the heavy seas and cause a major environmental disaster,' said the announcer.

The story was top of the lunchtime bulletin for Radio 4's 'The World at One'. Oil was definitely leaking into the sea, 'raising fears of a major pollution disaster'. A leading naturalist was billed as being about to tell listeners that the incident could be a disaster for local wildlife.

The news bulletin repeated the bare bones of the incident, and asserted that 'some experts' were forecasting an environmental disaster in what is one of the most important places for wildlife in the Northeast Atlantic.

Minutes later, the presenter said: 'It is feared that this could be an ecological disaster,' and introduced the Royal Society for the Protection of Birds' Dr Nancy Harrison who told us of the area's international importance for birds in the summer. Luckily many species were away, but all the same there were eider duck, shag, and auk at risk. Dr Harrison said it was hard to do anything for oil-struck birds: 'The only answer is to keep these incidents from happening in the first place and it's very hard to see how anything but a disaster can take place now.'

The presenter introduced Greenpeace's Paul Horsman, who told us:

> The potential consequences are quite severe. That area is well known as a very sensitive marine environment; as everyone knows, it's a beautiful area. There are birds nesting on the cliffs and there are seals which will have pupped last year on the beaches and it's a well known fishery area. Now, fortunately most of the birds are at sea and so perhaps we shouldn't have such a severe effect on birds as we might at another time of year, but certainly the fisheries and seals are at risk, and once the oil gets on beaches, and particularly on soft sedimentary beaches, certainly that oil is going to be around for a very long time.

But had we learned anything over the years, inquired the presenter? Horsman went on:

> Although technology has improved in some ways and lessons have

been learned over the decades we have been plying oil around . . . it still is a fact that with the best technology available you recover less than 10 per cent of the oil which gets into the seas. So . . . particularly with the conditions we have here, very little oil is going to be recovered.

Yes, said the presenter, but had we not often been at this point in an incident and found there were anxieties which were not actually fulfilled in the event? Horsman replied:

It depends on who you talk to. Certainly the oil industry makes a massive effort to try to downplay the effects on the environment of an oil spill, but the reality of it is that when you go back, months, years after an oil spill the environment has been damaged . . . The oil industry is out of control at the moment . . . they can use whatever ships they like . . . Accidents are increasingly happening.

At that point, on the first day, only one thing was certain. There would be an enormous amount of media attention surrounding the event.

Something odd is going on. Do we not recognise in ourselves and others, as modern citizens of the world, a curious appetite for the view that something – perhaps nearly everything – is amiss? We are uncomfortable with material progress, and feel we must pay some unspecified price for it. Disasters almost seem heaven-sent. They appease our sense that our misbehaviour will earn some divine retribution.

The media is alert to this subconscious desire and is very grateful to Greenpeace for helping to tell the story. A Greenpeace comment seems to have several prime journalistic merits. It stresses the possibility of ecological disaster. It comes from the heart. It is short and understandable. It comes from people who are not part of 'the establishment'. The media and Greenpeace share an understanding of the world. Things go wrong because vested interests are careless, and they stay wrong because of the cover-ups which vested interests go in for. Neither the media nor Greenpeace ever admit that they too are vested interests, with readers and supporters to keep amused and excited. Nor does the media admit that it seldom challenges Greenpeace in the way journalists challenge other campaign groups on other subjects. Greenpeace, in the media's eyes, and the public's eyes, bears witness to an unease which cannot be named, let alone disputed.

From the start, the news media reported the *Braer* incident using four main players, amongst which Greenpeace was very important. All the media's chosen voices had natural and necessary biases.

For the first couple of days, the government fielded a junior minister – Lord Caithness – who did his best to show concern for the locals and wildlife while defending the record of the regulatory framework but also suggesting that the official world would try to learn from the tragedy. He was required to bat an unattractive wicket: defensive and yet cautiously open-minded. He did not go out of his way to remark that it had been known for years that shipping regulations needed a thorough overhaul, though any likely reform might well not have averted this shipwreck. Only the shipping experts dared to say that this accident might be the one which would have escaped the best regulations.

Because this was the Shetland Islands, and therefore the scene for years of very big oil industry developments and many tanker movements, there was every sign of preparedness both technically and even politically. The *Braer* was only incidentally a Shetland disaster. The oil she was carrying did not originate from and was not going to the local Sullom Voe terminal. So the *Braer* incident was not precisely the one for which Shetland had been waiting for years. Nonetheless, this was a place which had already thought a good deal about how one responds to oil accidents.

Even early on in the crisis, the media could broadcast competent-sounding local managers who were able to point out that this was highly evaporative crude which would largely break up in the gale-driven seas. The managers looked convincing when they said they had resources and skills to deploy, once the weather allowed. Local politicians and the local MP were heard telling of their frequent badgering of the government about this or that element of regulation which they had thought inadequate.

The media sought out a handful of scientific experts. These tended to stress that this was as convenient a type of oil as could be spilled, and that the gales would do a good deal of the clean-up work. One stressed that it would be handy if the oil came ashore on sandy beaches, because these were easily cleaned by heavy machinery. Another pointed out, a little later in the crisis, that very little oil was coming ashore. There were one or two opportunities for scientists from institutes partly or mostly funded by government to describe the effects of oil on particular species.

The final players were the environmentalists. By and large, the campaigners from the Royal Society for the Protection of Birds restricted themselves to describing the effects of the spill on particular birds or bird species. There was, however, a good deal of reference by the RSPB and others to threats to sea otters, especially if the oil were to find its way round to the east and north of the islands (rather than the west where it tended to go, in the event).

It was Greenpeace, though, which from the start was the favoured source of opinion on the environmental aspects of the accident, and they took a pessimistic view. When the oil was thought to threaten sandy beaches, the group said that if it landed there it would stay for a very long time (while the other experts pointed out how easy it would be to remove it). When oil dispersant was used for a while, in order to try to reduce the spread of the slick, Greenpeace was there to say that dispersant-use should be abandoned (though an RSPB spokesman thought that limiting the spread of the slick was the one action which was worth trying). Later, there was to be a good deal of Greenpeace activity around the risks posed by hydrocarbons in the vapours which were blowing ashore from the wreck.

On Friday January 8, the fourth day of the drama, Radio 4's 'PM' programme started its coverage of the *Braer* with this introduction:

R4: Pollution experts are tonight warning that an air-borne slick, the so-called sheen of oil, carried on the wind, could prove more hazardous to humans and livestock than the oil in the sea. The sheen is much more than the fumes from the tanker's cargo, that cling immediately round the wreck and according to local people is contaminating literally everything. But what is it exactly? Well, one man who knows is Dr Paul Johnston of the Earth Resources Centre at Exeter University. . . .

Paul Johnston: When the sea is made rough by the wind and when it beats against the coast a spray is formed which can be carried inland. Well, normally of course that consists of salt water but in this case it's consisting of droplets of oil and these droplets of oil are coming ashore and being deposited on the land and deposited on people's crops and being breathed in by people and [it is] generally an unpleasant and as far as I'm aware an unprecedented situation

R4: Unpleasant, but how toxic?

PJ: Well that is the open question. We do know that crude oil inhalation can cause problems by upsetting the delicate balance of the lungs; we do know that certain components in crude oil are

carcinogenic [capable of causing cancer] and mutagenic [capable of causing genetic changes in offspring]. What we really don't know in this case is how much of a health hazard it poses either in the short term or in the long term.

R4: Is there no precedent?

PJ: Only the experience we have of industrial accidents where workers have been exposed to oil sprays from, say, ruptured pipelines and under these circumstance there is evidence of central nervous system suppression, dizziness, nausea, vomiting and in some cases eye problems and skin problems following long exposure where tumours can actually form on the skin.

The news report then went on to cover locals and their experience of the 'poisonous sheen' on animals. Dr Johnston was asked to comment on these problems, and in particular whether the islanders would have to go so far as to wear facemasks:

PJ: Masks will provide a certain degree of protection against the droplets but unfortunately these are not going to be effective against the volatile hydrocarbons which are of the most toxicological concern. [There was some discussion of effects on animals here.] There are two real solutions to avoid exposure, one is of course to remove the oilslick which everyone is trying to do. The other way is to, obviously, to remove the people from the island and I think that's a solution which would have to be considered.

The presenter asked about long-term effects, other than immediate nausea and so on.

PJ: The effects could be a lot more serious than that. Benzene, for example, which is a fairly large component of light crude, is an agent that causes leukaemia and of course children particularly can be very susceptible and so there could be long-term implications and some long-term monitoring is going to be required to monitor the oil that's present in the soil, the crops, the livestock, and some sort of follow-up health study is most certainly going to be needed in my view.

Dr Johnston's remarks were classic environmentalist stuff. He mentioned carcinogenicity, or cancer-formation, accurately enough, but did not mention that almost all cancer-formation is a matter of amount of dose and length of exposure. Light exposure for short periods is hardly likely to be a problem in the case of oil droplets. Another important trick is to say something 'could' be a major

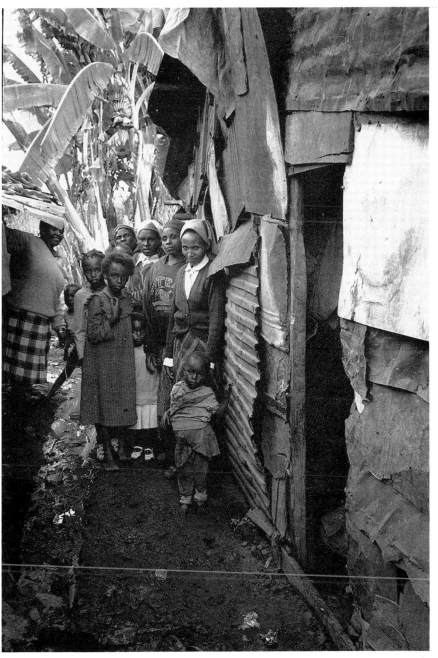

1 Mathare Valley, Nairobi, Kenya.

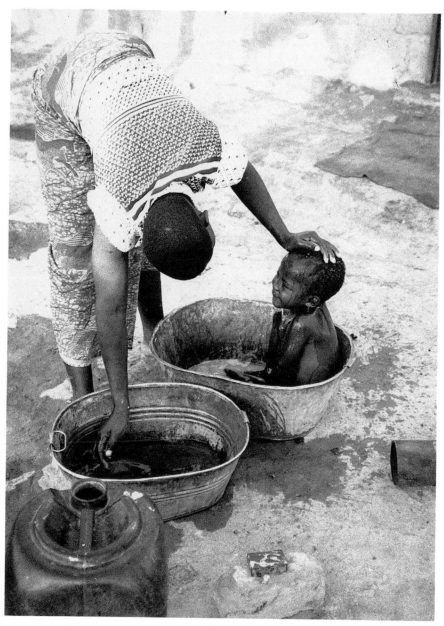

2 Bathtime in a Lusaka shanty, Zambia. Fairly basic facilities and strong local government make some shanties much pleasanter places to come to than others.

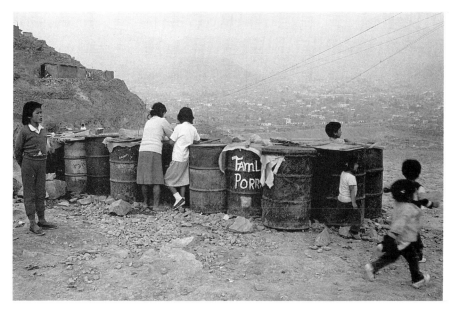

3 Water supply facilities in the Lima shanty town of Independencia, September 1988. Each family has to rely for water storage on an old oil drum, filled from a tanker – at a price.

4 Children eager to learn in their school in Mathare Valley, Nairobi. The children insist on wearing a uniform and the school operates in the afternoon only, after the youngsters have finished scavenging in the city's markets.

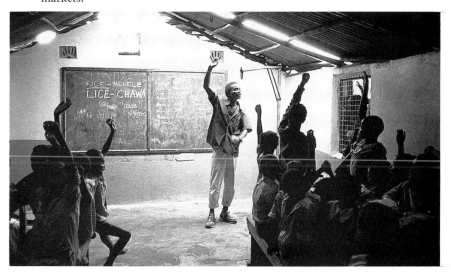

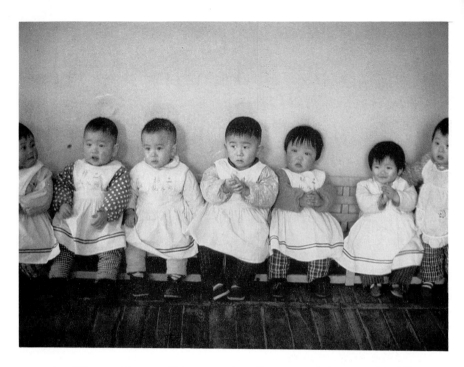

5 Chinese babies: the UN predicts that China's population growth will be at the low end of projections for developing countries, and the country is displaying astonishing economic growth, though this has been achieved by methods which sometimes offend western liberal democratic ideals.

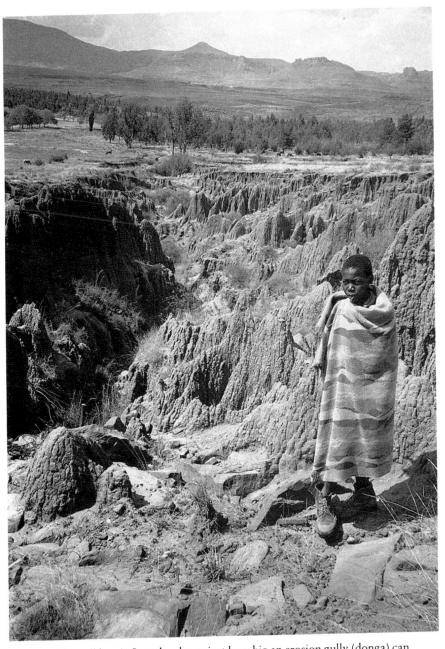

6 A small boy in Lesotho shows just how big an erosion gully (donga) can be. Local people are setting up grazing committees to try to avoid erosion; planting grass has proved successful in binding gully banks.

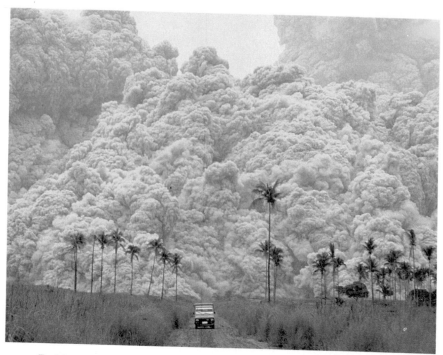

7 Nature's own climate-changing events can be very powerful, as in the case of the eruption of Mount Pinatubo in June 1991. All the same, it is hard to duck the growing consensus that humankind's emissions are on a scale likely to produce a rate and degree of climate change unseen in human history.

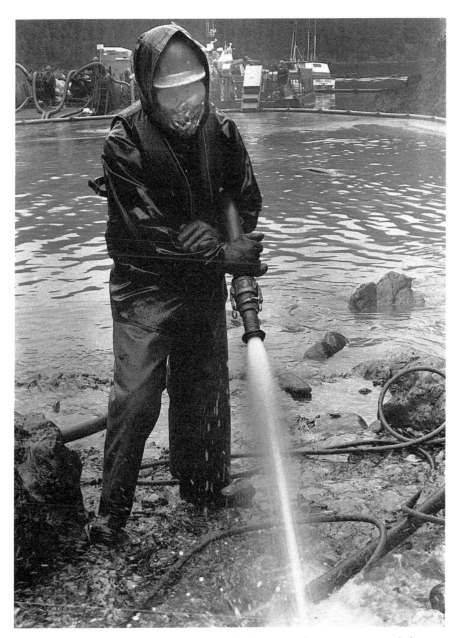

8 An Exxon oil spill worker sprays high-pressure hot water on an oiled beach in Prince William Sound. Subsequent studies suggested that much of this work was counter-productive: winter storms could have been left to do the work more safely.

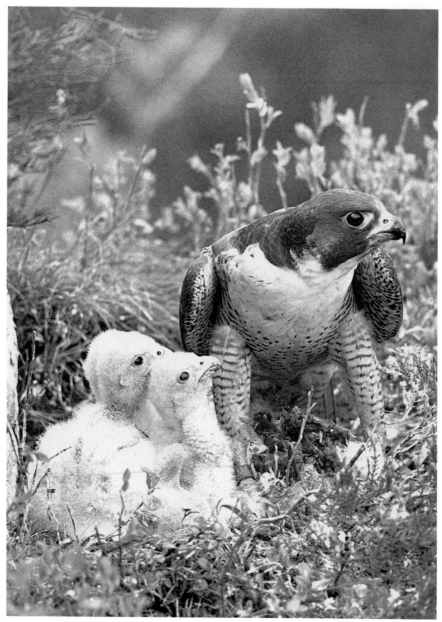

9 A peregrine falcon with its young: populations of these birds and many other predators were severely reduced during the period of heavy use of some organochlorine pesticides and are now bouncing back following bans.

long-term problem. The 'could' lets one off ever being called to account for non-appearence of problems. The accentuation of the long term allows that nothing much is happening now (and, it is true, reflects the long maturation period of most cancers). Campaigners like to imply that we have no experience of the latest problem, so that the impression conveyed is that industry puts us in a situation where we have no guide, only fear.

Radio 4's broadcasters must have known they would get material like this from Dr Johnston. They billed him as someone who had particular knowledge of the issue, but they did not point out that he is a scientist who is well known to the media and whose opinions are profoundly at odds with those of most of the conventional scientists in the fields on which he most often comments. He is, for instance, well known for arguing publicly that high-temperature incineration of toxic wastes should be halted because of the risks posed by the burners' emissions, a view which is not shared by any official regulatory body in the western world (see Chapters 7 and 8 for incineration).

Announced as Dr Paul Johnston of Exeter University's Earth Resources Centre, there was no indication that he is a Greenpeace International employee running Greenpeace's unit at the university. Dr Johnston apparently made clear to the programme's researchers exactly who he was.[1] The broadcasters for their part were happy with presenting his evidence as neutral and expert, rather than quite possibly expert but also certainly committed and, I suggest, thoroughly partisan. Dr Johnston insists that, as an honorary research fellow at Exeter University, he is a scientist and not a campaigner, and also that passionate conviction is no crime.[2]

There is an important subtext here about the impartiality of scientists, even those who can boast the imprimatur of a university affiliation. It is a pity that a university should give houseroom to a campaigning organisation with a long record of being cavalier with evidence (see Chapter 7). Dr Johnston of course strongly disagrees, and pointed out to me, 'There are many scientists from industry who are sponsored by corporations to be in universities'.[3] From his perspective, it is no odder that there should be a Greenpeace scientist at a university than that there should be researchers from industry.

To return to the *Braer*. Soon on the scene was Dr Gerald Forbes, the director of the Scottish national statutory authority, the Environmental Health (Scotland) Unit, based at the Ruchill Hospital,

Glasgow. Dr Forbes gave me this account of the public health implications of the hydrocarbon emissions from the *Braer*, and of his run-in with Greenpeace activists on the island, who were taking a similar line to Dr Johnston:[4]

> I know that disaster is always good news and I made it quite clear that there was no health risk and there was no need for evacuation and that what Greenpeace was saying was quite unacceptable. There was a showdown with them in the end, in Sumborough. I've written a paper on this.[5]
>
> What I was concerned about was basically the effect this [media attention] was having on the population. The problem was that the number of reporters equalled the population. There was a reporter for every person, and they had to find a story. In press conferences we were able to put our story across to the press quite easily, and they in general were very responsible, and we were able to sort things out with them, but it was this sideways movement from Greenpeace that was difficult.
>
> If you take Shetland and the middle of London you've got two different atmospheres. We've got the odd car and that's about it. The average smell you were getting from *Braer* was not much worse than you get on the forecourt of a garage. Droplets [of oil] were being blown about 3 miles inland. It was the worse weather that had ever been recorded in Orkney. The majority of people were inside, they didn't get out. The children were taken about in cars.
>
> I was sent up there on the Thursday [January 7th] and [had to decide] whether it was or it wasn't a major health problem. [He decided it was not a long term hazard, and said so immediately, the day before Paul Johnston's remarks.] I've been at this game for forty years, it's what I get paid for. People were getting irritation of their eyes. You could smell it: it didn't smell strong; a smell not to make you feel ill. Throat irritation, headache, eye irritation, that's all. In the first three days, that was when the volatiles were getting blown about. The population was at least half a mile away from the source. The nearest hamlet was over two miles away.
>
> We know the occupational exposure levels for these things. The levels found were well within occupational exposure levels. The first day they couldn't detect any. Only later did they detect benzene, zylene, toluene: all these volatile hydrocarbons were all well below occupational exposure levels.[6]

Occupational exposure limits are calculated by the Health and Safety Executive, under the direction of the Health and Safety Commission (on which employers and employees sit). The HSE limit for

all hydrocarbons together is 100 parts per million, accumulated over a working week.

Dr Forbes went on a public platform and said categorically that there would no long-term risks. His account continued:

> The night the *Braer* broke up we got a good feel – on the 11th – and at the wreck sites we had six parts per million (ppm) total hydrocarbon, and in residential areas we had less than 1 ppm. Your normal London street at rush hour is at about 11 ppm total hydrocarbon.
>
> Our own director of public health, Dr Cox, had the same opinion [as Dr Forbes]. We never wanted to play down the cancer risk. We did tell people there was a problem, and to wear a mask [if they faced contamination outdoors]. We got in touch with the people who provide these masks and we got the right masks for droplets and vapour.
>
> The occupational health people were comfortable with it [the information and risk assessment], the doctors were comfortable with it, and that put my mind at ease. Yes, evacuation was a possibility. But moving 600 people in the middle of winter? Somebody's going to die in my opinion: an old lady of eighty, or a road accident, or a heart attack.

I think that Dr Forbes was too generous about most of the media: but we will come to that. He was also wrong if he told people simply that there was no health risk from the oil. There was almost certainly some elevated risk, however slight, from breathing oil-contaminated air rather than fresh air. But the on-the-spot, official advice and view was far less wrong and was better supported by the evidence than Dr Johnston's and that of the Greenpeace campaigners on the ground.

Most people receive their impressions of dramatic events from television. This is a pity, since in the *Braer* incident the 'heavy' newspapers did pay at least some attention to calmer opinion from knowledgeable people. The television reporters mostly seemed content breathlessly to press any interviewee into expressing just how bad things were or might become and then to voice their own sense of the tragedy which was unfolding. Through the hail of their wind-tossed questioning, one sometimes detected an informant trying quietly to suggest that things might not be going quite as badly as it seemed. Only Alex Kirby, the BBC's environment correspondent, presented his brief reports with anything other than a blizzard of cliché and prejudice.

Early on, it was clear that the overwhelming assumption by jour-

nalists was that Big Oil had perpetrated one of its characteristic assaults on the environment. Reporter after reporter shouted the required mantra about how environmental or ecological disaster, usually billed as major, had already arrived, or soon would, or was inevitable, or very likely indeed. Sometimes the idea of an economic or a human health disaster joined the environmental or ecological predictions.

The electric media were happy to broadcast the campaigners' speculation about the problems the accident would bring, and perhaps did so because they had the idea that we had seen this situation before. The *Amoco Cadiz*, *Torrey Canyon* and *Exxon Valdez* shipwrecks had all been ecological disasters and this could not be a lesser event. The media felt it was safe and necessary to reach for words like 'major ecological disaster'. Actually the journalists were re-using adjectives and attitudes which were wrong when they were first used twenty years ago, but had been gathering credibility since.

The previous famous incidents were not ecological disasters, nor indeed any sort of disaster at all except to the creatures they killed. These casualties were usually small in number and in ecological significance. Beyond the suffering caused to the tens, hundreds, thousands or in a very few cases thousands upon thousands of animals of particular species, we have no evidence of long term serious damage from oil slicks.[7]

The incidents did not involve a loss of human life, unlike many shipwrecks. So far as one can tell, no one lost their living as a result of the accident. Local people suffer disruption but make money as a result of tanker accidents.

All this information could be had from people who have visited the sites of previous oil spills. Indeed, when I set out in 1991 to find scientists who had visited oil spill sites in the years following incidents, it was striking that not one had any other sort of environmental story to tell. Most of these scientists work for quangos (quasi-autonomous non-governmental organisations) or universities, which, unlike campaign organisations, often have very weak or diffident relations with the media. Another factor is distrust. Because many of the best-informed sources are official or semi-official, the journalists bracket them as establishment and part of the enemy.

Dr Roger Mitchell is the senior marine specialist with the Joint

Nature Conservation Committee (JNCC).[8] He told me, in 1991:

> I went to the Roscoff coastline in the days after the *Amoco Cadiz* spill.
> It was pretty horrific at the time, oil is so visual and it smells, and the
> poor French squaddies were being sick as they cleaned it up. But the
> next year, it was a very different picture.

Dr Mitchell described a process of a return to near normality – both
aesthetically and in conservation terms – which saw rapid progress
after the spill in 1978, with the last of the noticeable damage restored
in three years or so. A skilled biologist could detect impacts from
spills like this many years afterwards. But these amount to slightly
skewed species distribution, and are very different from aesthetic or
ecological blight. None of the scientists I have spoken to about
follow-ups to spills were complacent, but all of them were anxious to
get away from talk of ecological disaster, and on to a subtler sense of
loss. Slicks join many other human activities and accidents which
erode the value and beauty of the world's shorelines. For Dr Andrew
Price, a tropical coast expert, it was the way tar pavements join litter,
debris and land reclamation in producing whole coasts which are
ugly and less useful for wildlife. For Dr Pat Doody, the senior coastal
specialist of the JNCC, it was the way human beings are 'taking bits
out of the environment', with no sense of the cumulative effect.
Marinas and seaside promenades in tropical paradises may matter
more than slicks.

Exxon Valdez, the Gulf, *Torrey Canyon*, *Amoco Cadiz*, the
Haven, constitute the ranks of incidents which mattered less than we
first thought. Their proper lesson is that every scrap of variety lost,
every creature and plant which dies, is part of an accumulation of
damage which, though it may not spell ecological collapse, erodes
the amount of beauty and naturalness in the world.

Experts who have visited the site of the *Exxon Valdez* grounding
and spill as recently as the summer of 1992 have a view of the scene
there which could not be more at odds with the standard idea of how
such a place would now look. They made their visits annually for
three years, in 1990, 1991 and 1992. They did so as consultants to
Exxon itself, and therefore cynics might say that their word was
fatally tainted by their fee. We need not agree with the cynics.

In 1991, two conflicting accounts of the after-effects of the 1989
Exxon Valdez spill were released in the United States. One, rather
gloomy, was written for the US Department of Justice as part of the

legal proceedings which wrap American accidents in litigation practically as hazardous as oil tankers. It pointed to high – and disputed – losses to various populations, and especially of murres (which we call guillemots). The report suggested that perhaps 300,000 of the 1,400,000 murres in the Gulf of Alaska died, and that studies in 1991 would reveal the population status of the remaining birds. Similarly, it suggested that only studies later in 1991 would reveal the population losses – if any – among wild salmon which were larvae at the time of the spill. Certainly many of them were damaged. Some whales were missing. Sea otters died miserably during the spill, and even two years later showed lower survival rates in areas which were oiled. Sea lions and harbour seals were in decline before the spill, confounding attempts to asses the total damage, though the seals appeared to be suffering more in the aftermath of the spill.

Much of the report's unease flowed from insisting that the present position was hard to assess, and that answers must await further research.[9] A very different sense emerged from Robert Clark, Emeritus Professor of Zoology at Newcastle University and then editor of the *Marine Pollution Bulletin*. He was one of many scientists paid by Exxon to research the impacts of the spill from its ship, and one of the authors cited in Exxon's own upbeat report on the damage.[10] Returning from a trip to the disaster area a fortnight previously, he said: 'The place is absolutely marvellous. You wouldn't know it had happened. The winter storms have polished most of the beaches. You have to look for signs of oil.'[11] He reported tourism as booming in 1990. People talked of the damage to the murres as severe, but Clark's observation of the colonies was that 'zillions of birds fly off when you approach'. He reported oiled beaches as being 'very healthy-looking'. The area's beauty was not long blighted by the spill, and aesthetics matter. So, however, does being seen to do something: the US National Oceanic and Atmospheric Administration had just reported that much of the US$2 billion clean-up in Alaska delayed nature's own recovery.[12]

Clark was much more bullish about the likelihood of nature repairing itself than is fashionable among those who hype nature's fragility:

> Since the 1920s, perhaps tens or hundreds of thousands guillemots a year have been oiled in the Northeast Atlantic. That's been going on for fifty or sixty years, and when we started thinking about it in the

1950s and 1960s no one – me included – could believe the populations could sustain the losses. But the populations have actually exploded in recent decades.

He was equally certain that fish populations in the Gulf of Alaska would stay high as they did throughout the spill and have since. Yes, there were abnormalities in the larvae of some fish. But, according to Clark: 'These are observed after pretty well any spill, and have never affected commercial fisheries later.' Guillemots and salmon are very different creatures: but their breeding habits are usually well able to accommodate big yearly losses of individuals.[13]

No seriously contentious scientific argument would go unchallenged by the science press (in the United Kingdom, the various medical journals, and *Nature* and the *New Scientist* in particular) whose mission includes the airing of controversy. These journals are a delight because they enjoy publishing material which includes the sometimes informal but usually well-informed inspection of shibboleths, myths and any other twaddle. I have come to respect the process of science not because I trust the opinion of each and every accredited scientist, but because those who publish in the journals operate in a crucible of testing opinion. And yet, there is sometimes the doubt that scientific consensus can be at least temporarily as powerful as any other crowd-effect. We are on a knife-edge when we try to balance the individual maverick against the conformist gang.

Still, when Dr Jenifer Baker, Professor Robert Clark and Dr Paul Kingston (the latter two are academics at British universities) write in robustly cheering terms about the recovery that has happened on sites oiled by the *Valdez* accident, I am inclined to believe them, even though I know Exxon paid for their studies. And I comfort myself that even if they wrote rubbish, many other marine scientists would enjoy making their own reputations by exposing them. Greenpeace's scientists are not challenged because the most distinct and powerful of Greenpeace's remarks are made on the hoof to the media and are matters of policy and opinion rather than pinpointed risk assessment or strict science. The scientific specialists in the field seem to think there is not much point in trying to engage Greenpeace in an ordinarily scientific conversation because that is not what Greenpeace is about.

The outcome of the *Braer* incident was not predictable in detail. But right from the start it was fair to say, as I and one other

journalist, Matt Ridley, did, that the *Braer* incident would not amount to a large disaster if it was no worse than previous such shipwrecks.

As I write this, late in June 1993, it is still too early to say what the final effects of the *Braer* shipwreck will be. Dr Forbes refers in his forthcoming paper to misgivings about some of the dispersants which were briefly used. It may turn out that tighter regulations are required there. The gales did very swiftly the job which all along the experts had said would probably get done. The wind-lashed waves pounded the slick into so many bits that it could sink into the sea. The Ecological Steering Group of independent experts set up by the Scottish Office reported in May 1993 that much of the oil appeared to be submerged in sediments in two main locations of the sea near Shetland. Its final fate remains a matter of some speculation. Fish landings are still monitored and some salmon farms and shellfish harvesting remain restricted. Controls on harvesting and sheep grazing have mostly been lifted.[14] With luck, most of the oil still in the sea will be consumed as food by the enormous range of organisms opportunisticly waiting in the ocean. The chances of the *Braer* incident now turning into an ecological disaster are even more slight than they were at the outset.

Camelford: something in the water

In Britain in 1988, 20 tonnes of aluminium sulphate was tipped into the drinking water supply of Camelford, a small town in Cornwall. The public was given confused information, including scattered reassurances that the water was safe to drink. Naturally enough, there was nationwide concern that the local people would be poisoned by this incident. Almost as predictably, various local people took it upon themselves to campaign on the issues. They focused firstly on the water company's manifest failure to safeguard the water supply (and accused it of much else besides), and then drew attention to the various illnesses which were said to have flourished subsequently in the population.

Various players in the Camelford incident certainly made mistakes. The water company did not properly manage the way water-cleaning chemicals (the aluminium sulphate) were handled at the pumping station. The company and the health authorities both broke a cardinal rule: if people are worried about any problem in

something they might eat or drink, tell them to avoid it until some investigations are made. In this case, the water which came out of many people's taps looked and tasted odd and should clearly have been avoided.

However, the authorities did one thing right, eventually – and they have been reviled for it ever since. The government appointed four distinguished scientists to investigate the incident. They came out with a report in 1989 which suggested that there was no scientific reason to suppose that people would come to any harm from the aluminium sulphate they drank following the incident.[15] The group explained why the public's exposure to the chemical was nothing to worry about. They gave chapter and verse about the evidence and said that the public's worries had been whipped up by campaigners and the media and that the scientific evidence did not support the scare. This view has never been disputed, so far as I know, in any peer-reviewed academic journal.

Of course, the scare did not die down. People in Camelford and some others who had been there at the time, complained of mysterious illnesses, some of them quite like ME, while others reported that they or their children had behavioural or memory problems. Because the scare showed no signs of abating, the government reappointed the original team and augmented it with a researcher versed in psychological investigation.

In the wake of the announcement that the Clayton Committee had been asked to take later evidence under review, and had been augmented by a clinical psycologist, there was a further spate of media commentary. In October 1990 the *Guardian* published a piece by Melanie Phillips which will stand as good example of how even the quality press handled the issue:

> The Camelford scandal deepens. It is hardly surprising that the sick and bewildered residents have passed a motion of no confidence in the inquiry team that investigated the health effects of the poisoning of the area's water supply in 1988.

She went on to describe the reconvening of the Clayton Committee as a 'further morsel of surrealism', given the 'mounting evidence' that the committee had got its first investigation 'so wrong'. At various points in her article she listed a range of illnesses reported among the residents, included memory and speech problems, joint problems, and toe-and finger-nails dropping out.

In part the article is based on a simple misreading of the report. Phillips at one point says that the inquiry's findings were 'breathtaking' because they 'categorically dismissed' the suggestion that the incident might have long-term effects. In fact the inquiry team wrote:

> We consider it unlikely in the extreme that long-term effects from copper, sulphate, zinc or lead would result from exposures of the degree and short duration that occurred after this incident. Although the possibility of effects due to to the interaction of these chemicals cannot be wholly excluded, we can find no supportive evidence. Increased absorption of aluminium may have occurred in some individuals who persisted in drinking the heavily-contaminated water . . . [W]e have concluded . . . that delayed or persistent effects following [the brief exposures experienced] are unlikely.

Phillips complains that the expert committee conducted no clinical research among the population, a point which the reconvened inquiry group addressed in the second of their reports.

In late 1991 the reconstituted inquiry group reported, declaring that the passing of a couple of years since their last report had produced no new evidence which required them to change their view that the citizens of the area were not suffering from aluminiun poisoning.[16] The group added that the emergence of future long-term effects could not categorically be ruled out, though they repeated their previous assertion that it was unlikely.

The scientists cited a long list of inaccurate media reports which they said played a large part in exacerbating the shock and anxiety which the incident would have generated anyway, and contributed to the occurrence of those mysterious illnesses. Though the *Guardian* was particularly taken to task, *The Times* and the *Independent* got some stick too.

It is worth understanding something of the backgrounds of the members of the Lowermoor Incident Health Advisory group. It is chaired by Dame Barbara Clayton, Honorary Research Professor in Metabolism at the University of Southampton. Dame Barbara sits on the Royal Commission on Environmental Pollution, and was an early proponent of the view that exposure to high levels of lead might be a problem for children. Another member of the group is Professor Jim Edwardson, a senior Medical Research Council worker at Newcastle University. He is one of the few scientists who has long believed that long-term exposure to aluminium may be a factor in

Alzheimer's disease, and is an established expert in the field. Both these people have held and promoted unfashionable views when they felt that science justified them, both have held and hold views which have turned out or might turn out to be inconvenient to industry and the regulators. They are not establishment stooges.

True, there was one member of the team, Dr Ron Packham, who was senior in the main water industry research body. But even if that taints him, it might be remembered that for many years he also sat on World Health Organisation committees which set the pace in water clean-ups.

If she has a failing, Dame Barbara might be accused of a certain naivety about the media. She was genuinely surprised at the way the media poured scorn on anyone who suggested that the aluminium sulphate at Camelford simply could not have had the effects claimed for it unless our understanding of several biological pathways and processes is seriously flawed.

The committee's case was quite discursive and quite inclusive. For working purposes it took the worst possible case at all points to see what might have happened in the incident. It tried to work out what would be the effects of a dose of acidity, copper and aluminium (all involved at Camelford) which was more potent than any experienced at Camelford. It took at face value people's claims that they had drunk large quantities of contaminated water, even though such contaminated water would have tasted and looked foul and so been difficult to drink.

The committee also took at face value the physical and mental effects people claimed from the contamination. It could make no connection between such effects and the contamination. Moreover, it pointed out, local GPs did not complain of excessive or lengthened patient lists in their waiting rooms immediately following the incident, and did not do so even following the media scares. In other words, a few people claimed effects, some severe, some trivial, but their neighbours seemed totally unaffected. The hospitals did not report any unusual occurrence of illness. The inquiry team, so often painted as aloof and maverick, received evidence from eighty experts (listed in the second report) and knew well the views of the medical practitioners on the ground.

For the second report, the committee looked additionally at possible mental effects following contamination and could find none of chemical origin. There was a separate area of inquiry – culminating

in a conference in February 1990 – in which some local people and some psychologists pressed their claim that children in the district had suffered behavioural and learning difficulties following the incident. The transcript of this meeting is faintly disturbing.[17] Proving that a child is behaving slightly less well or learning rather more slowly than he or she might is never particularly easy. In Melanie Phillips' *Guardian* article of October 1990, a good deal is made of the papers presented to the conference, but only of the views which support the gloomy case. The full proceedings of the event show that there is a good deal of room for doubt as to whether there were any real – as opposed to psychosomatic or actually illusory – effects from the poisoning of the water.

Needless to say, the psychology experts could not agree. Some who were involved with the parents claimed that the behavioural and learning difficulties were clear for any fair person to see. Others said they were equally clearly as unmeasurable in degree and type as they were physically unlikely granted the contamination involved.

In the case of the reported cases of immuno-suppression and mystery diseases, one can at least say that these are increasingly being claimed to occur all over the western world, and variously believed to be complete nonsense, of neurotic or emotional origin, or due to the widespread use of synthetic materials. The Camelford victims can at least take comfort that plenty of their fellow affluent citizens of the west are reporting similar problems without having first to drink aluminium sulphate.

In the case of the behavioural and learning difficulties, the available evidence is that the people reporting them, and the investigators who support their claims, are finding extremely small deviations from the norm, if anything at all.

It is difficult to see how the media mostly came to regard the committee's work as a whitewash. They were not merely 'apparently' distinguished, as the *Guardian* had it. They were actually distinguished. The five scientists were working in a world of vigorous academic argument. They trawled every source they could for wisdom about the possible effects of people being exposed to aluminium sulphate and the bunch of other metals likely to be consumed as a result of the water and chemical industries' mistakes that day in Cornwall. The group sought out the people who most disagreed with the first report and asked for chapter and verse, which they then discussed, point by point. The group published its findings

at length and cited its sources.

At the time of writing (March 1994), there is still no evidence that flaws have been found in the reports. The pages of *Nature*, the *Lancet* and the *British Medical Journal* have not been full of rebuttals of the arguments in the reports. The stack of peer-reviewed science journals, which would have loved to engage in controversy, have not.

Undeterred by Dame Barbara's strictures against sloppy reporting, the *Independent*'s account of the 1991 report of the official group began: 'Victims of Britain's worst water pollution incident received a new setback yesterday after a second official report in 28 months concluded that their loss of memory and skin diseases were not caused by the poisoning.' The attitude of this news report was that the residents' claims are beyond dispute. The report also assumes that we accept that it is a setback for people to be told there is good evidence that they have not been poisoned.

Yet one can see the reporter's point of view. The possibility of the award of damages turns good news about the likely absence of long-term effects of the incident into bad news for those who claim – however falsely or wrong-headedly – to be its victims. Some of the residents who think they have been poisoned, and the experts who support and oppose their claim, will soon be putting their case in front of a judge as claims for damages are pursued against South West Water (the inheritor of the water authority which made the original mistakes). So the strengths of the opposing cases will be assessed in direct and head-on competition.

There is a good case for saying the aggrieved residents should also sue the media for the harm done by its dreary fascination with anything it can dress up as a scandal, however partial it has to be in the process. After all, lots of people made mistakes in Camelford, but it was the media which spread fear, and played ducks and drakes with the evidence as it did so. And if fear, however unfounded, hurts and causes illness, as it is increasingly claimed, then the media should head the queue into the dock. It will be very exciting to see how these arguments unfold in court.

Notes

1 Personal communication with the author, 4 April 1993.

2 Personal communication with the author, 4 April 1993.

3 Personal communication with the author, 9 March 1993.

4 Bennett, W., ' "Green" group is accused of scare', *The Independent*, 15 January 1993.

5 *International Journal of Environmental Health Research*, Stratchlyde University, forthcoming.

6 Personal communication with the author, April 1993.

7 The nearest to such evidence I have seen comes in 'The harlequin duck: birds of the white waters', in the *National Geographic*, November 1993 p. 130. This suggested that the declining numbers of the harlequin duck in the United States may in part be due to the poor breeding record of some populations following the *Exxon Valdez* accident. The article even suggests that may be due to the way oil was spread into sediments by misapplied solvents, as had been discussed in the *Geographic*'s important article, 'Alaska's big spill: can the wilderness heal?' in its January 1990 issue.

8 JNCC is the successor to the chief scientist's team at the disbanded UK Nature Conservancy Council, and therefore the official adviser to the UK government on conservation affairs.

9 *Summary of the Effects of the Exxon Valdez Oil Spill on Natural Resources and Archeological Resources* (Washington DC: US Justice Department, March 1991).

10 'Environmental recovery in Prince William Sound and the Gulf of Alaska: The field observations of Jenifer M. Baker, Robert B. Clark and Paul Kingston', supplement to the authors' scientific review 'Natural recovery of cold water marine environments after an oil spill' (Edinburgh: The Institute of Offshore Engineering, Heriot-Watt University), June 1990.

11 North, R., 'Slick turns in the oil debate', *The Sunday Times* April 21 1991.

12 'NOAA says efforts to clean Alaskan shoreline may have backfired', press release, The US Department of Commerce; news release, NOAA, ref NIL 91–28, April 9 1991.

13 North, R., 'Slick turns in the oil debate', *The Sunday Times*, April 21 1991.

14 The Ecological Steering Group on the Oil Spill in Shetland, 'An interim report on survey and monitoring', May 1993 (Edinburgh: The Scottish Office, 1993).

15 Clayton, B. *et al.*, 'Water pollution at Lowermoor, North Cornwall, report of the Lowermoor Incident Health Advisory Group' (London: HMSO, July 1989).

16 Clayton, B. *et al.*, 'Water pollution at Lowermoor, North Cornwall, second report of the Lowermoor Incident Health Advisory Group'

(London: HMSO, November 1991).

17 'Lowermoor water incident', Proceedings of the Conference held on 3 February 1990, at the Postgraduate Centre, Royal Cornwall Hospital (Treliske), Truro. Published by the Cornwall and Isles of Scilly Health Authority (St Clement Vean, Tregolls Road, Truro, TR1 1NR).

6

Aesthetics versus ecology: wind and water at war with the landscape

Much of the environmental damage we see around us is really far more aesthetic than it is ecological. The confusion between the two gives scope for a lot of powerful campaigning which plays on the public's anxieties but does little to enlighten it.

Ecology or aesthetics?

A tanker accident, a new road, a killed whale, a damaged wilderness, a quarry used as a rubbish disposal site. These are all far more often an assault on our emotions than they are on the life support system of the planet. The effects of some accidents or developments are, for instance, genuinely temporary and are often little more than local ecological perturbances. It is a constant refrain of the despairists that even small ecological disruptions eventually add up to a large disturbance, or even the risk of ecological collapse. But in case after case, we find they do not.

In many cases of development, the damage done is much more a matter of taste than of survival. People are, of course, free to campaign in favour of a way of life which preserves the natural appearance of things. Very often, and rightly, people will be campaigning against intrusive overdevelopment of housing, transport infrastructure, indeed urbanisation in general.

But sometimes they will be campaigning against what are temporary pieces of 'vandalism', as when, for instance, a field becomes a quarry, only later to be transformed into one of the many artificial lakes which are proving a boon to many species of birds. We may have lost naturalness in this process. But we can be seen, too, to have

gained it. We have lost meadow species and gained wetland alternatives.

We have lost something else, and again this is a matter of aesthetics rather than ecology. Every development, every change in the countryside brings with it a sense of loss. And yet, the loss of the valley when a bypass is made should not necessarily be mourned in ecological terms. Or rather, if the new road spares the town being the scene of traffic jams, one might fairly argue that the new road brings with it cleaner air for the townsfolk (as well as peace and quiet). The ecological balance here may be quite fine, as is the aesthetic one.

In recent history, we have seen ecology invoked in support of leaving some places more natural than developers plan. The public are not very sure how to make ecological judgements, and are inclined to defer to the environmentalists on such matters. And yet, if the decision was seen more clearly as an aesthetic one, as a matter of taste rather than survival, then the public would feel on surer ground. The trouble, from the campaigners' point of view, might be that the public would often choose the development because public readings of aesthetic matters are different to those of the green-minded people.

Ecology is often invoked to bring an element of scientific finality to what is really a matter of personal predilection. Often it is invoked to lift a local issue into a regional or global affair. Often these moves are successful, but that does not mean they were based on a proper argument.

Windmills: 'alternative' energy or vandalism?

A classic modern rural issue reveals very clearly the problem of aesthetics versus ecology. We worry about climate change, nuclear power, and oil spills. Naturally, many of us have high hopes of some kinder, more natural source of power. Yet, as we celebrate the obviously charming technologies, such as wind and water power, and worry about the obviously 'nasty' ones such as nuclear, it is worth remembering that things are seldom what they seem.

In the autumn of 1991 a British government planning inspector endorsed – and the Welsh Office approved – a windfarm development near a National Park in Wales. It was hotly contested by the Council for the Protection of Rural Wales. 'We knew we would immediately be accused of hypocrisy,' said Neil Caldwell, CPRW's

director soon afterwards. 'We went into it with our eyes open.' If a green organisation did not support renewable energy, who would?

The Welsh decision particularly upset the conservationists because it was such a sensitive site, and the government had not considered other, less sensitive ones. Besides, the Welsh decision was made before there was official guidance on the criteria for siting windfarms; the guidance appeared in draft form in 1992, and it has upset many greens. The Countryside Commission, the landscape and amenity quango,[1] disliked the way the new guidance suggested that renewable energy is so important that 'serious consideration' must be given to proposals for it, even on land which is supposed to be protected from intrusion by every other sort of development except in cases of dire need.

Technically speaking, Britain could produce all its electricity from ecologically-sound wind power. 20 or 30 per cent should be easy, and would save a huge amount of greenhouse gases and other pollution. For anything like this to happen, the British would have to unlearn their love of defending countryside from development. The British would have to learn to abandon an important part of their aesthetic.

To do them credit, the campaigners are bending over backwards not to be Luddites. As the Welsh decision was going ahead against their wishes, CPRW was endorsing another proposal for a site not far away. In December 1991, a wind farm at Delabole in Cornwall started operation. It was not opposed by the Cornwall branch of the Council for the Protection of Rural England, though several others are. However, by January 1994, CPRW had decided to oppose any further windfarms in Wales, which by then already had 400 wind turbines in 19 windfarms, with two farms being built and a further 20 plannned.[2]

Some in the industry believe that the more windfarms there are, the fewer objections there will be. They believe windfarms are their own best ambassadors, since the farms are neither as ugly nor as noisy as people fear. According to Dr Andrew Garrad, of the Wind Energy Association: 'It is very difficult for people to address this issue in a rational way because there's so little experience in the United Kingdom of what a windfarm is or looks like.' Whether a clutch of turbines the size of Nelson's column is a blight or an exhilerating innovation is a matter of taste. Whether they will grow in acceptability depends at least partly on whether people accept they are decently planned.

Whatever the government might permit, few windfarmers believe it is worth trying to site windfarms in National Parks or other obviously outstanding places. They cannot afford the money or the time involved in high-profile planning battles. So they have been making moves toward more humdrum countryside where they feel they have a better chance of quickly winning planning consent. Sometimes this involves picking sites which are less than ideally windy, which brings a technical and economic price. A site with 25 per cent less wind than the optimum must have twice as many wind turbines (on twice as much land) to get the same amount of electricity.

One would think that small is beautiful with windmills. After all, they are only generators with blades to catch the wind. Surely every suburban garden could and should have a thing about the size of a power drill, with blades stuck on it, stuck on a pole to catch the breeze? Apparently not. 'The age of the household wind turbine is some way off,' says Dr Garrad. 'The price per kilowatt from a small machine is very high compared with electricity from a large one. The energy you get goes up with the size of turbine, but the price does not go up in the same way.' Laws of physics dictate that a doubling of size of a turbine brings a quadrupling of the power output. It costs hundreds of pounds to buy a machine to run a lightbulb. It would cost several thousand pounds to buy enough wind power to run a household, and the neighbours would probably complain about the mini-forest of machines, or the single substantial machine, which would be required.

However, there are strong technical arguments for farmers to invest in wind power. Many could use it for their own grain-drying and similar operations, and export surplus power down the same cable which brings in their basic supply from the national grid. David Porter of the Association of Independent Electricity Producers has campaigned for years to make the bureaucratic rules governing such operations less intimidating to potential small-scale generators.

Dr Garrad believes that an optimistic scenario has about half of all windfarm proposals failing at the planning hurdle, and perhaps 2 per cent of British electricity being generated by wind by the year 2000, and perhaps six times as much again thirty years from now. This is three times the government's target for all renewables.

Water power: huge potential for energy and 'vandalism'

The potential of wind power in Britain is dwarfed by the potential of the Severn Estuary to drive water turbines. The proposed tidal barrage on the estuary of the Severn – with its famous bore – could generate 7 per cent of the nation's total electricity demand, and outstrip the government's year 2000 renewables target tenfold at a stroke.

There are formidable hurdles in the way of tidal barrages. They present an even tougher dilemma for conservationists than windfarms. Barrages seem likely to flood the food-rich mud birds need. As a consequence, barrages – there are proposals to harness the rivers Conwy and Wyre as well as the Mersey and Severn estuaries, amongst several others – will probably be fought to the last ditch by the Royal Society for the Protection of Birds. The best potential sites from an energy point of view are likely to be the ones most hard-fought. But the conservationists are the first to point out the dangers to their favoured muddy estuaries posed by rising sea levels – one predicted (and disputed) outcome of the acceleration of the green-house effect.

Yet it appears that the most dramatic of the barrages – the one on the Severn – may actually prove a boon to wildlife. Dr Nigel Clark of the British Trust for Ornithology has researched possible impacts of barrages for the Department of Energy and the scheme's promoters. He says: 'I can't make a cast-iron prediction, but it looks as though the possibilities range between a 25 per cent loss and a 50 per cent gain in birds.' The gain might come because the estuary would become a less violent hydrological system, and that might actually increase the area of mudflats and the numbers of birds able to feed on them. 'It's clear that the more work we do, the more we can say there will not be a very large reduction of bird populations on the Severn', Dr Clark said. He believes that even the Mersey barrage – on a more difficult site from a conservation point of view – might not be all disaster.

Notes

1 A quango is a quasi-autonomous non-governmental organisation.

2 'A New way to rape the countryside', *The Economist*, January 22 1994, p. 26.

7

Chlorine: devil's element or useful member of society?

Bhopal, Seveso, dioxins, DDT, PCBs, PVC: these are all names and acronyms to raise the hackles of the modern observer. They are all important players in the chlorine story, and help explain why this chapter is so central to this book.

Chemicals and the chemicals industry are feared in the modern world, not least because of their association with warfare and disasters. Chlorine is a chemical which several national Greenpeace groups argue should be banned. In extraordinary developments in the United States, it even appears that the official Environmental Protection Agency has come close to endorsing this line. I argue that chlorine is useful but not indispensible, and that the public can trust the regulators who advise politicians about how to control this and other chemicals.

The chemicals industry and Greenpeace on the Cote D'Azur

The chief of police looked as a Mediterranean crook-chaser should. Round, short, with his hair brushed dashingly back. There was a gold bracelet. The autumn sun was warming all our backs as we stood at the quayside. No one quite knew what to say to the Greenpeace crew member aboard the brightly-painted Sirius, a converted trawler of some sort. The ship looked odd – happy, childish almost, in its playroom primary colours (green predominated), but with workmanlike undertones – alongside the gleaming white gin-palaces of the harbour of Monte Carlo. It looked out of place.

As I opened my mouth to speak, the chief's henchman held up his hand to signal me to stop, and the chief – with a self-deprecating half

smile of apology to me – addressed the man at the top of the gangplank. 'You are most welcome here,' said the policeman. 'But, if you please, no . . . no manifestations.' The crew member seemed to prevaricate in his response, and the chief of police repeated his demand.

There were no manifestations. Greenpeace had come to the Cote D'Azur in its most reasonable guise, to bear witness to the hopes of a generation of people who love nature. The campaigners had come to run up banners in the harbour hard-by a conference of 500 (mostly) men, gathered for the 1992 Third Global Chlor-Alkali Symposium, whose special theme was to be 'Chlorine in Perspective'. For their part, the executives had gathered to defend their business from the worldwide assault of environmental campaigners, and Greenpeace in particular.

The industry was trying to promote the virtues of firms whose processes or products have definitely damaged the planet's defence against ultraviolet radiation (in the case of chlorofluorocarbons, or CFCs), have contaminated seals (in the case of polychlorinated biphenyls, or PCBs), and generally been believed, sometimes on good evidence, to be behind more than their fair share of environmental scandal. Greenpeace had come with what the world at large would probably accept as a couple of damning reports on the poisonousness of this industry.[1, 2] Greenpeace had a scientist in the hall of the Loew's Hotel as a delegate. She did not attend all the sessions, but she was as respectable a presence amongst all the grey suits as could be hoped for.

Greenpeace's presence at the chlorine industry's conference was conformist enough for anyone's taste. Its ambitions, however, are profoundly not to the taste of the chlorine industry, which Greenpeace outfits in several countries – not the United Kingdom as yet – seek to outlaw, lock, stock and barrel.

This is an aim of a different class to Greenpeace's normal declarations. When it campaigns against the nuclear industry, it is up against a single, obvious danger which everyone recognises and whose value and risks are disputed but at least focused. When it fights nuclear radiation it does so within a well-developed framework of argument, and even some agreed data. When it campaigns against whaling, it is fighting against a single activity of marginal importance to the economies which sponsor it. Again, whaling is a focused activity, and even has an agreed forum in which

scientists, campaigners and politicians have been meeting for years.

When Greenpeace campaigns against chlorine it argues against a chemical which is rather seldom used in its pure form, but which turns up in various guises in dozens – hundreds – of products, and as a part of the production of hundreds more. Chlorine's derivatives also turn up as impurities in otherwise desirable products. Chlorine is involved in about half the output of the entire chemical industry.

Greenpeace are among several campaign groups which appear to have taken their language and attitude deep into the consciousness of several western nations, and perhaps especially the United States. In February 1994, President Clinton announced that his administration was to revamp the Clean Water Act 1972:

> The EPA's immediate intention is simply to study the impact of chlorine use. But what incurred the wrath of the chemical industry is the proposal's premise that in order to protect human health and the environment 'the Administration will develop a national strategy for substituting, reducing or prohibiting the use of chlorine and chlorinated substances'.[3]

In the realpolitik of the United States, it often happens that politically correct pronouncements such as this are watered down in practice by intensive industry and regional lobbying. The chemicals industry everywhere generally accepts that is has nothing to lose from rigorous scientific investigation. Yet something dramatic has happened when a chemical can go from seeming a saviour to near pariah status.

The beginnings of the chlorine story

In eighteenth-century England, Runcorn, on Merseyside, was a spa town, famous for the invigorating qualities of its salt and fresh waters, and set in what was an overwhelmingly rural environment. But it was equidistant from the great salt plains of Cheshire and the coalfields of Lancashire, and a natural place – being close to the port of Liverpool – for a salt-based chemicals industry to set up. Soapmaking was just the right sort of industry. Demand was increasing because of textile-making and the hygiene revolutions which were to improve so many lives.[4] People were increasingly able to keep themselves and their immediate environment clean.

There had been soapmaking in more or less haphazard processes (increasingly less haphazard) for centuries. It required animal fat,

some source of an alkaline substance (stale urine, seaweed ashes and many other materials were used), and heat. By the nineteenth century, salt became the preferred source of the alkali required.

Runcorn, Liverpool and Widnes rapidly became the seat of the British alkali industry. The process required lead (for the chamber in which the process took place), sulphuric acid (the demand for which increased dramatically), coal (for heat and carbon), and lime (from Derbyshire limestone).[5] The alkali it produced was necessary for soap and glass manufacture. There was also sodium carbonate, known as caustic soda.[6] And there was chlorine, too, which was useful in the textile and paper industries as a bleach.

Right from the start, the environmental revolution in people's lives was attended by environmental problems in the industry's surroundings. The Muspratt family, one of three big players, had to close one factory because of persistent legal action by a local landowner claiming crop and tree damage from its pollutants. By 1862, the pollution was worrying enough for the House of Lords to hold an inquiry into injury from noxious vapours, which led to the first Alkali Act of 1863.

One of the late-nineteenth-century players in the chlor-alkali business, who was to become enormously successful because of his innovativeness, was Ludwig Mond, a German Jewish chemist and manufacturer who made his home in Britain and was the very model of an industrious, public-spirited, tough entrepreneur. In 1926, Mond's son Alfred took his father's chlor-alkali firm into ICI, whose formation he largely engineered, and Britain's chemical giant has remained a major chlor-alkali producer. Partly for this act of industrial empire-building, Alfred Mond was ennobled, as the first Baron Melchett. Ironically, his great-grandson, the fourth baron, is executive director of Greenpeace, UK.

In 1873 John Brunner and Ludwig Mond, who had both worked at Widnes, established works at Winnington near Northwich to produce alkali. Ammonia from gasworks and brine (salt and water) from the Cheshire saltfields were the starting points for the new Solvay process (which Brunner and Mond had under license from the Belgian giant).[7]

The Solvay process had the advantage of being less polluting than the main process it displaced, but it was not at first a producer of chlorine, which was then in increasing demand for use as bleach and germicide. The process eventually became a chlorine producer in an

elegant way, as explained by *The Times* in October 1862:

> In the ammonia-soda [Mond's] process the chlorine of the salt, which
> is the raw material of both processes, is run down the sewers [not
> nowadays] in the form of chloride of calcium. Regarded merely as a
> waste-product, this salt has the enormous advantage over the foul-
> smelling alkali waste of the Leblanc process [which Mond's was
> competing with] that it is odourless and soluble. But waste of this kind
> is an offence to the soul of a chemist like Mr Mond, even though his
> works pay in spite of it a dividend of 50 per cent. He has accordingly
> turned his attention to the problem of utilising the chlorine as well as
> the sodium of the Cheshire brine wells, and by combinations of the
> most striking boldness and ingenuity the problem has been solved.
> Chloride of lime made by the new process is actually upon the market,
> a large and efficient installation is at work, and the increase of the
> output to any required extent is a mere question of time and plant. The
> new chlorine process has been made to dovetail in the most beautiful
> manner with the old ammonia-soda process, and the combination
> does its work with ideal completeness. The raw materials are salt,
> consisting of chlorine and sodium; chalk, consisting of lime and
> carbonic acid; and coal. The products are soda-ash, consisting of
> sodium and carbonic acid; bleaching-powder, consisting of lime and
> chlorine; and energy derived from the combustion of the coal and
> employed to effect the new grouping of the four substances in
> question.[8]

If we pause here for a moment, we can see several elements which
might surprise a late-twentieth-century observer. First, there was
environmental pressure on the chemicals industry from the very first.
Landowners successfully litigated against its pollution. Second, it
was inquired into and legislated against right from the first. The
House of Lords' inquiry was extensive and deep, and the Alkali Acts
were world-leaders in legislation. Third, chemical engineers from the
very first wanted both profit and elegant, waste-free processes.
Fourth, there was, at least initially, an appreciation by lively jour-
nalists that chemical engineering was exciting, creative and capable
of elegance.

The Brunner-Mond success story continued in spite of the
emergence of a challenge:

> In 1897 a new competitor entered the market when the Castner-
> Kellner Alkali Company started production at Runcorn. Taking its
> name from the two chemists who founded it, the company exploited

an efficient method of producing chlorine and alkali by passing an electric current through brine (salt and water), a process known as electrolysis. By 1920 Brunner and Mond had a controlling interest in the company and in 1926 it became part of the newly-formed ICI.[9]

Brunner-Mond faced considerable pressure in the 1880s from the emerging labour movement, whose investigators infiltrated chlor-alkali plant and exposed the working conditions. Brunner and Mond became pioneers of better working conditions. Driven by Mond's fierce devotion to high educational standards and to the science end of his business, the firm acquired a reputation for a certain gentlemanliness and even scholarliness of style and operation.[10] ICI was to inherit something of that mantle. Its manner of dealing with the outside world has over the years shown a complacency which grew partly from a tremendous sense of the competence of its scientists and technologists. This attitude did not and does not help it deal with what it thinks is irrational Green protest.

To return to the chlor-alkali world. The commercial and the chemical aspects of the chlor-alkali industry are hard to disentangle. Firstly, different processes emphasise the production of either the alkali or the chlorine side of the equation in different quantities and purities. It is a common accusation, hotly denied by the industry,[11] that in the preferred modern process chlorine became an embarrassing by-product of the production of alkali, and that some of the uses found for chlorine followed production of the chemical, rather than motivating it. Either way,

> In 1900 the market for bleaching powder [the main previous use for chlorine, along with drinking water purification] was saturated. Therefore CK [Castner Kellner] sought new outlets for chlorine products. This led to the development of . . . dry cleaning fluid and PVC (polyvinylchloride).[12]

It is at this point that we see a crucial development in chlorine's history. It was being combined with carbon molecules to make organochlorines. These gave both the chlorine and the carbon parts of the new compounds properties which were wonderfully useful and sometimes wonderfully dangerous.

Chlorine in disasters

From the start, the chemical industry was dangerous to work in, and

the chlor-alkali business was no exception, with workers at great risk from breathing in chlorine gas, lime, or their combination as bleaching powder.

The story is told in a masterly way by V. C. Marshall in his *Major Chemical Hazards.*[13] Marshall says, of the early days:

> Major chemical hazards, as we know them today, were in their infancy, except for a few incidents involving the manufacture and storage of explosives. The reason for this was the small scale on which chemicals were produced and the low pressures which were technically feasible in operating chemical plant.[14]

Chlor-alkali production drew attention to itself because of the toxicity of chlorine and its derivatives. The industry also attracted attention for the caustic properties of its materials, which burned people, animals and vegetation. Here is Marshall's background to the chemical:

> Chlorine is a greenish yellow gas which is 2.5 times as dense as air . . . it is an intensely irritating gas . . . Chlorine attacks the lungs, producing oedema, i.e. a copious secretion of fluid. This fluid is abstracted from the bloodstream and leads to thickening of the blood . . . Legge (1934) in a review of accidents reported to the factory inspectors in the United Kingdom between 1908 and 1931, records that there were 177 cases of gassing by chlorine but only 1 fatality . . . [A recent assessment] said that United Kingdom production of chlorine was currently [1981] running at 1 million tonnes per annum and 7 million tonnes per annum for the remainder of western Europe out of a world total of 30 million tonnes per annum. During the past 25 years in Western Europe, there have been 8 fatalities out of 550 million man hours worked. Very approximately, this works out at about 1 fatality for every 12 million tonnes of chlorine produced in Western Europe. This is much better than the record of the coal industry expressed in fatalities per million tonnes which is, for the United Kingdom today, about 1 fatality by death or disease per million tonnes.[15]

Chlorine's toxicity has, of course, been used deliberately, most famously by the German army on April 22, 1915 when 168 tonnes of the gas were deployed, killing several thousand and horribly poisoning thousands more. Not until the accident in a plant producing chlorine-derivatives at Bhopal, central India, was the chemical again implicated even indirectly in killing on anything like this scale. Accidental releases tend to be very much smaller, and, of

those which run into tonnes rather than kilograms, Marshall lists 20 between 1939 and 1981. The majority of the listed releases run from a couple of tonnes all the way up to 30 tonnes, with only one above that, at 90 tonnes. The fatalities do not run proportionate to the quantity of the releases and are mostly nil or small, though a couple of accidents killed 19 people each, and one killed 60.

But it is not for the release of the chemical in its pure form that chlorine has a bad name in modern times. At Bhopal in December 1984, methyl isocyanate (MIC), a chemical used in the manufacture of Sevin, a pesticide, killed around 3000 people and injured perhaps a quarter of a million more. MIC does not contain chlorine, and the victims of the accident were not exposed to chlorine in any form. However, the plant's process involved two chlorine derivatives, and so it follows that a ban on chlorine chemistry would have avoided a Bhopal.

The non-use of MIC because its 'parent' chlorine was banned might well be a mixed blessing, however. Bhopal was an accident in a pesticide plant which involved chlorine (though MIC is not an organochlorine). Suppose that we had instead relied on organophosphates, the other main category of pesticide? Though he does not discuss this issue, Marshall in another context makes the point that:

> Sevin [the main product for which Bhopal's MIC was a precursor] is much less toxic to humans and animals than is, for example, parathion [a leading organophosphate] and it is much less persistent than DDT [an organochlorine which as we shall see has proven trickily persistent, for all its great usefulness in some of its applications].

I have seen no discussion of the ecological balance to be struck between a pesticide which is benign in use but hazardous in manufacture as against one whose properties are the reverse. Indeed, I have seen no discussion on whether the manufacture of MIC is inherently more dangerous than the production of any other pesticide. Worse, one has to face a very real difficulty in this sort of discussion. Bhopal's killing of 3000 people is a clear disaster, but it does not necessarily militate against the manufacture of MIC. The disaster at Bhopal depended far more on poor management, under-investment and bad urban planning than it did on the inherent hazardousness of MIC plant.[16]

However, MIC has been known to be extremely toxic for years,

and Marshall – a markedly unhysterical author – criticises the plant's owners, Union Carbide India Ltd, for not knowing more about their product. He points out that a good deal was known about MIC before the disaster and that MIC 'is now known to cause prompt deaths by pulmonary oedema, and to injure the eyes, the stomach, the liver and the skin'. Marshall suggests that until more is known, it would be wise to rate MIC as 25 to 30 times as toxic as chlorine, which makes it more toxic than hydrogen cyanide, one of the most feared substances on earth.

I come to the Seveso accident after Bhopal, though it happened in July 1976, several years before the Indian disaster, because it leads into a debate which has continued to dominate the chlorine issue until now, and will for years yet. The reason is that at Seveso, there was a release of chemicals which are known informally as dioxins (and more properly as PCDDs, or polychlorinated dibenzo-p-dioxins), which have a fearsome reputation amongst the public and environment campaigners, though they are viewed much more ambiguously among scientists.

One particular dioxin has caused tremendous controversy. It is known as the most toxic substance on earth because it is quite extraordinarily toxic to guinea pigs, though much less so to hamsters and human beings. From now on, I shall refer to it as dioxin 2,3,7,8 (more properly 2,3,7,8-tetrachlorodibenzo-p-dioxin).

Dioxin 2,3,7,8 is 1000 times more toxic to some species than the least toxic dioxin (octachlorodibenzodioxin). That might lead one to think that dioxin 2,3,7,8 is the compound in the dioxin group which gives the greatest risk. In fact if the analysis of, say, a soil is looked at, it is quite likely that dioxin 2,3,7,8 will contribute only 1 to 2 per cent of the total toxicity for which the dioxin family is responsible in that soil sample. Indeed, it is quite likely that the sum of all the dioxins will contribute less than 10 per cent of the total toxicity as measured by the TEQ (TEQs are 'toxic equivalents' and are units of measurements by which toxic substances are reckoned to be toxic in relation to some known substance which is taken as a standard).

It is fair to see dioxin 2,3,7,8 as a very toxic substance, but necessary to remember that a part of its significance for us is that it is a marker of a whole group of chemicals, various of whose members are likely to be present when dioxin 2,3,7,8 is present.

Chlorine-derived itself, dioxin 2,3,7,8 is found as an impurity in a

chlorine-based herbicide 2,4,5-T (trichlorophenoxyacetic acid) which was a component in Agent Orange, and sprayed as a defoliant in Vietnam in the 1960s.[17] There have been persistent allegations that Agent Orange caused cancer in personnel who came into contact with it, and they have been as stoutly denied.[18]

The dioxin group is not known to cause cancer in humans and it is not known to be mutagenic (to cause genetic change in offspring) in humans. This does not mean that it is known not to cause cancer or genetic change in humans; only that the scientific consensus is that it has not been proved to. All we know about its carcinogenicity (its ability to form cancers) is from animal evidence. Campaigners, then, are within their rights to say that dioxin is very, very carcinogenic, but only if they add that it has not been shown to be so to humans.

We do know that, amongst humans, dioxin 2,3,7,8 causes chloracne, a skin disease which is curable (though severe cases lead to permanent scarring). We know the chloracne connection because all major exposures to dioxin 2,3,7,8 have led to this problem, and to no other definite results in humans. This is reassuring because we have had plenty of experience of high-dose exposure to dioxins. If they had major or even reckonable effects, we would know about it.

Marshall lists six cases (there have probably been a few more than that) of large-scale exposure to large doses of the dioxin group. They were spread more or less at random across the years 1949 to 1976. They all involved mistakes in the manufacture of the disinfectant TCP, or 2,4,5-trichlorophenol, and the scale of numbers of people affected ranged from 17 to 1000 (in the case of Seveso). One classic and important event occurred at the Coalite coal-to-chemicals plant at Bolsover, South Yorkshire in 1968. Followers of environmental stories are interested in this occurrence because the firm's incinerator smoke-stack is heavily implicated in recent (now abated) dioxin contamination of cow pastures.[19] (A stream, the Doe Lea, has even more recently been found to be contaminated by dioxins downstream of the firm's liquid outfall.[20]) Back in 1968, a person was killed in the Coalite explosion, but from falling masonry, not chemical exposure. To give the flavour of the outcome, here is Marshall's review of the evidence:

> May (1973) comments on treatment of 79 cases of chloracne arising from the Coalite accident. The great majority of cases made an almost complete recovery in four to six months. Ten men recovered only after steam bathing followed by ultraviolet treatment. No other illness

attributable to dioxin 2,3,7,8 made its appearance. In March 1969, there were two further cases of chloracne among contractors' men, one of whom had a son who also showed symptoms. Hay reports that there was no evidence of chromosome damage [which might indicate potential for birth defects in future] but some evidence of damage to the immune system. Another worker claimed that there was evidence of impaired liver function in some subjects.[21]

In the Seveso case, Marshall's review of the research into the outcome suggests that 'only relatively few cases of chloracne made their appearance, most of them mild . . .'. The outcome of the Seveso accident is very different to what one might expect of an accident which has assumed epic proportions in the disaster industry's demonology:

> Seveso (1978) [the report of the official inquiry] deals extensively with medical follow-up which included analyses of death rates, birth rates and abortion rates. No clear picture emerges however. Homberger *et al.* claim that, broadly speaking, nothing abnormal was disclosed. 'So far the pathology related to these parameters has remained within the range which is current for the population of this region and could not correlate with the exposure to dioxin.'
>
> A very detailed study by Bruzzi which forms part of Coulston and Pocchiari (1983), gives an account of the difficulties involved in setting up a sound epidemiological study in the area of Seveso. The study agrees with the conclusion that there is nothing in the mortality pattern which correlates with exposure. With regard to abortions, matters are different. In the period immediately following the incident, the rate of induced abortions was higher by a statistically significant amount. It is believed that these were caused by fears of foetal damage arising from exposure to dioxin. The rate of induced abortions fell after 1978. There seems no clear indication of correlation of birth defects with exposure though there is some suggestion that this may be the case in a few instances. As to cancer incidence, the latency period is generally too long for study to reach any conclusions yet. Bruzzi agrees with the finding that there is a statistically significant correlation between some neurological symptoms and exposure to dioxin.[22]

So, it is a little too early to be sure that the heavy exposure of workers at Seveso has led to no additional cancers. Most cancers have a development period of between ten and twenty years from even heavy exposure to a carcinogen. But it would be surprising if it did,

granted that in all the previous cases of dioxin 2,3,7,8 exposure, cancer has not only not been proved, but not seriously suggested by researchers.

If we return to the only known certain and serious human effect of heavy dioxin 2,3,7,8 contamination, we can again quote at length from Marshall's summary of the chloracne effects in the wake of Seveso:

> The Report [of the official inquiry] . . . suggests that in early 1977, only 9 patients could be classified as serious and that by the beginning of 1978 there were no cases classified in that category.[23]

In other words the known medium-term (two-year) human upshot of Seveso was that there remained no serious cases of the only illness it was known to cause. The above accounts also allow that there are one or two shadows to this picture. There is the possibility, improbable perhaps, of cancer-formation, some suspected liver damage, suspected birth defects and some suspected neurological damage, but none so certain or serious that they have been pursued by a medical profession voraciously interested in this sort of issue.

What about environmental effects? Marshall's review of the Seveso accident says that large numbers of animals died because of the explosion, many from chemical burns not directly associated with the dioxins present.

> It was only in the immediate vicinity of the factory that there was obvious damage to vegetation. This must have been due to phenolic and caustic effects as dioxin 2,3,7,8 has never been shown to injure vegetation.

Chlorine: 'killing in small doses'?[24]

We have looked at some famous disasters, in which people were exposed to big doses of dioxin 2,3,7,8. A further concern involves the same group of chemicals but a quite different sort of exposure to them. This is relevant not least because the chemicals' reputation for toxicity depends on their being extremely toxic in small doses, and to two other factors which are usually mentioned in the same breath: they are persistent and they bio-accumulate.

Dioxins are a part of a wider family of chlorinated organic substances. The family is made up of molecules which are basically made

from coal or oil but which have molecules of chlorine-derived material attached to them at various points. The arrangements and amount of the various different points at which the chlorine molecules are stuck to the hydrocarbons are distinctive to each chemical, and are crucial to the way they work when they meet human, animal or plant cells. We are dealing with dioxins, whose proper name is polychlorinated dibenzo-p-dioxins; furans, whose proper name is polychlorinated dibenzofurans; and PCBs, whose proper name is polychlorinated biphenyls. Sometimes the most potent of the dioxins, dioxin 2,3,7,8, is referred to as TCDD.

The account that follows is culled exclusively from a paper given by Frances Pollitt, a toxicological specialist at the United Kingdom Department of Health. She was speaking at a seminar arranged by Pamela Shimell, an environmental consultant who runs Industry and Environment Associates and who wanted the official and 'orthodox' scientists and the scientists and campaigners from Greenpeace and one or two other groups to discuss things in a relaxed atmosphere.

Pollitt's review begins with a discussion of the toxic effects of various chemicals. By this is meant the power of chemicals to poison organisms. This is their power to interfere with the healthy workings of the organs or metabolisms of creatures. (It usually excludes the idea of cancer-formation, which is seen as a special capacity to make cells reproduce in an unhealthy way.)

> The reputation that TCDD [dioxin 2,3,7,8] has gained of being 'the most toxic chemical known to man' is due to the fact that a single very low dose can be fatal in certain animal species. That is, it has a high acute toxicity. Acute toxicity has traditionally been measured by the LD50 [the 'lethal dose' 50 per cent, the dose of chemical required to kill half of a group of animals in a test population]. The oral LD50 of TCDD in the most sensitive species, the guinea pig, is only 2 micrograms per kilogram of bodyweight (ug/kg bw). In the rat TCDD also shows high acute toxicity, with an LD50 of only 50 gg/kg bw. This can be compared with the LD50 of [the extremely poisonous] sodium cyanide in the rat, which is over 6000 gg/kg bw). However, there is considerable variation in the susceptibility of different animal species to this acute lethal effect of TCDD: the least susceptible of the species tested – the hamster – is more than 5000 times less sensitive than the guinea pig.[25]

The account then goes on to say that other dioxins are much less toxic even to the extremely sensitive guinea pig. The next less toxic

dioxin is 100 times less potent, and the one after that is at least 1000 times less. Many other dioxins are even less toxic:

> These compounds – the vast majority of the PCDDs [dioxins] and PCDFs [furans] – are generally of negligible biological activity and are not important in terms of health concerns.

Repeating the insight that the chemicals show no acute lethal effect in humans, even after quite high exposures, Pollitt turns to the effects on animals of long, low exposure. She says that there are a wide range of effects, with some animals showing chloracne effects, and others liver effects, and effects on the development of the immune function in some.

Even scientifically illiterate people now know far more about the human immune system than any previous generation because we hear so much about the HIV virus and its power to make people fatally prone to diseases which the body can normally defend against. However, in the case of dioxins and furans, Pollitt's review suggests that the animal evidence about immuno-suppression does not seem to carry over into a human concern. Non-human primates – which are assumed to be quite like people in their biology – are less susceptible to the chemicals' damage than other animal species. Besides, evidence suggests that the chemicals would have other more obvious effects before immuno-suppression became a factor.

Pollitt then turns to another central concern: that, even in tiny quantities, dioxins cause birth defects. She says the research is far from trustworthy, but it suggests that the reproductive performance of female rats is adversely affected at very low doses of dioxin 2,3,7,8. The chemical can make pregnant mice produce deformed offspring.

In non-human primates, exposure to dioxin 2,3,7,8 seems to produce stillbirths or abortions rather than deformities, but only at high doses. I say high doses. These birth effects were seen at doses in the animals' diet of 50 parts per trillion (ppt) or the equivalent of 0.002 micrograms of dioxin 2,3,7,8 per kilogram of body weight per day. A microgram is a one millionth part of one gramme. So 0.002 micrograms is a 2,000th part of a millionth part of one gramme. (A packet of sugar has 2,000 grammes in it.)

No wonder we worry. These bizarre numbers convey just how powerful the effect of dioxin 2,3,7,8 is in some species. However, in non-human primates, Pollitt says the same research found that

'overall reproductive success' was not affected by a dose of 5 ppt in the diet. In other words, at a dose of dioxin 2,3,7,8 which was a tenth of the one which produced bad effects, there were no effects. This matters: we are inclined to think that doses of toxins have effects in proportion to their dose. This is often true, but it can be a deceptive guide. It would be truer to say that chemicals are often toxins at a given dose in this or that species, and that reducing the dose will often decrease the effect proportionately. But in many cases, a decrease in the dose can reduce the effect to nil. Or, quite often, turn a toxin into a medicine.

Most dioxins can be shown to produce cancer effects in animals. These vary according to species and dose, and include diminution of some sorts of cancers. Some of the worst cancers, of the liver, only occurred at doses which caused other marked effects to the liver (we will come to this later as an important argument). At a dosage level of 0.001 microgram per kilogram of bodyweight per day for two years, there were no observable effects.

We have talked a good deal about the absence of long-term human cancer effects from exposure to dioxin 2,3,7,8 in accidental emissions. But we need Pollitt's review to give us a sense of what has been done to establish acceptable exposure levels in humans in the light of the animal cancer data she provides. She notes that the apparent absence of long-term cancer effects in Seveso's victims happened in spite of evidence of very high levels of dioxin 2,3,7,8 being around:

> Recently, serum concentrations of TCDD [dioxin 2,3,7,8] have been measured in blood samples from victims of the accident in 1976. Some of these samples show exceptionally high levels of TCDD – up to 56,000 ppt. This can be compared with a background level of TCDD in the general population of 3–20 ppt.[26]

She goes on to cite evidence that earlier concerns about the cancer-forming powers of pesticides contaminated with various dioxins do not seem as valid as they once did, and mentions that a follow-up after 34 years of workers exposed in a German accident involving dioxins showed no increase in cancer mortality overall. 'A small increased risk was recorded in all cancers combined, for cases detected beyond the twentieth year of exposure.' In other words, there were a few more cancers, but none had matured into fatalities, as yet.

A further long term study was reported in 1991. It took place

amongst the medical records of over five thousand US chemicals industry workers and found that after twenty years' exposure to dioxin 2,3,7,8 at levels occurring in factories producing it as an impurity, there was a small increase in mortality from all cancers combined, but suggested that previous suggestions of 'high relative risk' for many cancers were not confirmed and concluded that:

> Excess mortality from all cancers combined, cancers of the respiratory tract and soft-tissue sarcoma may result from exposure to TCDD, although we cannot exclude the possible contribution of factors such as smoking and occupational exposure to other chemicals.[27]

Is this good news or bad? It suggests that one long-term effect on workers exposed to higher than normal levels of dioxin 2,3,7,8 is a slight but significant raised risk of cancer, though the cause is not definite and may lie elsewhere. At least it suggests that we want to avoid smoking (which we knew) and that exposure to dioxins but also other unspecified chemicals in factories is unlikely to be a good idea.

So we are worried by the uncertainties surrounding dioxins. What should be the level of exposure to them at which we feel tolerably safe? It is the job of government to decide how to interpret all the available evidence, and then to set limits in the light of the evidence. In this case, the government asks an independent Committee on the Toxicity of Chemicals in Food, Consumer Products and the Environment (COT) for advice. This committee is, of course, aware of the work of other similarly expert bodies (especially the World Health Organisation). Taking everything it could read into account, COT has established a level of 1 picogram (1 million millionth of a gramme) per kilogram of body weight per day as the level of exposure to dioxin above which citizens should be protected by investigation and action against contact with the chemical. These measurements, though often expressed in terms of dioxin 2,3,7,8 allowances, are usually done in terms of a dioxin 2,3,7,8 toxic equivalent level (TEQ). In other words, when we talk about an allowance of dioxins, these are all assumed to be dangerous in a set relationship to dioxin 2,3,7,8.

We noticed earlier that researchers found no birth defects in non-human primates at doses of 0.02 microgram per kilogramme of bodyweight per day of dioxin 2,3,7,8 and no cancers in them at 0.001 microgramme/kg bw/day. So the committee recommended, in

effect, that we take action at one thousandth of the level of exposure which was found to have no effect – neither birth defects nor elevated cancers – in non-human primates.

Officialdom has another way of reckoning what is acceptable as an exposure to dioxin 2,3,7,8. This is the Tolerable Daily Intake (TDI) – which is the level of consumption at which it is felt no action need be taken. The World Health Organisation set this at 10 picogrammes per kilogram of bodyweight per day, ten times greater than the levels of exposure at which United Kingdom authorities reckon to investigate and discourage sources.

The good news for United Kingdom citizens is that average human intakes of dioxins from food are are less than a quarter of the World Health Organisation's (WHO) tolerable level.[28] Food is believed to be the main route of exposure to the chemicals by the general population. The bad news is that the average level is twice the 'trigger' level which COT set (see above). In other words, the whole of Britain is in effect an area in which sources of dioxins ought to be sought and reduced.

A sense of the difficulties involved can be had from the Environmental Data Service:

> International studies of breast-fed babies have estimated their dioxin intakes to be about 100pg/kg bw/day, expressed as a TEQ – ten times the Tolerable Daily Intake. However, the COT comments that the toxic effects of dioxins are chronic rather than acute, and there will be 'insufficient time for the body burden in babies to reflect the higher intake during breastfeeding'.[29]

There is plenty of scope here for mischief-making by campaigners and for genuine anxiety as people hear of the widespread presence of levels of dioxins which exceed one official precautionary limit for babies during breastfeeding. There is also an important poor argument which needs knocking out. It is stated in a clear way by the Ministry of Agriculture, Fisheries and Food [MAFF].[30] Describing the COT paper we talked about above, MAFF says:

> The key finding is that UK consumers do not consume unsafe amounts of dioxins in their food; levels are in fact so low that only the most sophisticated analytical techniques, capable of measuring accurately to two parts in a quadrillion (one thousand million) can detect them.

So what? We can, of course, be glad that the quantities we consume

in our food are not unsafe (though we are suspicious of anyone who says things are safe), but there is no logical connection between their being likely to be safe and their being small. It is of no comfort at all to know that only recently could we detect the ubiquity of dioxins because they are present in amounts so small they are hard to measure. We are not frightened of dioxins just because they are everywhere, or just because they are hard to measure, or just because they appear in small quantities. We fear these things because we have been persuaded that, like radiation, they mysteriously have the power to hurt even at these unimaginably low levels, which we are unable to avoid.

Inscrutability, detectability, insidiousness and ubiquity have been at the heart of this story from the start, and they all contribute to anxiety about organochlorines being a distinctly modern concern. The organochlorine problem is very different from the medieval plague. Then, it was clear that people were dying horrendously and in their thousands. What was missing was our knowledge of a plausible agent or pathway by which it reached human beings. How different, also, is the organochlorine story from the cholera story in the nineteenth century. Here again, people were dying in droves, and at first there was no plausible or detectable agent or pathway to be identified. But this case yielded an historic advance. A doctor realised that there was something wrong with the water supply even if he could not analyse precisely what. He worked out the route by which human beings were affected, but not the means. He had a strong correlation and assumed an as yet unknown cause. By forbidding people access to their water supply, and finding that they got better, he was able to deduce firmly that the water was carrying the agent of death, whatever it was. (Later, the chlorine industry provided the means of killing the agent.)

In the organochlorine story, we see a different set of workings altogether. We now have, not an epidemic seeking an explanatory pathway and agent, but a suspect agent, one of a large group which has definitely committed some crimes, and we wonder what sort of crime it might be perpetrating against us. There is nothing wrong in this suspicion, but there is a requirement to understand that when we worry about organochlorines, we are worrying about things in a different and distinctively modern way.

Organochlorines: dangerous and indestructible?

It was not the low doses at which dioxins killed some rodents which first made the chlorine industry famous, but the way some organochlorines, especially DDT and other chemicals, affected wildlife. As we try to describe these early beginnings of the organochlorine saga, we find that it is a rich territory for mythmaking. Here is part of a Greenpeace document:

> In 1962 the publication of Rachel Carson's *Silent Spring* alerted the world to the crisis facing the natural world as a result of the widespread use of chlorinated pesticides. Their hazardous properties are shared by the whole group of organochlorine compounds, yet thirty years on, despite the warnings and the ever-increasing catalogue of catastrophic effects, the release of organochlorines into the environment continues to grow.[31]

Greenpeace's paper tries to tar with one brush all organochlorines. This is poor history. Actually, Rachel Carson's book was an important event in raising public awareness about the environment, but action on the most important problems it talked about had already been initiated. Carson's book publicised the work of government scientists, and strengthened their arm in getting funds for their work. *Silent Spring* alerted the public. It was not needed to alert the regulatory scientists which the public's taxes were quite rightly already paying for.

In the early 1950s, Lord Zuckerman (then almost as ubiquitous in government committees as are organochlorines in the environment) chaired a group looking at farm pesticides as residues in food. The government-sponsored Nature Conservancy, which was later to become the Nature Conservancy Council and later still English Nature (with Welsh and Scottish equivalents), was commissioning research into reports that pesticides were poisoning wildlife. A scientist who worked on the problem recalls:

> Pesticides were clearly becoming a problem, but at that time everything appeared to be reasonably under control – not for long. In 1954 – unbeknown to us – the first field trials on two very toxic persistent organochlorine pesticides [the 'drins', now heavily regulated] were being carried out by Shell. The first vertebrate wildlife casualties from these chemicals were reported in 1956.[32]

In 1960, the British Nature Conservancy formed a Toxic Chemicalsand Wildlife Section, under Norman Moore. Moore tells

us that it was brought to his attention that, amongst many other pesticides,

> an organochlorine insecticide of low toxicity had a major effect on the population of western grebes of Clear Lake in California. These facts convinced me that, in the long run, persistence could be more important than toxicity.

Moore became a determined fighter against the unnecessary use of certain persistent insecticides. It became clear quite quickly how these new pesticides were working in the environment. The quality which made them different from other pesticides – their capacity to survive as active agents for long periods of time, and to spawn substances more persistent than they are themselves – was making them behave as wild cards in the environment. Here is Moore's description of the process:

> In the 1950s and 1960s nearly all the insecticides used as seed dressings belonged to the group known as organochlorine or chlorinated hydrocarbon insecticides. Some of the insecticides in the group, such as dieldrin, are themselves persistent. Other organochlorine insecticides are not persistent themselves, but their metabolites or breakdown products are. For example, the insecticides heptachlor and aldrin are much less persistent than their respective metabolites, heptachlor epoxide and dieldrin. Most DDT is turned into DDE which is extremely persistent.
>
> Unlike other persistent pesticides, the organochlorine insecticides are very soluble in fat, with the consequence that they build up in the fat of any animal which eats sub-lethal quantities of them. If a predator or scavenger then eats an animal with a store of insecticide in its fat, it may consume a considerable amount of the pesticide. If it receives enough in this way it will die. . . .
>
> It is the combination of persistence and fat solubility in the pesticide or its metabolite which makes DDT, TDE, aldrin, dieldrin and heptachlor so unusual and such a potential threat to wild animals. These pesticides not only affect individual species but, by acting through food chains, can poison other species in the ecosystems of which they are part.[33]

Now that we are familiar with this process, it is almost too ordinary to cause comment. Yet the discovery that man could make substances which, in the jargon, are 'persistent and bio-accumulate' was revolutionary. We knew we could make persistent substances,

because that was the point and advantage of these particular pesticides. We knew about the food chain, because that was an elementary ecological insight, made familiar in the past century. We knew pesticides were poisonous, because that was the idea of them. Putting the three elements together was obvious once it had happened, but only with twenty-twenty hindsight. The price we paid for not noticing that these things would happen was the unwary development of substances which led to diminished numbers of sparrow hawks, kestrels, otters, and perhaps seals, and various other carnivorous creatures. Worse, we had created a problem whose root was the longevity of a substance. By definition such a problem could not go away quickly, even once we had reduced or eliminated the flow into the environment of the substance which caused it. What was there already would take years, decades and even centuries to dissipate entirely.

However, we tend to forget the capacity of nature to recover from damage. The Natural Environment Research Council reported in late 1992 that many of the bird-species which were damaged by organochlorine pesticides are now bouncing back. The persistent organochlorine pesticides were brought under controls which massively reduced their impact on wildlife within a year or so of their harmfulness being discovered, and are now banned for all but a very few uses. Arguably, indeed, our keenness to preserve wildlife led to the premature banning of DDT in some of its applications. The battle against malaria until recently depended on the availability of DDT; spraying campaigns in the tropics, and their cessation probably caused unnecessary deaths.

Pesticides remain problematic, not least because some of them contaminate underground drinking water supplies long after their application on the surface, and because even the least persistent insecticide reduces the range of food available to birds. Yet it becomes less and less likely that they are having effects which we cannot detect. We now live in a closely monitored world, and one in which our knowledge of ecological pathways is very sophisticated. Our watchfulness makes it probable that if they were having serious effects, we would know.

If we turn to the human health effects of pesticides, by far the worst effects are from direct poisoning of workers in countries where farmers cannot read the instructions on packages, or do not understand how important they are, or are not given the chance to work

carefully. As to the tiny residues of pesticides in food and water, both the British Medical Association[34] and the Agriculture Committee of the House of Commons have researched the problem of pesticide residues and provided reports whose overall effect was soothing rather than scandalising. The chemical contamination of our food and water is monitored and controlled closely enough for it to be a small factor amongst all the risks we face; but it is still right that we insist that poor products, practices and processes be abandoned.

A new type of chlorinated substance became known as a result of analyses for the persistent organochlorine pesticides. Norman Moore says the researchers of the 1960s knew something mysterious was present in the wildlife samples they were working on, but they did not know what it was. In 1966, the work of a Swedish scientist revealed to them that the mystery signals on their monitoring graphs were caused by polychlorinated biphenyls – chlorinated chemicals which were to become notorious as PCBs.

> These substances were used in paints, plasticisers, waterproof sealers, printing inks, synthetic adhesives, hydraulic fluids, thermostats, cutting oils, grinding fluids and in electrical transformers.[35]

PCBs would not conduct electricity and were nonflammable. They were a great advance in electrical and hydraulic uses, not least in reducing fires in coal mines. So far as anyone knew, or could reasonably deduce, their inert nature meant that they were non-toxic to humans. Their toxicity to wildlife was an unpleasant surprise.

PCBs had as many routes into the environment as they had industrial uses: smoke-stacks, liquid outfalls, leaks from equipment, scrap-yards where equipment was dumped. They were fat soluble as well as persistent, and so were bio-accumulative. They were ubiquitous, and might well be proved to have the same sorts of insidious effects on wildlife as organochlorine pesticides. Moore thought they might be doing some of the damage which had previously been attributed to the pesticides.

But at this stage PCBs were known to exist, rather than to cause damage. Later, research showed that one PCB was about one-thirteenth as toxic as DDT, while others were more toxic than the pesticide. They could kill. It was not until much later again that it transpired that PCB contamination of seals seemed to affect their reproductive system, and not until even later was it noted that it seemed to effect their immune system, making them more susceptible

to disease.

Much more recently, controversial work has suggested that mothers with high levels of PCBs in their breast milk produce children with slightly lowered intelligence. It is far from clear how seriously to take these sorts of findings (see the Camelford incident, Chapter 5).[36] Even if they are substantiated, they get us nowhere. The world accepts that PCBs are to be treated as very serious human toxins even if they are not. Proving that they are mildly or even very toxic would not change our behaviour toward them. It is already very cautious.

PCBs were, then, clearly problematic. Luckily, they mostly came from one manufacturer. Immediately the problem was identified, this firm, the chemical giant Monsanto, first restricted the sale of the product to uses which would be less likely to cause environmental pollution and then, in 1977, withdrew PCBs from sale altogether. PCBs were still available, but were not used by respectable firms in the developed world.

This was not the end of the problem, and PCBs remain a difficult issue. There are now thousands of tonnes of the chemicals, mainly locked up in elderly electrical and hydraulic equipment, and they constitute a vast disposal task. The only known method for ridding ourselves of these highly persistent and bio-accumulative materials is high-temperature incineration. The catch is that the incineration of PCBs at anything less than very high-temperatures creates dioxins, and even high temperature incinerators can create dioxins if their exhaust gases are treated poorly.

There are great hopes that biotechnological progress will help us eliminate PCBs.[37] But in the meantime, an industry has grown up throughout the western world whose purpose is to burn these and other organochlorine wastes at temperatures of at least 1000 degrees centigrade for around three seconds. The result is ashes which are only mildly hazardous and can go to landfill, and exhaust gases which have to be scrubbed and quenched so that emissions to water treatment plants and to air are tolerable.

From the start, the incineration industry was highly controversial, particularly because it was blamed for the presence of dioxins anywhere people cared to look for them, but especially around industrial sites. Greenpeace has campaigned for the incineration industry to cease, suggesting that PCBs be safely stored until a better technology comes along. The campaigners who advocate this policy are

undeterred by the fact that one country, Canada, pursued it for a while in the mid-1980s and suffered a medium temperature, dioxin-producing, accidental fire at just one such store. Greenpeace later campaigned against the remains from that fire being brought to Britain for what the regulators and many others believed to be a better, deliberate and competent disposal: high-temperature incineration.

In spite of the widespread anxiety about them, it has never been likely that the kind of high-temperature incinerators needed for PCB disposal were a major contributor to the dioxins we find all around us. In nature, almost everything contains chlorine in one form or another, and so burning nearly anything will create dioxins. Burning wood, coal, tobacco or food will always create dioxins, and there is nothing we can do about it. The incineration of PCBs is almost certainly a much smaller dioxin-creator than the burning of other materials simply because it is done under such strict controls.[38] Very recent research strongly reiterates the industry's view that its most famous plant (Rechem's at Pontypool, south Wales), has not caused a serious problem. There are raised levels of PCB contamination very near the site; even so they are within health guidelines.[39]

Intensive monitoring of the country's newest toxic waste incinerator – Cleanaway's plant in Cheshire – reveals that all its emissions are well inside the standards set by the European Union and the United Kingdom. In the case of dioxins, its emissions run at between a tenth and a hundredth of the legal limit and are even below the 'guide' limit, which is set as a desirable, but not necessarily achievable target. At their highest, the dioxin emissions of this plant are lower than the standard which the European Union has set as the limit firms must achieve by 1997.

We cannot easily afford to burn all our waste with the kind of technology which is used for PCB-contaminated materials. For instance, the plastic PVC is made in huge quantities, and absorbs about a third of all chlorine supplies. For all that it is longlasting in the slight majority of its uses, in others – packaging for instance – getting on for half of it is in use for a rather short amount of time before it must be scrapped. Because it is so inert, PVC is safe enough in landfill, though it takes up space. But it is a very controversial material when it is part of municipal rubbish going for low temperature incineration. The difficulty here is that there is a wide range of chlorine-bearing materials present in ordinary waste, and

they all have the potential to produce very small quantities of dioxins when burnt.

While some campaigners see this as an argument for banning PVC, one might just as well see it is a part of an argument for maintaining or introducing tight controls on the incineration of municipal waste. Indeed, according to the bulletin which most consistently reports this debate, the operator of one municipal waste plant in the United States noted that its exhaust gases were considerably more contaminated when it burnt coal than when it burnt PVC-bearing municipal waste.[40] It has also been noted quite often that increasing or reducing the percentage of PVC in municipal incinerators has remarkably little effect on their production of dioxins.[41]

Even if PVC were banned, good burning and exhaust-cleaning technology at municipal waste incineration plants would still be needed. Without such technology the plant would be dangerous irrespective of PVC content.

The nature of organochlorines

A pesticide containing organochlorines (in other words an organic pesticide containing chlorine) can be designed to hang around in the environment doing its work for a long time. In this sense organochlorines can be designed to combine two properties which seldom co-exist. They can be highly biologically active in a very selective way, but also in various degrees immune to biological degradation. Some organochlorines can be designed to kill a very limited range of organisms (highly desirable in some pesticide applications) while they will stay around and go on doing their killing for a very long time (also highly desirable in some applications). It is important to remember that just because organochlorines can be designed for longevity, that does not mean most are. The general trend in pesticides, for instance, is towards quick biodegradability.

Greenpeace say organochlorines represent 'a burden of toxic persistent chemicals of a type and on a scale that natural systems have never encountered before'.[42] They are also numerous and unnatural, and most

are toxic, persistent and tend to bio-accumulate in the environment. Around 11,000 organochlorines have been identified. Very few of these occur naturally. Production now exceeds 40 million tonnes per year. Inevitably, then, the release of organochlorines into the environ-

ment is also growing. Most organochlorines are extremely stable. As a
result they persist in the environment for a very long time – some for
hundreds of years or more. Organochlorines bio-accumulate because
they dissolve in fat and so build up in the fatty tissues of living things.
Organochlorines are highly toxic: because they are largely foreign to
nature, most living things have not developed any specific means to
break them down and get rid of them. They act in several ways to
interfere with some of the most fundamental biological processes.
They can cause reproductive failure and infertility in females; impair
the development of offspring; lead to feminisation and
demasculinisation of males; disrupt the immune system, leaving
organisms more susceptible to disease and infection; contribute to the
development of cancer; and damage the nervous system, liver, kidneys
and other organs.[43]

Not a bad litany of disaster, and it is echoed by the views of bodies
such as the Women's Environmental Network. We have already seen
some of the evidence for some of these claims. But we ought to
unpick some more of this view. Here are a series of statements from
Ian Campbell, an environmental scientist employed by ICI, who has
kept an eye on Greenpeace (in this case he is answering an earlier
Greenpeace document, but the points remain relevant):

Chlorine compounds are not unusual in resisting biological
breakdown. Wood lignin, for example, is very resistant to
degradation. Inorganic chlorines are not unusual in being fat-soluble.
The essential vitamins A and D congregate in the body fat. This does
not, however, condemn them as inherently harmful. [A 100 year
degradation in organochlorine compounds] is quite the exception. In
any case many quite natural substances have even longer lifetimes, for
example amber. Some halogenated[44] compounds are indeed not very
biodegradable, but they represent only a small fraction of the total of
all chlorinated compounds used, and are nowadays under strict con-
trol anyway. Similarly, some hydrocarbons like benzene are now
regarded as carcinogens and are strictly controlled, but that does not
stop us all filling our cars with petrol, which contains a great many
closely related hydrocarbons. I entirely agree that the level of dioxins
in human mother's milk gives cause for grave concern, but those
dioxins did not originate entirely or even mainly from industrially
manufactured chlorine compounds. They came from the chloride in
coal that was burnt in all manner of fuel situations or from the
chloride naturally present in refuse that was incinerated and will
continue to do so for as long as coal is used or refuse is incinerated in
old-style garbage incinerators.[45]

The fact is that nature makes organochlorines, including dioxins, as part of its ordinary processes. It often does so starting not with chlorine – which is so reactive that it rarely stays around for long in nature – but from chlorides, the same starting point that human beings use to get to chlorine and chlorinated carbons. It makes them from salt, usually from the sea.[46] It finds the same uses for organochlorines as do humans. Creatures in nature are armoured against other creatures, often by the use of toxins which they unconsciously manufacture, and also by the use of self-manufactured bleaches.

Saul Neidleman describes the position of chlorinated substances in nature in the following terms:

> Nature is very aware of the value of chlorinated compounds, goes to great lengths to make them and has, in addition, developed techniques for eliminating such compounds from the ecosystem. Without chlorinated compounds [and/or other halogenated compounds] all of which are made by nature, it is probably safe to say we would not exist, and what I mean by that is: we have enzymes that can chlorinate [and variously halogenate]. We, as part of our defence mechanism, make active chlorine derivatives which then, in a sense, go out and chlorinate, or bleach if you will, the invaders – the invaders being bacteria, fungi, viruses. So we do have, intrinsic to our biochemistry, the ability to chlorinate. The fact of the matter is that, like with anything else, the persistence of chlorinated compounds varies tremendously. There are some [chlorinated compounds] that are very quickly eliminated by natural systems. Nature makes many more tonnes per year of halogenated compounds than industry and the fact of the matter is, we are not buried in chlorinated compounds made by natural systems because they recycle.[47]

We have seen that some, not all, organochlorines are biologically extremely active and environmentally persistent. But why they should be so can only be seriously discussed on a case by case basis, chemical by chemical. However, there is a way of seeing biological processes – a model – which is of general use. We can see the body as composed of building blocks, not static of course, but highly animate. These blocks – cells – are built by chemical bonds between molecules. It happens that the chlorine atoms in some molecules often make extremely good intermolecular chemical hooks. But molecules fit together within cells with greater or lesser snugness and with more or fewer points of contact. It appears to be the genius of

some chlorinated molecular compounds that the array of chlorine atoms they sport make them very snug fits as well as efficient at hanging on to certain important biological sites, known as Ah receptors, heavily implicated in some cancer formation. Additionally, an otherwise neutral chlorine atom may block the site of normal biological degradation – much as the visor of a fencer defends the combatant's face.

Bodies are also brilliantly designed to recognise different compounds as useful or not. This idea fits with a way of describing the life of cells which sees them as engaged in a game of espionage and counter-espionage. Our bodies are constantly being invaded by agents – viruses, bacteria, nutrients, poisons – and it is the job of our cells to discern friends from enemies, welcoming some and mobilising against others, and sometimes turning potential enemies into friends. The HIV virus, for instance, is so dangerous because it is recognised as a 'friend' by the DNA in cells. Ensconced in the cells, it then leads to the attrition of the counter-espionage cells, and thus knocks out people's immune system and makes them vulnerable to a wide range of illnesses which normal cells fight perfectly well or adequately.

The metabolic processes of plants and animals, including of course human beings, can mobilise against many chlorinated compounds. In some cases, nature hydroxylates the chlorinated molecule, and so makes it soluble and excretable. But in cases where there are many chlorine atoms in particular sites around the molecule, all the favourite sites for metabolic hydroxylation are blocked, while at the same time the arrangement of chlorine atoms makes the molecule a perfect fit for the Ah receptors.

The weird names of these invasive, clingy and potentially cancer-forming compounds – those such as dioxin 2,3,7,8 – are determined according to the positions of chlorine atoms around the complex chlorocarbon molecule. Too many chlorine atoms make some molecules too large to be a good fit with host cells; too few make them a poor fit. But if the arrangement is just right, then they can fit very snugly and securely in cells.

There are markedly different responses to chemicals between species. As we have seen, the guinea pig's metabolism cannot cope with even small doses of dioxins, but a rat's and a man's can stand much bigger ones. This example of extreme variation in sensitivity can be repeated for any chemical one chooses to mention, and varies

surprisingly between families or races within the same species, let alone between species. One has only to consider allergies within humans to see this.

Modern science is always trying to find ways of predicting better which substances will have what effects on which humans. We want to be able to generalise and particularise. We want, for instance, to be able to say what sort of diet is good for any human, and we want to be able to tell each individual which variant of that diet would be right for him or her. The enterprise is fiendishly difficult because the underlying mechanisms are so complex and new to our understanding. On the one hand, we have grown to an understanding that smoking is an enormously important killer, and dwarfs all other avoidable cancer-causations.[48] On the other, we know surprisingly little about why one person gets cancer from smoking and another does not.

In the case of cancer, we know that we can quite easily demonstrate which substances will have a generalised ability to cause cancerous cell transformations by interfering with DNA. The Ames test uses bacteria to predict which substances can be described as being in principle cancerous to all complex life-forms. If a substance disrupts the DNA in bacteria, it should disrupt the DNA in anything else.

Unfortunately, at least from the point of view of neat prediction, we find that things are not quite so simple. Some substances do damage to DNA in bacteria, but not in mammals. Conversely, many substances which do not damage DNA at low doses, will, at a high enough dose, cause cancers within some parts of entire metabolisms. This effect often arises because the substance does such severe toxic damage to an organ that the massive cell-creation required to do repair work creates a higher likelihood of the formation of cancerous cells. The substance does not cause damage to normal cells, but can – at high doses – do sufficient non-cancer-forming damage to provoke what becomes a cancerous response.

So we build up a tentative picture of some chlorinated carbon molecules as highly capable operators in some metabolisms, often highly useful and very much part of the body's natural workings. Others are equally effective for harm. And we also see that some organochlorines might be highly cancerous in some species and not in others. Some might be cancerous in some species at high doses, but not at lower doses.

But we can find few general rules. The cells of this or that species may not be damaged by this or that organochlorine. Another species might well be. Their reactions would be predictable if we knew more. This is not a tautology, since some things in life are – finally – unpredictable, even with a lot of knowledge. But the behaviour of organochlorines is not arbitrary. We are not dealing with chemicals or processes which are whimsical, but they are subtle. The effort now being put into understanding the workings of organochlorines will almost certainly yield such increased knowledge about them that we can decide far more rationally how much of a risk they pose.

Public attention has focused on the carcinogenicity of certain organochlorines. The more we learn about cancer and organochlorines, and find it largely reassuring, the more campaigners are keen to switch to various other effects in humans which have been alleged or which might be extrapolated from known effects in wildlife. These effects are alleged to include birth defects in children and various other reproductive problems, especially to do with feminisation of males. Following up these lines reveals that there is hot dispute about their significance, and that – especially in the United States – there is a considerable effort to study their seriousness.

The new evidence led William Reilly, Environmental Protection Agency (EPA) administrator under George Bush, to put a vast new review of the regulatory position into effect. As a result there has been an unprecedented trawl of evidence, some new research, and a good deal of testing of public opinion as well.[49] *Chemical and Engineering News*, a respected popular chemicals industry magazine, cites Ellen Silbergeld, adjunct Professor of Toxicology at the University of Maryland, and Linda Birnbaum, director of the environmental toxicology division of the US Environmental Protection Agency Health Effects Research Laboratory in North Carolina, as believing that the huge review will probably not reveal a need to change the permitted exposure levels a great deal.[50]

The US EPA will probably have published its final account of its review of dioxins and dioxin-like chemicals by the time this book is published. In the meantime, we can say that we are manifestly not dealing with substances which are doing us immense harm, since we have a fair idea of human lifespans and lifestyles from the pre-industrial era and can be pretty sure that we enjoy a health status unparalleled in human history in spite of the comparatively recent

invasion of our bodies by synthetic organochlorines. We also know we are taking precautions to cease manufacture and eliminate sources of those organochlorines which we know damage species of animals which, unlike us, have bio-accumulated high doses of dioxins and other worrying organochlorines from particularly contaminated parts of the ecosystem.

So should we ban chlorine production?

We have looked at the range of chlorinated substances which are toxic in various organisms. Do they deserve to be condemned to history's final waste disposal system, as Greenpeace and some other campaigners demand?

In Monaco, Greenpeace campaigners were keen to assert that bodies such as the Oslo and Paris Commissions (inter-governmental marine pollution control treaties and secretariats) embraced their cause. It is indeed true that the Commissions had recently proposed a reduction in emissions of

> substances which are toxic, persistent and liable to bio-accumulate, in particular organohalogen substances [which include organochlorines] . . . to levels which are not harmful to man or nature with the aim of their elimination . . . and where appropriate, to supplement reduction measures with programmes to phase out the use of such substances.[51]

This is strong stuff, and indicative of a not very stringent view of getting the best ecological return for our environmental buck. Why aim at eliminating substances rather than reducing them below their ability to do harm? In any case, the Commissions' statement does not take us much further toward Greenpeace's argument for a complete ban on chlorine chemistry. Even where the Commissions are asking for elimination of production (rather than concomitant emission to the environment), the words, 'where appropriate' leave plenty of room for manoeuvre. Greenpeace missed out the 'where appropriate' when it used the statement as a stick with which to beat the government.[52]

The Commissions' position is a little too *dirigiste*, but remains within the order of thinking common to modern regulators. It is far more rational than Greenpeace's. We can easily agree with the official regulators that contamination of the environment which

damages wildlife is bad in its own right, and also bad because it risks damaging human beings. We need to protect ourselves against dangerous products and processes. But we need to do so substance by substance and chemical by chemical, and because of and in proportion to their potential for harm.

At the same time, we want the freedom to buy what we need or want, unless a good case is put up against our purchases. Of course industry will press hard that its past and present practices were and are respectable, and it will want to protect its present investment and markets and profits against campaigns by Greenpeace and others. Industry sometimes says and does foolish things. But we need not accept Greenpeace's black-and-white, oppositional, confrontational worldview, any more than we kowtow to industry when its needs do not reflect wider interests.

There is a balance which accepts that there are valuable materials which have difficult properties. A person with a heart condition will risk taking chemicals which have quite severe side-effects and which a person in good health would not need to consider. A person with a stained suit will accept that dry cleaning fluid ought to be made, though its manufacture and use are certainly tricky. But we are all becoming more environmentally sensitive, and we are asking ourselves tougher questions about how far to push nature as we pursue relief from heart conditions and dirty clothes.

In the words of H. A. J. Govers, of the Department of Environmental and Toxicological Chemistry of Amsterdam University, at the 'Chlorine in Perspective' conference:

> There is a general scientific explanation for the problems caused by chlorinated compounds. The use of many of these compounds is based on properties like dissolving or solubility in fatty substances (solvents), thermal and chemical stability (uninflammable hydraulic fluids, plastics) and the potential to kill unwanted organisms (disinfectants, pesticides). Simultaneously these properties cause them to be hazardous. Stability leads to persistence in nature and difficult waste treatment, solubility in fat to accumulation in food chains, breast milk included, and killing potential for unwanted organisms to the death of desired organisms.

We should ban those chemicals whose matching disadvantages clearly outweigh their benefits. That is what has happened with some of the organochlorines. A discussion of the merits of banning the

remaining organochlorines would require a comparison with the merits and demerits of the products we would use in place of those proposed for ban. Here is a brief attempt at discussing some of the balances involved.

Making the chemical

Production of chlorine is not a particularly polluting business. It is one of the more elegant chemical processes. In the past it has released substantial quantities of inorganic mercury. This is not the organic mercury which was such a blight at Minimata, Japan, though some of the chlorine industry's mercury will have become organic mercury in the environment. However, mercury emissions are now very small and as new plants come on stream, could be eliminated altogether.

The main direct emission of the industry is fugitive organochlorine substances to the air. Some of these are ozone-depleters and all contribute somewhat to photochemical smog (see Chapter 4). The standards for these volatile organic compounds are constantly being screwed down and at some point they will probably become insignificant.

The main indirect environmental problem with chlorine production is that it consumes prodigious quantities of energy which it usually buys from the national electricity grid: energy comparisons between the use of chlorine-derived products and their competitors will often be the key to the ecological balance between them.

Water treatment

Chlorine's most famous and obviously defensible use is for disinfecting drinking and other water supplies. This constitutes only a small proportion of total chlorine manufacture but has been one of the major benefits of the chemical industry. An epidemic of cholera in Peru and neighbouring countries followed abandonment of chlorination. The epidemic claimed 3500 lives in the first year of the outbreak alone.[53] The outbreak is believed to have occurred when water authorities stopped treating water on account of a misreading of an advisory note from the US Environmental Protection Agency which referred to cancer-inducing organic by-products of chlorine's reaction with organic material in water.

The relevant committee of the World Health Organisation, in the update of its internationally-trusted *Guidelines for Drinking Water Quality*, will almost certainly insist that the risks of chlorination

should not to be allowed to outweigh the benefits of its use and describes them as 'extremely small in comparison with the risks of inadequate disinfection'.[54]

There are alternatives to chlorination for drinking water. But they do not do the same plant-to-tap cleaning job and come with their own disadvantages. A judgement between chlorine and other methods would probably come down in favour of chlorine, and in any case reaffirm its great value to people. Its cheapness may well make it a firm and desirable favourite in the Third World even if the rich world could afford to satisfy its anti-chlorine feelings and use alternatives.

Almost all of us use chlorine-based bleaches around the home. The overwhelming majority of modern households discharge their waste water to sewer and thence to water treatment works. Sewage plants face various difficulties, but chlorinated waste water is not one of them. For people with private cesspits, there might be a case for alternative, non-chlorinated oxidants for hygiene purposes, but one doubts people would gain more by switching to weaker non-chlorinated bleaches than by reducing the doses of chlorine bleach to the minimum. Besides, non-chlorine based bleaches actually involve a greater, not a lessened, production of chlorine overall.[55]

Pharmaceuticals

Chlorine appears as a component in antibiotics and other medicines. It might well be possible to invent or discover drugs that would do the same job as chlorine-based substances. But the manufacture of the chlorine-based drugs is tightly controlled, and it is likely to be no more damaging than the manufacture of any replacment drugs. We would need an idea of the possible problems from the manufacture and use of alternatives before we could make up our minds about them. In some cases, by the way, the chlorine in pharmaceuticals occurs because it is put there by the organisms which make the substances and not by human chemists. The chemist merely cultures the organisms.[56]

Greens often say that complementary or preventative medicine would do away with the need for many chemotherapies. This is of course fine and good. We will be seeing within the next twenty years or so just how much difference to their health a generation of herbally-minded, keep-fit orientated people can make. It will be quite a surprise if their demands on the drugs industry are substan-

tially reduced. If their strategy gives them prolonged life, they might replace the heart drugs of the present middle-aged with those required for geriatric wellbeing. Even if their drug consumption was reduced marginally, the world as a whole still needs to expand its drugs industry, granted the expanding population, and that will leave open for continued discussion the comparative advantages of chlorinated and non-chlorinated drugs.

PVC (polyvinyl chloride)

This plastic – made by a reaction between salt-based chlorine and oil-based ethylene – has many merits as a material: cheapness, toughness, durability, flexibility, inertness, mouldability, relative non-flammability, lightness, excellent barrier properties (useful for hygienic uses). It now consumes about 35 per cent of European chlorine production, and poses a known and solvable problem in final disposal, as we have discussed. (Previous major workplace health issues – vinyl chloride caused cancer in workers – have been resolved.) Alternatives to the material are almost certainly possible to find or develop, but in each case would have to promote and defend themselves on the basis of an environmental case. For instance, the value of PVC in cheaply bringing clean water to the Third World is surely great. In matters like that, discussion of alternatives would have to be very serious.

Oddly, a major perceived problem is that PVC makes dioxins if burnt at medium temperatures (though it readily yields most of the thermal value of its original constituents, and so is quite a good fuel). Some campaigners have characterised it as a hazard in buildings. However, we can also celebrate the material for the usefulness of its fire-retardant properties in reducing electrical fires. The Paris Commission in January 1994 established a programme to investigate the best available technologies for producing PVC.

Pesticides

Agrochemicals are now heavily regulated and users in the west make their pest control choices within a regulatory framework which preserves something like a fair balance between a chemical's effectiveness in food production and its environmental or health disadvantages. Pesticide prices will probably continue to rise as increasingly strict regulations control the manufacture of the chemicals, and perhaps greater taxes are raised on them to encourage

lessened use.

Pesticides have been controlled chemical by chemical and without a bias against any particular family of chemicals. Thus we now have organochlorines and organophosphates and many other chemicals on the market. There is a good deal of feeling about the merits of using the amount of pesticides modern farmers find profitable, of whatever sort, especially because of the damage they do to the insect life birds depend on. One might make a case for a general reduction and greater care in their use. This does not imply, however, that we should be taking an especially dim view of any particular group of pesticides without a proper environmental assessment.

Solvents

Organochlorine solvents are used for cleaning and for giving paints drying qualities, and are under intense scrutiny by regulators as much because of the role of some of them in stratospheric ozone depletion as the risk they pose to health. Solvents work because of their evaporative qualities. Their usefulness is that, released from containment, they quickly escape from liquids (glues, paints, varnishes etc) and into the atmosphere, leaving a dry, tough material behind them. Being soluble in fat, they also have the power to shift grease and oil from microchips, metal components and clothes. Their continued use is going to be made more justifiable when, as often as possible, they are recaptured after use, and this is beginning to happen. It may be that this approach will be more acceptable than abandoning them altogether. In many cases recapture is impossible (in household paints, for instance). Paint firms are exploring alternatives to solvent use. Some people in the industry expect that solvent-based paints will not have a long future. Some alternatives – mostly hydrocarbons – are more flammable, or involve a loss in energy-efficiency.[57]

Paper bleaching

The world's paper and pulp industry came under intense attack for its use of chlorine-based bleaches. The industry certainly was releasing dioxins, in rather small amounts, into their waste streams and in tiny quantities into products such as paper and board, but also nappies and tampons. There was little doubt that the level of dioxins coming into contact with consumers by this route was negligibly small, but for a while it was an important issue in consumers' minds.

The industry responded by improved effluent treatment which did not require a switch from chlorine-based bleaches, and by a partial switch from chlorine altogether. The issue is firmly on the regulatory agenda now, and there is even less room for anxiety.

What are the messages which come from these sketches? Most important is that each of the present uses of chlorine or chlorine-based chemicals brings its own distinct difficulties, just as it brings its distinct benefits. The pluses and minuses can be considered piecemeal. The disdvantages can be tackled by sensible regulation of the chlorinated substances themselves, a process which will (for good and ill) often lead to substitution by less tightly controlled non-chlorinated substances.

The attempt to lump all the chlorine family together, as well as being scientifically spurious, is practically redundant, however much it charms the campaigners. All molecules which combine chlorine with carbon are in Greenpeace's sights. But substances which contain carbon and hydrogen; substances which contain hydrogen, carbon and nitrogen; and others which contain carbon, hydrogen and oxygen, are all proven human carcinogens without provoking an outcry against carbon, hydrogen, nitrogen and oxygen.[58]

The desire to make large and simple statements ignores the way and the degree to which the modern world is regulated. There are now virtually no points at which industry or consumers can dispose of waste, either of manufacture or consumption, without a regulator assessing its impact pretty thoroughly.

The crucial issue here is not whether one can trust industry to handle its processes and waste properly, or whether individual members of the public can ever learn enough about the technologies involved to form their own judgements. The most serious problem is whether the public can learn to place trust in the regulators. In time, we may come to trust that the regulators in the United States, the European Community and in individual countries are getting very tough and more or less setting worldwide standards. We may come to accept that the regulators properly frame requirements to reduce wastes, and then ensure that wastes all go to their most appropriate destination.

We are beginning to see these proper balances being struck, and indeed there is a case to be made that some industries are set unnecessarily strict standards. The high-temperature incineration

industry, in common with others working in difficult areas, does not, on the whole, make that case. It is a high-cost, high-investment, high-profit industry and survives only because strict regulation is forcing more companies to send more of their wastes to this very expensive disposal option.

The result of the modern regulatory approach is that what works is allowed and what does not is shut down. The upshot, in our case, may be a healthy chlorine industry, with its many products intact; or it may be a limited industry because so many of its products are legislated out of existence. It might not matter much if the end result is that there is no chlorine industry at all. We could certainly get along without a chlorine industry.

Of course Greenpeace may be proved to have guessed properly. In purely propaganda and political terms, its battle against chlorine may prove effective. It may succeed in sunsetting the industry. It might even turn out to have guessed right in its reading of many of the environmental issues surrounding chlorine. It may turn out that the sum total of the balances in favour and against all the alternatives to chlorine is favourable to the banning of most or all chlorine products. But none of that, which may or may not prove to be true, justifies Greenpeace in not properly weighing up all the evidence in arguing its case.

Society should not celebrate failures of reason, or victories for hysteria, or using false anxieties even in virtuous causes. We need to arrive at sound industrial processes by sound discussion and judgement, and by the steady accumulation of decent evidence. It is disturbing the way so many people follow some campaigners in thinking that exaggeration and wishful thinking are necessary substitutes for reasonableness.

Notes

1 Johnston, Paul, and McCrea, I., (eds), *Death in Small Doses*, (Amsterdam: Greenpeace International, Sept 1992). Greenpeace International, Keizersgracht 176, 1016 DW Amsterdam, Netherlands.

2 Finaldi, L., *Chlorine, an industry with no future* (Amsterdam: Greenpeace International, Sept 1992).

3 'Chlorine in the dock', ENDS no. 229, February 1994 pp. 15–7.

4 Halton Borough Council, 'Industries of Runcorn 1800–1850'. Available from Catalyst: The Museum of Chemical Industry, Mersey Road, Widnes, Cheshire WA8 0DF.

5 Halton Borough Council, 'Early chemical trades: Pre-scientific chemical industry' (Widnes: Catalyst Museum).

6 Halton Borough Council, 'Alkali firms in Widnes and Runcorn', (Widnes: Catalyst Museum).

7 'Aspects of the chemical industry, Sources on the chemical industry in Cheshire' (Widnes: Catalyst Museum).

8 *Ibid.*

9 *Ibid.*

10 Buxton, N. and Aldcroft, D., (eds), *British Industry Between The Wars* (London: Scolar Press, 1979).

11 Dr Dieter Becher, Member of the Board of Management, Bayer AG, Germany, in a paper given at the Chlor-Alkali Symposium, Monaco, 1992.

12 Halton Borough Council, 'Castner-Kellner and the electrolysis of brine' (Widnes: Catalyst Museum).

13 Marshall, V. C., *Major Chemical Hazards* (Chester: Ellis Horwood, 1987). This section is based almost entirely on Marshall's account because I have never found him contradicted by other commentators and because his work is densely sourced. Dr Marshall was a chemical engineer and a member of the Major Hazards Advisory Committee of the Health and Safety Commission and was a senior lecturer in Chemical Engineering at the University of Bradford.

14 *Major Chemical Hazards*, pp. 6, 7.

15 *Ibid.* p. 327.

16 Kharbanda, O. P., and Stallworthy, E. A., *Saftey in the Chemical Industry, Lessons from Major Disasters*, (London: Heinemann, 1988).

17 Marshall, 'Major chemical hazards', p. 346.

18 Hansen, D., 'Dioxin toxicity: new studies prompt debate, regulatory action', *Chemical and Engineering News*, August 12 1991.

19 'World highest dioxin levels found downstream of coalite site', ENDS, April 1994.

20 North, R., *Country Life*, October 29 1992; and *ENDS*, Oct 1992.

21 *Major Chemical Hazards*, p. 365.

22 *Ibid.* pp. 365–6.

23 *Ibid.* pp. 364–5.

24 Johnston, Paul and McCrea, I. (eds), *Death in Small Doses* (Amsterdam: Greenpeace International, 1992).

25 Pollitt, F., 'An overview of the health effects of dioxins, furans and PCBS', paper given at Dioxins, PCBs and Furans seminar, Industry and Environment Associates, London, September 1991.

26 *Ibid.*

27 *Ibid.*

28 'Dioxins in food' Ministry of Agriculture, Fisheries and Food (MAFF), Surveillance Paper no. 31, (London: HMSO 1992).

29 *ENDS* no. 205, February 1992.

30 *Food Safety Directorate Bulletin* 23 (London: HMSO, February 1992).

31 Johnston, Paul and McCrea, J. (eds), *Death in Small Doses* (Amsterdam: Greenpeace International, 1992).

32 Moore, N., *The Bird of Time* (Cambridge: Cambridge University Press, 1987) p. 151.

33 *Ibid.* p. 158.

34 The BMA Professional, Scientific and International Affairs Division, *Pesticides, Chemicals and Health* (London: Edward Arnold, 1992).

35 Moore, N., *The Bird of Time* p. 195.

36 Interdepartmental Working Group, 'Dioxins in the environment', Pollution Paper no. 27, (London: HMSO, 1989).

37 Snyder, J., 'Bacteria chow down to clean up the environment', *Smithsonian*, April 1993.

38 Interdepartmental Working Group, 'Dioxins in the environment', Pollution Paper no. 27 (London: HMSO, 1989).

39 Welsh Office, 'Panteg monitoring project', 22 April 1993.

40 *Warmer Bulletin* no. 25, p. 18. (83 Mountain Ephraim, Tunbridge Wells, Kent, TN4 8BS).

41 Totsch, W. and Gaensslen, H., *Polyvinylchloride* (originally published by Elsevier Applied Science, 1992; now available from Chapman and Hall, London).

42 Johnson and McCrea, *Death in Small Doses* (Amsterdam: Greenpeace International, 1992).

43 *Ibid.*

44 Halogenated substances are molecules which include fluorine, chlorine, bromine, or iodine.

45 Cambell, I., comments on 'The Product is the Poison', Chlorine Information Service, ICI Runcorn, Oct 1991. ICI Chlor-Chemicals, Communications Manager, PO Box 14, The Heath, Runcorn, Cheshire, WA7 7QG).

46 Rappe, C. (ed.), *Chlorine, Element of Surprise*, ICI Runcorn.

47 Heidleman, S. in C. Rappe (ed.), *Chlorine, Element of Surprise*.

48 Peto, R. *et al.*, 'Mortality from tobacco in developed countries: indirect estimation from national vital statistics', *Lancet*, vol. 339, 23 May 1992.

49 Bretthauer, E., Office of Research and Development, EPA, 'The US Environmental Protection Agency's reassessment of chlorinated dioxins and related chemicals', paper given at Chlorine in Perspective, Monte Carlo, October 1992.

50 Hansen, D., 'Dioxin toxicity: new studies prompt debate, regulatory action', *Chemical and Engineering News*, August 12 1991.

51 'Final Declaration of the Ministerial Meeting of the Oslo and Paris Commissions', Paris, 21-22 September 1992.

52 Greenpeace press release, 30 April 1993.

53 *Nature*, vol. 354, 28 October 1991, p. 255.

54 Galal-Gorchev, H., 'Chlorination and water disinfection', a report on the Washington Conference on the Safety of Water Disinfection: Balancing Chemical and Microbial Risks, given at Chlorine in Perspective, Monte Carlo, October 1992.

55 Rappe, C. (ed.), *Chlorine, Element of Surprise*.

56 Campbell, I., personal communication, ICI, Spring 1993.

57 Wolf, Yazdani and Yates, 'Chlorinated solvents: will the alternatives be safer?', Air and Waste Management Association, USA, August 1991/CIS/ICI; Heathcote, M., 'Chlorosolvents under pressure' *European Chemical News/Chemscope, Environment Review*, July 1992, p. 33.

58 Campbell, I., personal communication, ICI, Spring 1993.

8

Oh for the simple life: right living, right technology

There was a time when those of us who cared thought we knew how to be green. The message which we believed and propagated was: simplify, get back to basics, make-do-and-mend. It was really a hippie message, and a Luddite one. It underpinned much of the desire for a self-sufficient lifestyle which was so much promulgated twenty years ago. Now, being green is not quite so simple. Many of the favoured solutions of the past, most of them vigorously touted by environmentalists at different times, turn out to be less efficient or attractive than was once thought. Some of them, as we saw with windfarms, make conservationists fall out with environmentalists.

This chapter looks at two obviously worthy green buzz-words and shows how they conceal dilemmas: recycling, and the green consumer. The final section looks at some myths surrounding our health and at some reasons to be very glad we are modern.

How shall recycling make a comeback?

An enormous proportion of what we throw away goes to landfill, and about 6 per cent goes to incineration, of which half brings with it the reclamation of energy. The government intends that we reduce the amount of household waste going to landfill by a quarter by the year 2000. Ministers want it recycled instead. The target will be difficult to achieve and still leaves a lot to be landfilled or burned. There always will be. Luckily, according to most people knowledgeable in the field, the dependence on holes in the ground does not matter in the United Kingdom in quite the way it might in western Germany or the Netherlands. The UK has big quarries, and is begin-

ning to regulate landfill sites well enough to be tolerably content that they will not in future pose the sorts of problems of leakage which have historically plagued dump-sites. However, many in the landfill industry are concerned that the modern, highly contained landfill (while it provides solutions to the old problems) is tending to make landfills too sterile. This argument suggests that landfills are now so sealed up that the rubbish in them will not be allowed to decay as it should. The difficulty is that to go down the alternative route, and encourage decay, would produce methane, a greenhouse gas. The regulators and industry are a long way from being certain that more active landfills can be both safe and economic producers of this gas, but are also aware that if the gas is not trapped and used, it is a factor in climate change we can do without. It is this sort of problem which inclined the Royal Commission on Environmental Pollution to look favourably on the incineration of wastes (see below).

We have the recycling target, which few dispute is worthwhile. Equally, no one yet knows how to devise a strategy to fulfil it. There are strong suspicions that countries which do set very high recycling rates – as Germany has – will have to use a lot of energy, resources and money in what will partly be gesture policies. There is already a good deal of anger that tough standards have led to a surfeit of used materials from Germany looking for dump-sites in the rest of Europe and beyond.

One way into the recycling problem is to ask if some materials are inherently bad. No clarity here. Different materials present differing advantages in use, and different recycling possibilities after it. Each supplier of a material, especially those used in packaging, can legitimately claim environmental efficiency over the others provided the circumstances are right.

For instance, aluminium is a high-value product, because it takes a lot of energy to make it. But it can be recycled with a very small proportion of its original energy-take: a mere 5 per cent of the original. Compared to aluminium cans, steel cans are much cheaper to make because little energy is required. But steel cans are less efficient in recycling. Still, steel cans can be recycled in a melting process which uses only 25 per cent of what was required to make the virgin product. Moreover, magnets can and do cheaply pick out steel cans from mixed waste streams at some municipal plants, which puts them, potentially, amongst the easiest products to recycle. But, said Jeff Cooper, the waste minimisation officer with the London Waste

Regulatory Authority: 'The way we've been designing waste facil-
ities for years now, there simply isn't the room for the kind of
conveyor-belt systems you need for magnetic extraction.' If we want
that option, big investments will be required.

It is very unclear what form of can we should concentrate on (the
same sorts of problem apply to other packages, as we shall see). It's
no clearer what system is in general best for handling our household
waste. One option is for householders to separate wastes into
various different types before the binmen come. This is especially
likely to be useful in the cases of paper, plastics, and even steel, all of
which can be recycled more easily if they are clean. This approach
might also help with combustible or compostable materials.

But the systems required to pick up separated materials all depend
on expensive new ways of working refuse lorries and sorting waste.
One, tried in parts of Sheffield, in Milton Keynes and a seaside
district in Sussex, is the 'Blue Box' system, based on North American
practice. Householders separate some of their rubbish, and a binman
then further separates it into containers on a special lorry at the
curbside. 'This system is totally absurd, it just does not stack up,'
says Jeff Cooper. He believes the economics and ecology of the thing
are simply not efficient, not least because it involves a completely
separate, extra, collection round.

Another system is being tested: the 'split bin' (householders
separate all their waste into two bins, each divided into two), in
which only one lorry is needed. But this entails messy later separation
work at a central depot. Cooper wonders if this is healthy work, and
whether people can be found to do it on a large scale. All the same, he
and others believe it may well be the route to follow, in some places,
and that the central handling might eventually be done by machines.
Worldwide, there are plenty of experiments in mechanised waste
handling, but in Britain, shortage of funds has stopped a good deal of
research.

If it is too expensive to collect separated waste from householders,
why not play on the fact that many people will take their wastes to
reclamation banks of various kinds? These banks are often sited at
supermarkets, which people drive to anyway. There is evidence that
they might work well if intensively sited in some suburbs and vil-
lages. But the system is voluntary and there is a general feeling that
too few people would make the extra effort to produce really high
return rates.

Even if they did, would the result be a real ecological saving? One analysis of the steel industry's Save-a-Can scheme suggested that it costs British Steel at least twice as much in transport and capital costs to get a tonne of London's cans to its recycling plants as they were worth in scrap terms. Until we get real environmental assessments of these schemes, we will not know the degree to which we and industry are indulging in feel-good gestures.

There is some evidence that the ecological benefits of 'bring' systems are at best marginal. At the moment, the public helps the glass industry recycle a good many of its bottles in bottle banks. The scheme is self-financing because remelting glass saves the glass industry enough to merit its paying £30 a tonne for the broken glass local authorities deliver to it. But Ian Boustead, an energy expert who has pioneered research in this area, suggested in 1992: 'The energy savings are never going to be handsome: yes, you save a quarter or a third of the energy needed to make the glass, but you have to set transport costs against this.' And it is at the consumer end of the process that things can go wrong. 'The energy saved by using a kilo of broken glass is about enough to take a car a mile and a quarter,' said Dr Boustead. In other words: one should not imagine that one is being ecologically sound if one makes even a short extra car journey to deliver glass to a bottle bank. Indeed, Boustead was keen to remind people that the tiny energy savings that can be made even with efficient recycling efforts are small compared with those that a small change in our driving habits could bring. Besides, he pointed out: how ecologically-minded are people, really? About a quarter of recyclable glass containers find their way to bottle banks. Most of us simply do not bother.

Perhaps we should be re-using bottles, in the nice old-fashioned way? Dr Boustead is very sceptical; the trouble is, refillable bottles tend to be heavier than one-trip equivalents. It will not take many people failing to return them for there to be an even greater waste than now. He pointed out that even the near-perfect case – the traditional milk bottle – is less efficient now that more people forget to return them, or do not have a milkman in the first place. However, as milkmen become self-employed entrepreneurs, we may find them offering a wider range of delivery services which could incorporate the return of containers. The Japanese, for instance, have for years returned and reused huge quantities of beer bottles under a similar system to our milk rounds.

Many people feel that a deposit system could encourage high return levels, whether for re-use of the container or recycling of its material. But North American experience shows that while these systems work well in reducing litter, they are less effective in reducing the amount of waste going to landfill. Also, they have the effect of reducing the quantity of higher value waste in the waste stream, which may reduce the profitability of centralised recycling systems. So drinks bottlers such as Coca Cola-Schweppes have a point as they campaign against the idea of compulsory deposits as a means of encouraging re-use of bottles and the return of cans. In places where central sorting gets established, we may want to encourage high-value waste to stay in the main waste-stream.

These examples make it clear that doing the ecologically-sound thing begins with jettisoning preconceptions and anecdotal prejudices. We need better evidence of what works. Recent research commissioned by the government into the economics of the various collection and recycling systems suggested that only further new evidence will allow us to decide between them.[1]

Now. What to do with household waste, once it has been collected or brought to banks? The public believes that recycling must make money because waste is turned into a new resource. In the case of most dustbin waste there is no evidence to support this view. 'The crunch is that the value of most of the recoverable waste in a dustbin is about £15 a tonne,' said John Barton, of Warren Spring, a government research laboratory, speaking at a seminar in 1991. Domestic waste had a recycled value of about £15 a tonne in 1950, when that sum of money would have employed the resources to run the sorting system which gave rise to it. The fact is, the price of raw materials has fallen dramatically compared with the costs of the energy and labour needed to recycle them. This may be a good thing because so far as we know energy-use is the one factor in our lifestyle which poses severe problems. It is good that prices are at least marginally tending to reflect the fact. In spite of our reluctance to admit it, there may well be a case for increasing the price we charge for landfill, but only if we also increase the price of energy-use.

Barton had a gloomy table of estimates which suggests that the cost of collecting and disposing of household waste to landfill will vary between a low of £30 a tonne, to a possible high of £60 a tonne. The cost of recycling will vary between, with luck, £50 a tonne and a worst case of £70 a tonne. In other words, recycling costs more than

dumping, which is bad enough. Worse, recycling often wastes energy, and may thus sometimes backfire ecologically.

Money is not everything, and may not be a good proxy for ecological costs, at least until the price we pay for things reflects their environmental cost. Yet it is surprising how little thought has gone into the following proposition. If it costs ratepayers a lot of money to get recycling done, will they do more ecological damage as they earn the money for energy-costly recycling than the recycling can help repair by saving cheap virgin resources and landfill space?

Exploring ecological costs

Measuring real ecological costs and benefits is difficult. Things are not what they seem, and seemingly obvious villains turn out to have heroic possibilities. In the United States, McDonald's have halved the packaging a customer carries away with one of their meals since the 1970s, and want to use yet less. The firm was so pressurised to reduce plastics that it investigated switching to paper for its clam-packs; the result of the investigation was odd.

Franklin Associates of Prairie Village, Kansas, is the virtual founder of a twenty-year-old discipline generally called life-cycle analysis (though not by its founders). This is used to try to tease out the ecological impacts of products on a cradle-to-grave basis. It assesses the energy and pollution involved in making, using and disposing of products. It is fiendishly complicated and yields less clear answers than everyone would like. In the case of fast food clampacks for hamburgers and pizzas, the study found that, compared with an all-paper alternative, polystyrene uses a third less energy, causes well over 40 per cent less wastes to water and air, but uses up over 40 per cent more space in landfills.[2] But there is a greater possibility of future recycling of the polystyrene, and if a third of polystyrene clampacks were recycled, the landfill they would take would equal those of paper. Game, set and match to the detested plastic option.

Enter a curious finding. By using a thin sheet of polyethelene between two paper sheets, McDonald's and Franklin found that the ecological costs could be 70–90 per cent better than the next best, all-plastic, alternative. The only difficulty, and it did not dent the overall advantage, is that no one knows how to recycle the new, mixed, packaging.

So, a point for cleverly-used plastics, in spite of the prejudice people have against them. The plastics industry is beginning to be robust in its defence of the way modern food delivery systems depend on its despised material efficiently to cut down the food and other wastes households and restaurants throw away. They point out that Mexico City's dustbins have six times the food waste of those in American cities.[3] They argue it is preferable to have food processing done in factories (where the food wastes will be utilised at an efficient, industrialised scale), than have the old mess arising from food being, say, defeathered, deboned, and degutted at home or restaurant.

Convenience has non-ecological benefits. The plastics revolution has helped free women to be waged workers, which most prefer to unrelieved housework. It is not practical in free societies to propose that on green grounds one member of a household should be devoting himself or herself to staying at home doing to food the things factories now do. And it may not make ecological sense either. Enthusiasts say that plastic wrapping ensures that the food people buy gets eaten. This line of argument suggests that it is energy and resource efficient to use a little carbon to preserve expensively-grown food. And the argument reminds one that customers would complain vociferously if microbial infection had got to their food before them because of a weak pack.

Even so, it clearly makes sense to re-use plastics if possible. But the cleverness of plastics makes many of them, much of the time, unlikely candidates for real recycling. They are often very light in the energy taken to make them, and very dirty by the time they come to be recycled. They also vary very widely in their properties, and in the technologies which might be used in their recycling. Separating dustbin plastics so that each can go to appropriate recycling may be more trouble than it is worth.

Plastics contribute about 7 per cent of the volume of landfill. They are amongst the least troublesome of materials in landfill, because they do not rot (though this virtue is turned into a sin in those few landfills which use some of the gases released by rotting to produce gas for fuel). The industry is now working out which plastics can be retrieved in usefully large, clean quantities for genuine recycling. The back doors of supermarkets are proving a rich source. Some of these schemes are commercial. Farm and other plastic wastes are being recycled into sheeting in Yorkshire, and a Midlands firm takes waste

– some of it municipal – and turns it into pipes. Both these enterprises have been threatened by the German waste dumping mentioned earlier.

In other cases, especially in Germany, industry is exploring expensive new technologies to remelt, or in other cases chemically reconstitute, a vast range of variously contaminated plastics. Few of these show signs of making useful ecological or economic contributions. But enough pressure – and the German government is applying it very hard – will find out which of the systems work. There is a strong argument, favoured by many British experts, for letting rich and conscientious Germany work through these options on our behalf. The British can cheaply learn from German mistakes.

Dr Boustead, who suggested that plastic bottles may be a sound way of delivering drinks, was sure that one route above all will be useful for disposal of plastics: 'Oh, burn them!', he says, robustly. But incineration, even with energy recovery, is very unpopular (see Chapter 7).

The plastics industry argues behind its hand that incineration will turn out to be the right thing to do with quite a lot of plastics in quite a lot of situations. Plastics are the nearest thing to pure fuel in municipal waste (they boost its burnability, which on average is about a third of an equivalent weight of coal). All the same, it will be very important not to spend more energy getting very bulky plastics to an incinerator than could be got out of them in heat. In countries such as Britain, landfilling plastic may not be the worst option.

In countries where reducing landfill matters, there are clear advantages in the way incineration reduces the volume of wastes by 70 per cent. Even the ash which remains may have more uses than we have yet found for it, say in road-making, where the toxic materials in the stuff appear to be pretty well locked out of harm's way.

The purist is bound to resist incineration. Surely it is a crying shame to burn, say, paper? People have been recycling that for years. But Mike Flood, an energy analyst, suggested that aiming at recycling all the available paper may not make best sense:

> Virgin paper comes from forests which can be managed for sustainable re-use and sometimes are. Part of the tree which doesn't make paper can be used to fuel the process which does.

Virgin paper production unlocks carbon dioxide (by cutting down trees and burning some of them) but then can lock it up again by

replanting trees. (Carbon dioxide is the gas which contributes about half the human acceleration of the greenhouse effect.) Flood goes on:

> Recycling paper in Britain, on the other hand, uses large quantities of fossil fuel which releases carbon dioxide from coal and oil on a one way trip to the atmosphere. There's a balance to be struck, and it may not be appropriate to try to recycle all the paper: maybe some of it should be used as fuel.

Part of these arguments finds reinforcement from one of the best sources available. The Royal Commission on Environmental Pollution in its seventeenth report comes to the conclusion that incineration of chemical and domestic waste can be acceptably safe, and is increasingly well-regulated. Intriguingly the Commission made a case that incineration is preferable to landfill on ecological grounds. This is specifically because it does not create methane, an important emission from landfill sites.[4]

This tendency to see incineration as relatively benign picks up credibility as we take into account the existing worldwide glut of waste paper, brought about as a result of some countries' aggressive legislation against waste. Germany's actions in insisting on the collection of waste paper has led to a huge surplus, some of which is dumped, says the waste paper industry, in Spain and Italy. One effect has been weakened prices for waste paper, in Britain to the point where shops and businesses have to pay to have their waste removed. Maybe we should be burning the stuff.

Perhaps, alternatively, we should also be encouraging – perhaps by government diktat – a market for recycled materials like paper. We had better be sure the ecological sums of the thing are right, because while government command is not always successful in bending economics, it cannot bend ecology at all.

Anyway, ideally we would be finding alternatives to burning the carbon in waste materials. This could come as part of a strategy that handled paper, cardboard and all the rotting material from a dustbin as a source of compost. In 1991 Bryn Jones, of Landbank, an environmental consultancy, prepared a report for the Gateway supermarket chain which heavily promoted this route.[5] He pointed out that combustible materials in dustbins add up to about 65 per cent of the total. Much of this material is putrescible. As it rots, it produces methane which could be used as an energy source. Unburnt, methane is a much more potent greenhouse gas than

carbon dioxide. But burning methane emits far less carbon dioxide than getting the same amount of heat from fossil fuels. Landbank has suggested that much household waste should be treated in anaerobic digesters, whose products would be useful methane gas, and humus material which could be used in land reclamation if handled carefully.

Actually, quite big technical and logistical problems stand in the way of composting household waste on a large scale. In Britain brave composting ventures have often failed commercially down the years. But composting might be made to work and plenty of schemes are being tested both here and abroad.

It should be clear that it is not easy to make all the possible solutions to our waste problems overlap. We cannot encourage both steel cans and aluminium cans. We cannot legislate both for centralised sorting of waste and for bring or separation systems. We cannot both recycle and compost paper. We have to make choices.

The problem is not that there will be no answers to these dilemmas, only that it is folly to pretend that we will find the right ones quickly. Only research and a genuinely holistic, all round, analysis will serve us. The counter-intuitive and the controversial – for instance, incineration – may in some cases be a better solution than recycling, however much we are taught by environmentalists to disbelieve the possibility.

John Barton was far from despairing. Of the conflicting evidence of various recycling experiments, he said bravely: 'We had to start somewhere.'

The green consumer: spoiled for choice

It would be nice to know how to buy the things one wants and at the same time claim to be green. In recent years, manufacturers have been tumbling over themselves to make claims of ecological virtue for their products. Many of these have been honestly meant, but not all. Most are deeply flawed. None of them offer a way of being a green consumer, only of having marginally less impact.

To sort out the muddle, the European Union and governments around the world have begun to develop schemes which award eco-labels. Mostly, the judgements made depend on life-cycle analyses (LCAs) which (as we have seen earlier) tease out the ecological cost of difficult products which do the same job and assess

which has the least environmental cost. Even the best of these yield less clear results than everyone would like. As the diligent Environmental Data Services bulletin, ENDS, pointed out, they usually confirm 'the observation of sceptics that there has been an uncanny tendency for published LCAs to reach conclusions broadly in line with the interests of their sponsors'.

Still, LCAs and the eco-labels derived from them are likely to be amongst the best tools we have in trying to prompt consumers in the right direction. Rich dilemmas ensue in the attempt. The genuinely ecological choice is often left out. For instance, no one dares remind consumers that cars and bikes can often do the same job, and that the eco-label belongs on the bike.

So eco-labellers try to find the least damaging technologies for cars, and give a label to them. In Germany, catalytic converters for cars get a label. Catalysts, as we have already discussed in Chapter 4, hugely reduce emissions of acid-rain-making nitrogen oxides, sulphur dioxide and hydrocarbons. Absurd, though, to give them a sticker, say British critics. Catalytic converters do nothing to reduce emissions of carbon dioxide, an important greenhouse gas and therefore potentially the biggest villain of them all.

Most importantly, the overarching message to ecologically-aware car-users should be to remember that all fuel consumption has problems, and we need technologists to design machines that concentrate on delivering high all-round emission standards and very low fuel consumption rather than, say, racetrack performance or armchair luxury. The German system does not send that signal at all because it offers equal 'Greenie' points to owners of fast or big cars as to small or economical ones.

Not everyone needs a car. But anyone with a baby needs nappies, or diapers. Tradition says buy cotton and have laundry day. Convenience has led huge numbers of people to buy the throwaway item. The Canadian green labelling system awards Greenie points to the traditional, right-minded alternative. Fighting back against this tendency, Proctor and Gamble in the United Kingdom proudly proclaimed – contrary to the Canadian view – that disposable nappies are about on a par with re-usables. The Women's Environmental Network took offence, perhaps ironically given their feminism, and stood up for tradition and washday. Yet one of the few experts on the subject says: 'I wouldn't put my head in the tiger's mouth on this, either way. It's difficult to decide who is right.'[6]

Franklin Associates have done a United States study which found that across a baby's months of use of nappies, disposables consume half the energy that was required in re-usable nappies washed at home.[7] Disposables cause half the emissions to air and 10 per cent of emissions to water of the washables. They consume much less water, which is nowadays an ecologically expensive product since it requires a good deal of energy to move it around and treat it. On the other hand, home-laundered nappies caused only a quarter of the solid wastes of the disposables.

That study and several others were paid for by the paper industry. The Women's Environmental Network hotly disputed the evidence and used Landbank (see above) to come up with an analysis of existing data which swung heavily behind washables. Among other things, they claim the industry-sponsored work heroically bumps up the numbers of cloth nappies babies get through. The industry counter-claims that it is campaigners who have got the data round their necks.

The anti-disposable campaigners point out that even sustainable forestry – the source of most of the paper in disposables – should not be regarded as benign. They say that even Scandinavian forestry does not allow the ecological richness of virgin forest. This is partly true, and slightly complicates the issue, unless we trust rich northern tree-growing countries to strike a good balance between cropping trees and preserving virgin landscapes.

One problem is that one of the products of babies – which either system simply delivers to waste streams – is the baby's faeces. One might well argue that washing nappies delivers this degradable material to a sewage disposal system which is likely to be a less damaging disposal route than that offered by wrapping it up and chucking it in landfill. Curiously, life-cycle analyses of nappies reveal that commercial laundries are much more ecologically-efficient than home-based washing machines. It might well be that the right ecological thing is to send all laundry to them.

That will not happen, probably. In the meantime, it fell to Britain, under preparations for the European Community eco-labelling scheme, to lead the process under which criteria for awarding plaudits to home washing-machines. Studies discovered that machines vary considerably in the amount of detergent, water and energy they use. Energy is the most important of these – not in the manufacture of the machine, but overwhelmingly in its use (the same

applies, by the way, to cars). This implies that keeping an old washing machine may mean running a gas-guzzler instead of trading up to an energy-sipper. Built-in obsolescence may even be a boon. Bang goes another green goddess.

Pippa Hyam, now of PDA International, an environmental consultancy, but before that of Friends of the Earth, is on the committee advising the Department of the Environment on eco-labelling, and found this issue perplexing when we talked in 1992:

> Saying that every three or four years you ought to change your washing machine in order to buy into the latest energy-saving technology might be logical, but it still doesn't make sense somehow. Luckily, even if that were the message, I think the British green consumer would take it with a pinch of salt.

The UK Eco-labelling Board, on which Pippa Hyam sits, believed eco-labels should be given only to the very best products of each type. The argument is that if the standard is weakened, consumers will not trust it to mean anything. Besides, the label is supposed to send a signal to manufacturers about aspiring to the best, not the mediocre. So the label will go to, say, the top 10 per cent of performers. Hyam says:

> You want the label to be attainable, and be on enough machines to constitute a wide market, certainly not so exclusive that it is only on the most expensive – you don't want to price the label out of the market. But it does turn out that three or four makers, out of about a dozen, are substantially better than the others, and then there is one machine which is highly, highly computerised and so on, and that is head and shoulders above the others in cost as well as environmental performance.

Perhaps to be green is to be elitist.

There is an irony here which is seldom discussed. Suppose it turns out, as is probable, that the most expensive washing machines are the most sound ecologically. It follows that we need to take account of the ecological damage which is incurred by people as they earn the extra money to pay for ecological virtue. If no account is taken of the ecological impact of encouraging people to get rich in order to pay for them, then eco-labels may merely encourage a sort of green yuppy-ism. People might not only feel virtuous in buying green, but also feel that being rich is required as a part of that virtue. This would be a very odd signal to send to would-be Greenies.

There is a way out of the bind. A sharp way of reducing the nation's total washing machine energy would be simply to insist that all machines must be made energy-efficient. If 100 per cent of washing machines achieved a target (less rigorous than that required for an eco-label, but higher than the present industry norm), one might achieve very much more than could be achieved by aiming at a very virtuous top 10 per cent. This way, everyone would be buying machines which do less damage to the environment without the eco-label's disadvantage that it makes people feel falsely virtuous.

These are not cavils. All the same, starting from where we are, it is worth celebrating the main result so far (January 1994) of the European Union's eco-labelling process. According to *ENDS*, a British firm is the first to have applied for and received an eco-label:

> Hoover's New Wave machines meet the environmental standards quite comfortably, mainly because of the electronic system employed to control energy and water consumption and the use of an 'eco-ball' in the machine's sump to stop detergent loss. In all, they use 31 per cent less water, up to 36 per cent less detergent and up to 40 per cent less electricity than Hoover's previous range.

Hoover's machine was not unqiue in meeting the standard. Other firms, however, had not applied for the eco-label, perhaps because they were uncertain whether the fee involved would be justified by increased sales.

The British washing-machine study produced fairly sensible results. It is much less clear that, for instance, the French will be able to come up with useful criteria for paints, varnishes, batteries and shampoos, or that Italy will be able to make sense of packaging. These are much more complicated products about which to discover green virtue.

Under the same EU eco-labelling process, the Germans were asked to look at detergents. This was one of the areas in which much green nonsense was generated during the late 1980s, as manufacturers – some of them very new to the game – claimed all sorts of virtues for their products and then charged a lot of money for them. Several washing-up liquids, for instance, advertised themselves as phosphate-free. They may well have been, but phosphates had never figured in any of these products. Several washing powders claimed to be virtuously biodegradable when the conventional products already were required to be anyway.

The Royal Commission on Environmental Pollution recently looked at the phosphate issue and was at pains to say that it was important to know more about the substitutes for phosphate before legislating against its use in detergents.[8] Some of the substitutes create more problems at sewage plants than the phosphate we are supposed, probably wrongly, to worry about.

The entire phosphate debate may be largely irrelevant since the chemical's presence in detergents is not the major ecological problem. One could remove phosphate from detergents and not much relieve the need for sewage handlers to trap the chemical because of its occurence from non-detergent sources.

Indeed, there is, actually, little or no need for most of the public to take an interest in the things they use as household cleaners. The vast bulk of people in western Europe have wastepipes connected to drainage and sewage systems which are strictly regulated. The problem of sewage disposal in effect exists only for water undertakings and their regulators, and it is their requirements which matter. It may well be counter-productive to get consumers to buy products which might be environmentally-sound if they were to end up untreated in the environment, when in fact they will spend a lifetime in a closed system with a sophisticated treatment process at its end.

Anyway, the Germans dislike phosphates (and have a lead in the market for the main alternative, zeolite). Their first official detergent eco-label study suggested that eco-labels be given only to 'components' systems, which separately package water softeners (which they believed should be phosphate-free), detergents, and bleaches. The German eco-labellers believed the environmental load of washing wastes can be significantly reduced if the three components are juggled according to circumstances, and used as sparingly as possible. That is true in principle for the component system, but chemical firms like Albright and Wilson which are heavily involved in phosphate production (and the alternatives), were disappointed by what they called a prejudiced piece of gesture politics against the ingredient.

Albright and Wilson and other phosphate producers funded research which looked eminently respectable[9] and said that wash for wash, phosphate-based washing powders and liquids are less, not more, polluting than phosphate-free alternatives. This is largely, the research claimed, because phosphate-based detergents are efficient, and can be used in small quantities.

The new compact detergents – with or without phosphates – seem to have the least polluting effect of all, provided one uses as little of them with each wash as possible. And it seems for the moment that phosphate-based compacts are the best of all. The debate is not over yet, but it is very far from clear that phosphate-free is best. In one way, this is a pity. Buying phosphate-free detergents was many people's first tentative green step. On the other hand, this case may help people realise that ecological wisdom will not often flow from devotion to wrong-headed clichés.

A long and healthy life

Many people believe that industrial society is bad for their health. This seems to be nonsense. Most western people live to an age which edges close to the likely natural human lifespan. In North America the average life expectancy at birth is 74.6 years, and in Europe it is 73.2. The average life expectancy at birth in the developed world in general is 72.3 years, and in the developing world it is 57.6. At its very briefest, we can surely say that it seems to add to one's chances of living out a full natural lifespan to be rich and living in an industrialised society.

The developing countries may be suffering the ill-health effects of living in societies with very primitive and therefore polluting industries. Even if this is true, the answer remains that their best hope looks likely to come from some modern version of the industrialised societies which they envy in the west. We seem to live in a world in which poor people in poor countries suffer two, perhaps three, profound dangers to their health: a hazardous childhood, infectious diseases, and hunger.

At quite modest levels of improvement in development, these give way in marked degree to death at a rapidly increased average age from diseases of the circulatory system and cancers, though the former start to kill at lower levels of affluence and longevity than the latter.[10] Developing countries have much longer life expectancy under their present scale of industrialisation than they had even two or three decades previously.

The same statistical tables reveal that you are far more likely to die of cancer in the rich world than in the poor world, but that is because you are far more likely to live to the kind of age when cancer kills in the former than the latter. In any case, life expectancy in North

America has risen by more than five years in the last thirty years, and in Europe by six years in the same period. Things are getting better, not worse.[11] People are, indeed, living so long that a large proportion of society's wealth needs to be spent looking after them and treating the diseases of degeneration to which they are inevitably prone. And yet many of us are subject to two modern conditions: chemophobia and technophobia. There is of course the possibility that people are indeed being poisoned and that they are living lives which could be longer still but for this unfortunate fact. It might also be the case that modern health treatments are only needed to counteract the effects of our having been poisoned. Yet the longevity remains as a fact.

There seems to be little serious discussion of these issues, and I can only hint at tentative lines of discussion. Clearly, if health interventions were reduced, so would be the average age at which people die. Another effect would be the greater discomfort or immobility of others who would not, however, die as a consequence of the withdrawal. Conversely, some would live whom modern medicine kills. Some would live out the last months and years of their lives in greater comfort if they were treated as if in need of care rather than cure. It may even be that old age is not a goal to which we need aspire. A full and comfortable life ended at seventy or eighty may often be much preferable to one which is prolonged into senility by attention to healthy living, by good luck, or medical intervention. Doubtless, western patients will refine their view of what treatments are worthwhile, as will cash-strapped doctors.

But how to explain to western chemophobes that they do not seem to be poisoned? Perhaps the best thing would be to look at a seminal paper by Richard Doll and Richard Peto.[12] This valuable piece of epidemiology began with the assumption that one could try to tease out the likelihoods of various cancers being avoidable, in the sense that they had an anthropogenic agent as their main or signal cause. Doll and Peto are firm in their conclusion that smoking, and perhaps diet, are by a very big margin bigger culprits in what they call avoidable cancer formation than are environmental causes. Pollution caused, they thought, perhaps 2 per cent of all cancer deaths.

We live in an age in which the scourge of cancer frightens all of us. But subtract the cancers formed because of smoking, and there is actually a slightly declining death toll from cancer. Doll and Peto suggested diet was a problem not because it is the vehicle by which synthetic chemicals or other environmental contaminants enter the

body. The problem revolves round strictly nutritional rather than contamination issues. In short, the problem of the carcinogenic effects of foods is very like the debate about which foods are contributing to heart disease. In some degree, like cancer, heart disease is avoidable. There are some pieces of advice which seem generally sound (i.e. avoid overeating and avoid animal fat). But some well-informed researchers are very sceptical of what they think of as a fundamentalist anti-fat case, especially as sponsored by the World Health Organisation.[13, 14] It may be that ordinary healthy eating is a mild defence against some sorts of heart disease, and that only those who already definitely have heart disease will benefit from going beyond ordinary moderation. In time, we may learn to recognise those individuals who could avoid heart disease by severely restricting their cholesterol intake. We may find that for most people a little regular exercise is a better preventative than strict dietary regimes. In the meantime, we need better epidemiology and better science if hunch is to become serious opinion.

There is, to return to the contamination issue, extreme doubt as to whether levels of pesticide residue in the western diet are any sort of problem (as we discussed in Chapter 7). Even if they are present as poisons, they may well be an improvement on the sorts of chemicals which plants would otherwise naturally produce to keep pests at bay.[15]

The average age of death in the world correlates pretty well with affluence. Though the ranking of the causes of death varies in different rich countries, the average age of death does not. This means that the Mediterranean diet, or the Japanese diet, though they may reduce one cause of death, seem – by the same logic – to increase another. The fact is, we all die – British, Japanese and Italian – at about the same age.

The authors of 'Choosing the limits of life', a fascinating paper in *Nature*,[16] argue that we should look carefully at each proposed environmental control to be sure that it is efficient. In particular, the authors stress that blindly and expensively trawling every chemical and all chemicals for their carcinogenic effect may not be as rewarding as looking harder at those chemicals about which we already harbour suspicion.

It may yet turn out that there is cause to further limit people's exposure to a range of chemicals which are common in the modern environment (some of them perhaps vastly preferable to the sorts of

things which were common in the historic environment). Some of the suspect chemicals will be synthetic, some not. There may be some very difficult problems to resolve as we discover more about the health effects of some quite serious candidates for concern, for instance, naturally-occurring radiation such as radon in households, or aluminium from natural sources, and possibly vehicle pollution.

And yet it may be that we have to accept that modern western lifestyles do not deliver much damaging pollution: overeating and under-exercise perhaps, but little important pollution. We may well be wise to listen to regulators when they stress that we can expect future environmental improvements to be expensive or difficult, and to yield rather smaller and less certain benefits than we are used to.

This seems an extraordinarily good time to be grateful for the pretty tolerable – if not quite perfect – safety of almost everything we eat, drink and breathe.

A lighter footprint from industry

Granted the success of campaigners and the media in presenting an alarming picture of increasing and relentless pollution, it is not surprising that the public mostly believes that little has happened to clean up industry. Part of the difficulty is that many of the most important improvements have been in total emissions of some important contaminants, such as the heavy metals mercury and cadmium. These matter but are little known.

Then there is the difficulty that while emissions per unit of production are usually very much lower than they used to be, there is a general picture of much increased production, so a far smaller overall reduction in the total of emissions.

Given these sorts of problems, it is doubly important to recognise that there are two quite different ways of looking at pollution from industry. One is to consider the track record in reducing emissions country by country, firm by firm, or plant by plant. The other is to consider the health of the environments of countries, or in the neighbourhoods of plants.

It does not, after all, matter a scrap if emissions are halved or more than halved if the environment which receives them remains overly damaged. Conversely, it would not matter at all if firms or countries failed to address their emissions if it transpired that the environment was perfectly capable of thriving alongside the pollutants.

In the real world, of course, rich countries develop environmental controls by both tightening emissions standards and monitoring the receiving environments. Regulators find themselves trying to assess the degree to which firms are right when they claim that further improvements will be technically or economically impossible. But the regulator is bound to press on. The public makes increasing demands for environmental purity. Certainly, at some point expenditure on pollution control will meet a diminishing return. Historically, as each pollutant became the subject of limits, firms tackled the easiest sources first and left the tougher ones until later. In many cases, the day of reckoning has now arrived.

The attitude of regulators is stiffened, even in a time of recession, by the knowledge that industry has always complained about pollution controls, but has always been able to meet them and never found meeting them the most onerous of tasks.

Even after only a generation or two of modern pollution controls, we have reason to be tolerably sure that there is little we want to make which cannot be made with minimal pollution. In many cases, pollution and resource use have in effect been 'unhitched' from economic expansion. Thus, while gross national product throughout the rich world has been increasing dramatically, fossil fuel requirements have remained pretty steady while much of the pollution from fuel-burning has quite dramatically decreased.

Not all air pollutants are under sufficiently strict control. Carbon dioxide, as we have seen, but also various volatile organic compounds (such as the solvents we met when we looked at chlorine, but also methane) and nitrogen oxides are increasing. But even in these cases the news is not all bad. We have discussed carbon dioxide' already, as a hard case. Most other emissions could quite quickly be stabilised and reduced, and probably will be, once their seriousness is assessed and technologies developed.

Water pollution presents a broadly similar picture. Most but not all of western effluents are treated before they reach natural watercourses. While there is a good deal of discussion as to how much further to go in eliminating emissions (both because the technologies become more and more expensive and because the benefits to the natural environment become less and less clear), it is hardly likely that the pressure for improvement will be reduced. Farmers, sewage plant engineers, and factory managers with discharges to rivers all feel the pressures and all are having to find

investment to meet increasing standards.

To return to our opening premise. In most western countries it is becoming clearer what is happening in almost all the environments we care about. Our air, water and soils are monitored more intensively each year. But because industry is being more open about its emissions (partly because it senses that to be so is the easiest way forward, and partly because of regulations), we begin to have a sense of what has been and can be achieved.

Bayer, the German chemicals giant, pubished its *Environmental Report* in December 1993. In 1992, the firm received a prize from a Dutch water supply company which uses lower Rhine water and is, naturally enough, very interested to see the upstream users of Rhine water improve their performance. Bayer's report shows that there has been massive improvement even in the years 1981–1993 in the emissions to water from its plants on the Rhine. Reductions by 50 and even 90 per cent are common, depending on the pollutant in question.

The reductions in the important air pollutants are mostly of a lesser order, though some have been altogether eliminated and the overall performance is impressive. Most emissions to air have been more than halved, and some have been reduced to well below half.

This sort of performance is almost routine in the modern chemicals industry. For instance, Du Pont in the United States:

> is committed to reducing its toxic emissions to air from US sites by 60 per cent betwen 1987–93, and carcinogenic emissions to air by 90 per cent between 1987–2000 at its US sites. Hazardous waste output from US sites was cut by 35 per cent per unit of chemical production between 1982–90, and the new worldwide target is to reduce hazardous waste by 35 percent from 1990 to 2000.[17]

The British chemicals multinational, ICI, published in March 1994 its third *Environmental Performance Report 1993*. This outlined four main environmnetal objectives for the firm. It wanted to ensure that its plants everywhere met the toughest regulations which applied to it anywhere (a mechanism which should mean it can operate in countries with weak regulations as though it was operating in its most strictly regulated environment). ICI have set themselves to reduce all waste, with special regard to hazardous waste, to half of their 1990 levels by 1995. The firm wants to control energy use and encourage recycling, not least among its customers.

The report showed good or moderate progress on them all.

It is the knowledge that they face vociferous complaints while meeting these sorts of progress targets, which themselves come on top of years of progress, which makes industry managers wonder what sort of results will satisfy the campaigners. The answer is, of course, that the excellence of the progress is a double-edged sword. The campaigner senses that there are really no limits to what industry may achieve. The campaigner is surely right that however much cleaner industry is now than it used to be, its present performance will presumably look primitive from the vantage point of history.

We risk, however, a curious phenomenon. Industry's sophistication may fuel the campaigners' fundamentalism. When industry can show that it can make the world a better place, the campaigners may press for a Utopian perfection. Many campaigners do, after all, seek a sort of paradise.

Notes

1 Atkinson, W. and New, R., 'An overview of the impact of source separation schemes on the domestic waste stream in the UK and their relevance to the government's recycling target', Warren Spring Laboratory, 1993.

2 Franklin Associates, Prairie Village, Kansas, USA.

3 Office of Technology Assessment, 'Facing America's trash', Washington: US Congress, October 1989.

4 Royal Commission on Environmental Pollution, *Incineration of Waste* (London: HMSO, June 1993).

5 Landbank Consultancy, 'Packaging: an environmental perspective', Gateway Environment Programme, January 1991.

6 Private communication with author.

7 Franklin Associates.

8 Royal Commission on Environmental Pollution, Report 16, *Freshwater Quality* (London: HMSO; June 1992).

9 Johnston, E., Constant, J., Chambon, P. and Leal, S., contributions to phosphate industry seminar, Copenhagen, 1992; Scientific Committee on Phosphates in Europe (industry group), Geneva.

10 WHO Study Group, *Diet, Nutrition, and the Prevention of Chronic Diseases*, WHO Technical report series 797 (Geneva: World Health Organisation, 1990).

11 *Ibid.* p. 32.

12 Doll, R. and Peto, R., 'Avoidable risks of cancer in the US', *Journal of*

National Cancer Institute, vol. 66., no. 6, June 1981.

13 A sense of the richness of this debate can be had by comparing *Diet, Nutrition, and the Prevention of Chronic Diseases* with Skrabanek, P., Gibney, M., and Le Fanu, J., *Who Needs Who?: Three Views on the World Health Organisation's Dietary Guidelines* (London: Social Affairs Unit, 1992).

14 Blaxter, K. L. and Webster A. J. F., 'Animal production and food: real problems and paranoia', *Animal Production*, vol. 53, 1991, pp. 261–9.

15 Ames, B. *et al.*, 'Dietary pesticides (99.99 percent all natural)', *Proceedings of the National Academy Sciences*, USA, vol. 87, pp. 7777–81, October 1990; and Ames, B. *et al.*, 'Nature's chemicals and synthetic chemicals: comparative toxicology', as above, pp. 7782–6.

16 Lohman, P., Sankaranarayanan, K. and Ashby, J., 'Choosing the limits to life', *Nature*, vol. 357, 21 May 1992. Dr John Ashby, of ICI, is an informant of this book.

17 ENDS, report 226, November 1993.

III
Humankind, nature and development

9

Paradise, wilderness and the nurseryworld:[1] the worlds we have lost

There are important emotional and intellectual weaknesses in the way the modern world romanticises the natural world and the surviving wildernesses (and the peoples and wildlife which live in them). In particular, it seems a pity to admire the natural world mostly because it represents a world untouched by human beings. Naturalness is often not what it seems, and people are not quite the wreckers they seem. This chapter explores some of our false thinking.

Ecology, the not-so-romantic science

Modern people feel alienated from nature. To an important degree, this worry flows from a misreading of the science of ecology. According to a very early definition, ecology is 'the comprehensive science of the relationship of the organism to the environment'.[2] Another, more sophisticated, way of looking at ecology is as the study of the processes by which life-forms organise themselves in defiance of the entropic rundown of this part of the solar system. This is seen most clearly, indeed luminously, in James Lovelock's work on the idea of Gaia.[3, 4] The Gaia hypothesis suggests that life – all of it – is combined into what amounts to a single organism with a profound ability to organise for its survival. In this view, life is like a valiant attempt by molecules to organise themselves for the enjoyment of the maintenance of life as the universe winds down.

Less romantically, ecology is the study of the way organisms get a living. It encompasses much behaviour which, in a human, would be condemned as brutal and even vicious. Humans find the natural

world lovely to observe, but the life-forms we admire are engaged in a life-and-death struggle. Yet ecology has come to be synonymous with virtue. We have already discussed (Chapter 6) a common mistake: the confusion of ecological merits with aesthetic ones. A further common misconception sees ecological processes as epitomising stability, harmony and balance.

For most of us, a natural ecosystem is the very model of stability. It is one of the disturbing things we think we know about ourselves: that everything in the biosphere was stable until we came along. In fact, even in the medium term, say within a human generation or two, there are often quite big observable natural changes in even quite big natural ecosystems and most of them involve pain or at least disadvantage for some species. We see this sort of thing when a natural fire sweeps through a forest and renews its vigour, or herds of elephants on one of their periodic population upswings change a landscape from scrub to grassland. Nature is in dynamic tension rather than balance.

In the longer term, say at the level of centuries and millenia, sea levels and ice cover come and go as part of one of the most important variables, the climate. But these changes bring disaster only to some species for some of the time, never to all species for all the time. Watching these phenomena leads some people to suggest that nature 'heals' itself. Perhaps she does, and certainly the process goes on without any regard for human beings, as the Gaia hypothesis suggests. And yet, the healing process – whatever it is – often allows nature to accommodate human inputs, and other changes, better than is often supposed, as we saw in Chapter 5. It is not necessary to see the processes as 'healing' at all. What looks like healing process merely arises because nature has produced so many life-forms that every new event – even what we call pollution – is an opportunity for some species or other.

Nature is not in balance but tension; and not so much comfortably stable and coherent as richly opportunistic. Human beings are just another factor in an extremely complicated set of equations.

The study of ecology helps us understand the rules by which nature runs the planet. But some of the most knowledgeable ecologists draw unnecessarily gloomy views about humans from their study of nature. In particular, ecologists seem to be rather poor political philosophers. Garrett Hardin usefully popularised a phenomenon known as the 'tragedy of the commons'.[5] This argues that

where a resource – a planet as much as a field – is owned in common or not at all, its individual users will have no immediate interest in preserving it. The idea flows from the observation that common land may become overgrazed because each owner of grazing animals is inclined to increase his or her own herd, even if the land's capacity will become over-stretched and eventually impoverished. This phenomenon was supposed to flow from the fact that each grazer would seek to get the advantage of a bit of extra grazing, even if they knew it was not sustainable, because if they did not, a neighbour would. The argument certainly seems to be well supported by our experience of the behaviour of fishermen as they overfish the oceans. As the *Economist* pointed out:

> Like hunters, fishermen will try and take what they can when they can, before anyone else catches it. A fisherman who tries to conserve the stock by leaving fish in the sea has no reason for thinking that he will gain by his investment: the fish he has spared, or their offspring, will probably be caught by someone else. On the contrary, if he catches more fish now he will be the richer for it. Although there will be fewer fish next year, the cost will not be borne by him him alone, but spread over the entire fleet. Without regulation, in other words, fishermen have an incentive to overfish.[6, 7]

So, we depend on law-making in these matters where social interest and individual interest are necessarily at odds. From the way we run traffic on our streets to the way we control whaling, the quality of regulations and policing is crucial.

We see the potential for a tragedy of the commons when we look at people's misuse of the atmosphere and a thousand other examples of unsound behaviour. But we are not in the grip of a remorseless process: we see, every day, thousands of examples of sensible co-operation and coercion designed to ensure the tragedy does not unfold. We also need to remember that over-regulation is almost as dangerous as under-regulation.

The odd thing about much thinking which derived from ecology was that it was not merely not very humane but was surprisingly authoritarian. Even gloomier than the tragedy of the commons was another idea associated with Garrett Hardin, but finding expression elsewhere. This was the 'lifeboat theory', and saw the planet not so much as a spaceship as a liferaft.[7] It was suggested that the planet has a limited carrying capacity which had now been reached or

exceeded. It was argued that helping to keep more people alive would sink the vessel, rather as an overloaded rescue boat might sink altogether if another half-drowned victim was hauled aboard from the sea. If the human species is too numerous, aid to the poor is counterproductive. Population control might have to be enforced, to reduce the potential for suffering in the future.

Much of this book has been devoted to suggesting that the lifeboat, which was so confidently predicted as being about to sink in the 1960s, has actually carried many millions of people fairly safely, and can be expected to carry many more in the future. The important point is to see that the tragedy of the commons and the lifeboat theory appealed to many people whose thinking was crucial to the development of what might be called political ecology, and we can wonder if it was sufficiently generous, or even whether it was very well informed. Even now, though few would dare or want to write in the terms which were around twenty and thirty years ago, many people believe that nature will 'get its own back' against human hubris, and that the human suffering involved will be deserved. This view stems in part from an undue worship of the natural and an undue distrust of the human.

Paradise and the theme park

For most of its history humankind has been preoccupied with the idea of paradise.[8] What was it? Who made it? Why were we not living in it? Was there anything like it on earth? Or only in heaven? Why had we been thrown out of it?

Paradise is an expression of the conjunction of two ideas which help define the human mentality. We want to know what a perfect person, and perfect physical surroundings would be like. We do so because of our restless discontent. Our way of thinking changes over the years, but it has certain constants, and discontent is one of them. So, therefore, is the attempt to posit a world – or a part of the world – in which there is no call for discontent.

We are not content with the fact of our beings, circumstances and behaviour. We want something, and want to be something, a bit better. Our discontent is not merely that of creatures which do not like their present circumstances. It is crucially informed – sometimes sharpened, sometimes eased – by our ability to imagine something better.

For the western imagination, deeply imbued with the idea of mankind's fall from grace, paradise on earth or in heaven has always been a wished-for state, but it is also a reward for virtue, grace or good luck rather than for good management. In the tradition, any earthly paradise must be somewhat flawed, and a fleeting experience: we have after all been expelled from Eden.

Now that the idea of God, and metaphors generated by traditional religion, are less powerful explanations and templates for the way we see the world, we have needed to replace them. The natural world has replaced God. Many people now see the natural world as a place which was a paradise until human beings, and especially westerners, came along and inserted aggressive industry into it. In this version of events, we were not expelled from Eden for eating the apple, but – more vulgarly – simply set about destroying Eden because we hadn't noticed that it mattered. In this modern way of looking at the world, our quest for paradise must be conducted in whatever parts of the world we have not wreaked damage. In the most despairing view, there is nowhere to hide at all. Bill McGibben's elegant *The End of Nature* suggests that humankind has lost a wonderful idea:

> An idea, a relationship, can go extinct, just like an animal or a plant. The idea in this case is 'nature', the separate and wild province, the world apart from man in which he adapted, under whose rules he was born and died.[9]

Because we have changed the climate, McKibben argues, we have interfered with the engine room of the planet's processes. This view underplays the scale of natural events, which match our own effects; it ignores our own naturalness; it overstates the sense that all was amiability and balance before people arrived.

McKibben takes to an extreme views which are a large part of the Green message, and which make a fair account of the religious end of the conservationist way of seeing those parts of the world which are largely untouched by human hand. A sense of paradise-envy accounts for the strength of feeling we have about the rainforest, for pristine environments, for Antarctica, and for the shards of naturalness which remain in our synthetic landscape nearer home.

It is, oddly, often precisely the undeserving who gain access to the modern paradise. So far from being a destination after death and reward for a virtuous life, or even during life in some future better time, people are increasingly considering paradise as a real place,

here on earth, and a reward, not for virtue, but for a year's successful work in the grubby old world as it is now. Travel brochures sell us paradise islands in which we can indulge many potent dreams. Coral reefs and palms and white beaches become luxurious temporary abodes in which we can find primordial simplicities, rediscover our eroticism, play at being noble savages, or wonder comfortably what sort of Swiss Family Robinsons, or Robinson Crusoes, we would make. This is paradise as a theme park. Paradise has to some extent become a leisure pursuit, a holiday destination.

We are capable of enjoying the theme park paradise on holiday, and yet carrying with us a sympathy for the view that there is important value in genuine, unvisited wildness and in behaviour which will safeguard it for future generations. Indeed, both wings of modern thinking – the one which is Green and dissident and blames human beings for destroying nature, and the one which is consumerist and conformist and claims nature as the park for human pleasure – share much. They both make the mistake of believing that paradise can be a place.

The wilderness, paradise and monks

The Judaeo-Christian world has nurtured ideas which resonate even now, and amongst people of no faith. Much nonsense has been written about these ideas by the Greens, but is counterweighted by some good green writing too.[10]

In the traditional view, God made the earth and made it lovely and innocent. Humankind brought sin into this paradise, this Eden, and brought into nature a violence which had never been there before. Human beings alienated themselves from nature by becoming sinful.

Conversely, people have argued that the western tradition is to manage and exploit nature, but that the process included ideas of respect, admiration and even love of nature and our fellow creatures. They had value, after all, by being God's creations and perhaps also by having been given into our charge.[11]

Our religious and literary traditions include plenty of endorsements of the value of nature. The earliest saints were described as being in harmony with the beasts of the wild, and that proved their sanctity. The beauties of nature have forever been used as a watchword of loveliness. Yet the sense of continuity with previous generations can obscure the most important way in which our

attitude to wilderness has changed significantly over the centuries. If we look back, we see that many of the historical descriptions of paradise, indeed one of its names, in the case of Eden, strongly imply or require us to see that loveliness consists in a garden.

Crucially, our modern view that pristine nature, the genuinely wild, is lovely, or paradisical, is very new. Paradise has for far longer been a place where human beings and nature lived easily and prettily together hand in hand. Traditionally, paradise was often far more like the cultivated oasis of the Middle East, or the productive farmscape of Tuscany, than the rainforest of Africa, the desert or blasted heath.

Perhaps oddly, the behaviour and beliefs of monks throughout our history show us a good deal about how attitudes have changed. We are discussing wildness, naturalness and paradise because they matter to us as expressions of our discontent with the ordinary and the workaday existence and surroundings we must manage with. The monk is quintessentially a person who takes that discontent to an extreme.

As I have mapped out elsewhere,[12] there were three important stages in what amounts to a complete reversal in the way monks saw and discussed wilderness. First, in the patristic and early medieval periods (say, from the first century AD until AD700–800) pious men thought that they ought to leave the cities and the temptation they brought, and retire into the wilderness where there were other awful threats, including solitude, listlessness, demons, wild creatures and the horror of starvation. To do so was to imitate Christ's own forty days in the wilderness, and the whole tribe of Israel's forty year Exodus. This is the period when men like St Antony and St Paul became famous and revered for forsaking the city, not for the merely rural, or the agricultural, but for the positively wild. The early monastics' view of their new home was complicated. As Derwas Chitty pointed out it included affection:

> Note this love of place. Throughout our records we find a contrast. On the one side, the desert is represented as the natural domain of the demons, to which they have retreated on being driven out of the cities by the triumph of the Church, and into which the heroes of the faith will pursue them. Is it fair to suggest that, while the great hermits were largely countryfolk, the writers of records were more often townsfolk, with always something of the townsman's fear of the lonely, unsheltered places? But they cannot hide the fact that the saints

themselves, while quite alive to this aspect, have at the same time a positive love for the stark beauty of their wildernesses. Anthony was to compare a monk out of the desert to a fish out of water. And when a philosopher asked him how he could endure without books his long solitude, he would point to the mountainous wilderness around him: 'My book, O philosopher, is the nature of created things, and it is present when I will, for me to read the words of God.'[13]

The desert might be fearsome or – less often – amiable. It was, in any case, inviolate.

In the Middle Ages, this view began to give way to one which saw the wilderness as a proper place to go, for many of the previous reasons, and for a new one: the likelihood that one could do honest work in taming and civilising the wilderness. These were the years in which we see farming becoming systematic and ubiquitous in the secular world as well. Monks – the Benedictines and the Cistercians particularly – helped push the frontiers of the farmed world deeper and deeper into the unproductive wilderness. Often, they did so as shepherds.[14] The wilderness had become less awful, and instead was merely wasteland waiting for something useful to happen to it. This period included the great adventure of intercontinental exploration, in which unclaimed parts of the world could be seized from their undeserving present human occupants, and turned to proper use by civilised man.

In the modern imagination, as it evolved in the last couple of centuries, we see a different view altogether. Now we find an interest in wilderness as representing innocence. We find monks building or reoccupying monasteries in wild places in celebration of their very wildness. So we find Cistercian monks in the lea of the Rockies at Snowmass, Colorado, or repopulating monasteries in Mount Athos in northern Greece, or in the Egyptian desert. Religious people do not now go into the wilderness to seek out its demons and fight them with God's will; nor do they go to gain a living in the wilderness because it needs taming. They go there with an attitude of loving admiration. The modern monk wears the same habit as his antecedents. He goes there not because the wilderness is where he can meet the fearful face of God's creation, but its most enduringly supportive and loveable face.

Trouble in paradise

We need to remember that paradise is an idea, an ideal. Paradise is the home of our aspirations; it is formless. The paradise we dream of is not in this world, it is a dreamworld. The notion of paradise was fine in an age of religion. God could deliver anything, including redemption, and the home of redemption: paradise. Paradise is what God can make if he wants to, and present to humans. We are free to think about it and imagine it. But we cannot make it or find it by ourselves.

It is mistaken to expect perfection – paradise – to be readily available to us in the real world, especially one in which so many of our fellows have to get a living. Expecting too much of the real world – expecting it to be everywhere or even in many places untouched, pristine and perfectly natural – invites hopeless pain and disappointment. A world in which five billion – soon to be ten billion – people are getting a living and making a vibrant range of choices is not one in which it is realistic also to expect wildness from sea to shining sea.

Earthly paradise is not attainable. But we do have much that is lovely. In the western world, it is clear that many of us live in or have access to an extraordinary range of attractive habitats. Whether we seek mountains, meandering rivers, farmscape or urban parks, these are all available. And yet, when some rather slight and limited damage is recorded to some remote place, we feel terribly hurt. Of course there are justifiable anxieties in our minds, but we can also suggest some more obvious, and far less attractive, reasons.

As people enjoy lives in which their material wants are catered to, they harbour rising expectations of a long and healthy life spent in an attractive environment. We want to live in an environmental paradise in which we can have both motorways and meadows. We want to drive our cars in the city while breathing air of the quality you might hope to find on some Andean slope. Instead of gratitude for our long lives with almost limitless opportunities for entertainment and challenge, we find a generation with an inchoate, romantic fantasy about some simple natural world in which they would be happier.

We cannot afford to forget that we all want competing things out of the world about us. We want what industry brings us and we want the loveliness which was there before industry came. When man faces irreconcilable opposites, he has to accept compromises. Yet

this issue is hard to compromise on because it has elements of the religious about it. And because we have become childish, we find it easier to sulk and stamp our feet and pout and complain, than we do to accept that adults take a balanced view, accept compromises and above all do not expect perfection.

We are still locked out of paradise. We should avoid taking the ex-wilderness in which we live and turning it into a Nurseryworld.

'Original affluence'?

In 1992, the western world revisited an old discussion about whether America should ever have been discovered by whites. It is an argument primarily about the rights of indigenous peoples, whose way of living and perhaps of thinking seem to some people from industrial economies to have been and in part to remain a preferred state of human existence. For the Greens, indigenous people represent the innocent, the natural, the untainted. The tribal person is someone who is living harmoniously with nature, knowing nothing of conducting genocide, but a potential victim of it. In the neo-religion of the Greens, the tribal man and woman are Adam and Eve, their home is the Garden of Eden, and their state that which can obtain before the serpent of greed makes people eat the apple of industrial development.

Naturally enough, for the Quinquennial celebrations of the discovery of America a new allowable way of discussing the matter had to be invented for our fastidious age. It was above all stressed that America was not, in fact, discovered at all in 1492. There were people there already. Of course, though this was seldom stressed, these indigenous people were Johnny-Come-Latelies themselves, having walked into what we call America sometime during the last Ice Age, about 10,000BC.[15] They then rendered extinct many of the large species they found there until they were reduced to subsisting on small prey[16] and farming. Much more recently, many of them had conquered and made themselves at home in their territories by processes as rough in intention and outcome, if not technique and scale, as those they were about to encounter from the Europeans. In this sense – and there are parallels with slavery later – the Europeans were doing nothing new and nothing that indigenous people did not do to each other. The Europeans were only acting more efficiently and on a larger scale. Besides, the people the explorers and some of

their descendants found so admirable were marginal even then. The Aztecs who were the core and bulk of the mid-American pre-European civilisations were even more excessive in their treatment of minority tribal peoples than the contemporary Spaniards and Portuguese.[17]

Columbus noted that many qualities he found in indigenous people corresponded strongly to what he had been taught to admire:

> I assure Your Highnesses that I believe that in all the world there is no better people nor better country. They love their neighbours as themselves, and they have the sweetest talk in the world, and are gentle and always laughing (Christopher Columbus, December 25 1492).[18]

Early on, European saw that the Indians they met were intelligent. They found many of the Indians to be honest, gentle and happy (the early explorers did not know the history of conquest of the people they met: part of their general ignorance about them). It is not clear why it did not seem incongruous to the Europeans that such people should be described as ripe for conversion out of their present state. Perhaps it was inconceivable to a clothed Christian that a naked pagan should not need to be converted. Perhaps it was inconceivable to a servant of a European monarch that an anarchic native might know the right sort of order already. Perhaps it was simply a matter of blunt necessity. Someone from exploited Europe could hardly risk his life to discover lands of opportunity and then let a few rustics stand in his way.

Anyway, these explorers were our close ancestors and the progenitors of our great civilisation. It is silly to dislike them, or to think we would have behaved any better. It is folly to imagine that the Indians they abused were inherently better people than the explorers, or than us, the explorers' descendants.

Modern people have not merely romanticised wilderness and tribal peoples. They have come to believe that the synergy between place and person in the 'primitive' world is a paradigm for how we all ought to live. This feeling has been bolstered by a very casual and partial reading of a fascinating piece of anthropology edited by Richard Lee and Irven DeVore, *Man the Hunter*.[19] In passage after passage the contributors to this book outline how often they find primitive people to be living well within the productive capacity of their environment, to have considerable leisure, to live to considerable ages, to allow the infirm to live amongst them, and to survive the

vagaries of climatic variation without the famine which sometimes afflicts their farming neighbours. One contributor eloquently suggests that Stone-Age people created the Original Affluent Society full of happy-go-lucky people.[20]

But this view of pre-history becomes bogus when it is extrapolated from partial account to dominant cliché. Many contributors to *Man the Hunter* saw gloomy and periodically hungry hunters whose stoicism was perhaps admirable but was closer to fatalism than light-heartedness.[21] Others noted that in good times or bad, the tribal people they studied combined their affection for one another with an easy indifference to the suffering of their fellows.[22]

Other researchers have noted that some Australian aboriginal women – before the challenge from white society – had eighteen children, but that the population was stable. Child mortality – this has often been deliberate in cultures surviving from the Stone Age – held the numbers down, in a mechanism which we recognise but can hardly celebrate. It was noted that tribal people as varied as the Australian aborigine and the northern Inuit suffered food shortages and starvation.[23]

Sometimes, researchers find themselves suggesting things cannot have been rosy, without quite knowing how to explain the causes:

> Despite the research that has been carried out on food and food problems among the Inuit, many urgent problems remain unanswered. Indeed, recent work suggests we rethink conventional wisdom; for example, though it is generally held that the traditional diet was capable of providing all needed nutrients in sufficient quantity to maintain bodily health, the question remains why did the pre-modern Inuit live such relatively short lives?[24]

There is a very important failing in the Original Affluence view: it does not discuss the shortcomings of Stone Age culture. For instance, we may mourn the magical which permeated the Stone Age world, but we forget how inadequate and nasty superstition can be. When a tribal person casts a scapula into the fire to determine the next day's direction of hunting, he thinks it is magic which he is invoking and which is good for his chances of survival. Actually, he has stumbled across a way of systematising the random, and enhancing the sustainability of his hunting. But it is we who are putting proper explanations to his actions, not he. When a young African attempts a new way of growing food and is frightened out of the scheme by the

threats of witchdoctors, we are not watching the human spirit at its most enlightened.[25]

The Original Affluent Society view implies at least one really dreadful proposition: that we should only celebrate societies in which no one ever discovered and deployed a new way of doing things. The one characteristic which we can be sure of in Stone-Age cultures which survives today is that they have not had an important new idea since the Ice Age. It seems that only affluence, and, in particular, leisure, provide the environment in which ideas happen. But something more is needed: the new must not be seen as threatening. In such leisure as the modern Stone-Age people had, it seems that either no one had an idea, or someone else told them to forget it.

The people who found themselves living in the desert, in the rainforest, in the far north, had often been pushed into these uncongenial places where no farming was possible with existing technology, evicted by stronger or more vigorous peoples. Here is a fairly typical and plausible account of one way of looking at the Stone-Age cultures as they have survived in Brazil:

> A final factor which characterised the primitive groups on the inter-riverine uplands is that they were typically denied access to the [much richer] floodplain environment by the warlike activities of the riverine groups. It was the continued threat of slave-raiding, head-taking, and in some instances cannibalism which held the non-riverine groups in their less favourable environment.[26]

Hardly Original Affluence. Some primitive people hung-in there perhaps by doggedness and perhaps by genius, but in any case by the exercise of existing skills and with no obvious use for new ones. Some of the Stone-Age peoples living alongside the modern world and destined to enter it have been marginal for all their history; and others have become marginal. They are the people who never tasted, or who got pushed out by, progress.[27]

Human beings were never quite the creatures children's comics suggested. There is increasing evidence that humans were never great hunters, living exclusively or even mostly on meat.[28, 29] Certainly, humans were hunter-gatherers. But if modern Stone-Age people are anything to go by, their hunting was rather less efficient than we often suppose, and also it was rather less diligent. Anthropologists now suggest that so-called man-the-hunter seems to set out with his weapons when he is so bored with unpalatable vegetarian food that

he feels he must. The story gets even less romantic. It seems entirely possible that early humans did not even hunt live prey terribly often. There is a line of argument which suggests that early humans were, to a large measure, carrion creatures.[29] He was like the despised vulture or jackal, allowing other predators to expend energy and adrenalin in the chasing and killing part of enjoying a meat diet. Man hung about waiting for his opportunity when predators had gorged themselves on their kills and nodded off, or had left a recent kill in a tree. Then as now, the man who hunts to eat rather than to show-off prefers that his prey be small; only the bored court risk.

Human social order, and the sharpening of intelligence and communication skills, may not have depended much on the activities of finely-tuned, militarily-commanded hunting parties. They are more likely to have emerged in the process of humans becoming sufficiently mob-handed and socially sophisticated to keep other scavengers at bay and to share lucky finds with friends, relations and acquaintances. Human beings discovered what it was to be bound to the rest of society by a web of favours given and received; they were traders from early on. No wonder people even now so like the marketstall. Self-sufficiency, the battle-cry of Green thinking since the 1970s, is not something one can find anywhere in the human record, outside the mythology of desert islands and hermitages. Mankind has a long history of finding security in large networks and in trade.

It seems that people honed their intellectual and conversational skills, not in developing lines of communication within hunting groups, but in gossip.[30] Gossip is to debate what scavenging is to hunting. It is a catch-as-catch-can sort of a discourse. It is ignoble, vicarious and cheap. But it is sustaining. It is the stuff, not of what people ought to know, but what they want to know. It is not about lofty matters, but about what matters.

The rewriting of the development of our early self-image so that it portrays human beings as gossipy trading opportunist scavengers allows us to see farming as an advance, not a betrayal. The idea of mobile and brave individuals, families and bands on a more or less peripatetic, voyaging sort of life is very fetching. It resonates even now with the romance we all feel about moving on, impermanence, constant discovery. In our personal lives we feel diminished as we grow up, settle down, fill out and narrow our horizons in devotion to a family rather than the exploration of our lonely destiny. Naturally

enough, we think something rather boring happened to human beings when they became farmers.

Now, however, we can see things a little differently. 'Man the nut-gatherer' and opportunist scavenger of other creatures' prey and occasional hunter, was presumably always looking for cleverer ways of getting prey animals to be around, and to die, where and when they were needed. Preferably these techniques should not involve a chase and combat. As gatherers, people would constantly have been noticing methods by which useful plants could be on-hand rather than having to go to them. Instead of being miles from home and in fear, people probably preferred to be with friends, trading titbits of information and provender. The most useful survival strategy was to build the social networks which made people alert to the latest tricks of getting a living. Without being valued within a network one was too prone to disaster, too dependent on courage and too little on skill.

Early humans were not, by the way, as in tune with nature as potent Green myth would have it. The bison was hunted close to extinction in places and deforestation was rife.[31] We have much evidence of pre-farming people acting unsustainably and carelessly.

When human beings became farmers they fulfilled the destiny their intelligence allowed them. Opportunism and brainpower allowed living with less terror and more likelihood that the family could grow. People might have had more leisure. Clive Ponting's *Green History of the World* – one of the gloomiest books ever written about humankind – describes civilisation as the increasing development of human capacity to spoil the planet and of élites to tax the time and resources of the lower orders:

> The main advantage of agriculture as opposed to gathering and hunting is that in return for greater effort it enables a much higher output of food to be obtained from a smaller area. Once that greater effort has been made there is normally a surplus of food over and above the immediate requirements of the cultivator's family. This surplus can then be used to support and feed individuals not engaged in the production of food. The first non-farmers were probably craftsmen producing pottery, tools and other specialised items for the community. But ruling groups, probably religious at first and then political, rapidly took over the distributive functions. Societies emerged with large administrative, religious and military élites able to enforce the collection of food from peasant farmers and organise its

distribution to other parts of society. In parallel, unequal ownership of land, and therefore of food, rapidly emerged.[32]

Ponting's analysis says nothing about the glory of culture or the sweetness of compassion which also attend civilisation.

Some of his themes are echoed in the writing of Paul Harrison, one of the most experienced and valuable analysts of the potential value of small-scale farming in the Third World, but also a committed critic of the historical process of agriculture's development.

> Permanent agriculture brings with it hierarchies of wealth, status and power. Surplus grain can be stored. Land can be mortgaged and forfeited, bought and sold. Wealth accumulates in fewer hands. Status increasingly depends on amassing possessions, on hoarding rather than giving. Some people live not by direct cultivation but by directing or exploiting the labour of others. Classes emerge. Warfare spreads, and with it slavery. Male dominance increases. The ultimate consequence of permanent agriculture is the huge empire.
>
> Empire represents the total denial of local environment.[33]

And so on. Ponting and Harrison are trying to bring ecology and other Green insights to bear on a broadly leftish view of history. The strategy is to say that human beings were more noble and natural before they were farmers. It is wiser to see that people as farmers and traders, exploring innovation and exchange, are in direct descent from primitive humans. Human life is not a denial of tradition. The difficulty is that for a broad, romantic, leftist tendency of thought, the tribe is easily presented as a sort of idealised communist and anarchist society, and every advance from it – whether technical or social – a betrayal.

Notes

1 James Lovelock invented 'Daisyworld' as a deliberately simplified planet whose workings show how the albedo effect might switch on and off an entire biosphere. I offer 'Nurseryworld' to suggest how romantic notions may rob our thinking of proper depth.

2 Ernst Haeckel, quoted in Sheail, J., *Seventy-five Years in Ecology* (Oxford: The British Ecology Society Blackwell Scientific, 1987).

3 Lovelock, J., *Gaia: A New Look at Life on Earth* (Oxford: Oxford University Press, 1991).

4 Lovelock, J., *Gaia: The Practical Science of Planetary Medicine* (London: Gaia Books, 1991).

5 For a useful discussion on the tragedy of the commons, see McCormick, J., *The Global Environmental Movement* (London: Belhaven Press, 1989), pp. 73–4, and Hardin, Garrett, 'The tragedy of the commons', *Science* 162:3859, 13 December 1968, pp. 1243–8.

6 'The tragedy of the oceans', *Economist*, March 19 1994.

7 For a discussion of the lifeboat theory, and other lines of green political thinking, see Dobson, Andrew, *Green Political Thought* (London: Unwin Hyman, 1990). Also: Hardin, Garrett, 'Living on a lifeboat', *Bioscience*, 24:10, October 1974, pp. 561–8.

8 Prest, J., *The Garden of Eden: The Botanic Garden and the Re-Creation of Paradise* (New Haven: Yale University Press, 1981).

9 Mcribber, Bill, *The End of Nature* (London: Viking, 1991).

10 Bradley, I., *God is Green* (London: Darton, Longman, and Todd, 1990). The writings of Robert Murray are interesting here: they posit that man was understood to have been put in a position of kingship over nature, which, in the Old Testament, was a position of onerous responsibility as well as power. See Murray, R., *The Cosmic Covenant*, Heythrop Monographs, 1992.

11 I naturally prefer this second version of the messages which have been handed down to us, as I argued in *The Animals Report* (Harmondsworth, Penguin, 1982). See also Keith Thomas, *Man and the Natural World, Changing Attitudes in England 1500–1800* (Harmondsworth: Penguin, 1984).

12 North, R., *Fools for God* (London: Collins, 1987).

13 Chitty, Derwas J., *The Desert a City* (St Vladimir's Seminary Press, 1966).

14 See Ryder, M. L., *Sheep and Man* (London: Duckworth, 1983).

15 McEvedy, C. and Jones, R., *Atlas of World Population History* (Harmondsworth: Penguin, 1978).

16 *Ibid.*

17 *Ibid.*

18 Sale, K., *The Conquest of Paradise* (London: Hodder and Stoughton, 1991).

19 Lee, R. and DeVore, I., *Man the Hunter* (Chicago: Aldeno, 1972).

20 *Ibid.*

21 *Ibid.* p. 89.

22 *Ibid.* p. 91.

23 *Ibid.* pp. 204, 242.

24 Freeman, M. M. R., 'Tradition and change: problems and persistence in the Inuit diet', in I. Garino and G. Andersen (eds), *Coping with Unreliable Food Supplies* (Oxford: Oxford University Press, 1988), p. 164.

25 Author's notes from a visit to aid workers in Zambia.

26 Lee and DeVore, 1972, p. 24.

27 *Ibid.* p. 23.

29 Blumenschine, R. and Cavallo, 'Scavenging and human evolution', *Scientific American*, October 1992.

30 Dunbar, R., 'Why gossip is good for you', *New Scientist*, 21 November 1992.

31 Ellen, Roy. 'What black elk left unsaid, on the illusory images of Green pimitivism', *Anthropology Today*, vol. 2 no. 6, pp. 8–12, December 1986. See also *Anthropology Today*, vol. 8 no. 3, June 1992, pp. 14–15.

32 Ponting, C., *Green History of the World* (London: Sinclair Stevenson, 1991).

33 Harrison, P., *The Greening of Africa* (Harmondsworth: Penguin, 1993), pp. 33–4.

10

Wilderness and the Manscape: what we can really expect from the primitive

Rich people diminish wildernesses by insisting on visiting or otherwise exploiting them. Poor people tend to damage them by trying to get a living in them. This chapter looks at several conflicts surrounding wild places, and the wild creatures and tribal peoples which live in them. Nearly everywhere is a 'Manscape' now, and we need not mourn the fact. There is still plenty which is beautiful and a solace, both within the Manscape and in the remaining wilderness.

Making the wilderness into a Manscape

It is only a century or so since there were large parts of the world in which no human being, and certainly no white man, had trod. Much of it was almost literally fantastic and fabulous, a place for the imagination and myth. Suddenly, photography means that the planet, from its deepest, smallest most intimate details, right out to its widest totality, has been turned into images for us. We see the extent of the work of human hands, and the human presence, in places we once thought of as wholly wild. The whole planet has become, to a greater or lesser degree, a Manscape.

We have ambivalent feeling about the knowability, the familiarity, of the wilderness. It is a distant, vicarious, voyeuristic, and therefore false intimacy we enjoy, but it affects us very greatly. It brings with it the advantage that we have the wildness to think about and contemplate. But it also brings the disadvantage that part of its essential value – that it was not known – has gone.

It matters very much to us that there should be places in the world which are free of what we think of as human taint. It is no defence

when one damages a wilderness that it is very large or mostly unspoilt. We appreciate wildernesses because of their extravagant largeness, their uncompromising wildness. This means that a little damage can seem very great. This is always the problem with notions of purity. They are satisfyingly about completeness, integrity and lack of compromise, but proportionately vulnerable. Wildness is like virginity: you only lose it once.

But the loss already sustained in the physical and psychic quality of many wildernesses cannot be undone, and can only accelerate. Even the most environmentally friendly of us wants to visit wilderness, which means diminishing it. We know that many poor people have a sometimes desperate need to exploit parts of the wilderness. And we know that many of the people who count in poor countries will be both greedy and unscrupulous as they exploit wilderness. We have a strong sense of our own claim and the claim of others to intrude upon and exploit the wilderness.

As wilderness is lessened and intruded upon around the world we need to treasure what remains of it. But we also need to recognise that within the Manscape which we are helping to create, nature's workings retain their pulse and their capacity to offer spiritual and recreational sustenance.

Britain's dilemmas: conservation in small crowded islands

Conservation in the modern world is riven with contradictions. The most important is that the preservation of the wild, or of elements of wildness, in the modern world is a self-conscious exercise. This is very peculiar. We admire and seek to preserve the natural because it predates us, reminds us of primordial simplicities and perhaps because it is more powerful than us. And yet much of it can only remain because a very sophisticated tendency in modern society defends and promotes it.

As Keith Thomas argues in his seminal book, *Man and the Natural World*,[1] our appreciation of wildness is quite modern, and flows from our alarm at our power to damage it. The late-eighteenth century – its art, poetry and tourism – show us the change very clearly as crags and mountains and waterfalls suddenly become objects of admiration. Improved transport – a feature of industrialisation – revealed to discerning people places which had previously been almost mythic in their horror. But industrialisation – its

obvious ugliness – also alerted people to a need for a new aesthetic which put the natural world centre stage in a new way. The human hand was suddenly suspect, and people sought places where human work had not wrought any change at all.

But we do not merely look to very wild places as a source of naturalness. We appreciate farmland – very definitely Manscape – for its qualities of naturalness, even though it is of course far from natural. We almost deliberately forget, or pretend to forget, that the cereal crops or the pasture we see are synthetic. They certainly are not wild.

And yet we are right to detect within the British farmscape a visible and important thread of wildness. More obviously than in the rest of our urbanised lives, in the rural scene we can take comfort that there remains a pulse of the primordial. In the scurryings and buzzings of the hedgerows, in the aerial migrations and terrestrial hibernations, in the blossomings and denudations of the broadleaves, we know that alongside the rural scene, even one with tractor prints all over it, there continues a living world which could reassert itself if our civilisation came to an end.

In farmland, nature is waiting in the wings, and we can sense its presence. Oddly, though, much of that naturalness now depends on human hands. Much of the wildlife which has survived in Britain has done so only because it has found niches within the rhythm of farming life. This is the case to such a degree that many species would die out without the yearly passage of the plough, or the yearly cycle of haymaking and grazing. In other words, we see flowers and animals now whose life-cycle evolved alongside a primordial post-Ice Age British scene. But they managed to hitch rides as the scene switched from natural (say, pre-Stone Age), through semi-natural (Stone Age to medieval), to the (post-medieval and modern) farmscape we know now. These species appear to represent the ancient and unchanging, and yet are amongst us because of the lucky coincidence of relatively recent habits of farmers fitting their own needs.

Much of the modern landscape is a place in which nature is subject to arrested development. Many of our best-loved species would lose their niche and perish if what botanist Max Walters calls the interrupted succession were to come to an end.[2] An uninhabited Britain might return to the condition which gave the species a home in the first place, but if there are to be people on the islands then nature can

often only survive if there is management.

The nature of that management is now very self-conscious and artificial. Britain is full of worked places, and in many of them conservationists are allied with the farming interests in being worried that the present use may come to an end; conservationists and farmers make unlikely allies. The problem usually comes down to the sheer technical and human difficulty of maintaining old-fashioned, low-energy, low-input farming systems when labour is expensive.

Of course, this is not merely a matter of preserving such existing methods as are useful. Usually, even where farmers are working in traditional ways, the conservation interest sees room for improvement. Almost every type of farmscape, however traditional it looks, could be more lovely than it now is, and more useful to wildlife, if it could revert to uses which were normal before the Second World War. Such a farming system is achievable, but only at a cost. It would now be economically artificial even though it would also be more ecologically natural.

The evolving argument about the place of naturalness in the farmscape shades into a similar problem about what to do with Britain's few obviously wild places. Where the land is so poor it is not worth enclosing, we begin to feel we are leaving the farmscape behind. But we are still mostly in Manscape, often created by fire, and in any case mostly still used to some extent.

To get to these places, the nearest we have to wilderness, one must either rise to high and very desolate ground or move to the far north.[3] If we go as far north as Caithness and Sutherland, we find terrains which are positively frightening in their semi-Arctic desolation. Here, on Britain's boglands, is sub-Arctic tundra some of which has seen so little human intervention that one can almost say it is genuinely wild.

There are very few places in Britain where this is true, but in the 700 square miles of the Flow Country of these two counties, one finds large areas where it could plausibly be argued that it might be a good idea to cease all human exploitation.[4] During the 1980s, there was, famously, a big row about forestry in this northerly region, on the grounds that it would destroy the only stretch of such boglands in the country. In the end, some forestry will have to be allowed on land which had been bought on the understanding it could be planted. Probably little new planting will happen, and one can thank stalwart

campaigning, partly by the government's own nature watchdogs, for that.

Very few of the people whose sympathies were against the forestry and were for the open bogland in Caithness and Sutherland had ever seen the terrain they were defending, and not many could have described its ecological qualities. But it is natural enough that people will fight to preserve such wilderness as we have left, even if its claim on the affections of the nation is tenuous. At the very least, as campaigners always say, they are preserving the options of future generations. Our generation wants to defend wilderness for its very existence value. There is no better way of expressing the way that wilderness needs preserving whether or not it is valuable economically; whether or not we visit it; whether or not we have images of it.

In one sense, the fight for the Flow Country was a fight such as is continuously being fought throughout Britain. Nowhere in Britain is free of competition between various uses for the land, apart perhaps from the tops of a few mountains. Indeed we feel that there is human pressure on very much of the land surface of the country. We have the feeling that everything is up for grabs, that there are people with schemes for all the space in Britain, even some of the wildest.

To a certain extent this is true. Much of the land surface of Great Britain is a battleground between planning authorities and would-be developers. This induces a feeling of fragility about the wilderness, and it is not merely ecological, but political. At one extreme, there are fierce arguments about how proper it is to put a ski development into the Cairngorms. At the other, there is anxiety that the meadows near many rural towns are being turned into golf courses. Everywhere, from the Isle of Harris to the most commonplace lowland valley, we fear we are losing too much land, too much scenery, to roads, buildings, and quarries.

The British are a deeply suburban people, who dislike cities and like detached houses. The car has fuelled this taste dramatically, and given us expanded and rambling towns and villages. Their inhabitants work in greenfield factories (necessary not least for ease of one-floor operation by forklift trucks and other industrial machines), and shop in huge out-of-town supermarkets.

This 'rurban' scene is not merely expanding the element of the urban in our lives. One of its features is a curious uniformity, never before sensed so powerfully. Many people fear that Britain is in

danger of becoming monotonous, a place in which uniform archi-tecture and infrastructure spreads as a blight.

The regions of Britain are in large measure losing their variety and individuality. Where once almost everywhere had many small farms on which a wide range of crops and animals were produced, now regions tend to be dominated by larger farms which specialise. Where once, some regions had tall old orchards, or tall hopbines, or distinctive barns, now dwarf species are employed, and buildings are becoming standardised. British people fear they are losing the very heart of the British scene: traditional images, variety, smallness, regional distinctness.

A certain amount can be done to halt these advances into dullness. The state and the voluntary sector can fund the planting of desirable trees, or even whole orchards, and help other traditional signs of rural life. We could preserve old or even develop new nature reserves, and create new forests. Farmers can begin to market locally-grown and locally-processed foods. The planning system can insist on better design of buildings. More ambitiously, the planning system can refuse to allow developments such as roads and factories in inappropriate places. Common Ground, an important small group, are promoting many schemes, such as encouraging villagers to make maps of their surroundings in the form of works of art or craft. Common Ground also hold conferences in which ideas such as 'Local distinctiveness: place, particularity and identity' are dis-cussed.[5]

And yet it would be a mistake to imagine that the process of increasing rurbanisation and erosion of local distinctiveness can be halted. The arguments in favour of development, and the technological pressure toward a high degree of uniformity of infrastructure, are overwhelming. So are the processes by which localities lose their ancient cultural isolation and distinctiveness. Modern education and employment are both gained in processes which are nationally uniform, though they may afford individuals increasing freedom. Indeed, surely we see cultures moving toward almost a global uniformity in which individuals, rather than localities, find a distinctness?

This is not to say that the country will be overrun with roads, factories or anything else. The planning system and political pressure will apply a considerable brake to development. But it is hardly likely that the proces of development in the countryside can be halted, let

alone reversed.

An important strand of nature writing has emerged to mourn several different sorts of loss we sense as rurbia encroaches. Richard Mabey's work, perhaps especially in *BBC Wildlife* (a monthly magazine), expands on themes he made his own with his beautifully written book, *The Common Ground* (1980).[6] Growing up after the war in the Chilterns, Mabey knew the luxury of messing about in places where wild flowers were ordinarily available, without fuss or special reverence. His work was especially valuable in the late 1970s and early 1980s because he identified the way in which scientific conservation risked making the preservation of nature a matter of the cold museum-keeping of rarities. He stressed the value of the commonplace as well as the rare. His sense of loss attached to the decline in the commonness of some plants and wildlife as well as to the threat of their extinction.

Of course, Britain remains a beautiful country, and nature has not been banished. Counties as near to London and as threatened by suburbia as Surrey or Kent have handsome farmscapes with their fair share of wildness. Sussex is very rich in them. Move out as far as Yorkshire or Hereford – less than three hours from London – and England offers farmscapes which are not only beautiful but very extensive, and include larger elements of the wild. These are not wildernesses, though the Pennines and the Yorkshire Dales can seem ferocious and lonely enough.

And yet, even in places we think of as more obviously wild, we complain that people are doing damage or simply dominating the scene. There is something odd in coming across fluorescent adventurers such as droves of hang-gliders on Hay Bluff in the Brecon Beacons, in Wales. It is positively infuriating to find people driving cars on the sheep swards there. Intrusive as one might find both uses, the hang-gliders leave little impress behind them; the motorised intrusion seems both more offensive and more likely to leave a permanent impress.

Many people believe the Lake District to be too crowded. There is certainly erosion caused by walkers in some important sites. Yet, as one of its senior rangers has reminded me, it is possible to be five minutes from a road and in very wild places indeed. That is even more true of the uplands of Cumbria, north of the Lake District, or in Scotland. In December 1993, a woman climber died of exposure within two miles of a car park in the Cairngorms. The Scottish

mountains proclaimed their wild power forcefully during the early months of 1994: they claimed the lives of 16 walkers and climbers. Britain is a rurbia with teeth.

The American wilderness

The idea of the wild has always been far more potent in the United States than in the United Kingdom. America has never forgotten its pioneering, frontier, civilisation. The whites built their society, often within living memory, by invading terrain which they had to claim from wilderness. They also claimed it from the previous native inhabitants. Those who now defend wilderness values most fiercely have had to come to terms with the fact that the United States was in one sense a Manscape way back in the nineteenth century. The Indians populated it with human activity and meaning, though their ecological impact was fairly low.

But there remains a strong sense in which American history is about the conversion of primitive landscape into Manscape. Responding anxiously to this feeling, many Americans harbour a desire to see at least part of their country, and especially the West, as their great grandparents did, virgin, entire, rugged, unpolluted by human activities and intentions, full of prospect.

Certainly, the country is large enough and much of its terrain rugged enough for there to be plenty of room for an argument about how intrusive human beings should be. Should people be allowed in territory wild enough to support, even now, such creatures of the immediate post-Ice Age world as bears? Does it matter if careless tourists get eaten? Or suburban joggers mauled by mountain lions? Are the modern motorised hunters really – as they fantasise – in the tradition of the frontier human? Or are they merely fostering a gun culture which kills people on city streets? Should coyotes be hunted? Should fires in Yellowstone be regarded as natural and allowed to rage, or should they be fought?[7]

In recent years, there has been intense debate as to what controls and costs should be imposed on ranchers who keep cattle on publicly-owned lands in the western states. Should they be allowed to plant nutritious grasses? Should their cattle numbers, and the pattern of grazing, be more rigorously controlled? More practically: should ranchers pay a proper price for the grazing rights, even if doing so risks the survival of the most fragile family businesses?

It is a common view amongst romantic and especially Green-minded Americans, that the cowboy wrecked and is wrecking the purity of the prairie with his cattle. Many young campaigners in the 1970s were impressed by the novelist and essayist Edward Abbey, and the founders of the radical group, Earth First!, drew inspiration from his book *The Monkey Wrench Gang*. Here he is in full flood against ranching:

> Overgrazing, I think, is much too weak a term. Most of the West, and especially the Southwest, is what you might call 'cow-burnt'. Our public lands are infested with domestic cattle. Almost anywhere and everywhere you go in the American West, you will find herds – *herds* – of these ugly, clumsy, shambling, stupid, bawling, bellowing, stinking, fly-covered, shit-smeared, disease-spreading brutes. They are a pest and a plague.[8]

The argument appears simple enough. The proper, natural, inhabitant of these places is whatever wildlife it would primordially have supported, and – at a stretch – the Indian who sustainably and bravely predated the herds of wildlife. There is a burgeoning movement which sees the reintroduction of the buffalo as a distinct possibility, and in some quarters a feeling of fitness in the prospect of the cowboy finally losing his old battle with the Wild West and its 'proper' inhabitants.[9]

Actually, as usual, there is a middle way.

One of the most serious and considered writers on the entire set of western states issues – water, grazing, mining, forestry – is Charles F. Wilkinson, a law professor at the University of Colorado. In *Crossing the Next Meridian: Land, Water, and the Future of the West*, Professor Wilkinson argues that the catchy slogans of the romantics – 'Cattle-free by '93', and 'No Moo by '92' – indicate an inappropriate approach. He believes that the controversial and long-running attempts by successive US administrations to raise the fees ranchers are charged on rangeland may also be misdirected. The risk is that increased fees might make ranching impossible for small-scale operators, but that the land-use which replaces them may be no better for conservation.

Meanwhile, according to Wilkinson and many others with practical experience, there are workable management policies which allow cattle and soil conservation to live alongside a tolerably thriving rural way of life. Certainly, it has often been pointed out to

me that there are far fewer cattle on the prairies now than there were in the 1930s, while coyotes, mountain lion and elk are all doing well in many western states.[10]

Those who argue that vast areas of prairie should be returned to their natural state do so on the premise that modern cowboys, and their ranching are intrusions. This is fine for someone who wants to wind the clock back to some supposed pre-white period. But it seems odd that purists should ignore the claims of the modern cowman, or any of the descendents of the romance and mythology of the west. There is a strong vein of modern writing which convincingly celebrates the toughness, and above all the hopefulness, of many of the parents and grandparents of the present westerner. True, many of the old-timers died of drink and general failure, and many were exploitative in their ambitions. But they had a great dream, and that was worth a good deal.[11] The cowboy and his family are, after all, people who are preserving some important American traditions which, it might be argued, matter at least as much as wilderness. Rural America and its links with the peasant cultures of Europe have real value, and make a useful counterweight to the politically correct world of urban America and the rootlessness it also represents. Indeed, it is the emergence of an urban class in previously rural western states that most produces extremist, if voyeuristic, demands for 'pure' wilderness.

In the closing months of 1993, the US administration, in the person of Bruce Babbitt, the Interior Secretary, tried to work out a workable management programme for public lands. The plan appears to be of the kind which might appeal to Charles Wilkinson, but neither to Ed Abbey nor the average cowboy. As the *Washington Post* had it:

> It is a 'New West' regulatory structure. But it has run into an 'Old West' mythology, which western senators have ably exploited to win the support of colleagues from other regions who have no public land grazing in their states.
>
> 'The mythology is the big barrier,' Babbitt acknowledged. Although public land ranchers are a tiny group, he said, they are able to exercise significant influence 'because of the culture and history and mythology of the West in which the image of the cattle rancher has come to embody – through popular fiction, movies and the Marlboro man – all of the American virtues'. His home state of Arizona, Babbitt notes, is far more more urbanised than Virginia and has fewer cows

than West Virginia. 'But that mythology kind of gets in the way of reality.'[12]

Given the different terrain and the different questions its raises, it is not surprising that the US conservation movement should be very different from Britain's. Right from the start, the US movement's heroes were concerned with big spaces, especially in the previously Wild West. While the British were constructing a conservation movement around farmscapes (admittedly in the quite wild Lake District), and – even more – round old houses and their parklands,[13] the Americans were designating some of the wildest places as pleasure grounds for the people.

It is certainly good to know that the more wild areas of the American West are preserved, if not intact, at least for rude rusticity and backpackers. Doug Peacock, a man with an intense admiration for Edward Abbey, and someone who loves the American wild, and grizzly bears in particular, once told me that such places should be left unwardened altogether and that much more of America should be allowed to run wild properly.

Doug Peacock believes that grizzlies and humans simply do not mix, and that in such encounters as they might have in an ideal world, the grizzlies' rights would be respected. The essence of his view is that trying to manage places so as to accommodate wildlife and human beings misses the point if it favours the latter, while real wilderness has few human friends:

'Wilderness' is what keeps conventional wildlife management from speaking up for grizzlies. There is no paycheck in wilderness, nothing to manage. Yet human intolerance keeps anything less than true wilderness a deadly battleground where grizzlies always lose and die. The bears could probably adapt to us but we have not given them the chance. We don't maintain a culture that allows us to live with another clever and predatory species. So for now, grizzlies must have wilderness.

And that is fortunate because humans need it too, since, cribbing from Thoreau: In wilderness is the preservation of the world. In practical terms, this means tearing up roads and parking lots and dismantling buildings, and saying no to capitalism or socialism of any size or variety. Grizzlies need big, uncompromised wilderness with no trails, scenic flights, human conveniences, human management, or 'improvement' of any kind. The wilderness has to be there for its own sake, and for the grizzly.[14]

In the mid-1980s Earth First!, under the leadership of David Fore-
man (who has since left the group, thinking its approach too uncom-
promising) developed maps of the United States in which vast tracts
of land were to be abandoned to nature. Instead of the present 2 per
cent of the nation which is gazzetted as wilderness, Earth First!
proposes 30 per cent, some of which would be reclaimed from
human management. More famously, Earth First! campaigners were
above all activists. In line with the ideas in Ed Abbey's most famous
novel, they spiked trees by driving nails into them to foil the
chainsaw, pulled out survey pegs, and disabled earth and tree
moving equipment by putting sand and sugar into fuel tanks. Dave
Foreman published *Ecodefense: A Field Guide to Monkeywrenching*
as a manual to these activities.[15]

A prime difficulty for these romantics, but also one of the greatest
spurs to their activity, is the strong utilitarian element in American
conservation. There is a powerful American tradition of the
exploitation of wild resources. Right from the start it did not seem
inconsistent to preserve the wild – as Gifford Pinchot sought to do
when he invented the Forestry Service under Teddy Roosevelt – and
to pursue its productivity.

It is the competition between these lines of thought which has
made the Pacific Northwest into a battleground in recent years, as I
found when I visted there in April 1993.

Missey Barlow is the daughter and granddaughter of people who
pioneered white homesteading on the banks of the Hoh River, in the
Olympic Peninsula, the most westerly point of the United States.
'When I was a girl, the only way you could see a hundred yards was
to look straight up,' said Missey. 'You couldn't see out. You just saw
the trees.' Elizabeth Barlow is a born woodswoman, and dislikes the
way the 'Greenies', as she called them, have shut down parts of the
industry that she has watched for years as it transformed what was
plain wildwood into working woodland.

'This family is supported by timber dollars', says sign after sign in
the few streets of nearby Forks, the logging capital of the world.
Missey Barlow so forgot her good breeding as to swear lightly when
she mentioned the spotted owl, which has put so many out of work.
It is the Greenies' favourite bird and the symbol of the most famous
and furious conservation row in the country. In the end, President
Clinton had to go to Portland, Oregon in April 1993 and conduct
one of the seminars in which he excels. He convened a committee of

experts and their advice is out for consultation by all the embattled parties. The president's team suggested a new low level of harvest, some new conservation measures, some money for hard-hit logging areas. President Clinton may be able unblock the legal logjam which has brought much logging to a halt, but he will be lucky to satisfy both the Forks folks and their Green critics.

'You won't find a moonscape here, you know,' one outspoken Forks pro-forestry campaigner told me on the phone before I arrived. 'The filmmakers find places which look bad, that's all.' And yet in the last half hour of my flight from the east to Seattle, the pilot took us low over mile upon mile of mountainside which looked like a severe case of alopecia. Logging has made a patchwork of wooded areas and more or less square bare bits. Down below could be seen exactly the scenes with which the Wilderness Society worries its members. Not a moonscape, perhaps, but certainly a Manscape.

Armed with this sort of impression, the outsiders flock to Forks, and vent their feelings on the locals. The ex-logger who helps his wife run a fine bed and breakfast in town is fed up with guests berating him for having contributed to this insult to the paradisically wild. Yet the more time one spent on the ground, the easier it was to overcome initial disquiet. The Olympic Peninsula is an extraordinary place. Within sight of a big snow-capped mountain range, there is – towards the Pacific coast – an expanse of cloud-enshrouded temperate rainforest, with swampy land from which rise (and quite often fall) moss-clung fir trees. In between, there is some old growth, or natural, dry forest and a good deal of land which has been clear-felled.

It was great timber country until someone discovered that the northern spotted owl was sometimes found in the woods, as it is sporadically all over these states. The bird is quite rare. Wildlife officials decided that the owl needed protection under the Endangered Species Act. As the years have rolled by, more judges have ordered the US Forest Service and private owners to leave successively bigger tracts of trees unfelled wherever an owl is found. By 1993, in the Pacific Northwest, 5.5 million acres of forest, much of it one-time ancient forest which was harvested and replanted years ago, are no-go areas in consequence of the owls. Some conservationists have proposed doubling that area to keep the bird's population intact.

Even presidential plans for a reduced harvest and a reduction in

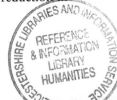

the forbidden areas will probably cost the US economy billions of dollars. Presuming there are perhaps three or four thousand pairs of spotted owls, this is conservation at several million dollars a nesting pair.

It is true that the economics behind this kind of sum are suspect, and that the industry had been cutting jobs by raising productivity, but even so the conservationists seem content that thousands of their fellow countryfolk lose their jobs on account of preserving owls. The loggers say they are keen to preserve some owls, in some forest, but not every owl, wherever it is found. This view is regarded as hopelessly pragmatic, and worse. 'Maybe they don't see me as a child-molester or a bank-robber', said Gerry Lane, a mild-mannered manager of a timbermill, 'but I'm right there on the same page.' He pointed out that the United States can have its timber from home production, or from Canada, Brazil, or Siberia. Is the wildlife any safer in these other countries than in the strict United States? Would it not be better, says Lane, if Americans realised, as they used toilet paper, and lived in timber houses, that things cannot be perfect, but can be acceptable?

The reason the public seems unwilling to compromise, according to Bob Lee, a sociologist at the University of Washington, is quite simple. 'We are watching a religious conflict,' he said. 'There is a fundamental philosophical position which is impossible to budge. In this whole argument you see very little movement on the conservationists' side. Out in the logging communities, it's different. Those people fight the neighbours, but in the end they've learned to give and take. People can have the National Parks as their sacred territory, but in exchange they ought to accept that much of the rest of the world must be at least a bit profane.'

Missey Barlow thinks the Greens' position is in any case mostly ecological nonsense, and has a botany degree to back her opinion. She drove me along miles of road with tall, substantial trees on either side. In the very early 1960s, this patch of country had been clear-felled and replanted. It is now, she points out, a legal requirement that all felled forest be planted. We measured one of these new-growth trees. It was 18 inches in diameter. That is not a lot compared with the 18 feet diameter of a 600-year-old spruce we found standing alone in a meadow on a friend's land. But it is no sapling, and is one of thousand upon thousand trees that have grown in a logged habitat which at first provided open ground for the huckleberries and for elk.

Reforested areas soon boast a canopy which closes over to become pretty convincing woodland, complete with mushroom haunts whose location Missey guards even from her friends. Yet this is the kind of silviculture which conservationist bumper stickers condemn with the slogan: 'Tree farms aren't forests.'

'It's Kafka-esque', said a youngish US Forestry Service manager. 'I joined in 1976, and I was a rebel. I said, "Look, we're cutting the forests too fast." ' Now, he thinks, it is time to realise that after twenty years of reforms, the serious part of the conservationists' case has been met, if they did but know or care.

Of all the original forest area in the Pacific Northwest that the whites took from nature and the Indians, perhaps 10 or 15 per cent is left, and about a quarter of it is protected by being in National Parks of one sort or another. On the Olympic Peninsula, the proportion of protected forest is far higher: there are a million acres of National Park, half of them wild forest. Here, there are very small amounts of old growth outside the parks system. The majority of the logging which people see and worry about has been taking place in secondary growth in various ownerships. About a third of the logging has been in land covenented decades ago to help provide the local education budget, as a school governor pointed out as we flew over the terrain in his friend's Cessna.

Region by region, the argument now revolves on how much old growth should be preserved, and the degree to which secondary growth can be made to imitate some of the ecological value of old growth. According to the Forestry Service manager, the conservationists are on weak ground when they say they want to preserve the spotted owl by refusing to allow logging. The owl likes to eat small mammals, and these can thrive in managed forests which are managed in the right way. The birds have presumably got a living ever since the Ice Age because vast areas of natural forest are blown down in hurricanes (as happened on the Olympic Peninsula on a huge scale in 1921) or are ravaged by fire (as they tend to be every couple of centuries).

The foresters believe they are, at least to some degree, imitating nature's own habits. Forests are subject to natural disasters, which open up the habitat to species which like sunshine and can re-invade. 'My idea is that nature creates enough of a surplus for man to come in and take a share without doing any harm,' said the forestry manager.

He took me to places where the loggers should have left trees near to streams and in steep gullies, so soil did not collapse and wreck salmon spawning areas with silt. He pointed out roads which were poorly-designed and have an alarming tendency to slide downhill. But he pointed out places where better practice has been employed, and seems genuinely excited by the prospect of spreading the best practice everywhere.

One of the men who seems to have impressed the President is an ecologist, Professor Jerry Franklin, of the University of Washington. This academic has proposed that loggers should take their harvest, in old and secondary growth, but leave various trees, young and old, healthy and broken, so that as the new growth of trees occurs, it happens in a habitat which resembles the natural processes which follow natural catastrophe. This will especially help birds like the spotted owl, which nests only in rotting cavities and the jagged ends of snapped trees.

This tendency upsets some conservationists who feel that it allows the thin end of the commercial forestry wedge into what should be pristine old growth. In any case, Dr Franklin has irritated many locals by cornering the market in praise for these ideas. His critics counter that his so-called new forestry is not as revolutionary, as certain of success, or as cheap, as he claims. A colleague and – one suspects – a rival, Professor Chadwick Oliver, at the same university, believes that he has useful ideas about how to manage growing forests so that they quite quickly imitate some of the qualities of old growth. His message is preferred by the industry, but respected by some conservationists, too, because it looks capable of delivering profit as well as species.

Chad Oliver believes conservation and timber go together and that the Greens are barking up precisely the wrong tree when they get the loggers locked out of timberlands. 'The tendency is for people to argue that the forest ought to be kept in a particular structure which is actually not good for the owl or for timber production, either. It would be better if we could get in and do very selective thinning.' In managed forestry, the thinning is vital to help human beings imitate nature, create owl habitat, and allow the remaining trees to grow into more profitable timber. It is forbidden in large areas at the moment.

Pete Larsen, who flew the school governor and I around the Peninsula, has got a welcome contract to explore new ski-lift style

cable methods for thinning steep slopes where ordinary machines will not go. These new techniques are costly, but should demonstrate what human intelligence and effort can do. 'I am not saying we can instantly create old growth forest,' said Professor Oliver. 'But we can go a long way to mimicking many of its characteristics. People just don't seem to realise that lots of old growth really isn't always that old.'

Some of the things Oliver argues for would help earn money as well as mimicking natural processes. In the end, the further one goes in imitating nature, the more one restricts human harvesting, and yet some combination of the ideas of Chad Oliver, Jerry Franklin and the industry should produce a biologically-rich and a profitable forest. It will dent profits without satisfying purists.

Such an approach will not rid the landscape of the patchwork of clear-felled land and forested land. 'You don't mind that back in England, do you?' said Gerry Lane. 'You have wheatfields, and then stubble, don't you? D'you complain about the stubble?' Well, no we do not. But the felled areas will always shock the heart-and-soul wilderness-fancier.

The best of US conservationists are of course pretty sophisticated. Michael Anderson, working in the Seattle office of the Wilderness Society, demonstrates that conservationists come in many hues of green. Having achieved the preservation of a good deal of wilderness, this conciliatory campaigner thinks the conservationists' job has changed. 'Our emphasis has shifted more to maintaining diversity. That requires us to look not just at pristine forest but at stuff which is a lot less pristine.' This new purpose will bring the society into conflict with foresters, but it will also from the start require the conservationists to consider what is practicable and negotiable.

Michael Anderson and the foresters could easily enough put together a deal which would satisfy most of the people who know anything about the terrain. Of course, President Clinton's problem is to know what will satisfy Missey Barlow's disliked 'Greenies'. As the frontier spirit in America gives way to suburbanism, and as pioneers become yuppies, compromise is even thinner on the ground than owls are.[16]

Tropical wilderness: the scene of 'ecolonialism'

In most poor hot countries it is clear that only brilliant new politics
can resolve the very fierce competition which exists between poor,
numerous would-be farmers and the wildernesses they see around
them. The extraordinary thing about the better-run countries in
Africa – Zimbabwe, Zambia, Botswana, Kenya, to name four I have
some experience of – is not how little wilderness or wildlife they
have, but that they have as much as they do.

Before the white man came, in many of these countries few people
had much use for wild animals. There were, certainly, some hunter-
gatherers for whom animals were a – generally rather small – source
of nutrition. There were seasonally nomadic herders for whom
hunting predators such as lion had a social though not a dietary role.
For many such people to need to eat wildlife was to have failed in
god's work, which was the ownership and management of cattle.
Amongst the majority of people, who were farmers of one sort or
another, some herbivores were not useful for the pot, while many
wild animals were a nuisance.

The majority of black Africans had little reason to love wildlife
and were hungry for farmland. After all, the white rulers had
effectively co-opted for themselves the best land as, before them,
previous generations of incomers (black, but incomers none the less)
had barged weaker peoples out of their way. White people had not
only taken the best farmland but had insisted that their leisure lands
be kept sacrosanct, as European monarchs had once done in the
northern hemisphere. Having hunted out many parts of their new
home, whites demanded that the last strongholds of wildlife be kept
free of human interference.

Many of the great wildlife parks in Africa exist because white
people believed that they were necessary as preserves for hunting or
for wildlife conservation (the two were intertwined in people's
minds). In some, nomadic herdsmen were allowed their seasonal
invasions if they did not do too much harm, which was assessed by its
interference with wildlife. In others, they were excluded altogether.
In none were arable farmers allowed to encroach, however hungry
their existence on the fringes of the parks might be (of course, the
rules were often broken). Sometimes, it was argued – with greater or
lesser correctness – that the territory inside parks was inappropriate
for human use because of its tendency to erode under the feet of cattle

or the plough.

Cynically, one could say that the parks are now maintained because they earn foreign exchange through tourism. But it is also interesting to see that part of the modernisation of Africa is evidenced in the way, increasingly, even quite poor black Africans are becoming excited by their wildlife.[17] That is a measure of how much they are becoming like westerners.

There are now three crucial problems in preserving the areas of Africa which are kept free of intrusive use by people. One is to define what sort of balance of wildlife is the version of the natural state of affairs one wants to maintain. Another is to make the preservation of wildlife areas attractive to the people who have power in Africa. Another is to reduce the conflict between wildlife and those who live in or near national parks.

None of these is easy, and some powerful western conservationists make each more difficult than it would otherwise be. The modern west's ecological bullying is very unattractive. 'Ecolonialism' is often as thoughtless as the previous colonialism sometimes was. Ecolonialism does not even see the real problem: how to maintain wilderness alongside people in Africa. In modern times, the western world's love affair with wildlife effectively blinded us to the existence of humans in Africa. The African human as a person with a claim to African territory became invisible to western eyes as celluloid and video by the mile was expended to extol the loveliness of the animal world there. The human world in Africa was represented as tragic when it was not pathetic, as ugly when it was not dowdy. By comparison, African wildlife was obviously glorious.

The media has been especially preoccupied with one problem which has penetrated the mass western consciousness: how to stop animals, especially the African elephant (and to a lesser extent, the rhino) becoming extinct. In the case of the elephant, the argument is usually based on a misreading of the problem. There is not the smallest chance of the African elephant disappearing. It is doing well in many southern African countries, and has been at risk only in some countries where important parts of the governing élites have often connived at the poaching which reduced elephant populations.

The modern ecological understanding is that the plainslands of Africa gradually switch between being relatively wet and dry, according to quite long cycles of climate change. But beyond that, the mix of wildlife species determines and is determined by a cyclical

variation in the balance between trees, grass and scrub. The Masai Mara, for instance, is presently mostly grassland, with very few shrubs or trees. This is because of the presence of a good many elephants.[18] It is hard to tell what would happen if the number of elephants grew very rapidly, as it is known the population of this animal is prone to do, left to itself. It seems likely that they would soon suffer a dramatic decline as they ate themselves out of their home or became prone to epidemics of disease. There is a line of argument which suggests that the rise and fall of elephant populations, which can be very dramatic during drought years, should simply be allowed, because they are part of processes which work themselves out in changing, but rich, habitats.[19]

Others argue that it is proper and acceptable for human beings to cull populations of elephants when they are large enough, just as it is proper for them to take a harvest of kudu or any other abundant, meat-bearing species. An active policy, this argument has it, carries the advantage of bringing profit to parks while maintaining a degree of stability to the ecosystem. The culling could, in principle, mimic the parks' natural cyclical processes. Against this acceptance of human interference, questions are increasingly being asked as to whether the elephant is a specially intelligent and sensitive animal with a strong sense of family and even of impending doom.

The elephant issue is hotly debated because of the huge potential value of elephants as bearers of ivory, trading in which has been banned since 1989. The small but growing profession of resource economists has seized on the problem.[20, 21] What could be more natural, they argue, than that conservation should thrive alongside the ordinary rules of supply and demand? This line has garnered considerable support from several southern African states, notably South Africa and Zimbabwe.

The anti-culling, anti-ivory trade argument, as heard in Kenya and among its western supporters, says that any trade in ivory legitimises ivory as a product and makes its appearance in markets outside Africa hard to regulate. In other words, a trade in ivory would encourage poachers to supply a parallel, illegal market. Do you not see, this argument says, that ivory poaching has diminished in Kenya since a ban on the ivory trade in 1989? Yes, the sceptics say, but it diminished partly because Japan, one of the main markets, imposed the ban. So orderly a country would make just as good and orderly a market for a controlled trade.

Besides, say the would-be ivory trading nations, Kenya's poaching declined because the country finally policed its parks properly. Under a tough and charismatic Director of Wildlife, Dr Richard Leakey, the country was also much tougher with the illegal immigrants who famously turned poacher, and this happened to coincide with the ivory ban. Certainly, the Kenya Wildlife Service began to stress the importance of good policing in parks, to protect both tourists and elephants from criminal predation.[22] In March 1994, Dr Leakey resigned because he felt his policies were being undermined by tribal politics and corruption: it was widely feared that policing in the parks and beyond might slip as a result.[23] The WWF-Worldwide Fund for Nature, although it is a recent proponent of a ban, has produced a survey which accepted that in many countries (it did not study the Kenyan case), policing is very important and implies that it is very difficult to untangle the effects of increased policing and those of the ban.[24]

In the west, many people have firm views about the ivory trade: they mostly feel strongly that it should continue to be banned. These views are natural enough, given that in the west the media's coverage of the issue was for years dominated by reports from writers who overwhelmingly accept the Kenyan case (perhaps especially as put by Dr Leakey), have visited lovely Kenyan reserves, and have met Kenyan wildlife experts. The case of the Southern countries is much less heard, and the elephants it discusses live in parks which are much less famous than those in Kenya. But there is another reason – an important one – why the Southern countries' case has not been heard.

In the late 1980s, the World Wildlife Fund (as the WWF was then called) was undecided between the cases for and against the ivory trade. Some of its most committed and experienced staff and consultants believed the pro-trade, Southern countries' case. Others, perhaps more politically astute, thought that the Kenyan case had merit and more appeal in the west. By the end of the 1980s, WWF had given up its position of uncertainty and put its weight behind the Kenyan case. It was said at the time that its supporters in the United States had made it clear they favoured the 'no culling, no trading' position and that the Southern countries' experts – with their predominantly British connections – should be overruled. WWF argued in favour of a ban in the relevant international forums, and so contributed to the formal outlawing of the trade in 1989.[25]

One complication is that the income many countries derive from tourism is always likely to be far more important than their income from ivory. Anything which worries tourists worries such countries. Part of the case put by westerners in favour of banning poaching is the view that tourists will prefer to go to parks in which there is nothing so unpleasant as culling going on. It might be counter-argued that, other things being equal, tourists ought to to try to understand the needs of the poor countries which they visit.

A rich irony lies behind the elephant issues, and it shows itself in other important arguments in what has become known as wildlife utilisation. Modern colonialism – in the form of ecolonialism – often exports to the Third World values which the west can perhaps afford but which the poor countries of the world cannot. The west thinks the wild world is of value in and of itself. In poor countries, the wild world can only hope to stay wild if it is seen to be of definite economic or subsistence value.

In 1988 I joined a party of journalists being shown various projects sponsored by WWF in Zimbabwe and Zambia. All the projects we saw involved culling wildlife populations for profit and food and all were admirable. In some cases, outside National Parks, it was a case of allowing hunting in exchange for fees – a doubly profitable form of culling. Officials were trying to work out hygienic ways of ensuring that local people could have the benefit of the meat from such animals going into their markets. In the meantime, there had been a good deal of progress in ensuring that villagers neighbouring National Parks received a share of the income from the parks.

In one remarkable place,[26] we were shown a ranch which had once been overgrazed by cattle for small and diminishing profit. The owner had now got rid of his cattle and allowed the wildlife of the country to repopulate his thousands of acres. He was in the safari and wildlife meat business now, and his acres were greener as well as more profitable as a result.

It was not long before British television got hold of stories such as these. 'The Cook Report'[27] made a programme which described the WWF as condoning cruelty and nastiness. The programme-makers could not or would not see that there is an excellent and serious case that wildlife populations living in thriving ecosystems make a better source of nutrition and income for Africans than do half-starved cattle on denuded terrain. Nor did the film-makers consider that, without generating income and pushing it toward local people, it is

very hard to persuade African farmers on the eroded fringes of plush green nature reserves that they should avoid grazing their animals on the lusher pastures inhabited by protected wildlife.

Cook's criticism notwithstanding, WWF was and remains involved in these most heartening experiments in all the history of conservation in poor hot countries. WWF is trying to find ways of making wildlife, habitat conservation and human needs mesh together so that none of the elements need lose, and all gain.

Another big mammal, or: how many whales do we need?

Everyone knows, do they not, that whaling is wholly indefensible and that the Leviathan of the deep is being hunted to extinction? On millions of bedroom walls in the west, there are pictures of the tail-flipper – a fluke, in the proper terminology – of a whale, making a big splash in the Pacific, Indian or Atlantic oceans. The whale is the ocean elephant: a huge mammal, a symbol of the wilderness, a mighty imponderable, a creature of dinosaur mystery and bulk. Our hearts go out to the creature which we are told sings, communicates, even thinks and feels rather like a human, and whose very existence is threatened, not merely individually – which would be bad enough – but as a species.

Every few years, there is a flurry of excitement in the media as the International Whaling Commission (IWC) meets to decide the fate of the whale. Above all, the media and the campaigners nearly unanimously agree, we must fight off the moves by the Japanese, Icelanders and Norwegians to return to the whaling which only the brave actions of the Greenpeace Zodiac inflatables and their supporters halted.

Some species of whale certainly were, and some of them may still be, commercially extinct. This means that their numbers were so suppressed by hunting that it would not be worthwhile now to go out in ships and try to hunt them. The whales exist, but in small numbers. Out of the 38 species of whale there is none which have been hunted into actual extinction.

It is also the case that the very limited whaling which has been allowed by the IWC since the overall ban, and whose avowed purpose – scientific investigation – has often been a sham, did not seriously threaten any species of whale with extinction, commercial or otherwise. In the case of at least one species, the minke, there are

several populations around the world whose numbers either always were at, or have returned to, the point where a limited hunt could be sustained. The minke is the smallest of the fully-fledged whales.

Japan, Iceland and Norway (let's call them the JIN countries) all have closely available to their shores large populations of minke. All these countries would like to exploit the minke in a controlled, small-scale and sustainable way. All the countries would like to allow only small boats with small crews to do the hunting. All the countries want to do so because there is a good local market for the meat of the whales in question. They all claim that the people who want to go whaling are fishermen who live in rugged places where the marine harvest is the principle means of getting a living. They all claim that the means of hunting will be explosive harpoon which ensures that death will usually be rapid (nearly instantaneous) and very seldom protracted (beyond half an hour).

These arguments all seem sound enough. One could counter them with several others. The countries are all rich and could easily enough put the would-be whalers on the dole if their fishing activities cannot provide them with a living. In any case, it can certainly be argued of the north Atlantic fishermen that they would now be getting an easier and better living from ordinary fishing if they had not exploited the stocks of cod and herring to the point of near commercial extinction. The fishermen are partly to blame for their plight. There are bound to be some poor or less lucky shots amongst the harpooners. Some whales will suffer, perhaps horribly.

To help understand the way the IWC handles some of these issues, it is necessary to see the way it has changed fundamentally over the years. The IWC has gone, in essence, from promoting a classic sort of conservation to promoting a welfare sort. Beginning as a body to regulate whaling for the convenience of whalers, it was and remains a body in which national governments vote. It is thus open to whatever political pressures governments come under, and it gradually became concerned to conserve whales for quite different reasons than the convenience of whalers. Nonetheless, the IWC has never changed the terms in which it does its conservation work. Its rules allow and insist that whenever a stock or population of a species of whale is large enough, the IWC must say so and begin to allocate sustainable quotas to the countries which ask for them. It cannot, without changing its rules, say simultaneously that a stock is sufficient, and that hunting the stock remains forbidden.

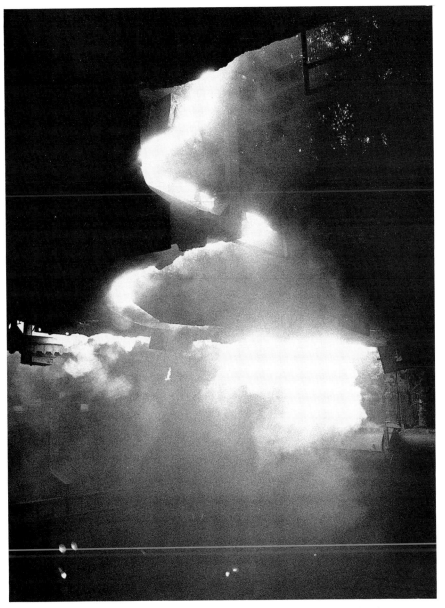

10　The open heath furnace at Huta Lenina steel works, Poland, taken in
1989 when eastern Europe had succeeded in its revolution against the So-
viet empire and westerners first had to fully grasp that the state-subsidised
enterprises were as polluting as they were inefficient. Furnaces of the kind
shown had become obsolete in the west thirty years earlier.

11 Beach salesmen take a break in Mauritius. The tropics represent a heaven on earth for tourists, but the travel business threatens a sort of 'paradise theme park'. Mauritius can at least claim that much of its tourism enterprise is local.

12 Thin cattle on poor land in Zimbabwe. Some farmers are instead giving land to wildlife which thrive and do less damage to the ecosystem while providing meat and hunting revenue.

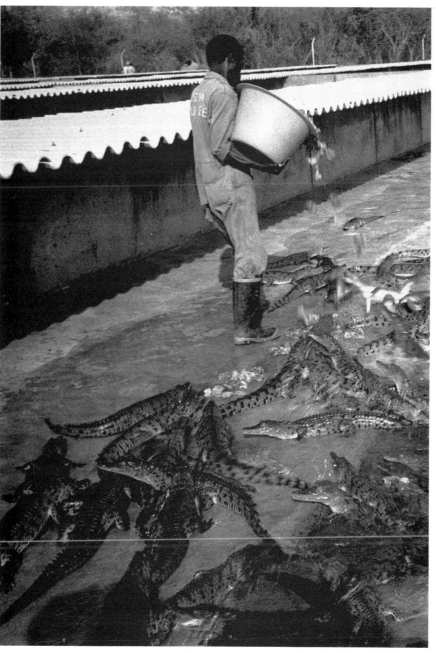

13 Sustainable resources: crocodile farming in Africa.

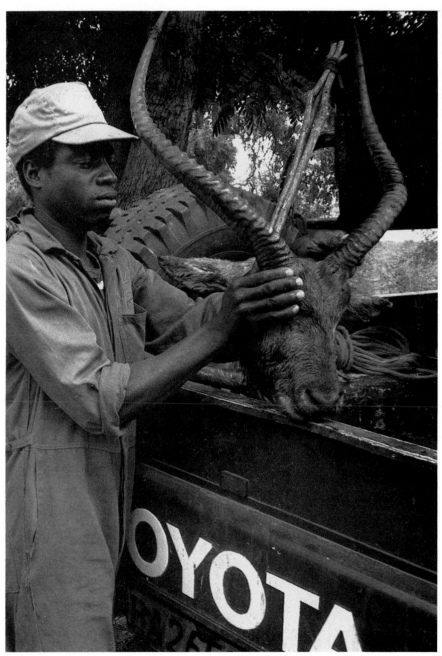

14 Sustainable resources: antelope hunting in Africa.

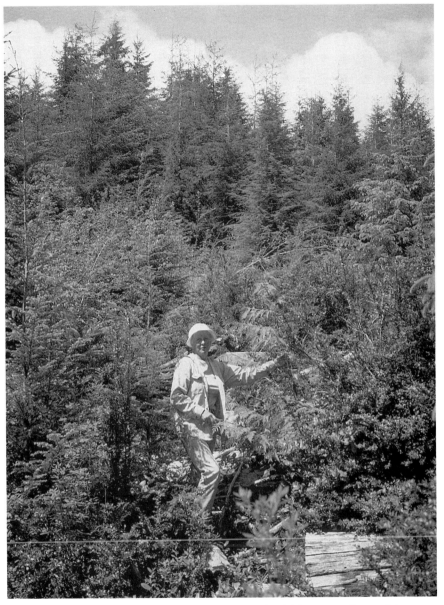

15 Elizabeth Barlow, a biology graduate with a lifelong experience of the forests of the Olympic Peninsula, Washington State, where the photograph was taken. She believes that the 'Greenies' overstate the barrenness of second-growth forests.

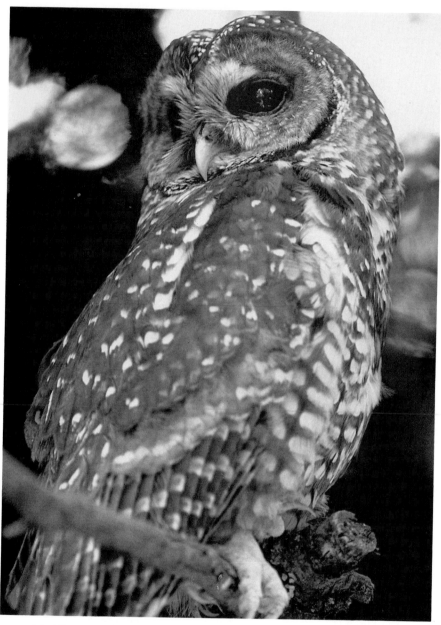

16 The spotted owl: more common and less fussy about habitats than once thought, this creature has for a decade symbolised the desire by (mostly urban) Americans to see the forests of the Pacific North West managed for conservation rather than logging.

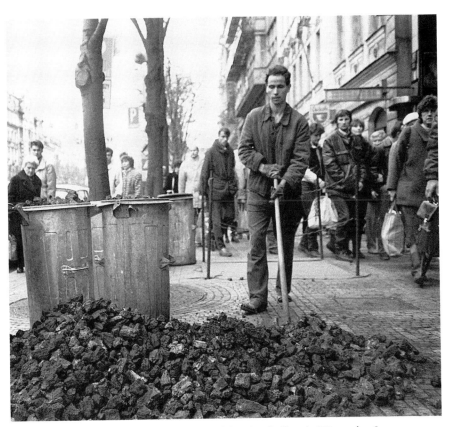

17 Coal being shovelled for central heating boilers in Wenceslas Square, Prague, in 1989. It was planning this sort of coal-burning in the 1950s which transformed London's air pollution problems.

18 The Centre for Sustainable Development of the ITESM, Monterrey's Institute of Technology, opened in 1993 and in large part funded by industry.

Over the years, and partly as a result of good lobbying by con-
servationists, the majority of IWC member countries are now sym-
pathetic to continuing the existing ban on most whaling, and even to
extending it. But most of the countries which dislike whaling have no
commercial interest in the activity, and many of them are under
pressure to appear more green in the eyes of their electorates. For
many of these – including the United States, France and Britain –
whaling is an issue on which it is cheap and easy to be virtuous.

The upshot is that IWC meetings have recently produced results
which look a little bizarre. They have voted that the IWC should
soon come, finally, to a decision on whether there are enough minke
whales to hunt. The last time I attended an IWC meeting, in 1990,
these issues were simmering. At the time I wondered if the JIN
countries were not engaged in arguing as hard as they could for an
important minority of their compatriots, but doing so with fairly
cynical indifference to the outcome of the debate. In other words,
they wanted to be seen by their beleaguered fishing communities to
be arguing in favour of whaling, but would not at all mind reporting
back to them that after a valiant fight, their negotiators had to admit
defeat. That way, the governments would be able to say they had
fought for the fishermen, while being able to placate the small but
growing number of conservationists of the welfare school in their
countries.

Few people would suffer if IWC went ahead and banned whaling
altogether, and most of them would suffer fairly little. Why not press
for this outcome? My own feeling is equivocally in favour of
whaling. Whales seem to rank, roughly, along with cows or pigs in
the scale of animals' capacity to suffer. They have the claim on our
attentions of most animals, perhaps a little higher than most. We
should kill them with despatch. But killing a whale represents no
more of a moral charge against its hunter than does, say, the
slaughter of the calves from the dairy herd which is the inevitable
result of humans drinking milk.

If we are to ban whaling, then we need to do so with a proper
realisation of what we would be gaining. We would be gaining
human non-interference in the life and death of whales. We might
gain a few minke, though because population dynamics are not
straightforward, we might not. We would not be saving the whale,
since it has, in conservation terms, been saved years ago, and
probably more by its commercial rarity than by the good intentions

of self-righteous and sometimes very brave campaigners.

Quite possibly, if no one had ever cared about a whale or cam-
paigned for a ban on whaling, if there had been no fuss whatever, and
the whaling industry had been allowed to continue, the position of
the whale in the world's oceans would be very much as it now is.
Whaling was grinding to a halt at the time it was banned. Jeremy
Cherfas, a knowledgeable commentator concludes as much:

> What if there had been no protection, no quotas, no agreements
> between the whaling nations? Is it not possible that all the fleets would
> one year have failed to find enough whales to cover their costs? And
> when that happened, as I believe it surely would have, the investors
> would quickly have pulled out of whaling.[28]

Cherfas argues that the years of argument allowed an orderly and
therefore relatively prolonged retreat of capital from an industry.
The prolongation killed, in the end, more whales than the industry
would have done if it had been allowed to go bust, fast.

By early 1994, it had become clear that Norway, at least, is
determined to hunt minke whale, even if that means leaving the IWC.
The Commission, for its part, determined at its 1993 meeting in
Kyoto that the viability of a harvest of minke stocks was still open to
scientific dispute. This is a polite fiction. In Kyoto, according to the
Financial Times report of the meeting:

> The anti-whaling nations succeeded in adding a proposal for a whale
> sanctuary in the southern oceans to next year's agenda. The UK,
> which best reflected the views of the anti-whaling group, explained
> that the government 'cannot even contemplate' an end to the ban until
> 'we are fully satisfied' about whale numbers, a management structure,
> and the humaneness of killing methods'.
>
> Responding to that argument, the Japanese delegation called for
> advice on how to run a 'foxhunt humanely' . . .
>
> But the Japanese and Norwegian representatives were most
> annoyed by the United States, which dropped the pretence of stalling
> on scientific grounds and opposed commercial whaling under any
> circumstances, reflecting the tougher line on environmental issues
> taken by the Clinton administration.[29]

The writer goes on to suggest that the US administration might be
heading in a generally fundamentalist direction on environmental
and conservation policy. He noted that the Chinese thought the US
approach a 'kind of imperialism', and that fishermen outside the

meeting thought the Commission was humane to whales and inhumane to people. The *Financial Times* report showed that, though the scientific committee of the IWC believed the numbers of minke justified a limited harvest, the United States and like-minded countries preferred good domestic politics to international scientific consensus or sustainable development (for definition of which, see Chapter 12).

The rainforest

For a hundred years, children have had books of pictures and facts about animals and birds. People knew and liked images of lions or elephants. But we had curiously little idea about what the home of these creatures was like. The disjunction between creature and habitat was at its most complete in the zoo. We thought we knew about an animal if we had seen it in a zoo, a place in which it appeared – necessarily – without context. Indeed, as an exhibit, it often appeared without any chance to show its natural or normal behaviour. It was bereft externally and internally.

But until very recently, we did not know about or take much interest in habitat. Perhaps this was because the language of ecology – the business of seeing things in the round – had not penetrated into children's books and the education system. Partly it must have been because the film-makers had not yet made the wider foreign scene as familiar as the more distant parts of our own country were. They had not brought us the pictures of the wider scene which constitutes habitat.

There was something, I remember, called 'the bush', but I had no picture of it because I only ever saw pictures of hunters and lions in the immediate thicket in which their encounters took place. We knew, did we not, that there was also something called jungle, and that it was impenetrable and steamy? But so far as I know I was not rare in not knowing what on earth jungle was really like, except perhaps that Africa was covered with it, as it in fact was not.

I did not know that there was jungle in Brazil, though I did know there was teak in Burma. Anyway, in the past ten years all this has changed very dramatically and, as is often the case with a new discovery, the world at large has fallen in love with a novelty about which it was supremely ignorant and indifferent a decade earlier.

The truth is, of course, that we know little enough about the

rainforest even now. Much of what we think we know is wrong. That does not stop the citizens of Europe and North America from forcing their politicians to put rainforest conservation quite high on the list of their diplomatic conversations with any countries possessing rainforest. History will probably record its pleasure that the issue climbed the diplomatic agenda. Historians may well smile at some of the arguments which were deployed.

What do we know about the rainforest?

First, that there is an enormous amount of it. Second, that very few people have found much of a use for it as it stands. Third, that it is surrounded by poor farmers. Fourth, that large areas of it could be used perfectly well for other purposes.[30] Fifth, that its rich biological diversity does not make a very strong case for preserving much of it. Sixth, that very few countries own it. Seventh, that we know precious little about what would happen if a large proportion of it was knocked down. Eighth, if the rich world wants to try to preserve it, it will have to do some very interesting politics. Nineth, that if things go very well, there will be quite a lot of rainforest left, and probably enough, but nowhere near the amount there is now.

There is something like a scientific consensus that we have lost perhaps half the rainforest that stood at the turn of the century.[31] About 14 per cent of the world's land surface is tropical forest and less than a half of that is moist forest,[32] which we will conveniently and not altogether accurately call rainforest. WWF put the remaining tropical rainforest as covering about 840 million hectares.

The gloomiest respectable figures for Brazil's annual rainforest depletion are five times gloomier than other respectable estimates.[33] Anyway, the news is bad enough. Many African countries have made big inroads on their stock of the habitat. In Bangladesh, India and Sri Lanka there is no rainforest left outside parks and reserves.[34] Within a decade, at present rates of destruction, only small patches of lowland forest will remain in peninsular Malaysia, Thailand and the Philippines. Central America as a whole was once about 80 per cent tropical forest. Now only 40 per cent is. Brazil has lost a forest area about the size of Sweden.

This is a familiar litany. And yet, we can construct a more optimistic picture. We have roughly half the rainforest which the twentieth century inherited from the nineteenth century, when it was substantially intact. In many regions, there is a good deal of the stuff by any standards. Central America remains, at 40 per cent cover,

substantially forested. The Amazon basin has just over 357 million hectares of closed natural forest. This is about an eighth of the world total's closed natural forest, and a bit over a third of the world's total of rainforest. A gloomy view suggests that it might be a tenth or an eighth smaller than it once was.

Africa's position is both good and bad. The continent has been the scene of larger depletions of its share of rainforest than other regions. But the good news is that the vast majority of its remaining rainforest, an area nearly a third of the size of the Amazon basin, is in a more or less complete block. In East Asia, there have been very large depletions in the closed forest, but there remains one sub-region with an enormous area of rainforest. It is at least the size of the huge African block.

Within these regions, there is the relatively convenient fact that the occurrence of tropical rainforest is quite concentrated in particular countries. Thus if the rainforest of the Big Three, Brazil, Zaire and Indonesia, could be saved, one would at a fell swoop have conserved at least 500 million hectares of tropical rainforest, or over two-thirds of the total remaining. The addition of a further five African or Asian countries – Cameroon, Congo, Gabon, the Philippines and Malaysia – would add a further 90 million hectares of rainforest to the total. The addition of Bolivia, Peru and Ecuador would add about 125 million. This produces a game with about a dozen major players controlling 85 per cent of the rain forest, with many of them already claiming that a proportion of their forest is safe from exploitation.

We must not be blinded by the enormous numbers involved – either of the rainforest estate, or the hectarages by which it is reduced in places. It is more important to try to think about why we need rainforest at all, and then we may get a feel for how much we need and where.

Rainforest is very attractive. Or rather, it has become highly fashionable and vicariously attractive even to people who have never seen it, and who might find its actuality frightening or hostile. Not many of us can ever expect to be in a rainforest, and those of us lucky to visit one would probably be nearly as content that it be the size of, say, Wales, as that it should be the size of France. Actually, it is possible that people want to preserve large amounts of rainforest simply because it is there, and to damage it seems hubristic.

But that sort of impulse is too obviously irrational and so other, more tangible, reasons for rainforest conservation are sought. It is

often and strongly argued that we dare not see rainforest knocked down because of the great diversity of life-forms it harbours. The serendipitous nature of biodiversity is stressed. You never know which hectare of rainforest will contain the plant which yields the drug which turns out to cure AIDS, so keep them all and defend them all with equal ardour.

People rightly associate rainforest with biodiversity, since half of all vertebrates, 60 per cent of known plant species and possibly 90 per cent of the world's total species are found in tropical forest, and the greatest diversity of all within the tropical moist forest.[35]

Actually, however, the maintenance of biodiversity makes a poor argument for the maintenance of all rainforest. It is probable that we could preserve, say, 80 per cent of the theoretical biodiversity of the rainforest by preserving perhaps 10 per cent of the rainforest.[36]

People are now working on maps of biodiversity. We will soon be able to colour in the parts of the map of the rainforest where we think the most valuably diverse biodiversity will be. Against the argument that the 10 per cent of the forest and the 80 per cent of biodiversity we might preserve might not include some particular piece of the diversity which might hypothetically have been of value, it is far more probable that we will miss some hypothetically valuable product which might have been developed from the 80 per cent of diversity we might pretty easily save. Besides, I suspect that if we are clever we will be able to preserve 90 per cent of the biologically-useful diversity on a well chosen 10 per cent of forest, and be kept very busy looking at that – still vast – amount of territory and biological potential. Granted that a fig leaf has 20,000 chemicals in it, we seem to have quite a job cut out for us as we begin the assay of our biogenetic inheritance. This sort of thinking, far from heretical, is the essence of modern realistic conservation.[37]

It has often been said that the tropical forest is very diverse and very fragile. Once it has been knocked down its thin soils are very vulnerable to erosion after a few years. The implication is that no rainforest can sustain changes in its use without shortly turning into a degraded desert. This is not true. In the first place, some commercially exploited forests have been shown to be quite rich in rainforest species. There are many places where it is technically and commercially possible for forestry to take place with little long-term damage,[38] and there are many more where farming is now conducted by tribal people without harm. There are plenty of others

where farming could be introduced.[39]

The problem with our view of the alternative uses for rainforest is that they are, naturally enough, coloured by what has happened in the forest so far. Rapacious logging and catch-as-catch-can farming (the latter more than the former) have done an enormous amount of harm. But that is no argument for not attempting something more rational. As in the matter of biodiversity, we need to see that the forest is not a vast homogeneous estate sharing in all its parts equal fragility and richness. In a world full of hungry and ambitious poor people, we have to look even at rainforest and consider how we can negotiate a path between different human requirements of it, only one of which is that it should fulfil our fantasies of wilderness.[40]

There are several ways of looking at these issues. One is to be glad that in at least some of the countries which matter in the rainforest saga, increased democracy and general electoral accountability may produce a situation in which the deals which have decided much of the fate of the rainforest in the past will be exposed to public view. In this sense, the forest is less likely in the future to be treated as the domain of an élite of profiteers. An important further factor is that in many countries, poor peasants seek out whatever land they may – even inappropriate rainforest – because land distribution is so skewed in favour of the rich few. With political reforms, land reforms of one sort or another are likely to follow and marginally ease the situation.

More important still, most of the countries involved are heavily in hock to government or government-influenced financial institutions around the western world. The west previously sponsored and encouraged forest exploitation and is now swinging behind conservation with the same energy. Already, Brazil is among other Latin American countries in abandoning tax regimes which encourage the destruction of rainforest.

Civilisation's encounters with the rainforest have not been particularly rational, organised or humane. Corporate and élitist interests have done their damage. Hungry peasants have done theirs, often by following in the wake of clearance and infrastructure work done by much richer parties. Neither the corporate nor the peasant interests have had much of an eye to the sustainable future of the forest, nor to the various people, such as rubber tappers and indigenous peoples, who were getting a living from the forest before them, often in a far more benign way.

Naturally, some campaigners have stressed the disgracefulness of all this, and invited people to send money so they can 'save the rainforest'. But there are other campaigners – the World Wide Fund for Nature particularly – who see that not all the rainforest can be conserved, and some of what is conserved will have to fulfil various and contradictory roles. They also see that the conservation of large tracts of habitat requires a curious mixture of diplomacies. On the one hand, no one can operate usefully in any country – let alone Third World oligarchies – without the co-operation of governments. On the other hand, there is a strong requirement to be sure that schemes that look good on paper also make sense to the usually very poor, often illiterate and almost always suspicious people who live nearest to whatever conservation schemes are in hand.

In Korup, an important area of Cameroon's rainforest, WWF combined with the official aid agency of the UK government and as many parties in Cameroon as they could get hold of, to produce what looks like a model conservation scheme. It involves an area of rainforest which was to be kept virgin. It was to be surrounded by buffer zones designated within the forest in which various degrees and types of exploitation were to be allowed. This delicate sort of operation irritates the purists but seems rich in potential to those who see themselves as working in the real world of difficult compromises.

Similar divergences are rife in perceptions of the tropical timber trade. Convincing voices argue that only a thriving market in highly-valued, high-priced tropical timber can ensure that the trees in some areas of tropical rainforest can turn in a profit to poor countries, be replaced within a rich forest habitat, and earn enough money to add to a convincing case that the governments of such countries should follow strong conservation policies.[44] Such an approach would conserve some forest as virgin, and allow some to be logged, but cleverly and with an eye to conservation for its own sake and for future profit, all of which are technically possible.[42]

There are plenty of problems in making a high-profit market in tropical wood and other forest products. As in the case of ivory, there is the difficulty in ensuring that the item being offered has come from a legitimate source. Mahogany is mahogany: how to ensure that the customer is paying a high price for the sustainably-produced article? There is the difficulty that the conservationists risk talking the market out of existence with their constant call for a boycott on

tropical timber.

There have been calls for indigenous peoples or their governments to receive handsome royalties on the products which may be developed by western companies from genetic material gathered in rainforest. This may not be a wise route for conservationists to follow. In cold negotiations, the west would almost certainly be able to buy the right to exploit rainforest genetic value more cheaply and with less conservation achievement than either the native people or their governments would like. We have already seen, at the Earth Summit in Rio de Janeiro in June 1992, the US government shy away from a treaty which might have helped preserve rainforest but which appeared to hold future pharmaceutical and other advances to ransom. (President Clinton has promised to review his predecessor's position.)

There are already two international agencies, each with its separate international agreement, which are rather feebly working towards sensible forestry and timber trade policies, and sometimes tripping over each other as they do so. Progress is painfully slow because some of the most serious players in the game have been reluctant to see any benefit in pursuing the sustainable rather than the simply exploitative option in their attempted management of the rainforest. For the countries which possess it, forest is a useful source of revenue and home, albeit temporary, for potentially troublesome poor farmers. For the rich nations, rainforest is an issue of importance to a small proportion of their electorates who need to be assuaged from time to time but who cannot force their concerns high on the political agenda. Worse, from the rich nations' point of view, there are immediate cries of humbug, ecolonialism and an unwarranted interference in national sovereignty whenever rich-world politicians dare raise the subject.[43] Moreover, the rich countries which are most dependent on the rainforest for their wood – Japan prime amongst them – have only recently taken an interest in the issue from the conservation point of view.

The environmental campaigners naturally try to overcome these reluctances and do so by stressing the international and global importance of the rainforest. Quite differently, they also stress the very local importance of the virgin forest to the indigenous people who live there.

It is clear the rates of burning of the 1980s released huge quantities of carbon dioxide and thus contributed to global warming. Again,

figures are, from the point of view of the campaigners, usefully vague. Respectable estimates suggest that postwar burning of forests may have contributed 5 per cent of the human contribution to global warming; or it may be 50 per cent.[44, 45]

The higher figure is worth ten times the fuss of the smaller figure, so it will be a great help in this debate to get some sharper figuring. The rich countries would clearly need to know more before they would be justified in expensively or patronisingly bribing or bullying tropical countries on the issue.

This applies to other supposed problems. It may be that rainforest plays a role in regional climates, and particularly in rainfall inland of oceanic regions. Again, these insights are of uncertain value, and need to be sharpened up if they are to be given their proper weight, which might be small. There have already been instances of disastrous floods following thoughtless deforestation in Asia and elsewhere.[46] The role of forest in watersheds needs to be thought through. Again, it can be overstated. There are other replacements for rainforest than bare and erosive soil. Agriculture can hold back the water, too, in many places.

Modernising the noble savage

Quite often the rights of tribal peoples do not much conflict with those of affluent westerners who can afford kindly liberal opinions. The people who most compete with the tribals are poor and often desperate. Some are greedy and violent. Some are, awkwardly, more advanced farming people of, roughly speaking, their own race. The frontier world is even less tidy than it was five hundred years ago.

There is plenty there which perplexes us. There are thought to be about 2.5 million forest-dwellers in the tropics today,[47] and it seems fairly obvious that so far as possible they should be allowed a good deal of habitat in which to live their lives in as much of a Stone Age way as they think fit. The truth of this proposition has dawned on many Greens partly or perhaps mostly because they recognise that preserving Indians is a way of preserving rainforest.

Similarly, it generally seems right to most people, especially westerners, that the few remaining hunter gatherers and nomadic or sedentary pastoralists of the savannah in Africa should be left alone so far as possible, and partly because their survival is a guarantee of the preservation of wilderness. There is a good deal of interest in the

Masai of East Africa, and it is generally thought that their life amongst their cattle is the very image of the ecologically harmonious. The Masai's survival is seen as a useful guarantee of the fringelands between the wilderness of the parks and the farmscape which marches up on it.

The idea of the mutually defensive roles of primitive peoples and their wild habitat is quite powerful. In fact, though, it is probable, as anthropologists and historians have always thought, that within a very few generations, there will be no Stone-Age people on earth, and this brings with it the corollary that humankind will then have to defend the wilderness for its own sake rather than for its value to a few scattered cultures which got a living in it. Earlier this century Hendrik Van Loon said it of the American native peoples:

> The red man, reduced from the rank of host to that of a guest, will continue to exist for a few centuries longer. Then he will be completely absorbed by his former enemies and will only survive as a vague historical memory. That is too bad, for the red man had many very excellent qualities, both of body and mind.[48]

The problem with a culture which wants to stand out against western civilisation is not merely that ours is more powerful but that it is more enticing. We once used force of arms to defeat Indians, and in places that still happens. Now, however, osmosis will mostly do the work for us. Five hundred years ago, Stone-Age cultures could not stand out against white invasion. They will be able to do so much less now, because nowadays our civilisation is perhaps even more dreadfully powerful when it is assertive, and certainly far more powerfully attractive when it is seductive.

Two propositions suggest what the future might be. There is no primitive society so coercive that it can stop its young people swapping their blow-pipes for ghetto-blasters. And there is no primitive society so self-consciously superior to the white civilisations it meets that the two will not sooner or later interbreed, probably to the benefit of both.

It is likely that tribal societies – like all others before them – will join the mainstream. They join the world that accepts that literacy, numeracy, individual freedom of expression and association, and freedom of mobility are highly prized. But they are more than prizes, they are rights. People who think that it is wrong to force primitive people to accept that their members live in the modern world and

have modern rights simply have not thought through the problem of what it would be like to live alongside a primitive culture which systematically denied its people what are now seen as elementary human freedoms. If an old culture denies these freedoms, it is inhuman; if it accords them, it dies.

In practice we do not expect quite the same standards of primitive people. In Brazil, according to one newspaper report, a tribal person cannot be charged with rape, on the grounds that such things are seen differently in the tribal world under which he is assumed to be judged.[49] It is accepted that tribal people operate a different and plausibly valuable moral schema of their own.

But is not this approach open to the accusation that it does not accord the primitive people quite the full richness of human characteristics? Do we allow them moral latitude because we do not think they are quite up to the full demands we make even of quite disadvantaged people in our society?

Primitive societies may be forced to modernise; but just as probably they will choose to. The reason is not that they will opt for a wholesale change. It is that, little by little, some of their members will choose the modern way, and eventually and increasingly infect the ones that stayed behind. The Masai send their children to school: they are forced, but increasingly pleased, to do so. Bit by bit they become infected with the modern. I have met quite a few Inuit and Dene who have been to university and are thoroughly citizens of the modern world, though proud of the tradition they carry in their blood.

The process is not happening, by the way, merely with Stone-Age peoples. The Japanese have as much of a wrench as the Chinese as they sniff the free air of western civilisation and demand its individualism. I knew quite well people from a generation of French peasants who were joining cosmopolitan society and whose children rejected peasant narrowness of view. Even in supremely western societies – the United Kingdom, the United States and Australia – the rustic has not been destroyed and can still be found. But it is going fast.

As we see the passing of the Stone Age, the right thing is to mourn the passing of another piece of variety, the loss of another part of the mosaic which demonstrably makes up the past as it lives in our present. But when we lose primitive cultures, we are not necessarily losing people (though many people have died miserably in the clash

of cultures and peoples). We are losing the way they used to live.

The most we can hope for is that these processes happen at a pace over which individuals have an element of dignified control and that they can negotiate a decent respect for the traditions which have nurtured them and almost all of which will be lost. Bending over backwards, we may even say that white civilisation has something to learn from the exchange. We certainly do need some of the skills which indigenous people possess. There is truth in the views of people such as Robin Hanbury-Tenison:

> even the most imaginative of western scientists are still desperately short of ideas about how the rainforest resources can be tapped efficiently, profitably and, above all, sustainably. Only the tribal people who live there know this.[50]

But it is too easy to stress primitive respect for nature as though the west had lost it all. Besides, we know of the primitives' respect for nature from sources which enjoy reporting that side of their lives. We can suspect the sources of partiality if not of credulousness. Cooler observers might find equal evidence that tribal people who are subject to the whims of the natural world are bound to a respect in which there is a good deal of fear. Living in harmony with nature may be a fancy way of saying that people seldom get the chance to lift their noses far from the soil. People from Stone-Age cultures may not so much desist from doing damage as lack the ability to alter the circumstances in which they find themselves. It is too easy to take the tribals' utterances (typically: 'We belong to the land, not the land to us',[51] or 'Make all your decisions as though from the point of view of your grand-children') and think that these words are worth whole libraries of western thought. The dicta deserve a place on our shelves, but do not subvert or demolish our own wisdom.

To preserve their right to live in the Stone Age, we think we can put a fence around the terrain we allow the Stone Age. But this fence cannot be strong enough to preserve the Stone-Age purity without being an offence to our liberalism. The membrane we put between the Stone Age and civilisation cannot be impermeable. If it were, the fence would constitute the bars of a prison or a zoo. We cannot imprison the Stone-Age people just because it is 'for their own good'. We know they must decide what they want to do about the modern world. That means they must visit it, and that in turn means that they must destroy their purity. In the degree to which the Stone Age and

the modern world intermingle, the process spells the end of the isolation of the Stone Age, and it is isolation which largely defines it.

It is right of course that western companies should seek to trade with Indian peoples and exploit the products of the rainforest. For instance, the Body Shop's involvement with the rainforest and some of the people living in it was likely to be useful. But at least at first the firm celebrated its involvement in terms which were dangerously oversimplified. In a comic-book, it presented the Indians as being in tune with nature, preservers of the simple life and the custodians of the forest's ability to provide useful products.[52] The story was simple and was about simplicity. It also seemed far too simple to be true, even to those of us who know little of the rainforest or its people. It proclaimed itself as being about 'Trade, not aid', an old and interesting slogan. The Body Shop press release trumpeting the new deal for a trade in Brazil nuts with the Kayapo tribe said:

> Anita and Gordon Roddick, who pioneered this programme, believe that the project might prove to be a model for other businesses to emulate. Believing trade can be a positive force for change, The Body Shop is keen to replace aid scams with trade schemes that are practical solutions to the threat of environmental destruction.[53]

Its sub-text was an object lesson in the risks of combining business with campaigning. The Body Shop may be a little more virtuous than other companies and has certainly done as much as many other advanced companies to look at its environmental impact. But it trades on virtue as well as cosmetics, and its messages seem as important as its cosmetics. The firm's desire to produce simple messages risked taking inherently complicated situations and reducing them to attractive slogans. Is it, for instance, really right to denigrate aid?

Two months after the launch of the Body Shop's wild Brazil nut product and its rainforest associations in April 1992, there were reports that one of the most important figures in the deal was facing a charge of rape. The scandal involved Paiakan, a leading member of the Kayapo tribe and a person the Body Shop had been keen to promote as legitimising their work. The story broke in a leading Brazilian magazine during the Earth Summit at Rio in June, 1992. It bore all the appearance of a furore which was being hyped up by a white Brazil fed up with the claims of Indians to limitless ecological merit, and with the fact that the Indians were bound to star during

the meeting of foreign leaders on Brazilian soil.

Journalists and others friendly to the Indians suggested that there was at least a possibility that Paiakan and his wife were more or less innocent victims of politically motivated false accusation.[54] Whether or not Paiakan and his wife, together or separately, roughed up and sexually abused the young woman in question, and whether Paiakan raped her, as was alleged and denied to have happened during May 1992, the story's background revealed that the frontier world between the whites and Indians is densely complicated.

It became clear that Paiakan, widely seen as a representative of the tribal lifestyle which had been held up as the model of sustainability, was living anything but the simple or obviously tribal life. His style of life – involving homes in the city, cars, and drink – seemed a world away from the village and forest simplicities presented in the Body Shop material, and would probably have deeply shocked the conscientious T-shirt moralists shopping at the Body Shop franchises.

It is important to see that behind the firm's brochures with their glowing pictures of charismatic tribal chiefs and tribal life, the Body Shop is bringing international trade to the tribals, and perhaps doing so more benignly than others. The firm said it was seeking to provide an alternative to the way some branches of the Kayapo tribe were already receiving millions of dollars a year in royalties from gold mines and timber franchises (the beneficiaries, it has been alleged, included individuals such as Paiakan).[55]

By their diligence, the Body Shop may be able to be particularly good trading partners, but we should beware imagining that they can simultaneously involve tribal people in the cosmetics industry *and* help them maintain whatever remains of their Stone-Age values. We can celebrate the Body Shop's moves, but not quite in the terms of the Body Shop's own publicity. It is fair to note that, in early 1994, the Body Shop dropped its 'Trade, not aid' slogan for its work with indigenous peoples. It now uses the less contentious 'Fair trade' for its programme. Even so, even the most recent Body Shop literature is full of examples of a kind of moral triumphalism which to my mind rather undermines the attractiveness of their attempts to be in the vanguard of what might be called sustainable commerce. No doubt Anita Roddick is sincere and committed, but that does not make up for the self-congratulation her firm indulges in.

It will be better for everyone when the native peoples of the world cease to be paraded around the west as exemplars, saints and icons.

There was something very embarrassing about a book such as *Jungle Stories: The Fight for the Amazon*, written by the singer Sting and Jean-Pierre Dutilleux,[56] with its gushing text and the colour photographs with their constant, curious placing of the square-jawed star and the plate-lipped chiefs. Perhaps this is the way the world works, and perhaps this is what constitutes effective politics in a country with a polity as dramatic, colourful and bizarre as Brazil's. Perhaps this is the way to produce change in a world where statesmen have to take account of the charismatic posturing of stars and of simplistic campaigns in the media. But it was at least very curious to flip though these pages in which the rainforest and its people become a backdrop for a rockstar's self-presentation.

The style of Sting's involvement with the Amazon seems curiously at odds with its intention. Even if his showbiz methods are necessary and inevitable, the rest of us can notice that the Stone Age cannot simultaneously be defended by these methods and survive them. The defenders of the Stone Age will risk wrecking the remaining simplicities of the Stone Age they have come to fight for.

We worry about forcing modern freedom and responsibilities on to primitive cultures; and we worry about withholding them. We worry about interning tribal people in theme parks, or in reserves which look uncommonly like zoos, prisons or museums. What we had not expected until very recently is that the tribals would become such vigorous – and in some cases very willing – partners of the media and marketing circuses. They have gone from the Stone Age into the ultra-modern, and by-passed the ordinary experience of the vast majority of the rest of the human race in the process. They went from being unknown to being famous with a speed which would have astonished even Andy Warhol.

It is one of the most bizarre turns of fate that the survival of the Stone Age on the earth is entirely in the gift of civilisation. From now on, the modern world will define itself by its preparedness to preserve instead of annihilate the last shards of the Stone Age. It has come to that after all. If the Stone Age continues to live in the middle of the modern world, it will largely be as an artifice. The Stone Age people will become unconscious attractions in a Flintstone theme park. When they realise this, it will be the greatest trauma of all.

Notes

1 Thomas, K., *Man and the Natural World* (Harmondsworth: Penguin, 1984).

2 Private conversation with author.

3 For a discussion on Scottish land management, see Jim Crumley, *Among Mountains* (Edinburgh: Mainstream Press, 1993).

4 The case for being worried by the modern celebration of management of nature is eloquently put by Richard Mabey, 'Laird of creation', BBC Wildlife, January 1992.

5 Clifford, Sue, *Local Distinctiveness: Place, Particularity and Identity* (London: Common Ground, September 1993), (41 Shelton St, London, WC2H 9HJ). See also Neal Ascherson, 'A diverse England we can shape to our taste', The *Independent On Sunday*, October 3 1993.

6 Mabey, R., *The Common Ground* (London: Arrow, 1981).

7 For a fairly comprehensive account of the Yellowstone issue, see, 'The great Yellowstone fires', *National Geographic*, February 1989.

8 Quoted in Wilkinson, C. F., *Crossing the Next Meridian: Land, Water, and the Future of the West* (Washington DC: Island Press).

9 Charles Laurence, 'Buffalo to roam as West goes Wild again', *The Daily Telegraph*, March 5 1993.

10 Dick Randall, 'Wanted dead or alive?', *BBC Wildlife*, February 1992.

11 Stenge, Wallace, 'America's West: after the mirages, hopeful realism', *International Herald Tribune*, March 31 1992; Critchfield, Richard, 'On the prairie, Hippocrates meant something', *International Herald Tribune*, May 12 1993.

12 Kenworthy, Tom, 'Battle over grazing fee plan pits visions of 'old' vs 'new' West', *Washington Post*, October 31 1993.

13 See Graham Murphy, *Founders of the National Trust* (London: Croom Helm, 1987).

14 Peacock, Doug, *Grizzly Years: In Search of the American Wilderness* (New York: Henry Holt, 1990).

15 Foreman, David, *Ecodefense: A Field Guide to Monkeywrenching* (Tucson: Ned Ludd, 1985) (PO Box 5141, Tucson, Arizona, 85703, USA).

16 This is an extended version of a piece 'The owl and the lumberjack', which appeared in *The Times Magazine*, February 26 1994. For a fuller account of the saga, see William Dietrich, *The Final Forest, The Battle for the Last Great Trees of the Pacific Northwest* (New York: Simon & Schuster, 1992).

17 Pye-Smith, C., Borrin I. Feyerabend, G. and Sandbrook, R., *The Wealth of Communities* (London: Earthscan, 1994).

18 Wilson, A., *Guidebook to the Masai Mara Reserve* (Nairobi: Friends of Conservation/Friends of the Masai Mara, no date).

19 Simon Trevor, 'Elephant as architect', *BBC Wildlife*, September 1992.

20 Swanson, T. and Barbier, E., *Economics for the wild: Wildlife, Wildlands, Diversity and Development* (London: Earthscan, 1992).

21 Barbier, E., Burgess, J., Swanson, T. and Pearce, D., *Elephants, Economics and Ivory* (London: Earthscan, 1990).

22 The Kenya Wildlife Service, 'A policy framework and development programme 1991–96', Nairobi, November 1990.

23 Sam Kiley, 'A wild life', *The Times Magazine*, April 2 1994.

24 'The impact of the ivory ban on illegal hunting of elephants in six range states in Africa', WWF-World Wide Fund for Nature, February 1992.

25 Raymond Bonner's *At the Hand of Man: Peril and Hope for Africa's Wildlife* (New York: Simon and Schuster, 1993) is interesting here; an account of its argument is in 'The hype is as high as an elephant's eye', Raymond Bonner, *The Independent*, April 10 1993. The book was very heavily criticised, perhaps predictably, in a review by Cynthia Moss, *New Scientist*, December 11 1993. Jonathan S. Adams and Thomas McShane, *The Myth of Wild Africa: Conservation Without Illusion* (New York: W. W. Norton, 1992) bids fair to be a useful account of the issue, to judge from a short article by Adams, 'Life with the wild', *Choices, The Human Development Magazine* (Geneva: United Nations Development Programme).

26 North, R., 'How to save animals by shooting them', *Independent Magazine*, January 7 1989.

27 'The Cook Report', Central TV, July 30 1990, and Richard North, 'Woof-woof on the horns of a dilemma', *The Suday Times*, August 5 1990.

28 Cherfas, J., *The Hunting of the Whale* (London: Bodley Head, 1988), p. 216.

29 Robert Thomson, 'Culture clash creates an endangered species', *The Financial Times*, May 15/16 1993.

30 For an account of some human interventions in the rainforest which are sustainable, see Gradwohl, J. and Greenberg, R., *Saving the Tropical Forests* (London: Earthscan, 1988).

31 Johnson, B., 'Responding to tropical deforestation', World Wildlife Fund and the Conservation Foundation, USA and UK, 1991, p. 7.

32 Overseas Development administration *Biological Diversity and Developing Countries* (London: HMSO, 1991), p. 26.

33 Johnson, B., 'Responding to tropical deforestation', p. 7.

34 *Ibid.* p. 9.

35 ODA, *Biological Diversity and Developing Countries*, p. 26.

36 See contributions by Holdgate, M., and Poore, D., in Polunin, N. and Burnett, J. (eds), *Surviving with the Biosphere* (The Fourth International Conference on Environmental Future, 1990) (Edinburgh: Edinburgh University Press, 1994).

37 ODA, *Biological Diversity and Developing Countries*, p. 27.

38 Christina Lamb, 'Passion in the forest', *Financial Times*, May 13 1992, and 'Chopping down rainforest myths', *Financial Times*, January 8 1992.

39 Pearce, F., *Turning up the Heat* (London: Bodley Head, 1989), pp. 78ff.

40 Marguerite Holloway 'Sustaining the Amazon', *Scientific American*, July 1993, is an interesting account of how many experienced rainforest hands are beginning to explore sustainable exploitation of the Amazon.

41 Johnson, B., 'Responding to tropical deforestation', p. 39.

42 Poore, D., *No Timber Without Trees* (London: Earthscan, 1989).

43 The prime minister of Malaysia is especially eloquent on these themes: speech to the Rio Earth Summit, June 1993.

44 Grubb, M., *Energy Policies and the Greenhouse Effect* vol. 1, Royal Institute of International Affairs, Dartmouth, 1990, p. 23.

45 Intergovernmental Panel on Climate Change, *Climate Change* (Cambridge: Cambridge University Press, 1990), p. 10.

46 Johnson, B., 'Responding to tropical deforestation', p. 19.

47 *Ibid.*

48 Van Loon, H., *The Home of Mankind* (London: George Harrap, 1933), p. 445.

49 Rik Turner, 'Brazilian tensions emerge in rape case', The *Independent*, June 10 1992.

50 Porritt, J., *Save the Earth* (London: Dorling Kindersley, 1991), p. 137.

51 *Ibid.*

52 The Body Shop, 'Trade not aid', publicity campaign material. April 1992, including comic book *Fight for the Forest*.

53 The Body Shop, 'Kayapo Indians from Brazil visit London to press for recognition of tribal rights and alternatives to standard aid programmes', press release announcing a press conference with Paiakan held in London, April 9 1992.

54 Alexander Cockburn, 'A crime in benefit of land grabbers', *Los Angeles Times*, September 9 1992.

55 Julia Preston, 'Trial spurs debate on Brazils' Indians', *Washington Post*, August 17 1992.

56 Sting and Jean-Pierre Dutilleux, *Jungle Stories, the Fight for the Amazon* (London: Barrie and Jenkins, 1989).

11
Facing facts in the rich world

The purist Greens believe they have found a new way of seeing and running the world. I want to look at two areas where the enterprise is less interesting than often assumed: Green thinking, and Green campaigning for tougher regulation. I look at the possibilities of a more rational view of the problems facing us.

A new way of seeing the world

In 1984 in his book *Seeing Green: The Politics of Ecology Explained*, Jonathon Porritt, one of the clearest and strongest of the Green voices, wrote:

> There are still many who willingly acquiesce in the system, pledging loyalty to the dominant world view and its attendant myth of progress. And there's still a great deal of hypocritical humbug, of narrow, linear thinking that postures as politics.
>
> Opposition to the dominant world view cannot possibly be articulated through any of the major parties, for they and their accompanying ideologies are part of the problem. Green politics challenges the integrity of those ideologies, questions the philosophy that underlies them, and fundamentally disputes today's accepted notions of rationality.

And this, on the distinction between the old-fashioned conservationists and the heart-and-soul Greens:

> At the other end of the scale are the radical, libertarian environmentalists, heirs to the very different tradition characterised by the anarchist ideals of Kropotkin, Thoreau and Godwin. They too are keen on small-scale, self-sufficient communities, but as a means of

escaping from the bureaucratic, hierarchical pressures of contemporary industrialism. Personal autonomy is high on their list of priorities, and theirs is a decidedly optimistic assessment of human nature. They are opposed to the present industrial system, totally reject the idea that the present crisis can be solved by one technological fix after another, and are keen to adopt new lifestyles. For them messing about on the margins of social change is simply not enough, for they seek a fundamental change in values. Such environmentalists usually are green.

Seeing Green goes on to expand these themes, and will touch a nerve in anyone who worries about the trivial, the vulgar, and the material extravagance in modern Western society. And yet the more I used to read Porritt's books and speeches, the less did I think his case had substance. How many of us want to live in self-sufficient communities? How many want to overthrow the values of the west? Who really is voting for a public world with profoundly new values, or much adjusting their lives in light of new values? Yet, I wondered, are we really failing to turn round some of the redundant attitudes of western culture? Do we really need the green revolution of the spirit which he is calling for?

There is a good deal of support for some attempt to find a better way of running the world. Writers such as Jonathon Porritt attempted a Green analysis of nearly every aspect of the human enterprise. Modern science, the Green argument said, was overly Descartian. It was minimalist and soulless. In its place they proposed a new 'holistic' vision. Religion, they thought, was anthropocentric and triumphalist about 'man'. They proposed that a reverence for nature was, if not a new religion, a sounder way of expressing and reforming the human spirit. The attempt by Greens to discuss religion, spirituality and science was interesting but finally not rewarding. In attempting wholly to transform these enterprises, they merely reminded us how various and rich our tradition is. The Greens did not succeed in presenting a convincing challenge to more conventional western lines of thought, not least because the Greens themselves are direct descendants of many of them, while others they disliked were actually very strong and worthwhile. Rationality, participatory democracy, freedom of worship, respect for the individual, and an interest in the natural world are the fundamental values of our society. We have struggled for centuries to find a system which allows individuals full expression, while binding them in a net of

obligations which they do not find crippling. Our science and ambitions involve us in a continuous search for cheaper, more ecologically sound, better ways of making things, delivering services and treating people. These are encouraged in the real world of industrial society and constitute progress. The Greens have a modest role in helping that progress define itself, but were immodest when they thought they could somehow transform our thinking.

The Greens attempted political activity. Modern politics, they thought, was based on a crass and vulgar massing of two opposing tendencies, the right and the left, in which neither capital nor labour realised the world could not sustain the greed they equally encouraged.

There has been some sympathetic and intelligent moderate green analysis of the different forms an attempt at green politics took in different parts of the world. In Germany, it seemed to flow from a post-Hitler generation anxious to distance itself from the world into which it had been born. The movement seemed neurotic, too much dependent on left-wing thinking, and too much associated with a rather hysterical feminism.

Our own Green politicians mostly seemed individually to be insubstantial, and collectively to be hopelessly given to faction. Once the Green Party was abandoned by Jonathon Porritt and Sara Parkin, the only Green spokespeople to have attracted public interest, there seemed nothing left of the party. Porritt and Parkin had attempted to express some sort of realistic Green agenda, and certainly managed a generally rather attractive rhetoric. I often felt either of them would have been welcomed in any of the parties in Westminster, except that their starting premise had always been the bankruptcy of conventional parties.

It is hardly surprising that Green politicians could not agree amongst themselves on their huge programme for the reform of every aspect of human life. They attracted some protest votes, many of them, one suspects, from people who would not have seriously endorsed anything like the whole of the Green agenda had they believed there was the smallest chance of its being implemented.

The Green political enterprise has so far failed because its thorough-going analysis is simultaneously too thin and too bold. Its failed boldness is seen nowhere more clearly than in its attempts to discuss economics in a new way. The impulse of Greens to push the planet's needs higher up the human agenda necessarily involves a

discussion of whether, if only we saw the world more clearly, economic man would be revolutionised out of his greed, selfishness and aggressiveness into a new creature, ecological man. The 'new economists' want to see if they can make economics less indifferent to the value of people and the planet they live on. Such thinking is directly descended from the work of Fritz Schumacher, whose *Small is Beautiful* attracted many people who feared the rise of impersonal technologies owned by impersonal large firms. Yet even this rather vague thesis now seems to attract little support. It does not seem to have been able to maintain momentum during the far louder discussion society is now conducting about the role of the state and of markets.

In an age which may well come to be characterised as that of Reagan and Thatcher, even though these two have now left the stage, it was always likely that people who think the environment matters would spawn a line of thought which said the environment was also economically valuable. If the Greens could construct a world view as coherent as the Reagan-Thatcher promotion of individualism and materialism, the Green economists thought, they might defeat the opposing ideology with a powerful one of their own.

Yet at its most distinctive, the new economics enterprise almost always seems to depend on the world becoming full of extraordinarily nice people who would rather live in a commune, than in the free-wheeling western world. Ideas about democratically-controlled work, convivial technology and full-employment abound, but not often with any greater effect or cogency than you would find in ordinary, unfashionable left-wing thinking.

The problem is not that the Green economic thinking is hopelessly uninteresting. Rather, it seems the preserve of the virtuous rather than the realistic. Where it is halfway plausible, it has a ready home in the thinking of mainstream centrist or leftish parties everywhere. Probably the best text of the would-be new economics is *For the Common Good*, by Herman E. Daly and John B. Cobb Jr.[1] Quite apart from its economic analysis, the book is perhaps the best and most attractive summary of the general Green intellectual stances mentioned above. It has been endorsed by many key Green luminaries (including Amory and Hunter Lovins, Paul Ehrlich, the New Economics Foundation, and Kenneth Boulding – the author of the most fashionable economics textbooks of the early 1960s).

However, where Daly and Cobb fail it is not likely that lesser

minds will succeed. And they do fail. We can agree easily enough with the authors' view that gross national product is a curious and inadequate measure of whether a society is doing well for its people, as we shall discuss in Chapter 12. But it is also easy enough to rewrite how we measure the wellbeing of a society without necessarily believing that we can easily rewrite how we measure economic success. Gross national product is not an irrelevant measure of an economy's activity, it is merely a limited one.

The heart of the case which *For the Common Good* argues is that nations should rig their economic life to favour small communities, encourage employee ownership and influence within firms, and that they should protect their national economies against the ravages of the world economy. The difficulty is that the western world more or less exhausted its interest in these themes in the 1960s and 1970s. The 1980s and the 1990s, so far, have developed a consensus that capitalism must be left to operate with as little, and as carefully targetted, political interference as possible. As we shall see in the next chapter, the political support for free trade and market economies is now so great that it has marginalised all left-wing thinking, including green-tinged left-wing thought.

For the Common Good contains a good deal on the idea and value of community, and some of it is subtle and attractive. It at least recognises how tiresomely claustrophobic communities have traditionally been. It is valuable on the subject of what in Britain is often called a basic income taxation system which would ensure all members of society an income whether they work full-time or not. Basic income may yet come into its own if we find that structural, large-scale unemployment becomes a feature of modern societies, as it may well. But, as I reluctantly realised when I made a radio programme on the subject in the mid-1980s,[2] society would have to be hard-pressed to adopt the idea. The great advantages of a basic income system could be gained only at a massive expense in taxation, and would only work in extremely consensual societies. On these grounds, we could expect a country like Denmark or Sweden to pick up these ideas long before Britain or the United States do.

Daly and Cobb offer their analysis as a balm to the social and economic failure they see around them in the United States. If these failures are real and become very serious, then it may be that people do address the way they look at the world, and turn to what we might as well call 'alternative' lifestyles and thinking. But so far they see no

compelling reason to do so, and are probably not at all sure that these solutions are the ones that will work even if the social and economic situation deteriorates. Besides, America and Britain, and other western societies, have older models of thriftiness and neighbourliness they could rediscover if they wanted. These countries may not need a new idea so much as to remember old ones.

Many people seem to find green ideas attractive and comforting, but do not really let this part of their thinking and feeling alter the way they live. Thus, there are many business and professional people who take an interest in green matters, but whose personal and professional lives are as fully and as enjoyably affluent as possible. Conversely, there are many people who dislike waste, use public transport, and generally behave with at least a tangental recognition of green values, but who distrust much of the opinionising and soul-searching that characterise many Green luminaries.

It may be that people really can value the environment, but do not need the professional Green thinker to help them organise their ideas about it.

Regulatory fundamentalists: Greenpeace

Leaving aside their appeal to a rather incoherent green impulse in society, it is crucial to see how far the heart of Green policy campaigning is from reality. Greenpeace, so much admired for its glamour, begins with an entirely irrational approach to some fundamental issues. None of the three specific environmental policy goals claimed by Greenpeace is attainable or wisely-based.

First, Greenpeace demands zero emissions of toxic chemicals to the marine environment from industry by the year 2000. Second, it demands an end to legalised pollution. Third, it uses a strict reading of the 'precautionary principle' as an argument for bans on any substance the group dislikes.

Articulating the first principle, a Greenpeace spokesman told me in 1992: 'The National Rivers Authority should be making it clear to companies that the endgame is zero for emissions to the environment by 2000.'[3] This statement is a Nurseryworld statement. No regulator could begin to press for zero emissions by 2000. There would not be a job in the country if industry had to obey this injunction. No one seriously believes emissions to the environment will ever be zero, or anywhere near it by 2000. More cheerfully, between now and 2000,

almost all important emissions by industry will come under tighter
control than ever before, as a result of a process which Greenpeace's
second policy-plank directly campaigns *against*.

Grenpeace demands an end to legalised pollution. Tim Birch, a
Greenpeace campaigner, told me firmly in 1992: 'We do not recog-
nise that companies should have a right to put chemicals into water
at all.' Yet it has been an important development within western
society that so many laws governing pollution exist. To imagine that
one could regulate industrial society without such laws – i.e. that one
could ban legal pollution – is simply perverse. Yet that is precisely
what Greenpeace demands. Greenpeace may say that it is pro-
foundly wrong that government should sanction pollution. But it is
in fact quite right that the state should sanction what it does not
outlaw.

The third plank of Greenpeace policy is a strict reading of the
precautionary principle.[4] A Greenpeace spokesman told the BBC2
programme *Nature*:[5]

> The precautionary principle is a principle that puts the burden of
> proof onto the polluter rather than onto the environment. If a polluter
> cannot prove that what he is discharging will not damage the environ-
> ment and will not harm the environment then he simply isn't allowed
> to discard that sort of waste.

The first sentence of this view is fairly reasonable. It usefully draws
out the 'innocence' of the environment and casts the polluter as the
villain who has to make his case to society. But the second sentence
does not flow from the first, and takes leave of the rational. It is
inevitable that every human action would fail this test. We could do
nothing, eat nothing, drink nothing, breathe nothing, if we had first
to prove to ourselves that it would do us no harm. Never mind
industry: each and everyone of us, every day, will take actions whose
consequences might harm the environment and perhaps inevitably
must, in some degree. The precautionary principle, thus stated,
would outlaw all human action.

This is not to say that the precautionary principle should be
dismissed altogether. As stated by the German government (the
principle's most authoritative proponent), the principle becomes one
which attempts the following:

> The protection against specific environmental hazards;
> The avoidance or reduction of risks to the environment before specific

environmental hazards are encountered;

and as a future perspective the management of our future environment, in particular the protection and the development of the natural foundations of life.[6]

But in the German regulatory process, the principle operates in a tension with two other competing principles which discipline the extreme actions which it might otherwise encourage. These are the principles that action should be 'proportional', and should not be 'excessive'. In other words, even its German proponents require that environment protection argue its corner as to the costs and benefits incurred and expected.

Seeing that the precautionary principle was attractive to its continental neighbours, the British government spent a good deal of time in the 1980s working out what a reasonable version of the principle might look like. It needed something which it could agree to operate with its neighbours which also fitted in well with its own thinking. The British approach had previously been to concentrate on developing two sets of competing desiderata. One was to consider the ways society wanted to use particular environments and to put them into a tension with the capacity of those environments to absorb pollution and maintain those uses. The other was to establish the effectiveness of various pollution-limiting technologies and then consider the competing economic expense and ecological merit of insisting that industries fit them. Both these approaches seemed too permissive and pragmatic to environmentalists and continentals.

The British government attempted over several years to find a way of accommodating the more fundamentalist view within a workable policy framework. The government's White Paper on the Environment, published in 1990, put its new approach this way:

> Where there are significant risks of damage to the environment, the Government will be prepared to take precautionary action to limit the use of potentially dangerous materials or the spread of potentially dangerous pollutants, even where scientific knowledge is not conclusive, if the balance of likely costs and benefits justifies it.

The last phrases of this statement might seem to water down the principle to the point where it becomes perfunctory. But this is not really so. This version of the precautionary principle merely enshrines the tensions which, in the German approach, require three separate principles. In the end, the issue comes to this: environmental

action has to satisfy the criteria of affordability and effectiveness.

The precautionary principle usefully reminds us that while it is never possible to prove that a thing is totally safe, it is worth remembering that sometimes we have to act because the balance of probability that a substance or process is damaging has swung against it, even if final proof of its villainy is lacking. This tolerable version of the precautionary principle suggests that it is wise to legislate against pollutants which are suspected of doing serious harm even if it has not been finally and scientifically established that they do the suspected damage. Taken in a mild form, this is unexceptionable. It reminds us that positive proof that a substance does harm may never come but at some point we have to back our informed hunches anyway.

But Greenpeace spokespeople often trot out the principle in support of the idea that we ought to ban emissions, or use, of any substance Greenpeace decides to campaign against. In this, useless, form, the principle judges all substances guilty until they are proved innocent.

For years now the public has heard Greenpeace statements on the media and has usually, in an anxious but thoughtless way, found them attractive. Opinion polls repeatedly find campaign groups more trusted in environmental matters than governments, scientists or – perhaps less surprising – the media.[7]

The group has achieved this effect both by exaggerating the plight of the natural world and by persuading the public that often words of reassurance by scientists, the government or industry are a cover-up. The group asserts, for instance, that: 'The government and the National Rivers Authority are allowing British industry to destroy our rivers and seas.'[8] Actually, our rivers and seas – though the former, especially, are far from pristine – are better protected than ever before from effluent, and the regulatory framework safeguarding them gets tougher year by year. Rivers and seas are less and less likely to be open to destruction than at any time in recent history.

The public accepts that some degree of pollution is inevitable, but also accepts that Greenpeace has a point when it forever presses further and faster than industry wants. Greenpeace probably also commands a good deal of support when it indulges in the easy dissidence of accusing regulators of not sharing the group's purity of purpose. Peter Melchett, the UK chairman of Greenpeace, was

recently challenged to explain Greenpeace's strategies and told the BBC2 *Nature* programme:

> I think the uncompromising stance comes from a determination to say what's right for the environment, so it's true we do not say this is what would be quite a good idea if you could possibly do it over the next couple of years sir. We say this is a requirement for the environment; this is what we need to do to protect the environment and to prevent further damage and destruction. And that's uncompromising because we're speaking for the environment.[9]

This is fundamentalism, and is as unattractive as most other kinds of fundamentalism. It is a poor recipe for deciding big issues about the progress and future of civilisation.

Campaigners, politics and dissidence

Greenpeace, arguing for impossibilities, is able to exploit a curious gap in the green debate. It is a gap which does not occur in the arguments about health, education or welfare policy issues. The main difference is that these social debates are older and more clearly political than is the ecological debate. The public and the media are well-versed in the competing positions of left and right in social issues. We are used to hearing the left argue for more expenditure and the right arguing for more self-reliance. The arguments have been enshrined in parliamentary divisions and in the papers of competing think-tanks.

The comparative youthfulness of green argument, but also the difficulty of fitting its arguments into the left-right matrix, have meant that the public has little sense of where the green ground is. More because of the deeply-emotional and romantic nature of our green aspirations, the public has felt that it is right to allow the romantic and fundamentalist wing of the debate a good deal of credence for fear that otherwise the aspiration will not be expressed at all.

It may be that the Green argument will never find a 'fit' with conventional left-right politics. That is partly because it is not suited to that sort of polarity, and partly because the conventional polarity is declining anyway.

In Britain, many issues are now being driven in an extra-parliamentary way. Cross-party select committees of the Commons, the

National Audit Office, judicial review, private prosecutions, House of Lords committees, arguments between think-tanks and campaigners: these are the means by which many modern issues are pushed into prominence. The green issue is like many others in finding its voice through these quite non-political channels. It is perhaps unique in never having had any other expression.

There is an important and clear danger here. Following the North American model, some UK Green groups have been dabbling in litigation. Few well-informed US campaigners believe damage-seeking has proved successful in the United States. Litigiousness tends to enrich lawyers rather than the environment, as long experience with the United States Super Fund has demonstrated. And yet it is natural that environmental campaigners, looking for non-political levers to pull, have found the threatening judicial review a useful option (for instance, UK Greenpeace's proposed actions against the National Rivers Authority in the case of pollution of the Irish Sea and against the Department of the Environment in the case of nuclear reprocessing).

Luckily, British courts have sometimes been quite clear in their rejection of this approach. For instance, in late 1993, the High Court did not accept that a tannery should be penalised for the unforseeable pollution which resulted from its activities thirty years ago. It is an extraordinarily bad principle – espoused by many Greens – that firms should be held responsible much later for the consequences of industrial processes which at the time had passed regulatory scrutiny. Society needs mechanisms to deal with these unforeseen consequences. But even long-delayed pollution effects need to be seen as flowing from actions which were sanctioned by society, rather than to become the focus of ugly finger-wagging.

Partly because the green debate is now gaining a history – in general of improved regulation – Green campaigners such as Greenpeace have begun to feel anxious that they may be marginalised. Journalists, regulators, academics – and following these, the public – are beginning to feel more bold when they stress the need for a sensible approach.

Greenpeace has had to rethink its position, as its programme director, Chris Rose, describes:

> In 1988, the heyday of green consumerism and the sudden government enthusiasm for matters 'green' disorientated the environment movement. Greenpeace had commissioned analyst Philip Gould

(whose other clients have included the Labour Party and the US Democratic Party) to look, amongst other things, at how the change in public mood had affected its potential public support. Gould identified two risks to the organisation at this time: marginalisation and co-option.

To counter these, Greenpeace set out to maintain its 'radical' positioning while enhancing its capabilities in specialised skills. These would enable Greenpeace to prosecute its campaigns with new tools, opening new and unxepcted avenues of attack. By the end of 1990 it had aquired a science unit, a media unit, a lawyer, a political unit and a specialist actions unit.[10]

Greenpeace has for years sought to present itself as scientifically sound, and has employed scientists to prepare its cases. It is now employing lawyers to develop legal clout. The group has developed the idea of 'enforcing solutions', which might help people feel that the group was not merely exposing problems but acting in a distinctive way to help solve them.

During 1992 and 1993, Greenpeace helped a manufacturer from the former East Germany to develop Greenfreeze. This refrigerator employs hydrocarbons and thus is free of the ozone and climate-changing CFCs, and the chlorine-free but Greenhouse-forcing hydrofluorocarbon (HFC). The campaigners claim that this move induced the refrigeration and chemical industries to accept that an ozone- and climate-benign refrigerator was possible, and note that the German manufacturer, Bosch-Siemens, soon followed suit by producing a butane-driven fridge.

For Greenpeace, the Greenfreeze episode demonstrates that it can usefully identify product developments which industry does not by itself investigate with enthusiasm because they are not especially profitable. This may well be true and valuable, but it is not likely that the group will often be able to find such products and processes (though it believes fuel-efficient cars might provide another arena for this sort of activity). Moreover, while the German and British environmental ministries (and the German Blue Angel eco-labelling scheme) endorsed hydrocarbon fridges as worthwhile, it will be interesting to see how prolonged life-cycle analyses of the new fridges stack up as against the industry's earlier compromise technology.

It is difficult to see how employing lawyers and scientists and getting involved in promoting specific products can simultaneously help Greenpeace avoid the prospect of marginalisation and co-

option. Successful and serious involvement in the processes of science, the law and manufacturing have usually involved crash-courses in realism rather than romance, and compromise rather than charisma.

Greenpeace's far deeper difficulty is to maintain the loyalty of its supporters, unless the latter develop – and allow the group to develop – a more rational and rounded understanding of the world they live in. Chris Rose writes that Greenpeace in the early 1990s undertook a study of its future and, from the outset

> took it as read that its core values would remain unaltered. This was, for everyone in the organisation, an essential constraint on any 'market-led' reforms. Greenpeace has extensive qualitative research which shows that its 'core values' centre around its 'actions', and that the views and beliefs of its staff are more or less indistinguishable in this respect from its supporters. This is one factor, a form of organisational honesty, which gives Greenpeace considerable power and resilience and creates a high degree of trust.
>
> The core values, which interestingly for an NGO (non-governmental organisation) are intrinsic, instrumental and transformative, are held to include: commitment to protecting the natural world; bearing witness; non-violent direct action; financial and political indepededence [and] internationalism.
>
> These lead Greenpeace to favour, as an internal dictum has it, 'the optimism of the action over the pessimism of the thought' and it is because these are treated as imperatives, that they lead the organisation to do things which are regarded as audacious, courageous and so on. The importance placed on action drives it away from compromise, and its 'positions' are essentially moral ones, intervening on the moral boundary of an 'issue'.
>
> Naturally this creates propositions which are 'black and white'. Greenpeace thereby tends to become involved in the elimination of problems, not their management. The internal culture of Greenpeace is, compared with many other NGOs, rather strong. In part this is because it treads the boundaries of legitimacy: carrying out acts which are legitimised by the moral deficit they address, rather than the means which are used.[11]

This, and much of the rest of the paper, looks like an attempt to justify Greenpeace's messianic – or at any rate crusading – right and duty to remain the visionary outsider while it at the same time becomes a player in processes which are many miles from its high profile marine operations.

The history of Green campaigning may have proved that confrontation and hype have been quite effective, and a case might even be made that nothing else would have worked. But victories have been won, and attitudes have changed. It is very unclear whether green-minded people will continue to want the groups they support to remain self-consciously dissident.

Luckily, there is a good deal of breadth and variety in what is wrongly called the green movement. The future lies with boosting the pragmatic green wing of the movement and weaning ourselves from the charms of the purist Greens. That there are wings in the green movement is not surprising. Nor is it surprising that some of the groups have found it hard or unnecessary so far to change their stance: campaign groups, like firms, are jealous of their market niches. Some groups, and especially Greenpeace, have seemed to shift between fundamentalism and respectability. Friends of the Earth, on the other hand, has for all its life agonised about its identity, and especially about how far it could seek real-world possibilities and policies without selling-out the romanticism of its supporters and campaigners. The group is to that extent a more realistic organisation, but also a less popular and less well-funded one.

Largely unnoticed by the British public, there has been a behind-the-scenes environmental movement in Britain. Bodies such as the Institute for European Environmental Policy and the environmental bulletin ENDS have been the formal expression of environmental concern which accepts that industry cannot and should not go away, but needs to be tamed, and that governments face real dilemmas as they seek action which voters will accept. At the heart of the dilemmas of government, and of these middle-of-the-road environmentalists, is an awareness that the public seem prepared to tell opinion pollsters that they care a great deal about green issues, but also seem unprepared to be charged high taxes or high prices to help bring them about.

It has also been little noticed how much industry wants to talk with those environmentalists who are prepared to eschew fundamentalism. This is not a question of industry's seeking to find people who have lost their soul. It is a question of finding people who are prepared to discuss the nature of reform rather than demand a revolution. Thus, people like Jonathon Porritt are regularly in discussion with industry, and that dialogue is not a sign of weakness on Porritt's part, but a sign of maturity in both parties.

Finding a balanced approach

A mildly progressive argument and a sensibly green one are very
close. There is, very importantly, a wide spectrum of green thinking,
and some of it is quite close to a progressive view. We face a problem
of definition. We have on the one hand the Capital 'G' Green, who is
a purist, and who must face the charge of pressing the claims of
nature too hard against those of human beings. On the other hand,
there is the person who accepts that some of their thinking is of a
lower case 'g' green kind, who perhaps has to face the charge of
avoiding the full force of nature's claim.

The Greens have adopted a directly and deliberately adversarial
role. They have elected to pose the claims of nature and press them in
distinction to the claims of humankind, and especially the claims of
modern society. There is merit in the existence of a body of people
who stand in defence of nature and who do so to a greater or lesser
extent with a deliberate disregard for human concerns. But to the
extent that they stress the claims of nature, the rest of us are required
to balance their claims against the human. The Greens challenge us
to defend our way of life against their views. They demand large
changes. It is hardly surprising if we take quite a lot of persuading
that the changes are worthwhile.

Some people stress that human claims and natural claims are
coterminous because human wellbeing depends on that of nature. If
it is true that nature's claims are identical with our own, one might
believe that sensible people everywhere could obey deeply Green
views and almost automatically safeguard their human concerns.

The claim that human interests and the interest of nature are
identical can take profoundly antagonistic forms. Crucially, they can
take green and Green forms. In one – deep Green – version, nature's
claims are pressed very hard indeed, while human beings are
enjoined to restrict their own demands very strictly so as to impose as
little strain as possible on the planet.

But there is a much more pragmatic interpretation of the view that
man and nature are interdependent. The 'sustainable development'
argument stresses that the environment matters to everyone –
affluent or not – and that everyone can be useful to the environment.
This line of argument reached its clearest statement in the work of
the World Commission on Environment and Development (WCED)
and its report, *Our Common Future*.[12] In fact, there had been

concerted attempts to discuss the proper use of the earth's natural resources and pollution sinks several years before. In 1980, the *World Conservation Strategy*[13,14] was the first fully-fledged attempt by conservationists and environmentalists to chart the way we might use not abuse the planet. The International Union for the Conservation of Nature (an international network of professional conservationists and academics with a secretariat and core resarch team in Gland, Switzerland) and the World Wildlife Fund (as it then was, before its renaming as the Worldwide Fund for Nature) co-operated with the United Nations Environment Programme in this work.

Proponents of sustainable development are following the World Conservation Strategy's thinking when they suggest that there are many accommodations which both human beings and nature can make as they live on the planet together. In other words, the sustainable development argument is in some sense progressive and anti-Green. Faced with the mutual exclusivity of these two views, one must, as usual in life, take sides between them, or at least accept that there are sides to take.

It can be argued that very few of the people who are really striving to find practical and workable accommodations between humankind and nature would call themselves Green and yet they do think they are preoccupied with green issues. People as diverse as agricultural aid workers and chemical engineers are trying to work out what is the appropriate reconciliation between the desire to produce and the desire to conserve, and few of these professionals would call themselves Green. Very few Greens would accept that these people are, properly speaking, green at all. The Greens are certainly suspicious of groups such as the Business Council for Sustainable Development, founded by the Swiss billionaire, Stephan Schmidheiny, with 600 mostly large firms now agreed about the need to adjust their operations to take account of the environment. The Council has honed-in on the idea of 'eco-efficiency', which in essence supposes that products must be produced with less ecological impact.

Of course, there is an element of forked-tongue in this approach. The most environmentally-conscious move many firms could make would be to cease to produce products of small usefulness and some or great ecological cost. It is not reasonable to ask capitalists to make that sort of choice, and so the most the rest of the world should

expect of them is that, finally, they should be honest about what they want to do, and open to the emerging social consensus around them. Industry should feel free to argue its corner without being branded as a pariah. One should not expect industry to be Green, only to be good citizens.

Assessing where the balance lies

There are many issues where scientific evidence is far more important than people generally suppose, and where the voice of science ought to be heard and argued over far more clearly. We need to build on the rational and democratic institutions with which we already address many environmental, health and safety issues.

In particular, we need to prize honesty of debate very highly indeed. Nothing we have seen so far justifies the sort of scare tactics which some Greens indulge in. Some western environmental problems have been nasty and worse for their victims, but have mostly been detected and handled by the ordinary authorities of society which exist to look after our health, safety and environment. The problems we know about and which are likely to emerge seem to have met and be meeting at least the beginnings of an adequate response in democratic societies. Often harried by campaigners, official bodies detect and research problems, assess them, and argue for legislation to solve them. There is room, of course, for any amount of voluntary activity and chivvying in these issues.

Once one finds, say, target chemicals and emissions, one must talk about them clearly and fairly, and aim the right regulations at limiting our risk from them. There is indeed now a substantial effort in the US and elsewhere devoted to finding out what sorts of regulations will most improve the quality of our lives with least cost and least waste. This matters because – to take an example – some proposed water regulations in the United States would have cost a couple of thousand dollars per household a year, and at best only confer the benefit of relieving households of a small chance of stomach upset. Interestingly, these costs would be incurred by families to clean up their private water supplies. The problem is not nearly so often caused by anonymous, uncontrolled corporations (there are none) as by wells and boreholes in peoples' own backyards.[15] The proposed law would deprive the citizen of the choice as to whether to take the risk.

A US law requires that the Environmental Protection Agency state what it thinks are the benefits and costs of any regulation it proposes. This makes sense, granted that hundreds of millions of dollars of expenditure have been imposed on the economy by regulations, often for rather small benefit. One such will reduce benzene emissions,[16] with an expected reduction in the formation of cancers which prices each cancer in the millions of dollars range. The regulation was intended to control exposure to benzene which, the EPA thought, was causing perhaps four cases of leukaemia a year, out of the total half million cancer deaths each year in the US from all causes. The regulations would reduce these by 90 per cent, to one every three years, and were expected to cost at least US$100m a year.[17]

Before we plunge wholesale into more such lawmaking, it is worth wondering whether anyone would consider an equivalent expenditure to reduce smoking, or even the elimination of barbecue smoke, which is probably a greater risk.

Environmental regulation matters. But we need also to see as precise and rational a discussion of risk as possible. First, we will often be able to avoid scares; second we will target our controls where they may work. Third, we may be able to persuade people in the west that there has already been a remarkable, evidence-led, response to public anxiety.

Helping governments gain trust

One of the reasons why the public is so worried about environmental matters is, perversely, that they hear governments issue reassuring noises about risk. The British authorities said: Drink the water (Camelford), drink the milk (after Chernobyl's fire), eat the hamburger (during the early days of mad cow disease). In each case, the government seemed to insist that the public was at no risk from a matter which was dominating the news media. The government was, probably, right about the risk in each case. But it should have had the courage, in each case, to say that nothing is totally safe and that each of these incidents had made the risks of consumption marginally greater. Such an approach would have given the media no room for its scare tactics, and vitiated the journalists' routine charges of complicity and cover-up as they revisit these issues.

We face a paradox. The governments of the western world have

always seen themselves as regulators. They uphold law and order. They also aim to protect their citizens from environmental and other damage. But the official world has a horror of panic and disruption – partly because of the expense of policing and alleviating them – and therefore has a long record of underplaying hazards. The official world has another, more serious, problem. When things go wrong, the public and media immediately blame the inadequacy of the government's regulations. This produces a desire in government to deny that things have gone seriously wrong. In effect, governments become crucially aligned with the wrong-doer who has slipped through the regulatory net. Worse yet, very often the government department which is charged with regulating an industry is also charged with ensuring the industry's economic success. It becomes terribly easy to claim that the industry and the ministry are in bed together, and especially that they connive at feeble regulatory controls.

Until recently, government owned many industries, and that made it virtually impossible to regulate them properly. One of the most glaring examples of the media's poverty of view arose during the process of privatising the water industry in the United Kingdom. The media could see that the government was selling the family silver (in Harold MacMillan's phrase), but could not see that this was an industry which it would be possible to regulate strictly. The government was at last emboldened to set up a tough regulatory framework and was indifferent to the capital borrowing required for clean-up.

When they are not overdoing reassurance, we find governments doing a surprisingly good job of regulating health, safety and environment threats. But one detects a new anxiety that the environment is very like the provision of public health facilities. The opportunities for expenditure are infinite, and at some point a line must be drawn. Environmental regulations, like health provision, have to be rationed. But by whom? And to whom? Members of the public are reluctant to take a serious part in the environment and the health debates because to do so is to accept that protection and provision cannot be total. And yet the line must be drawn, and must increasingly be presented in a way which is both truthful and acceptable to the public.

The only approach government can adopt is to generate genuinely independent advice about the costs and benefits of environmental

control. The new art of risk assessment gives government greatly increased opportunities to follow well-formulated and well-publicised scientific advice. Sometimes the advice will be to go forward and make society incur the costs of new controls. Often, the advice will provide the public with reassurance that the government is not being lax in resisting the imposition of new controls.

In the United Kingdom, citizens and government already enjoy a considerable array of independent advice on a plethora of risks. Every conceivable risk to every conceivable environmental medium has its expert committee, from the Steering Group on Food Surveillance Working Party on Radionuclides in Food, to the United Kingdom Acid Waters Review Group.

Dr Michael Abrams, Chief Medical Officer of the Department of Health, told a conference on tapwater regulation in late 1991:

> Much of the comment one sees in the media shows how little the public is aware of the substantial studies which have been carried out on the chemical composition of drinking water, or of the assessments which are regularly made of these issues. The Department of Health, for instance, routinely scans more than two hundred relevant specialist scientific journals, from which over four hundred articles are indexed every month. Where appropriate, searches of computerised databases of the worldwide scientific literature are undertaken. We maintain liaison with researchers on an individual basis, and through the Medical Research Council and other research organisations including the Water Research Centre. We also participate in the preparation of evaluations published by the World Health Organisation, including the current revision of the Guidelines for Drinking Water Quality. Of particular value is the willingness of many distinguished independent medical and scientific experts to serve the public by membership of the standing advisory committees or of *ad hoc* groups such as the Working Party on Fluoridation of Water and Cancer, or the Lowermoor Incident Health Advisory group. We are grateful to such people, who agree to take on this arduous responsibility, but by doing so run the risk of attacks on their personal and scientific integrity by those outside government who disagree with their conclusions.

Part of the difficulty is that much of this sort of advice is often designed to be given to ministers and is only incidentally in the public domain, or not at all. The general public is unaware the advice has been given, and has no easy way of judging its qualities. Then there

are the armies of scientists working within ministries preparing advice for ministers, mostly conscientious, highly intelligent experts. Their opinions are surrounded by a formal system of secrecy which individual civil servants disregard at their own peril (though they often do, thank goodness).

There is a simple remedy for these problems. The government ought to set up and fund an agency to bring together and coordinate all its separate sources of advice so that they come under a single imprimatur of undisputed independence and openness. The agency should be the statutory adviser of parliament and ministers, and all its advice and deliberations should be published. A separate committee of the agency should maintain a continuous vigilance on any claims that data or advice should be kept secret for reasons of commercial or state confidentiality, and report in public on what has been lost because of the need for confidentiality. Naturally, all the advice from the agency should be peer reviewed. Any regulations the agency proposes should have an economic and benefit assessment, so that when the advice goes into the political arena, legislators will have a feel for its real significance.

None of this would jeopardise the work of the three other independent environmental advisers of note: the House of Commons Environment Committee, the Science and Technology Committee of the House of Lords, and the Royal Commission on Environmental Pollution. They have all raised the profile of environmental concern and all raised the standard of debate. Their work is seldom seriously criticised by Green campaigners, and is praised in aid of the campaigners' case whenever possible.

A risk and policy assessment agency would massively bolster the public's awareness that they live in a modern, civilised, tolerably well-regulated environment whose regulation is in the daily care of many thoughtful and serious advisers. That would be a useful step away from unreason.

Even now, and this is important, there is an enormous amount of serious evidence-gathering going on. The two parliamentary committees and the Royal Commission are the equal of the Office of Technology Assessment of the US Congress, which itself produces very clever work. If one then judges the process by which the quality press and the science journals scrutinise the reports of this sort of body, and – crucially – the quality of the government's response to the reports, one grows in a sense that the most difficult issues of our

day – nuclear power, toxic waste, climate change, biotechnology – are under the most intense scrutiny by very good minds. Maybe we should do more, and certainly we could do more in the way some of the evidence is presented, but we are not far off-beam. If the people who make up these very large assessment processes turn out to have got it all wrong, I for one would rather be wrong in their company than in that of anyone I have yet met who works for Greenpeace or the other more strident Green bodies.

Uniting economics and ecology

After the initial froth of the first years of our having discovered the environment, we are now into a duller phase. The time for cool cost and benefit assessment has come. We want to know what is worth penalising by the imposition of taxes or rules, and we want to impose our penalties efficiently.

This may seem a prosaic matter: how to ensure that the polluter pays. Yet it matters. Taxes, charges and fines are the stuff of civilisation. They are the means by which we redistribute good things and penalise bad ones. So it is hardly surprising that there have been several attempts to suggest that some of the current troubles of the world flow from the failure of present-day economics to take properly into account the ecological needs of humankind and the planet.

One of the reasons we exhaust the capacity of pollution sinks to absorb our wastes, or overexploit some resources, is surely that we do not charge their users a proper rate for them. It is felt that if we could establish what the proper monetary value of environmental sinks was, we could charge their exploiters a sum sufficient to deter abuse. But this process is even harder than it looks. It is also profoundly different from a romantic 'new economics'.

Economics is a way of discussing the way that goods and services flow through and between societies, as they change hands – change ownership or user – and people charge and pay prices for their ownership or use. Many people have of course identified a failing here. Economics is no good at discussing the way some very important things are allocated and deployed. It cannot do much to discuss the allocation of desirables for which there is no market, or for which market activity is only a small factor in their deployment. People are sometimes prepared financially to reward heroism, poetry, and

beauty, but that does not at all mean that we feel that economics is brilliant at describing the way these things arise or are encouraged. Economics has its limits: some of the most important things in life are outside its remit. But what about, say, fresh air? Should not economics be able to describe its value?

There has recently been a lot of effort put into what is called resource economics.[18] This exercise is often very valuable: we have seen in Chapter 10 that there is a good deal to be said for the view that only when, say, wildlife is economically valued will it be preserved. In theory, it should be possible to see that since humans need clean air, clean air ought to have a value which can be expressed in cash terms. Actually, though, it does not take much reflection to realise that not all the computers in the world could discover the price people would pay for clean air if only they knew all the consequences of its being dirty. If the air was very dirty indeed, people would give their last penny for a breath of freshness. But it is hard to post prices for the various interim stages of dirtiness. We would for instance need to know the impacts of poor air on human health before we could begin to price dirty air, and we would need to know how to price the damage caused, say, by a 10 per cent reduction in lung capacity in a twenty year old. All in all we would be working in a surreal world as we made the attempt. It is not a world we do not know. Already judges are handing out awards to people whose health has probably been damaged by working alongside smokers, and insurance valuers work at these sorts of sums all day. But it will be years before we would dare say how much tax a car ought to pay to reflect its local, regional and planetary costs, and even then the enterprise would be pretty speculative.

Indeed, the failure of this sort of economics may be more fundamental.[19] Making polluters pay is as much penal as economic. We do not know what the value of clean air is, and in fact we will probably encourage our legislators to charge people for the right to pollute at a rate sufficient to deter would-be polluters from being too big a nuisance. In other words, we have not charged a price to compensate for the loss of clean air, we have charged a fine to deter people from dirtying it.

The resource economists are usefully trying to work out how best to impose charges and taxes so that they reduce pollution but do so without unduly distorting wealth creation. When the US Environment Protection Agency issues tradeable permits to pollute sulphur

dioxide, as it has begun to do, it is not selling off the right to pollute to the rich, nor turning 'bads' into goods for capitalists to trade in. It is simply trying to find the way to ensure that a tax is raised on polluters – partly to reduce pollution and partly to raise money – and to see that it is paid by those parts of dirty industry which can pay it with least distortion to economic activity and maximum environmental benefit.

One of the comforting aspects of taking the environment seriously is that energy taxes are actually rather a good and painless way of raising government revenue. In other words, making energy expensive may well be a better way of raising money than taxing enterprise or labour or expenditure in general. It may be, at least in this sense, that the ecologically and economically sound are coterminous.[20] But even here we should remember to be sceptical. Treasuries may well claim to be imposing an ecologically sound tax – say on energy – when they are really only imposing a fiscally-sound one. We may find energy being taxed at whatever level yields a high income without much denting people's willingness to consume fuel. It is an old trick. Smoking has always been taxed at whatever level maximises income without killing the cancerous goose which lays the fiscal golden egg. Energy use may well turn out to be rather inelastic,[21] and treasuries may delight in that even as environment departments despair.

It is tempting to see economic instruments – charges, fines, taxes – as the fairest and most efficient way of regulating pollution and resource management. In fact, ordinary 'thou shalt not' regulations are going to be required for a very long time. Getting them right is unromantic, a matter of compromise, a matter of science and debate, and also of natural prejudices. Industry, the public, politicians, and campaigners, all need a new open-mindedness as they explore this odd territory.

Notes

1 Daly, H., and Cobb, J., *For the Common Good: Redirecting the Economy towards Community, the Environment and a Sustainable Future* (London: Green Print, 1989).

2 North, R., 'Future lives', BBC Radio 4, June 23 1987.

3 Conversation with author, 1992 and Greenpeace press release, *Zero Discharges: The Only Option*, London, April 1993.

4 For a considered discussion on the precautionary principle, see the various contributions to the *Marine Pollution Bulletin*: Earll, R. C., 'Commonsense and the precautionary principle – an environmentalist's perspective', vol. 24, no. 4, 1992, pp. 182–6; Peterman, R. and M'Gonigle, M., 'Satistical power analysis and the precautionary principle', vol. 24, no. 5, pp. 231–4; and Stebbing, A. R. D., 'Environmental capacity and the precautionary principle', vol. 24, no. 6, 1992, pp. 287–95. Also: Timothy O'Riordan, 'Interpreting the precautionary principle', CSERGE Working Paper PA 93–03, Centre for Social and Economic Research on the Global Environment, School of Environmental Sciences, University of East Anglia, (Norwich NR4 7TJ).

5 'The devil's element?', *Nature*, BBC2, November 4 1991.

6 Royal Commission on Environmental Pollution 12th report, *Best Practicable Environmental Option* (London: HMSO, 1980), p. 12.

7 Robert M. Worcester, 'Public and élite attitudes to environmental issues', *International Journal of Public Opinion Research*, vol. 5 no. 4, 1993.

8 Greenpeace, 'No legal pollution', Press Release, 11 August 1992.

9 'Pressure point', *Nature*, BBC2, December 2 1991.

10 Rose, C., 'Beyond the struggle for proof: factors changing the environmental movement', *Environmental Values*, 2 (1993), pp. 285–98 (The White Horse Press, Cambridge). Chris Rose is the Programme Director of Greenpeace UK. His remarks about the organisation refer to Greenpeace UK.

11 *Ibid.*

12 The Brundtland Commission, *Our Common Future* (Oxford: Oxford University Press 1987).

13 *World Conservation Strategey* (Gland: IUCN/UNEP/WWF, 1980).

14 A popular account of the above was written by Robert Allen, *How to Save the World: Strategy for World Conservation* (London: Kogan Page, 1980).

15 Elder, J., Office of Ground Water and Drinking Water, US Environmental Protection Agency, 'Lessons from America', paper given at Water 2000, London, October 1991.

16 United States Environmental Protection Agency, 'EPA move to reduce benzene air emissions', US EPA, press release, August 31 1989.

17 *Ibid.*

18 Pearce, D., Markandya, A. and Barbier, E., *Blueprint for a Green Economy* (London: Earthscan, 1989); and see Cairncross, F., *Costing the Earth* (Harvard Business School (distributed in UK by McGraw Hill), 1993). 'Grossly distorted picture', *The Economist*, February 5 1994, is a useful account of several difficulties in national accounting.

19 The *Economist* seemed to think so in its useful and sympathetic account of the attempt to incorporate green matters into national

accounting: 'The price of everything, the value of nothing', July 31 1993.

20 *Green Futures for Economic Growth*, Cambridge Econometrics (21, St Andrew's Street, Cambridge CB2 3X) 1991, p. 23.

21 Demand for a good or service is inelastic when levels of consumption are relatively unresponsive to price increases.

12
Humanising development, developing humanism

The challenge for modern humankind is to prepare for a world in which 10 billion people live. We have looked so far at how we are technically capable of pulling off this trick, at the expense of being quite bold about some risks and some damage to cherished myths and dreams. This chapter considers whether western ideas can help the Third World help itself, and comes to a tentatively optimistic conclusion. We concentrate on the Third World, because that is where the new problems will be concentrated.

The literature of hope

I first came across the idea of a 'literature of hope' in a book co-edited by Gerald Leach.[1] Leach was a pioneer environment correspondent until he went to work for perhaps the most important think-tank in Britain: the International Institute for Environment and Development (IIED).

Little known outside its field, IIED applies good minds to discovering and promulgating ways of combining economic growth in poor countries with the ecological needs which underpin it. The institute was started by Barbara Ward and others. Ward was a passionate and brilliant writer, working for the *Economist* magazine for much of her career. She was a Catholic. Her several books are early examples of the literature of hope, though it was not called that then, so far as I know.[2]

The literature of hope is a small group of modern books which tackle various aspects of environmental and development concerns, but all eschew the clichéd version of events in which people are

described as more or less doomed, condemned by greed and folly to exploit the environment until it can no longer support them.[3] Each of the books tends to focus on quite a restricted and specialised area, but they build into a strong bastion against the doom-merchants.

Beyond their general assumption that the game is not lost, there are more things in common to the genre. For instance, in *Beyond the Woodfuel Crisis* Gerald Leach and Robin Mearns point out the flaws behind the assumptions that peasants will inevitably cause deforestation on a vast scale because they each have a fixed demand for fuel, there are increasing numbers of them, and there is a declining stock of trees to supply their needs. Leach and Mearns make clear that the apparently inexorable mathematics of this doom-laden view do not always work out quite as might be assumed. There are countries which should by now have been treeless if the forecasts and the thinking of the 1970s and early 1980s had proved right. But these countries still have trees. It turns out that peasants and the economies they live in often have, as you would perhaps expect, various strategies by which they get hold of wood without knocking down every last tree in their environment. Besides, it turns out that in many environments it is not the demands of firewood-gathering which strip out trees. Often, the demands of farmers are a more important factor.

The message here is the one which unites the literature of hope; let us not foist a generalised, stereotyped set of trends and tendencies on the Third World. We need to try to see the developing world as very diverse. It has diverse problems and diverse opportunities. To the extent that it does indeed suffer from some common problems, they are widely advertised. We might just as well stress it also has some shared advantages, not least among them the ingenuity of people. To see the Third World as one place is an excusably tempting device. It helps us to conceptualise it. But it also robs the citizens of the Third World of their individuality, and that is a serious disservice to their humanity.

Beyond the way we tend to extrapolate from a few vignettes – often just one stereotyped vignette – there is a further crippling mechanism at work in much of the doomsters' scenario. As we saw in earlier chapters, and especially Chapter 2, it is extremely dangerous to assume that trends always continue and accelerate to disaster-point. Our old friend, the exponential curve, is often the villain here. As an important engine of the exponential curve, there is the business

of building a large argument and a sense of terrifying exigencies by heaping heroic assumptions onto very weak numbers. So we find that the doomsters are producing arguments to say that deserts are spreading, deforestation is causing floods, peasants are starving, the timber trade is knocking down tropical forests (all true in some places, but not in all), and that the world is condemned to watch these phenomena grow and feed upon themselves until the planet collapses. The literature of hope unravels some of these arguments and finds them very wanting.

When we read the literature of hope, we seem to be reading the most interesting of the commentators; they help us get behind the cliché and into real cases. We get behind bogus statistics and into individual situations, and we get behind simple and often uninformed assertions and see some real insight. One draws strength from the literature of hope because it seems brighter and more knowledgeable than the polemic it replaces. The literature of hope is not Panglossian. It does not say that everything will be for the best in the best of all possible worlds. Certainly, this book, which I hope deserves a place in the literature of hope, does not say that everything will be rosy. The nature of its optimism is more that many – most – people born into the world in the next few generations should, with any luck at all, have a style of life which allows them to develop as human beings and to achieve a good deal of what they want in life. It assumes that what people want is very important. People's ability to make choices from a range of options is something we want to promote for as many other people as possible because we enjoy the exercise of choice ourselves.

The good news that dare not speak its name

The Limits to Growth was the most famous of the doomster books.[4] It seems an age ago now, but in 1972 this book seemed authoritative and terribly compelling. The power of computers had been brought to bear on an assessment of human folly. The human condition was modelled and found to reveal a plethora of exponential curves. Some plummeted downwards, some soared upwards, but they all moved in undesirable directions with catastrophic steepness. Shortages of materials and fuels, overloaded pollution sinks, undernourished, rising populations all threatened. Largely ignored at the time was the book's statement that a sufficiently intense international effort could

avert the crisis. The trends were to be seen as compelling and dangerous, but not inexorable.

Even at the time, and noted in the book, there were plenty of criticisms of the work. It was especially noted that technologies might produce new energy sources, new sources of protein; that there might well be new discoveries of raw materials. In other words, that ingenuity might make the future rather different than an analysis of merely present trends could show.

Something very like the *Limits to Growth* analysis came close to being the official US view, when President Carter endorsed the *Global 2000 Report* his Council for Environmental Quality prepared in 1980. There was of course a reaction. Led by Herman Kahn, a fascinating think-tanker and writer, the Hudson Institute trawled the evidence and came up with a very different view. Their point was partly that the Club of Rome's analysis of the existing trends was wrong. Soils, for instance, were not disappearing in the United States at the rate which had been described. There was no sign of shortages of minerals. And much more.[5] But the heart of the Hudson Institute's view was much more radical and exciting than that. A colleague of Herman Kahn's, Julian Simon, argued in paper after paper that rising populations represented rising economic opportunities.[6] This analysis saw new babies as new markets, new workers and new entrepreneurs in the making. Rising populations were not a threat but an opportunity. The two sides of the argument share an important fault: they are too global, too monolithic, too synthetic. They are too ideological, too encyclopaedic. They are condemned to the inadequacy of being overviews.

Anyway, the debate was nicely defined and the two parties – doomsters and boomsters – could be left to race along on their divergent tracks, each usefully provoking thought, but neither monopolising truth. They each risked not admitting the value of the tendency the other represented. The energy and ingenuity of humans was advertised by the Hudson Institute and underrated by the Club of Rome. Meanwhile, the value of the Club's warning was underrated by the Hudson people.

In 1992 the successors to the Club of Rome – some of its erstwhile members – returned to the fray with their *Beyond the Limits, Global Collapse or a Sustainable Future*. It is a curious book. Naturally enough, it reminds us that *The Limits to Growth* was a subtler work than its reputation might lead us to suppose. It was a warning not a

prediction. Looking at the modern world, the authors find them-
selves saying very odd things. On the one hand, they point out:

> In 1971 we concluded that the physical limits to human use of
> materials and energy were somewhere decades ahead. In 1991, when
> we looked again at the data, the computer model, and our own
> experience of the world, we realised that in spite of the world's
> improved technologies, the greater awareness, the stronger environ-
> mental policies, many resource and pollution flows had grown beyond
> their sustainable limits.
>
> That conclusion came as a surprise to us, and yet not really a
> surprise. In a way we had known it all along. We had seen for
> ourselves the levelled forests, the gullies in the croplands, the rivers
> brown with silt. We knew the chemistry of the ozone layer and the
> greenhouse effect. The media had chronicled the statistics of global
> fisheries, groundwater drawdowns, the extinction of species. We
> discovered as we began to talk to colleagues about the world being
> 'beyond the limits', that they did not question that conclusion. We
> found many places in the literature of the past twenty years where
> authors had suggested that resource and pollution flows had grown
> too far, some of which we have quoted in this book.
>
> But until we started updating *The Limits to Growth*, we had not let
> our minds fully absorb the message. The human world is beyond its
> limits. The present way of doing things is unsustainable. The future, to
> be viable at all, must be one of drawing back, easing down, healing.
> Poverty cannot be ended by indefinite material growth; it will have to
> be addressed while the material human economy contracts. Like
> everyone else, we didn't really want to come to these conclusions.[7]

So the authors found themselves quaking about what would hap-
pen when they punched the new data into their computers and tried
to find out where the trends were leading. We can stop a moment
here and identify some very important nonsense. We all know per-
fectly well that some people are hungry and very poor. We know that
some live in polluted environments, and other are condemned to live
on poor land. But what do we know about this business of the world
already being beyond its limits? In cold blood, we know nothing.
Locally, there are problems in some places: that is obvious. All the
rest, all the planetary talk, is speculation. Far more probable than
that we have overstretched the limits is that we have to learn – and
quickly – how to redefine the limits and live within them so cleverly
that as many as possible of the humans born now and likely to be
born can find themselves a decent life. Of course we cannot go on as

we have been: at no time in history has it been possible to go on in the future as people did in the past. The idea of having to do things in a leaner way is also as old as the hills. The human species has a long tradition of learning how to get more of what it wants for less effort and less waste of resources.

In short, while there are ecological rules on this planet – naturally – there are no obvious limits that we know of. Warmth, movement, food, shelter, education and all the other things we prize as humans can all be provided in dozens of different ways. Our task now is to find new ways of achieving them. That has always been our task. If this resource, or that pollution sink, or that production method has proved redundant or unsustainable, we must merely find another or find ways of making fewer demands.

To its evident surprise, which should make us suspicious of the authors' wit, this is exactly what the successors to the Club of Rome found when they did their modelling work with their computers:

> With some trepidation we turned to World3, the computer model that had helped us twenty years before to integrate the global data and to work through their long-term implications. We were afraid that we would no longer be able to find in the model any possibility of a believable, sufficient, sustainable future for all the world's people.
>
> But, as it turned out, we could. World3 showed us that in twenty years some options for sustainability have narrowed, but others have opened up. Given some of the technologies and institutions invented over those twenty years, there are real possibilities for reducing the streams of resources consumed and pollutants generated by the human economy while increasing the quality of human life. It is even possible, we concluded, to eliminate poverty while accommodating the population growth already implicit in present population age structures – but not if population growth goes on indefinitely, not if it goes on for long, and not without rapid improvements in the efficiency of material and energy use and in the equity of material and energy distribution.

The authors then, perhaps naturally, go off on a little voyage of what is surely self-deception. They say that the messages of the *Limits to Growth* need strengthening in the face of this new evidence. At no point do they face up to the fact that much of the thinking and tone of *The Limits to Growth* were just plain wrong. More importantly, their own words tell us that *Beyond the Limits* is not a continuance of *The Limits to Growth*, but rather provides good evidence that the

earlier book was simply misguided.

The authors of *Beyond the Limits* re-emphasise the need for political and social adjustment. But they cannot avoid stressing that the changes needed may actually be technically quite easy. They suggest the future offers a 'living choice, not a death sentence. The choice isn't necessarily a gloomy one. It does not mean that the poor must be frozen in their poverty or that the rich must become poorer.'

The odd thing about *Beyond the Limits* is that it might more reasonably have been called 'Expanding the Limits', or 'Why There Are No Limits to Growth'. In most important ways, it says very much what Herman Kahn and Julian Simon have been reviled for saying: namely, that the world is not in the pickle the doomsters suggest. Human ingenuity may well find sustainable alternatives to the present way of providing for human needs and wants, and even quite a lot of their whims.

There are several criticisms to be launched against *Beyond the Limits* – the clumsiness and (admitted) unreality of the computer model being prime amongst them. But the real difficulty is simply that the book and its thinking seem to take place in some real enough, but somehow irrelevant, place. The enterprise feels as though it has been cooked up in well-intentioned drawing-rooms and dens in some university town. Reading it does not give one any very strong sense of the political, human, economic and technological realities which give one clues as to where the bad and good news is likely to come from in the foreseeable future. This is what distinguishes it from the literature of hope, one of whose essential characteristics is that it is so rooted.

The market and social cohesion

One of my central aims in this book has been to expose some large clichés. But even if that mission is accomplished, we are left with a pretty big problem. We have seen that the challenges which the world faces are not uniform, and are often amenable to technological solution. We can suggest that the rich world can usefully continue its present path of legislating and organising for the continuation of wealth-creation within an ecological envelope. We do not know where this process will lead us. We do know that we have already demonstrated the capacity to respond to our knowledge of constraints, and we can be tolerably confident that the response will

continue to be interesting, competent and probably sufficient. Future generations of westerners are likely to live in a fairly agreeable environment and to live well.

We are very much less clear about what some of the poor of the world will do as their numbers increase and their environmental constraints worsen. One clear and simple way of seeing this problem, and to judge what would be a proper response to it, is to pretend for working purposes that the poor of the world now more or less pose the sort of problem which the poor of the rich world have historically posed.

As we look back over the history of the rich world, we do of course find argument about how much the poor are a responsibility of the rich. We find a fierce debate about how the rich can discharge their obligations to the poor, whatever they are. There are lots of arguments as to how people should have behaved in the past, and almost as much argument about how they should now behave.

The west has overwhelmingly moved toward a view that the state should not own the means of production. It has moved less certainly towards a view that even where the state provides goods and – more particularly – services, either to the poor in particular or to everyone in general, the provision should be done as nearly as possible in imitation of the way the free market works. There is plenty of confusion about how far to take this second view, and a suspicion that the people who most promote it may not really be committed to the state's provision of the goods and services at all.

The western world has developed a strong sense that there are responsibilities of equity – especially of opportunity of health and education, but also of basic economic welfare – which fall to states. But it has equally developed a sense – it is bound to be fragile during recessions – that markets are more efficient than bureaucracies at the business of provision of goods and services.

When we then turn to wondering how to ensure that the poor of the world survive and if possible prosper, and do so within a local, regional and global physical environment whose good health is important, we find powerfully divergent ideologies at work. The Greens, by and large, adopt the view that it is greed that is the undoing of humankind and therefore that the market is at best suspect as a means of bringing wellbeing to all, since it relies on the outcome of many individual desires to work well for the aggregation of individuals involved. As Jonathon Porritt wrote in 1984:

It seems unlikely that most people will be able to discern their own genuine self-interest until our society begins to shrug off the curse of individualism. There may well have been a time, at the start of the Industrial Revolution, when Adam Smith's assertion that the sum of individual decisions in pursuit of self-interest added up to a pretty fair approximation of public welfare, with the 'invisible hand' of the market ensuring that individualism and the general interest of society were one and the same thing. But in today's crowded, interdependent world, these same individualistic tendencies are beginning to destroy our general interest and thereby harm us all.[8]

The governments of the rich world, on the other hand, are inclined to suggest that the Third World needs the same medicine that did the rich world so much good over the decades: capitalism and the vigour of the market.

Even in its crudest statement, this view has some obvious merit. The economies of the world which have done well have mostly been enthusiastically capitalist and most of those which have done badly have been variously dedicated to techniques of command and control. It is true that China confuses us by its apparent success within a controlled economy. But we know too little about China to judge either the degree of its success or the degree to which it can be attributed to communism.

Besides, there are some very serious flaws in the view that emphasises how capitalism enriched the western world. It needs important qualification. Particularly, we can see some of the successful economies indulging in quite a lot of interference in the marketplace even as they generate wealth, let alone as they distribute it. Japan, Germany and France all have a tradition of quite powerfully centralised approaches to supporting certain industries and to promoting certain technologies. The United States and the United Kingdom are much less interested in centralisation, but both have powerful military-industrial complexes, as identified by President Eisenhower in the 1950s. Within the United States, there is a powerful tradition of pork-barrel politics which has channelled central government funds towards developments in various states. This is increasingly likely to be true also of the European Community, whatever the views of some of its individual states. Throughout the western world, money has been channelled into public education and health. In short, successful western societies have been considerably less *laissez-faire* than they seem, and even rather right-

wing people within them are often much more committed to central government action than might be supposed.

Even in thoroughly capitalistic western societies, there is an important and widespread view that the well-off have an obligation to the less well-off, and that everyone has powerful social obligations. There are strong voluntary movements in all western societies. In some, even the judiciary is in important part a volunteer movement. In most western societies the payment of taxes is accepted and avoidance quite rare. Charity and charitable foundations have important roles in most western societies. The web of obligation which binds the relatively weak with the relatively powerful is subtle but robust. It has grown alongside a more formal view that the legislators should play a part in ironing out the forces which structurally and systematically deny people an opportunity to thrive.

It is the failure of these subtle bonds and enabling laws to develop in much of the Third World which most puts it at peril. In many cases the strictly local bonds of family or tribe have been eroded or distorted, but no more generalised bonds within society established. In African countries, it often looks as though the worst nepotism of the tribal system survives, but not the valuable social support.

The Third World is home not merely to many poor people, but also to many rich people. Indeed, the sharpness of the inequality to be found in the Third World is probably the most shocking thing about it. Of all the accelerated evolutions which are needed in the Third World, the development of something like western politics and social webs are the most important. These webs are partly the means by which actual money flows from rich to poor. Almost more important, they are the channels through which opportunity flows from advantaged to disadvantaged.

So, however strongly we feel that a heady dose of the energy of capital and the markets is needed in the Third World, we also need to encourage a development of the sort of community culture which also strongly defines the western societies.

Intervening to end intervention

The difficulty is to combine this view with the competing, 'markets work', view. There is an overwhelming consensus of thought which suggests that economies work best if governments interfere as little as possible. Indeed, the international institutions that lend money to

Third World countries have become increasingly insistent that they will only lend to those countries which agree a handful of economic policies. These include:

- the abolition of state purchasing bodies which formerly controlled the trade and pricing of most home-produced and imported goods;
- the freeing of exchange rates so that countries allow their currencies to drift to whatever the market values them at, which is usually downward and so makes imports dear and exports cheap;
- the cancellation of subsidies on food which formerly kept urban populations sweet at the expense of underpaying farmers for their produce; and
- the strict control of government budgets to control borrowing.

The upshot of these policies is to turn poor countries into trading nations, and especially into countries which must export or die. With luck, and in time, these 'structural adjustment' programmes will – it is assumed – allow an economic revolution to sweep through nations, as farmers at last grow more, and industry arrives to take advantage of cheap labour. Few now dispute that these benign results, as well as initial extreme social pain, are the likely results of these policies. But when I first saw the struggle of poor people in Kenya and Lesotho to send their kids to school with something to eat at midday, it was odd to reflect that the poorest of the poor in Africa are supposed to provide their children with the means to buy lunch in the middle of the schoolday, while in the west children from families who are rich by comparison are given a free lunch by the authorities. Structural adjustment had taken away the free lunch for children without yet delivering the new promised wealth.[9]

The kindlier, slightly left-wing, sort of commentator, and especially the Green commentator, sees all sorts of problems in the capitalist scenario. First, he or she rightly dwells on the pain which countries experience as they make the adjustment, with poor people often paying vastly more for basics. But such commentators also see poor countries forced into a scramble for economic growth in which the product of their hands and soil will be siphoned-off to rich countries at low prices. They predict exploited labour and land in the poor world, and undercut workers in the rich world. In short, they see this as a recipe for the endless economic growth which they think has done so much harm already, but this time within a likely scenario of massive unemployment and pollution as well.

Over this picture now needs to be lain the worldwide move toward free trade. Read *The Financial Times*[10] and the *Economist* magazine or the comments of politicians, and one sees the General Agreement on Tariffs and Trade (GATT) as producing a world in which the Third World's producers are less discriminated against by rich countries. In this view, the world's poor should be able to sell their product into any world market, and also able to buy goods and services for their hard-earned money. The flow of money will do more to clean the Third World environment than fine words. Only have the courage to trade, this view has it, and all will be well.

There are attempts, uncertain at best, to assess which countries in the third world will do best out of the increased prices for some products and the decreased prices for others which will probably follow freer trade.[11, 12] There are attempts to work out, for instance, which countries will benefit and which lose when the rich world has less surplus wheat produced by subsidised grain barons to dump at reduced price on Third World countries.

There are anguished calls from environmental campaigners who note that environmental controls are hard to introduce when one is also outlawing barriers to trade. And yet the movement toward free trade, like the movement toward freer economies, goes on. It is promoted by all the leading economies of the world. The Organisation for Economic Cooperation and Development, the World Bank, the International Monetary Fund, the G7 ministers, most economists and most politicians who have a serious chance of running anything, all largely agree that freer trade and freer economies are, like democracy, likely to be a good thing. The left in rich countries did not even seem seriously to attempt to argue against the tendency. The opposition came from a small coterie of environmental writers (and, in one case, from food and farming campaigners associated with the eccentric millionaire James Goldsmith who has himself written sceptically on the value of free trade).[13]

The experiment in free trade and market-driven economies is the only game in town. This has several advantages, of which the greatest is that from Africa to the Urals, there is broad acceptance that free-market economics are the order of the day. This is the argument which a government must accept if it wants international aid, whether from international institutions or from individual rich-world governments. This is the standard by which poor governments will be judged to have tried to run things in a way which is good for

the economic wellbeing of their people.

If this experiment turns out to be wrong, the losers by it will be able fairly to claim that they played the game, lost by it, and now their plight is in some very sense the problem of the rich countries. When the world is an economic global village, one whose unity and method of working is dictated by the rich, we will presumably be even closer to a world in which the poor of one country are in some quite real sense the responsibility of the rich of another.

Redefining development

By themselves, economic insights are starkly inadequate when it comes to the discussion of how anything like equity in economic distribution can be achieved. So it is a great comfort to find that the World Bank's annual development reports have, in recent years, focused on the business of linking the general economic development of poor economies to the wellbeing of the poorest within those countries.

The *1990 World Development Report* was specifically devoted to, and entitled, *Poverty*.[14] In 1992, the World Bank's team addressed *Development and the Environment*,[15] and tried to find as many means to link economic development with positive, or at least not dangerously negative, environmental and resource implications as possible. These two reports complemented the effort of the 1991 report, which looked at the *Challenge of Development*,[16] and tried to see which policies in the postwar period had achieved anything like the alleviation of poverty in the Third World. These were all humane and intelligent efforts, and reading them is a sure way to feel that this species has chances as well as challenges.

The World Bank's reports demonstrate that it is possible to develop parallel lines of thought, the one devoted to increasing wealth in poor countries through hard-headed economic insights, and the other devoted to constant reminders that the most important beneficiaries of the new wealth ought to include the most poor.

The work of economists is subtly altering to take account of how the alleviation of poverty and the preservation of environments matter in development work. It is also fascinating to see how the formal definition of development goals is changing. The United Nations Development Programme (UNDP) has, since 1990, produced an annual *Human Development Report*. Its avowed purposes

include a slightly improbable attempt to rank countries in an index of human development. More usefully, its central purpose shows an important new line of thinking. The opening words of the 1990 report's overview say it clearly:

> This report is about people – and about how development enlarges their choices. It is about more than GNP growth, more than income and wealth and more than producing income, commodities and accumulating capital. A person's access to income may be one of the choices, but it is not the sum total of human endeavour.
>
> Human development is a process of enlarging people's choices. The most critical of these wide-ranging choices are to live a long and healthy life, to be educated, and have access to resources needed for a decent standard of living. Additional choices include political freedom, guaranteed human rights and personal self-respect.
>
> Development enables people to have these choices. No one can guarantee human happiness, and the choices people make are their own concern. But the process of development should at least create a conducive environment for people, individually and collectively, to develop their full potential and to have a reasonable chance of leading productive and creative lives in accord with their needs and interests.[17]

It is a bit odd to hear of such fundamentals described as choices, as though someone might choose not to have a long life. It is more to the point that these are important social goods which are not purchasable by individuals, almost irrespective of how rich they are, if they live in societies which do not nurture them. Good health and viable environments cannot be chosen or purchased solely by individuals. Like law and order, they are communal goods.

The special merit in the UNDP's enterprise is that enshrining human development as a goal is an important enrichment of the way we think about economic development. The UNDP's report goes on to identify some countries which achieved economic growth – that is, growth in their gross national product – but failed to achieve commensurate human development for their people (these countries included Mauritania and Saudi Arabia). It also identifies other countries which did not have fast-growing economies but managed to improve the human development of their peoples (these included Sri Lanka and Jamaica).

This process of seeing development in a rounded way would be useless without some sort of a recipe for success. We, thankfully,

have that as well. At the economic level, we see countries bullied, cajoled and coerced into a free-market approach. But increasingly we see descriptions of programmes which usefully help encourage human development and its role in economic growth. These characteristically include positive help for primary education and health care, and a basic social security safety net. All these have been shown to be cost effective either in promoting economic growth, or social wellbeing, or both. All were threatened in the early 1980s when structural adjustment was seen as the sole priority. All have the advantage of conferring great benefit at quite small cost. They imply strongly that many of the citizens of the world need to be richer, but their wellbeing need not depend on western levels of affluence.

It is a constant cry of the Green that western levels of affluence corrupt the westerner and are unobtainable by the Third World. This insight may be true, but it is not terribly important. Good food, good health, a long life, participation in the worlds of politics and entertainment, an education of quality, and many other of the most valuable human aspirations are not necessarily expensive. But they are not free and cannot be afforded by countries as poor as much as the Third World presently is.

We begin to see a quite clear development of a view which suggests that countries on both the giving and the receiving end of development aid know a language of development which encompasses both wealth-creation and social wellbeing. We know how money wealth can be turned into human wealth. We know a way of combining hard discussion of capitalism and economics with an equally realistic but more directly social task of equipping people to live their lives.

There is of course no certainty that aid of any kind can help poor countries. Certainly much aid has been squandered in the past. An important line of argument has emerged – especially in the eloquent hands of Robert Chambers[18] – which suggests that aid has been wasted because development specialists systematically failed to appreciate the knowledge of the people in Third World countries who were supposed to be helped. Most especially, they did not realise that the poor were allergic to the kind of risk-taking that most rich people too easily supposed was necessary if the poor wanted to become richer. As Chambers pointed out, many poor people prefer to stick with a small livelihood they expect to be relatively secure rather than chase the risky phantasm of new riches.

Of course, in practice there will be many kinds of aid given by rich

countries to poor ones, and it risks being useless if it is not aware of people's real needs. But it may also be useless if it flies in the face of economic realities. Helping a handful of peasants to become a little better off may salve consciences in the west but leave millions of the peasants' countrymen and women none the better off. It was not, we may care to remember, smallholder schemes which lifted the west out of periodic famine. It was hard-nosed yeoman farmers, often spurred on by the example of advanced aristocratic landowners. Even in poor countries, the very poor do not have a monopoly claim on our attentions. It is often people of small, but some, means who offer the most realistic growth point in the immediate future. The very poor are often too shackled by ignorance, fear and poverty of opportunity to be easily encouraged into economic activity. It is unrealistic to imagine that every peasant can become an entrepreneur, and western help may best be directed at the potential of the moderately well-off to become larger-scale employers.

We should not cripple ourselves with romantic clichés about development. It is likely that both peasants and plantations will be encouraged. Big water-schemes with dams and the development of ideas using a row of easily-gathered boulders will simultaneously seem useful. Large factories as well as small workshops will employ people.

The scale of industry in the Third World is a desperately difficult problem. We are bound to hope that smallish, locally-owned businesses will play at least as big a role in development as large multinational corporations. But small firms can often be highly exploitative. Often they are also highly polluting. One commentator, committed to the growth of the small business sector in Latin America, commented to me that many of these firms had quite serious emissions. Encourage them to grow and, at least for a while, they would be even more polluting. Subject them to increased regulation and they might go under altogether.

Many poor countries have very strict environmental regulation, often copied wholesale from the west. One of the most useful things the west could do might be to devise and help enforce and pay for decent, manageable and affordable environmental regulations for their trading partners. These rules might not be as strict as those we expect in the west, but it will be better to have adequate rules obeyed, than to have extravagantly strict rules flouted.

The issue of scale is at the heart of a modern Ludditism. We are

bound to fear that the historical move toward higher productivity from fewer workers is at last going to meet its match, perhaps in the west, but certainly in the Third World. In the west, technology has not, historically, produced long-term unemployment. We wonder if it is now beginning to. In the Third World, it seems very dangerous to unleash modern technology and modern corporate industrialism into societies which do not need affluence and do need enormous amounts of employment.

The technology of the modern world is not necessarily centralising (as we discussed in Chapter 3). Radio, television and computer technology are all capable of helping people to live and work agreeably in the countryside. They will increasingly release people from the inevitability of going to the city to find work, participate in social debate, and seek recreation.

And yet, clearly, finding the balance between technology and employment will be an enormous as well as an interesting challenge. However, the problem is not necessarily desperate. Human ingenuity seems to know how to create wealth better than it knows how to create jobs. It may be that in the future we will face a far greater problem in finding paid employment for people than we will in materially providing for them.

These dilemmas are inevitable, and it is unlikely that societies can somehow blank them out by throwing up a wall of Luddite, protectionist, command-and-control policies. The dilemmas present great uncertainties, but we are not entirely unarmed.

At least now there is broad acceptance about the big economic picture and a matching awareness of the need to be alert to the wisdom and needs of the people one is trying to enrich. We have, in short, something like a description of the process which enriched the western world and we think it can be modified and encouraged in the developing world.

After empire, international governance in the modern world

The end of the 1980s and the beginning of the 1990s have seen a curious mixture of very good and very bad news. In eastern Europe and throughout the old Soviet empire there seemed at first to be the wholly satisfactory upwelling of a democratic urge and people largely rejoiced. The more obviously right-wing thinking saw events as the collapse of iniquitous communism and seemed also to delight

in the confusion the changes spread amongst the left in the west. Even in Africa, so often and generally the scene of tragedy and pathos, there was the emergence in some countries of signs that multi-party politics might be tolerated. Tribalism may at last give way to some more modern form of government.

But as new wars in eastern Europe and old and new wars in Africa seemed to drench some of these hopeful signs in blood, one began to see the advantages of the older, more hierarchical order of Soviet rule in one case and colonial rule in the other. If tribes and nations in Africa or eastern Europe are committed to a medieval or even a Stone Age loathing of one another, might one not be glad of some over-arching power which simply stamps out internecine strife?

After all these years in which it has been impossible to talk honestly about the mismanagement of Africa by African élites, for fear of charges of racism, it has at last become possible to do so. Richard Dowden of the *Independent* made a television film in which he found plenty of voices in Africa prepared to say that only strong outside intervention could make some countries there work.[19]

Increasingly, there are signs that it is becoming allowable to talk honestly about the problems which undermine countries and relations between countries. The public is beginning to realise that hunger and depravation in many countries arise, not from a colonial legacy, but from bad government or civil strife between competing élites. Tony Killick's *Explaining Africa's Post-Independence Development Experiences*,[20] is a powerful account of how the 'patrimonial state' turned countries into something close to private enterprises for tiny élites and the bureaucracies they controlled. There were plenty of other elements to his account of Africa's failures and successes, and yet what sticks in the mind is the clarity of statement that it was in large degree the fault of Africans, and not of world commodity markets or colonial mismanagement in the past, that things had often gone wrong.

It is now possible to say that there is a certain yearning in Africa – as there has been outside it – for the honest if self-interested government which the European powers once brought to Africa. There are at least two modern forms of colonialism – both of them identified by Richard Dowden's film – at work today. There is the multinational firm operating plantations and other enterprises. And there is the more insidious but potentially even more powerful rule-by-conditionality by the international aid and lending organisations as

they require policy changes as a condition of making loans.

There has always been a good deal of feeling among Green and left-thinking people that the multinational is bad for rich countries and close to criminal in poor countries. There are plenty of ugly images of exploitation of natural resources, and not a few of exploitation of people. But even so this view is flawed. As I researched the resource and human implications of about thirty products and services which were commonly bought in the west but often produced in the Third World,[21] I came to realise that in many cases and places it was the strongly-resourced, widely-experienced multinational that stood a chance of doing things well. Not merely were its people and experience and cash capable of the sort of investment which Third World people and environments need. The multinational is accountable to rich-world partners – employees, shareholders, customers – who can stand as powerfully disciplinary influences on the firm's operations anywhere in the world. As a wise economist once said, there is only one thing worse than being exploited by a multinational corporation, and that is not being exploited by one. Being exploited by some thrusting entrepreneur of one's own race and nationality is likely to be more bluntly nasty.

The familiar bonds and arrangements between countries and corporations are likely to be matched or even dwarfed by new arrangements which emerge to control pollution problems, and to spread enabling technologies, around the world in the future. International treaties are likely in the future to promise aid from rich countries to poor ones in exchange for acceptance of new internationally-negotiated pollution and emission standards. Sometimes, Third World countries will be able to argue that only the transfer of technology on favourable terms will allow them to sign international accords. In a weak form, this has already happened with the convention to reduce CFC and other chlorine-forming emissions which damage the ozone layer.

The poor world has a sort of reverse power. It might overwhelm the planet with its uncontrolled pollution – say of carbon dioxide. It might even starve the biotechnology industries in the rich world of the genetic material it needs. These possibilities have encouraged some westerners to think that the poor world could come to the international negotiating table with some sense that it had cards to play, even if its attitude seemed unattractively that of the blackmailer (or, as *Rolling Stone* magazine called it, Greenmailer).

But, as Edward Mortimer of *The Financial Times* wrote during the Rio Earth Summit in 1992,[22] these tactics did not come powerfully into play at that meeting. For the time being at least the rich world is not much frightened by the Third World's capacity to do huge damage. Because Mortimer was one of the few writers to take seriously the proposition that the environment is now an important matter for North-South negotiation, it is useful to see what a dash of cold water he throws on the idea:

> Can the North's new-found interest in the global environment, and natural resources such as tropical rainforest located in the South, provide a . . . basis for a bargain? That, in essence, was the idea behind the Earth Summit, as its full title, the UN Conference on Environment and Development, suggests. Northern governments accepted that the South could not be expected to take ecological demands seriously unless its own agenda of economic development was addressed . . . Yet it is clear now that no real bargain has been struck in Rio.

Other writers said, rightly, that Rio was a success in putting many important subjects on the agenda of politicians and therefore of diplomats. But it was Mortimer who forcefully noted that there was no powerful sense of urgent interdependency, and certainly no sense of coherent blocks facing each other in negotiations.

The South is, for instance, deeply divided on such issues as whether energy should be taxed (the South contains oil-rich countries). Those countries which have rainforest dislike being told what to do with it. Conversely, the North is deeply divided about how important the issues of energy and rainforest actually are. In other words, there is no common position in the North, nor in the South. This deals a death-blow to the idea of a clear North-South polarity. There are no competing heaps of bargaining counters in play.

The South has nothing to bring to the table which the North needs. The few things it is in the North's self-interest to 'buy' from the South (lessened deforestation; low-energy economic growth; quickly lessened population growth) the South is in no position to deliver.

The only serious influence the North can wield is through aid or the cancellation of burdensome debt. In exchange for either, the North demands improved Southern governance. The North simply says: deliver these 'goods' to your public, or there will be no aid from us. This is not negotiation so much as arm-twisting. There is no

pretence of matched but competing needs being traded.

Except in the case of CFCs, where negotiations were in any case much easier than other greenhouse gases, it is the rich world which holds the cards and makes the conditions. When it is not bluntly imposing conditions, it tries to embarrass the South with high-sounding rhetoric about the green future of the world.

There are beginning to be some powerfully authentic pleas from various developing countries not to be patronised when politicians and electorates in rich countries wax sentimental about the value, say, of rainforest. The Prime Minister of Malaysia may have been using diplomatic histrionics when he complained of the tone of western governments on this issue, but he sounded serious and compelling enough.[23] The North shows no immediate sign of want-ing to switch from moralising to delivering real cash. Malaysia's primary industries minister, Lim Keng Yaik, appears not to have got very far when he said, during the Earth Summit, 'I'm poor and need my forests to get on in life, so if you want them you must pay – and give me technology and investment.' The North did not come run-ning with bags of cash.

The North may have a rude awakening. If their plight goes unat-tended, is possible that the poorest of the poor will become a political force in the regions where they live, and perhaps further afield, as their misery turns them into environmental, rather than strictly economic, refugees. They may also become terrorists as environ-mental degradation joins oppression as as disenfranchising force. Crispin Tickell – one of the first people to realise global warming was a threat – is one of those who speak of millions of people on the move, escaping infertile soils.[24]

Pressures such as these may bring a new urgency and self-interest to the North's concern to bring economic well-being to the South, especially by trying to help Southern countries become attractive to capitalist investment. Such pressures may encourage the North to help the South to be careful ecologically as well as thrusting economically. But it is at least possible that the South's poor will never be a serious threat to the peoples of the North. The alleviation of poverty will probably remain the problem it always was: a matter of conscience more than of expediency.

The transfer to the South of the best of the west – democracy, individualism, social cohesion, economic growth, and clean produc-tion techniques – will keep a generation or two busy. It will require

deliberate action as well as the vigour of markets.

Notes

1 Leach, G., *Beyond the Woodfuel Crisis* (London: Earthscan, 1988).

2 Ward, B., *Towards a World of Plenty* (Toronto: University of Toronto Press, 1968); *The Rich Nations and the Poor Nations* (New York: W. W. Norton, 1962); *The Home of Man* (Harmondsworth: Penguin 1976); *Progress for a Small Planet* (London: Earthscan, 1989).

3 My candidates for the literature of hope are listed in Further Reading.

4 Meadows, D. *et al.*, *The Limits to Growth* (London: Pan Books, 1972).

5 Simon, J. and Kahn, H., *The Resourceful Earth* (Oxford: Blackwell, 1984).

6 Simon, Julian, *Population Matters* (New Jersey: Transaction Publications, 1990).

7 Meadows D. and Randers J., *Beyond the Limits, Global Collapse or a Sustainable Future* (London: Earthscan, 1992).

8 Porritt, J., *Seeing Green* (Oxford: Blackwell, 1984), p. 116.

9 The Development Centre of the Organisation for Economic Co-operation and Development, Paris, has produced a series of monographs on the effects of structural adjustment.

10 Perhaps especially Dodwell, D. 'Environment better served by free trade carrot than protectionist stick', *Financial Times*, May 13 1992; and Mortimer, E., 'How to pay for eco-virtue', *Financial Times*, June 3 1992.

11 Page, S., Davenport, M. and Hewitt, A., *The GATT Uruguay Round: Effects on Developing Countries* (London: Overseas Development Institute, 1991).

12 Lang, T., *Food Fit for the World?* (London: Sustainable Agriculture, Food and the Environment (SAFE), February 1992).

13 For a sense of the argument, compare 'How to pay for eco-virtue', Edward Mortimer, June 3 1992 (pro-free trade view) and David Nicholson-Lord, 'Civilisation for sale', *Independent on Sunday*, December 12 1993 (which has a reference to Tim Lang, director of Parents for Safe Food, who has worked with Goldsmith, and who co-authored, with Colin Hines, an anti-GATT book).

14 World Bank, World Development Report 1990: Poverty (Oxford: Oxford University Press).

15 World Development Report 1992: Development and the Environment.

16 World Development Report 1991: The Challenge of Development.

17 Human Development Report 1990: Poverty.

18 Chambers, R., *Rural Development: Putting the Last First* (Harlow:

1983).

19 Dowden, R., 'White man's burden', BBC2 *Assignment*, March 9 1993.

20 Killick, T., *Explaining Africa's Post-Independence Development Experiences*, Working paper 60, Overseas Development Institute, London, 1992.

21 North, R., *The Real Cost* (London: Chatto and Windus, 1986).

22 Mortimer, E., 'Southern Discomfort', *The Financial Times*, June 12 1992.

23 Speech at Earth Summit, Rio de Janeiro, June 1992.

24 See also Homer-Dixon, T. *et al.*, 'Environmental change and violent conflict', *Scientific American*, February 1993.

Epilogue

In Monterrey, Mexico (May 1993)

Compare the gleaming cities of Texas to dusty Monterrey, in northern Mexico, and you discover very quickly that the 'Third World' does not really exist any more. And what there is of it has strange, amorphous borders. As I headed south, looking for the Third World of modern myth, the Stateside cafes were thronged by the scruffy, disturbed poor of the very rich United States. It was more relaxing to arrive, at midnight, at the border town of Nuevo Laredo, straddling the Rio Bravo, as the Mexicans call the Rio Grande. In the small hours in Monterrey itself, one felt one was among the ordinary, rather cheerful, bustle of poor countries anywhere.

Hanging on to the end of the United States, Mexico has been cast as a victim and a villain in recent times. Two very different American groups argued that the countries should keep their distance from each other. Greens are worried that the North American Free Trade Agreement, which came into force on 1 January 1994, will result in pollution in Mexico. The protectionists worry that – in Ross Perot's words – there will be a big sucking sound, as US jobs are vaccuumed south. With luck, both predictions will be proved wrong, but the talents and job-hunger of the Mexicans may make Perot's case the stronger. An uprising in a poor southern Mexican agricultural state in early 1994 threw a powerful spotlight on the difficulties the poorest farmers would face as subsidies came off their main crop, maize, while their markets were opened up to new competition from abroad. Besides, powerful local landlords seemed able to maintain an old-fashioned grip on power and advantage, whatever the reformers in far away Mexico City might decree or desire.

Each morning in Monterrey, an industrial city which seemed light-years away from these rural concerns, I would step out into the strange mish-mash of worlds Mexico is becoming. And each morning, the same surprise: there was something odd about the air. It was, if anything, sweeter than London's. Monterrey straggles haphazardly through heat-haze in the valleys and on the slopes of impressive mountains. The eagle cruising a thermal could look down on miles of freeway. Everywhere, there is the squeal of tyres on hot, polished concrete. Huge industrial plants litter several districts of the city. And yet, there simply is no pall of effluent in the air even though there are dark rumours of cowboy firms releasing effluent at the dead of night.

John Wolis, an American-born resident and Mexophile, explained the air. Cars now have their emissions tested twice a year. Wolis goes on: 'There used to be terrible public transport here. It was mostly old school buses from the States. Then the city simply confiscated thousands of these buses and parked them all down by the river. Now, you just do not see a bus spew out fumes.' In another sweeping change, the city insisted on cleaner taxis. Entrepreneurs bought 17,000 replacement vehicles, many of them VW Beetles with the front passenger seat ripped out for ease of access.

For Wolis, the key to this sort of rapid change is that Mexico is an autocratic country, and a pragmatic one. Shades of its Spanish origins there. 'Once people decided they couldn't breathe the air, they decided to fix it, and no one complained,' says Wolis.

I had gone to Mexico looking for an idle, incompetent, happy-go-lucky world ready to be chewed up by hard-assed capitalists from the United States. I expected educated Mexican opinion to be antagonistic to industry, as it would be in Europe. Actually, there seemed near-universal enthusiasm for industrial development.

Victor Zuniga, a sociologist more worried than many about environmental hazards, says, 'Mexicans know that they can't tackle environmental problems as they would like, because they haven't got the money.' Dr Zuniga accepts that more, not less, economic development is at least part of the answer. He is a member of the Colegio de la Frontera Norte, a team of postgraduate researchers funded by the government to study the development issues which the region faces. The Colegio has become one of the most powerful voices for environmental clean-up in the north, alongside some powerful women's groups.

Mexicans suggest that some of the environmental problems south of the Rio Bravo are not quite as advertised. From the US campaigners' perspective, the US-owned plant in Mexico, the *maquiladoros*, are nasty sweatshops. Dr Zuniga says: 'New industry has brought pollution problems to the territory, but the greater difficulty is the lack of urban infrastructure in the border cities.' While big industries – and perhaps especially the foreign-owned firms – are fairly well regulated, armies of hopeful Mexicans have descended on towns in which housing and roads have not kept pace. Water management is a monster of a problem in the north, as it is for the whole of the country.

Mexico has long been famous for the corruption and chicanery of its politics (the asassination of Luis Donaldo Colosio, the presidential heir-apparent in March 1994 made the point in an extreme way). President Carlos Salinas is generally believed to have rigged the election which brought him to power for the six-year term which ends in 1994. It has not stopped him being widely admired, in spite – or perhaps because – of his forcefulness in running the economy while opening it up. According to Victor Zuniga, Mexicans like a strong, almost paternalistic, leadership. The constitution does not allow Salinas to be re-elected, but his likeliest successor is in the same mould and even the leading opposition candidate from the left has realised he must drop the anti-capitalist rhetoric.

Much more than an Anglo-Saxon expects of a Hispanic country, Mexico is a test bed for the idea that capitalism and sensible government can work together to create and spread wealth. The country has, according to Dr Zuniga, a marked social cohesion. The 1994 uprising was unusual partly because such events have been very rare in a society in which deference and a pleasure in national identity are notable traits. Indeed, it is not clear how much the uprising was a genuine peasant affair, and how much the displaced activity of rebels no longer finding an outlet in other South American countries.

No one would claim that Mexico is a perfect place. Nonetheless, it is one of the stars of the United Nations' Annual Human Development Report. This is a 'Third World' country which contrives strong economic growth with much better than average improvement in education, health and welfare for its people. Now, Mexicans are wondering whether a strong trade union movement will develop. So far the bosses have kept the upper hand.

Yet, while Monterrey's industrialists are conspicuously successful,

many of them seem to want to be good citizens, too. The city is headquarters to Vitro, one of the world's biggest glass companies. In a classy new hacienda-style office building replete with sixteenth-century art and a decor which somehow combines the monastic and the palatial (more shades of Spain), the retired chairman of the firm, Adrian Sada, is determined to dispel all European stereotypes. 'We have joint ventures with your Pilkington Glass and with many other big firms around the world. We are advanced to the point that while shortage of technology is a factor, it isn't the biggest problem. We need markets, and especially capital, more.'

Sada insists that the workers in his glass firm are at least as well treated as any he's seen around the world. 'I know this is so because I know the people, the products and the processes of industries in several countries,' he says. Vitro bought glass firms abroad, and entered into ventures with others, not least so as to size up their operations. Sada, every inch the patrician, concedes that his people are paid less than westerners, but insists that the shortage – and huge cost – of local capital decrees that employment is found for more people than would be needed in the west. He even resists the idea that Mexico is building its industry on aggressive exploitation of its resources. For instance, though Mexico has soda ash of its own, Vitro imports the stuff from Wyoming because it's better.

'In the end, it's our technology which makes us competitive,' says Sada. This is the key to the US industry's combination of nervousness and enthusiasm about Mexican workers: they are cheap, but good. Maybe too damned good. Even the *maquiladoros* American capitalists built in the north have become star production units. 'The Mexican Worker: Low wages. High Quality. How Mexico does it – and the impact on world trade,' ran the cover headline on an issue of *Business Week* in spring 1994.

Monterrey, which is Mexico's Birmingham or Milan, proves that the technical skill and energy did not have to be imported from the United States. The city's engineers have, for instance, improved the design of mini steel mills, which are by common consent the development which has most transformed metal-bashing in the past twenty years. There is a vast old-fashioned steel mill in the middle of town, a rusting hulk of a thing, which was shut down years ago and is about to become an industrial theme park.

From the windows of his own steel company, Eugenio Clariond can see the old plant and reflects how over recent years Monterrey's

industry has largely stopped belching out fumes. He is Mexico's representative on the Business Council for Sustainable Development, the brainchild of Stephan Schmidheiny, the Swiss billionaire. The Council is the first systematic attempt by industry to try to discover an accommodation between economic growth and ecological soundness. Clariond points to a hard economic reason why Mexico has to clean up: if it does not, US corporations – terrified of future environmental litigation – will not invest.

No one suggests that Mexico – or any other country – has acheived a reconciliation between ecology and economic growth, but at least there is vigorous interest in the theme. 'I had no real concern for this subject a few years back,' says Clariond. 'But I was kidnapped by Stephan and my participation is now very personal: I am committed now. We have had to invest quite heavily in order to be a member of the sustainable development group without compromising my own ideas about what it is right to do.'

He now proselytises other, smaller firms, where the problem is not so much shortage of interest (though that's a problem), but shortage of skills and cash. 'We have done a lot of work to control our use of chemicals such as solvents, but I could tell you about thousands of small paintshops and workshops which are releasing solvents to the air: how do you control them? That's a big problem in the west, and a much worse one here in a developing country'.

At the other end of the scale, there is the problem of cleaning up the legacy of the old smokestack industries which everyone faces. 'And,' says Clariond, 'that's just a tiny fraction of the mess which Pemex, the state-owned petrol company, has made wherever it's gone. The problem with that sort of operation is that it's hard to hold them accountable. As businessmen we feel strongly that Pemex must be privatised, and then we can tackle its high-sulphur fuels, low quality gasolene, and the bad environment standards of its refineries.' To be fair, Pemex has shut down some of its most polluting plants, notably a filthy refinery near Mexico City.

One sign that Mexico's industrialists are hardly the top-hatted ogres of tradition is the scale of their funding of ITESM, the city's Institute of Technology, a postgraduate study centre. The Tec is at the heart of a network of twenty-six daughter campuses all over the country, each linked to Monterrey by satellite. In autumn 1993, President Salinas opened the institute's Centre for Sustainable Development. This is a twenty-storey tower in green glass, solar-

powered in part. The centre's student roll has grown dramatically in the last five years. There is state funding for one year at their erstwhile western salary for Mexican academics who head for home. These are people with western environmental views, so in effect companies are paying for the sticks which will beat their own back, and for the kit which will monitor their trickiest emissions.

One of Monterrey's most passionate environmentalists is Sonia Ramos, who worked as a civil engineer in Japan before returning to Mexico to work at the Tec. She took me on a tour of the most heavily-industrialised neighbourhoods in one of the city's many downtown areas. The biggest works is a huge and sprawling cement factory, complete with quarry. It is surrounded by neat and tidy but very modest houses – shacks really – which were built fifty years ago for the cement workers.

Ramos says: 'It would be far cheaper to move the people, but the people prefer to stay.' So, its offers of resettlement payments spurned, the works had to clean itself up. Sonia Ramos knows this Cemex site well and points to bits of new equipment which control its emissions. Cemex offered its immediate neighbours the chance to make gardens on their side of the factory wall. Now, each patch is named after a girl's name, or with exhortatory slogans such as 'Hope in the Future'.

'What a little money and work will do, Monterrey people will do,' says Ramos: she has fierce pride in the enterprise of the place. It is a theme echoed by Wolis: 'I have built and run factories all over the world, and the interesting thing about the Mexicans is that they are very ingenious. I know the Koreans, say: very methodical, and they run things with very tight control. But the Mexicans would come to me with creative solutions to problems.' Wolis says the same sort of attitude applies to Mexican environmental regulation: the agencies may be understaffed and underfunded, but, he says, 'They have enough people who know what's going on to know pretty well who to target and who they can afford to trust a little.'

All in all, the west patronises Mexico, and other so-called Third World countries, at its peril. Indeed, the west's attitude may even be part of what energises these countries. Rafael Rangel is the extraordinarily dynamic president of Monterrey's Tec. He has felt the force of European condescension: 'I visited Geneva and Zurich, and the attitude was that they couldn't believe that Mexicans can have really good technology.' He was speaking in a building which houses

a US$34 million super-computer (shared with the country's largest private bank), and in a room in which students will learn how to programme the latest robots. Mexico is looking forward to proving the outside world wrong.

Meanwhile, I met many Mexicans who combined their interest in economic growth and environmental clean-up with something a little like snobbery about America. 'We want their affluence, but we do not want their social breakdown,' said one man. Dr Zuniga, the sociologist, was optimistic. He was speaking in a suburb of a city in which satellite dishes beamed American TV into every home, but still believes: 'Mexicans can take what we want of the modern world and yet keep our traditions when we go home.' Now that would be a trick.

Further Reading

In Chapter 12, I spoke a little about the literature of hope. It seems now a good idea to put together a list of some of the books and sources which have shaped my thinking towards a cheerful rather than a despairing view of the past, present, and future prospects of human tenure on earth. This is not a list of all the influences which shaped my thinking: it is a list of those counter-intuitive books which did not merely please me but confronted my earlier green pejudices.

Firstly, it is important to acknowledge newspapers such as *The Financial Times* and the *Wall Street Journal* for pursuing their brief of informing moneymakers with perennially interesting articles about the plight of the poor whom moneymaking too seldom reaches. In a world in which hype afflicts so much journalism, they have dared to be dull. Good. I owe a great debt to the *Economist* magazine, whose reporting of the wider world is astringent, perceptive and far more morally driven than some might expect of a journal which likes to be loftily in favour of free trade whatever its consequences. In the past, the paper's impulse in kindly directions might partly be attributed to Barbara Ward (of whom more later), and more recently – oddly considering his giddy eccentricity of style – to Norman Macrae (for many years the paper's deputy editor and latterly a *Sunday Times* columnist), and very recently to Frances Cairncross, the paper's environment correspondent (see below).

Economist writers have traditionally helped make the World Bank's *World Development Report*, (published annually by Oxford University Press, Oxford and New York) readable as well as true to the relatively unfettered thinking of some of the bank's brightest staff. The *WDR* is a little too optimistic even for my taste, but is a reliable antidote to gloom.

The United Nations and its agencies often strike one as being too carefully liberal, even-handed and perhaps even politically-correct for strict honesty. On the other hand, for the sheer elegance and unexpectedness of much of their data and some of their insights, one is bound to respect offerings such as the United Nations Centre for Human Settlements' *Global Report on Human Settlements* (Oxford University Press, 1986) as a rich compendium on urbanisation, planned and unplanned. It will already be clear what I owe to the annual United Nations Development Programme's *Human Development Report* (Oxford University Press); the United Nations Population Fund, UNFPA, and its annual *State of the World's Population*; the United Nations Children's Fund (UNICEF), and its annual *The State of the World's Children* (Oxford University Press). The World Health Organisation, a UN agency, produces wide-ranging work, some of it perhaps a littler doctrinaire. But I found *Our Planet, Our Health*, the report of the WHO Commission on Health and the Environment (WHO, Geneva, 1992), very useful and cheering.

Most writing about ecology is rather gloomy about the role of human life on earth, and James Lovelock is not exactly a forthright fan of the human enterprise. All the same, he is luminously lovely about the very biggest of ecological systems, the entire planet and its chemistry, and I much enjoyed his *Gaia: A New Look at Life on Earth* (Oxford University Press, 1991) and *The Practical Science of Planetary Medicine* (London: Gaia Books, 1991). There is also a good deal to learn from Cosmos, *Earth and Man: A Short History of the Universe*, by Preston Cloud (New Haven: Yale University Press, 1978).

The rather slight anti-misery tendency in ecological thinking has solid and interesting antecedents. I very much recommend John Maddox's *The Doomsday Syndrome* (London: MacMillan, 1972) as a prescient piece of informed propaganda. John Maddox, the editor of *Nature* then and now, is updating this book, and it will make fascinating reading. Julian Simon and Herman Kahn edited *The Resourceful Earth* (Oxford: Blackwell 1984) as a counterblast to the ecological hype they saw all about them. I loved it then and love it now, though I suspect it does not attempt quite the balance it might. Julian Simon is producing an updated version of his *The Ultimate Resource* which is likely to appear in 1994.

The Greening of Africa (London: Paladin, 1987) and *The Third Revolution* (London: Penguin, 1993) are both important books by

Paul Harrison (the writer, by the way, of recent UNFPA *State of the World's Population* annuals). *The Greening of Africa* was the first systematic attempt to understand how Africa's farming peasants might develop soil-conserving methods of increasing production. *The Third Revolution* is a useful account of environmental issues around the world, including soil conservation. Harrison is clear that free markets and cash crops are important to poor farmers. However, I remain sceptical that Harrison's books are as useful as they would be if they were less dogmatically in favour of 'small is beautiful' and I think they are too generally biased in favour of thinking that the little person always knows best.

Rather similarly, it is hard not to like Fred Pearce's *Turning Up the Heat* (London: Bodley Head, 1989), a useful account of some of the biggest issues we face. Yet some of his other work, say on water management in his *The Dammed* (London: Bodley Head, 1992), seems too determinedly gloomy and monochromatic. On the subject of water, I preferred Bill Adams' *Wasting the Rain: Rivers, People and Planning in Africa* (London: Earthscan, 1992).

Barbara Ward was some sort of genius, as is surely shown by her *Towards a World of Plenty* (Toronto: University of Toronto Press, 1968) and *The Rich Nations and the Poor Nations* (New York: W. W. Norton, 1962). *Only One Earth* (co-written with René Dubos, (1992) (London: Earthscan, 1989), *Progress for a Small Planet* (1979) (London: Earthscan, 1989) and *The Home of Man* (Harmondsworth: Penguin, 1976), were all important to the thinking of a generation, and trod a fine line between realism and romance, between being right-on and blunt.

The sheer freshness of the view in *Conservation in Africa: People, Policies and Practice* (Cambridge: Cambridge University Press, 1987), edited by David Anderson and Richard Groves, made it a vital contribution to the vexed and continuing problem of thinking about wildness in Africa. A very different sort of book, by Martin Brown and Ian Goldin, *The Future of Agriculture, Developing Country Implications* (Paris: Organisation for Economic Co-Operation and Development, Development Centre, 1992) made me feel the world could be fed.

For a useful discussion on the tragedy of the commons and many other ideas which have gained perhaps too much currency, I recommend John McCormick's *The Global Environmental Movement* (London: Belhaven 1989).

The classic account of human relations with the natural world in

recent history is and will probably remain Keith Thomas' *Man and the Natural World, Changing Attitudes in England 1500–1800* (Harmondsworth: Penguin, 1984). It has the enormous merit of not pursuing a single line, but rather revealing that the British have always conducted a complicated relationship with nature, in which fear, respect and abuse have lived side by side. Granted René Dubos' work with Barbara Ward (see above), I was a little surprised and very delighted to find that *The Wooing of Earth* (London: Athlone Press, 1980) proposed that human alteration of the planet was inevitable and natural and demanded of us a certain *noblesse oblige*.

The idea that economics need not be dissociated from ecological considerations needed bold exploration, which one finds in any of the books by David Pearce, beginning with his co-authored *Blueprint for a Green Economy* (London: Earthscan, 1989). This is probably the basic textbook, but see also Frances Cairncross' *Costing the Earth* (Harvard Business School, distributed in the UK by McGraw Hill, 1993). (Economics applied very directly to natural resources can be found in Swanson, T. and Barbier, E., *Economics for the Wild: Wildlife, Wildlands, Diversity and Development* (London: Earthscan, 1992) and Barbier, E., Burgess, J., Swanson, T. and Pearce, D., *Elephants, Economics and Ivory* (London: Earthscan, 1990).)

Because 'saving the rainforest' is so poignant a call to many people, it was fascinating to find that intelligent work showed there were many ways of skinning this particular cat, including Gradwohl, J. and Greenberg, R., *Saving the Tropical Rain Forests* (London: Earthscan, 1988) and Duncan Poore's *No Timber Without Trees* (London: Earthscan, 1989). Similarly, it was refreshing to find that Jeremy Cherfas could write about whales without regurgitating the usual line. So I was delighted to have his *The Hunting of the Whale* (London: Bodley Head, 1988).

And then, of course, there was Gerald Leach's co-writing of the *Beyond the Woodfuel Crisis* (London: Earthscan, 1988) which first mentioned the literature of hope. Many of the authors above (Ward, Leach, Poore, Barbier, for example) worked or work with the International Institute for Environment and Development, and so it may be right to suggest that if there is a literature of hope, this is the Institute of Hope which importantly spawned it.

Index

Life on a modern planet

How will the world feed and care for the 10 billion people who are likely to be alive within a couple of generations?

In this major reevaluation of global environmental questions, Richard North provides a controversial answer: mankind should be able to cope rather well. He argues that the enlightenment ideal of progress is still possible, and that we can nurture and value all human life whilst taking care of the natural world.

North offers a skilful examination of the prospects for food, energy and materials provision for the human race, both present and future. Via a series of case studies he reinterprets the major contemporary environmental issues, such as feeding the growing global population, energy production, global warming, pollution, the protection of biodiversity and green consumerism. The Braer disaster, Camelford, the chlorine industry, Greenpeace, the American rangelands and spotted owl controversies, and rainforest deforestation are among the issues and incidents which come under his critical gaze. Hundreds of wide-ranging references root the book's arguments in fact, not just in theory.

The message is radical, fresh and ultimately optimistic: an antidote to what has become the pessimistic Green orthodoxy. Richard North draws on 15 years of broadsheet environmental journalism to rekindle the environment and development debate.

Richard North has written on environment and development issues for the *Independent*, *The Sunday Times* and *The Observer*.

Issues in Environmental Politics

Series editors Tim O'Riordan, Arild Underdal *and* Albert Weale

already published in the series

Environment and development in Latin America: The politics of
sustainability *David Goodman and Michael Redclift eds.*
The greening of British party politics *Mike Robinson*
The politics of radioactive waste disposal *Ray Kemp*
The new politics of pollution *Albert Weale*
Animals, politics and morality *Robert Garner*
Realism in Green politics *Helmut Wiesenthal (ed. John Ferris)*
**Governance by green taxes: making pollution prevention
pay** *Mikael Skou Andersen*
The politics of global atmospheric change *Ian H. Rowlands*